Pre-Raphaelite Sculpture

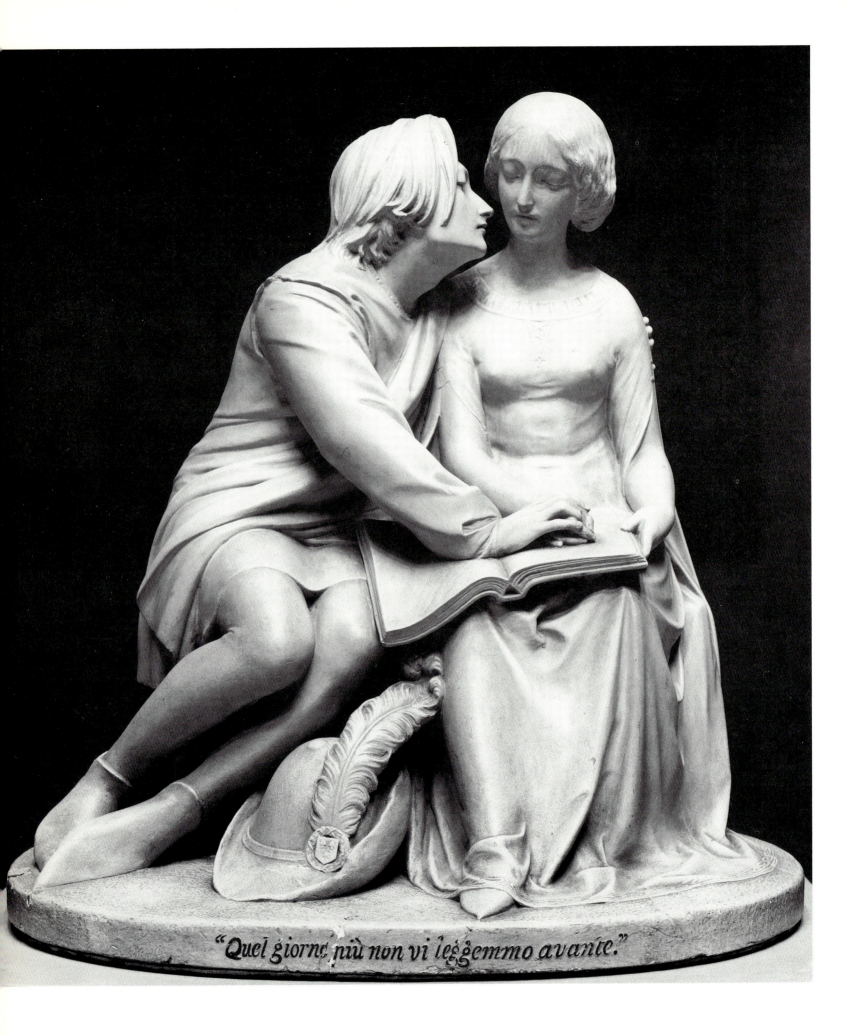

"Quel giorno più non vi leggemmo avante."

Pre-Raphaelite Sculpture

Nature and Imagination
in British Sculpture 1848–1914

Edited by Benedict Read
and Joanna Barnes

with contributions by
John Christian, Martin Greenwood, Thomas Beaumont James,
Alexander Kader, Katharine Macdonald, Leonée Ormond,
Juliet Peers

The Henry Moore Foundation
in association with
Lund Humphries, London

First edition 1991

Published by
Lund Humphries Publishers Ltd
16 Pembridge Road, London W11 3HL
in association with
The Henry Moore Foundation

Published on the occasion of the exhibition
Pre-Raphaelite Sculpture, organised by
Joanna Barnes Fine Arts Ltd, held at

The Matthiesen Gallery, London
31 October – 12 December 1991
and
Birmingham City Museum and Art Gallery
15 January – 15 March 1992

British Library Cataloguing in Publication Data
A catalogue record for this book is available
from the British Library

ISBN 0 85331 609 0

Designed by Harold Bartram
Made and printed in Great Britain by
BAS Printers Limited, Over Wallop, Hampshire

Frontispiece: Alexander Munro, *Paolo and Francesca*, plaster,
1851. Wallington, Northumberland

Contents

Preface

In this exhibition we are presenting for the first time a previously unassembled area of sculpture. Many of the exhibits, selected from private and public collections throughout Britain, have not been seen in public since the time of their making. Although there have been numerous Pre-Raphaelite exhibitions, until now none has been devoted solely to Pre-Raphaelite sculpture. Our intention is not only to start redressing the balance, but also to examine the fuller consequences of sculpture and Pre-Raphaelitism which have never been put forward in recent times. In addition to Woolner, Munro, Hancock, Smith and Tupper, sculptors whose association with the Brotherhood is well documented, we are making a case for sculptors of the calibre of Frampton, Gilbert and Reynolds-Stephens as inheritors and successors of Pre-Raphaelitism.

We would particularly like to thank Sir Alan Bowness without whose help the venture would have been considerably more difficult; Patrick Matthiesen not only for generously providing the London venue, but also for his enthusiastic encouragement; Evelyn Silber and Jane Farrington for lending their support and providing a second location for the exhibition; Philip Ward-Jackson for uncomplainingly travelling around Britain to take photographs in obscure locations and producing excellent results; Martinspeed Ltd for their kind sponsorship; Dr Andrew Ciechanowiecki for his generosity and support; Charlotte Burri for her sympathetic assistance in editing the manuscript and John Taylor for his gentle insistence upon the schedule. Joanna would also like to thank her long-suffering family. Finally we would both like to thank the lenders, without whose generosity there could have been no exhibition.

Benedict Read and Joanna Barnes

Introduction
by Benedict Read

'At Amathus, that from the southern side
Of Cyprus, looks across the Syrian sea,
There did in ancient time a man abide
Known to the island-dwellers, for that he
Had wrought most godlike works in imagery,
And day by day still greater honour won,
Which man our old books call Pygmalion.'

figs 1–2 Thomas Woolner, *Moses with the stone tablets of the Law, veiling his face on the Mount*, original plaster model, 1857. Location unknown
Thomas Woolner, *David Harping*, original plaster model, 1857. Location unknown

These lines start the first of the August poems in William Morris's *The Earthly Paradise* dealing with the story of 'Pygmalion and the Image'. The argument of the story is set out: 'A man of Cyprus, a sculptor named Pygmalion, made an image of a woman, fairer than any that had yet been seen, and in the end came to love his own handiwork as though it had been alive: wherefore, praying to Venus for help, he obtained his end, for she made the image alive indeed, and a woman, and Pygmalion wedded her.'[1] Images of women fairer than any that had yet been seen are by now only too familiar (and rightly so) to anyone in the least interested in the Pre-Raphaelites, but in all the literature and publicity on the movement since, say the end of the Second World War, which is now extensive and thorough, there has been little attention paid to sculpture in the Pre-Raphaelite context,[2] so that the sudden appearance of a sculptor and a life-enhanced work of sculpture in Morris's poem could seem a rogue blip on the screen of normal Pre-Raphaelite consciousness.

On the other hand, if one goes back to some of the original documents of the movement a sculpture presence is positive. The second entry in William Michael Rossetti's *The P.R.B. Journal* records the sculptor John Hancock having asked the sculptor Thomas Woolner, whether he might put PRB to his works,[3] J. L. Tupper, Bernhard Smith and Alexander Munro, all sculptors, feature at different times and to differing extents. At least thirteen works of sculpture by members of the circle are mentioned between May 1849 and January 1853; one of these by J. L. Tupper, a bas-relief illustrating Chaucer's *Merchant's Second Tale* is described as being 'at the extremest edge of P.R.Bism, most conscientiously copied from Nature, and with good character. The P.R.B. principle of uncompromising truth to what is before you is carried out to the full'.[4] In articles on 'The Subject in Art' in *The Germ* sculpture nearly always follows painting when Art is defined – the articles themselves are by the sculptor Tupper. Three sculptors, Pheidias, Ghiberti and Flaxman, feature in the list of Pre-Raphaelite Immortals (plus one painter-sculptor Michelangelo),[5] while discussions specifically on sculpture could take place – on Thursday 14 February 1850 we read of Woolner, Smith, W. M. Rossetti, Tupper and Holman Hunt holding 'an argument of frightful intensity concerning what Eastlake says of the properties of sculpture' which was maintained for some hours; 'but, when Woolner began to gnash his teeth, we left off'.[6]

Having established a presence for sculpture and sculptors in the days of the movement's closest coherence, it would be wrong to view it too exclusively. There was possible at times a quite clear interface between painters and sculptors: in September 1849 Woolner was being advised to execute in marble a figure of St Luke Rossetti had earlier designed for a picture;[7] there are clear interweavings of inspiration between Dante subjects of Rossetti, Munro and Hancock in the late 1840s and 1850s (see pp.48, 73); Rossetti and Madox Brown later felt free to criticise Woolner's *Bacon* (p.26; fig.17) with possibly some success;[8] Rossetti designed the tympanum of *King Arthur and the Knights of the Round Table* of 1857–8 at the Oxford Union building, executed by Munro and a *Pelican Feeding her Young* at Llandaff Cathedral of c.1860 executed by Edward Clarke; Rossetti and Elizabeth Siddal made designs for carvings at the Oxford Science Museum, Rossetti may even have actually carved a capital there;[9] Holman Hunt later occasionally made sculpture, both for and within a pictorial composition – see his large version of *The Lady of Shalott* for which he executed plaster reliefs of the Garden of Hesperides and dancing figures, while the memorial to Rossetti in Chelsea Embankment Gardens incorporates a bronze deep-relief portrait by Madox Brown.[10]

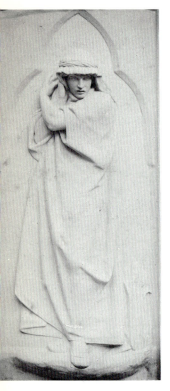
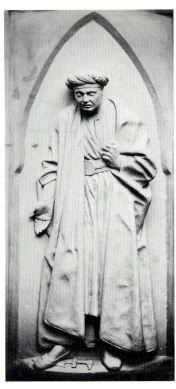

figs 3–4 Thomas Woolner, *St John the Baptist in a Camel's hair robe*, original plaster model, 1857. Location unknown
Thomas Woolner, *St Paul*, original plaster model, 1857. Location unknown

In addition we can see definitions of the properties of Pre-Raphaelite sculpture that are applicable in the movement as a whole. Holman Hunt specified as Pre-Raphaelite in sculpture 'excelling truthfulness' and 'strong poetic spirit'.[11] William Michael Rossetti proffered 'serious inventive thought in works of art' and 'care and detailed study of nature' in carrying them out.[12] Bearing these in mind, it is possible to detect in the work of all the sculptors concerned one or more of these properties in different degrees and combinations throughout their careers – it is possible to see a relentless truth to nature in Woolner's portraits (cats 68, 72, 83) (pock-marks and all) of Tupper's goatskin coat on *Linnaeus* (fig.39), a strong poetic spirit about Munro's *Paolo and Francesca* (cat.21) or Hancock's *Beatrice* (cat.16); the full range of these artists' Pre-Raphaelitism is investigated in the texts that follow. Even within the field of the portrait medallion (see cats 48, 49, 51, 52, 64, 66; fig.43) the various aspects of Pre-Raphaelitism each sculptor could contribute can be detected. This was a genre, not unknown at the time elsewhere (Joseph Gott, David d'Angers) which the Pre-Raphaelite sculptors tended to make their own, that is, they refined and brought a particular contribution to an art form already in fairly wide currency throughout Western Europe. Practised by both Tupper and Smith before their contacts with the movement, the new context sharpened its focus, no doubt inspired by the existence of early (i.e. pre-Raphael) Italian Renaissance prototypes, and it became a vehicle for sharp delineation of natural appearance (Woolner cats 57–63) or poetic character (Munro cats 21, 30).

A further particular context for Pre-Raphaelite sculpture was suggested by William Michael Rossetti, himself a full member of the Brotherhood and one whose information on the movement as he himself claims 'may be taken to represent with some degree of exactness and authority the aims and aspirations of the originators of the school'.[13] He claimed that foremost among the causes of the poor quality in the sculpture of the time was its divorce from architecture.[14] Elsewhere, describing the 'noble style' of thirteenth-century English figure sculpture from Wells Cathedral, he prescribed: 'the student who will put himself to school with Gothic works shall find their soul as vital to this hour as their form; more vital, rather, for he can improve in a variety of ways on the latter, – too happy only if in doing so he shall have penetrated deep enough into the former to make his improvements worth having'; the highest beauties of these monuments resided in 'the earnestness, the singleheartedness, and solemn yet impulsive gravity'[15] (cf. 'serious inventive thought' above).

This helps confirm a Pre-Raphaelite reading for Gothic Revival buildings such as the New Science Museum and the Union at Oxford or Llandaff Cathedral as restored. All three incorporate or at least envisaged a combination of two- and three-dimensional Pre-Raphaelite decoration. The Oxford Museum in addition to sculpture by Munro, Tupper, Woolner and possibly Rossetti and Siddal, foresaw at one point painted decoration by the Pre-Raphaelites as well.[16] The Oxford Union had murals by Rossetti, Burne-Jones, decorative painting by Morris, as well as the Rossetti/Munro doorway tympanum; while Llandaff had, in addition to sculpture by Woolner (figs 1–4) and Rossetti, a painted reredos by Rossetti and stained glass by Madox Brown and Burne-Jones.[17]

This reading of an element of Gothic into Pre-Raphaelitism was not solely W. M. Rossetti's – the *Art Journal* as early as 1851 had referred to 'a few young men who style themselves the Pre-Raffael-ite school, but more properly might be called the Gothic School',[18] while another member of the school, admittedly of the second generation, William Morris, wrote that the 'new' Pre-Raphaelite School 'was really nothing more or less than a branch of the great Gothic Art which once pervaded all Europe'.[19] In principle Morris was all for sculpture: he too may have carved a capital at the Oxford Museum incorporating 'foliage and birds, done with great spirit and life',[20] he experimented in modelling and carving,[21] he wrote *The Story of the Unknown Church* in which the narrator is designer-cum-sculptor of an abbey church and is described chipping away. On the founding of the Firm in 1861, 'Carving generally,

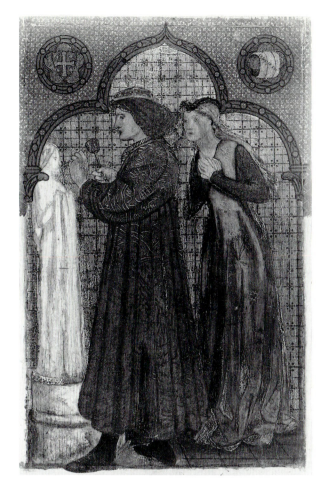

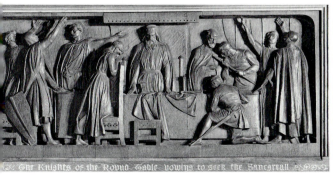

fig.5 Edward Burne-Jones, *Sculpture* from *King René's Honeymoon Cabinet*, 1861. Victoria & Albert Museum, London

fig.6 Henry Hugh Armstead, Detail frieze on the Model of the *Albert Memorial*, plaster. Victoria & Albert Museum, London

fig.7 Henry Hugh Armstead, *The Knights of the Round Table vowing to seek the Sancgreall*, wood. Palace of Westminster, London

as applied to Architecture' is listed in the opening prospectus among what was on offer,[22] while one of the painted panels on the 'King René's Honeymoon Cabinet' made for J. P. Seddon features sculpture, painted by Burne-Jones (fig.5). On the other hand it must be said that Morris's commitment to sculpture did not develop beyond the theoretical (unless we except the dragon he later carved in the hedge at Kelmscott)[23] and his concentration on other forms of decoration in buildings parallels the relatively figure-sculpture-free aesthetic of Butterfield and Waterhouse.

If one accepted for the moment a Gothic element in the definition of Pre-Raphaelitism there might be a danger of expanding the field to an extreme extent. There was after all a considerable body of sculpture work prepared in nineteenth-century England to go with Gothic Revival buildings, and the statuary by John Thomas on the external façades of the Houses of Parliament or that by Farmer and Brindley on Bradford Town Hall is all designed in a strictly 'Pre-Raphaelite' historically-suited style to fit in with a revived, post-classical, pre-Renaissance building. Indeed where an architect had a special feeling for sculpture on his Gothic buildings, as with Gilbert Scott, we can find foliate capitals (e.g. at Trefnant) whose sculptor has studied specimens of French carving of the thirteenth century backed up by observed natural specimens gathered from the woods and hedges around[24] to produce sculpture as true to nature as anything to be found in the Chapter House of Southwell, or the flora and fauna of Thomas Woolner. Scott derived his *Albert Memorial* from medieval shrines and early Christian ciboria, but only the sculpture on the model truly represented how he wanted it. This had been drawn out initially by his studio assistants, but finally executed by Henry Hugh Armstead (fig.6)[25] – and here we do perhaps attain a genuine Pre-Raphaelite sculpture without being of the movement which is an equivalent in sculpture to a revived Giotto style in painting. In fact it transpires[26] that Armstead was a lifelong friend of Holman Hunt's who transferred to sculpture from silverwork only about 1862. In addition to his frequent work with Scott, he had designed reliefs at Ettington for John Prichard (who was Seddon's partner at Llandaff) as well as the statue of *Aristotle* among the assembled scientists at the Oxford Museum. He executed for the reredos at Westminster Abbey figures of St Paul, David and Moses, the same subjects as on Woolner's Llandaff pulpit. Finally, for the Houses of Parliament he executed figures for the New Palace Yard arcade (*c*.1867–9) and a series of relief panels for the Royal Robing Room representing scenes of Arthurian romance of 1867–70 (fig.7),[27] these latter being in their way more sculptural Pre-Raphaelitism than anything the Pre-Raphaelites executed.

If this is pressing too far in expanding the field of Pre-Raphaelite sculpture, another area cannot be denied so easily. It is reasonable to demonstrate a contribution from the painter Dante Gabriel Rossetti to Pre-Raphaelite sculpture (see above), and one scholar has argued that Munro's *Paolo and Francesca* (see frontispiece & cat.21) is the only piece of Pre-Raphaelite sculpture precisely because of its D. G. Rossetti association.[28] What then are we to make of the impact of Burne-Jones on a younger generation of sculptors?[29] One cannot cavil at Burne-Jones as a second-generation Pre-Raphaelite, but if this is accepted, and the case for Rossetti's contribution to sculpture is accepted, then the designation of certain works by Alfred Gilbert, George Frampton and William Reynolds-Stephens as Pre-Raphaelite via Burne-Jones must follow. This is not a new suggestion; Kineton Parkes in 1921 derived certain works by Frampton from Rossetti, Morris and Burne-Jones,[30] while of Reynolds-Stephens he wrote: 'Consider his Lancelot and the Nestling or his Guinevere and the Nestling! [cat.44a & b] They are compact of the feeling which you get from a survey of Gilbert's Clarence Tomb at Windsor, combined with the medievalism of the later Pre-Raphaelite School. He is a consistent member of that school, for he is a craftsman as well as an artist.'[31] The Gilbert identification simply finalises the definition, as his inspiration from Burne-Jones is well documented. In Gilbert's *Fawcett Memorial* of 1887 in Westminster Abbey we read of 'its knight errant, lady in distress, and heavily robed saints deriving from the romantic dream world of the later Pre-Raphaelites – and in particular from the

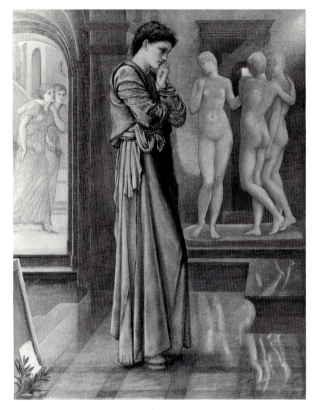

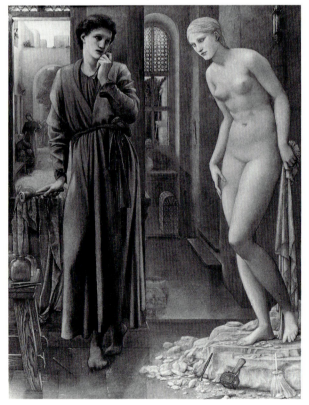

fig.8 Edward Burne-Jones, *Pygmalion and the Image* (I *The Heart Desires*), oil on canvas, 1878. City Museums and Art Gallery, Birmingham

cat.5 Edward Burne-Jones, *Pygmalion and the Image* (II *The Hand Refrains*), oil on canvas, 1878. City Museums and Art Gallery, Birmingham

paintings and stained glass windows of his . . . friend Burne-Jones',[32] while his St George on the *Clarence Tomb* at Windsor (col.pl.8) is held to 'epitomize the moment in the history of English art when the last flowering of Pre-Raphaelitism merged with Art Nouveau . . .'[33]

Burne-Jones's relationship to sculpture and its effect is examined more fully elsewhere. But his treatment of the Pygmalion myth in painting (figs 8, 9, 10 & cat.5) does bring us back to where we started, with the quotation from Morris's poem that eventually gave rise to the paintings. The myth is in itself almost a summary of the central concerns of Pre-Raphaelite sculpture: nature, the imagination, reality, art. In Ovid's account of the story,[34] which has always been the main source for later periods, one very much has the feeling of Nature rampant over art – fine, so Pygmalion does make an image to which he gives a beauty more perfect than that of any woman ever born. But nature is determined to overcome art; having fallen in love with the statue the sculptor kisses it and thinks his kisses are returned, he seems to feel his fingers sinking into the limbs he is groping. After a prayer to Venus he sets to again and his statue now responds almost like a blow-up rubber doll, yielding beneath his fingers as he touches her breast; he fears he is mistaken so keeps on again and yet again with his hand; finally he kisses her, she comes to life and nine months later a baby daughter Paphos is born.

Morris's version is rather bland by comparison.[35] It is only with divine sanction that life is brought to the work of art, the artist's marriage to her/it is almost a religious reward, i.e. triumph in art has a religious sanction, art is become religion and society (of which the marriage is a token). The Burne-Jones paintings in turn derive from Morris's poem, but there is perhaps an additional dimension beneath the surface of the story, in the artist's mingling of his life with the work of art, along the lines of Burne-Jones's drawings of himself jumping into the canvas, the artist submerged in art.[36]

A last version to be considered is the poem *Pygmalion* by Woolner, published in 1881. This is certainly lively though equally certainly not in the same way as the Ovid. Numerous elements tie in with the real-life sculptor and his work: he is 'ardent-eyed, of eager speech/which even closest friends misunderstood'.[37] In his works he seeks:

'to animate the forms he wrought
With nature's varied movement; pause and play
Of impulse: complex outwardly in strain
And laxity alert.'[38]

Elsewhere we read of 'The statue telling its own simple tale' (art for art's sake?), Pygmalion's father fighting the Egyptians (à la *Coriolanus*, fig.26) and Lycurgus' call to arms, not a million miles away from *Achilles Shouting from the Trenches* (cat.73).[39] In the matter of the statue coming to life and being married to the sculptor, Woolner evades an issue that could have embarrassed a man who felt so strongly in favour of the Deceased Wife's Sister Act which Holman Hunt ventured to disregard that Woolner never spoke to his brother-in-law again. In Woolner's *Pygmalion* the sculptor marries the model who resembles the statue, once divine sanction has enabled the sculptor to instil that element of vitality into his statue that he had previously only briefly observed in the model. Much of the rest of the poem is taken up by the thwarted attempted assassination of Pygmalion by representatives of the archaising school of sculptors (the tribe of Gibson?) in alliance with the inferior sculptors turned potters (who must be parian artists). Pygmalion then turns soldier, saves Cyprus from the invading Egyptians and is made king. There are nonetheless themes relating to Pre-Raphaelite sculpture – whether a statue that looks so like the model can represent a goddess (reality *vs* art) and indeed the central sculptural theme, the uniting of imagination and nature.

The story of Pygmalion, in its various treatments, encapsulates the central concerns of Pre-Raphaelite sculpture, the varying claims of nature, reality, poetry and the

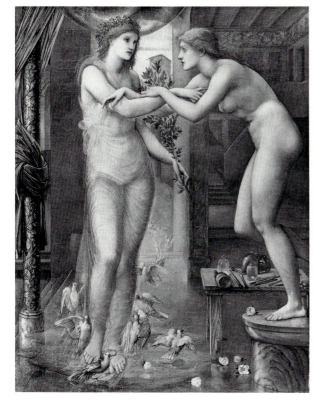

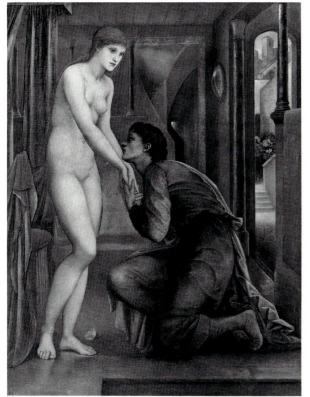

fig.9 Edward Burne-Jones, *Pygmalion and the Image*
(*III The Godhead Fires*), oil on canvas, 1878. City Museums
and Art Gallery, Birmingham

fig.10 Edward Burne-Jones, *Pygmalion and the Image*
(*IV The Soul Attains*), oil on canvas, 1878. City Museums and
Art Gallery, Birmingham

imagination on the work of art. This was not simply a small, incidental phase in the movement as a whole in its early days: it was an area of considerable theorising and practice by its various members that had a strength and vitality to grow and flourish through to the turn of the century. Perhaps now (to paraphrase Morris on Pygmalion) it should be allowed day by day to win still greater honour.

Notes

1 W. Morris, vol.IV, p.189
2 The exceptions are Gere; Tate Gallery 1984; Read 1984,
pp.97–110
3 Fredeman, p.3
4 *ibid.*, p.96
5 *ibid.*, p.107
6 *ibid.*, p.54
7 *ibid.*, p.15
8 See Surtees 1981, pp.185–6
9 See Blau, pp.74–5; Marsh, p.68
10 Bennett 1969, p.57; see Read 1982, p.273
11 Hunt, vol.I, p.128
12 Rossetti 1906, vol.I, p.160
13 Rossetti 1867, p.xi
14 *ibid.*, p.341
15 *ibid.*, pp.84–5
16 Blau, pp.74–5
17 See Seddon, pp.28–30, 49–51, 66–70; Read 1975–6, pp.6–15
18 *Art Journal*, 1 July 1851
19 M. Morris, vol.I, p.302
20 Blau, p.75
21 Mackail, vol.I, p.106
22 See Arts Council 1961, p.5
23 W. Morris, vol.IV, p.xvii & ill. opposite
24 Howell, pp.1086–8
25 See Read 1982, pp.159, 269, 161
26 See Armstead
27 See Handley-Read, p.29
28 The exceptions are Gere, pp.509–10; Tate Gallery 1984
29 See, in addition to John Christian's essay below, Read 1989, p.59
30 Parkes, vol.I, p.96
31 *ibid.*, vol.I, p.125
32 Dorment, p.63
33 *ibid.*, p.168
34 Metamorphoses x, 243–97; I am very grateful to Albert Read
for help with the original text
35 See W. Morris, vol.IV, 'The Earthly Paradise II', pp.189–207
36 Harrison & Waters, figs 209–13
37 T. Woolner 1881, p.3
38 *ibid.*, p.13
39 *ibid.*, pp.57, 82, 21–22

Bernhard Smith:
'The Missing Brother'
by Juliet Peers

To assess Bernhard Smith (fig.11), one must confront an artist who has little independent stature beyond the testimony of his own writings and those of his daughter. Neither source entirely fulfils the needs of scholars. Smith's opinions ebb and flow constantly in direct spontaneous prose. The mutability of his ideas makes it hard for an outsider to place him: several concurrent answers can be found among his letters for important questions such as why he gave up professional artwork or whether Australia oppressed or exhilarated him. Yet such issues would not have worried him. Independence of mind and philosophy was a long-standing trait of Smith. Even as a young man he eschewed the path of conventional success and it did not matter to him whether he followed the wishes and judgements of other people. To interpret Minnie Bernhard Smith's passionately committed writings involves a degree of diminution of the image of Smith, which she creates. To allow the limitations of Minnie Smith's manuscript to colour our perceptions of Smith renders the sculptor a disservice. This essay intends to outline the complexity and richness of Smith's artistic activities and create a less feeble persona than the artist is usually credited with in historical accounts.

William Michael Rossetti's published correction of the inaccuracies in a letter from Bernhard Smith to his brother J. P. G. Smith of Swegney Cliffs, Shropshire, 8 May 1881, casts a pejorative light upon the artist. Quoted by Smith's nephew W. A. G. Wise, in the *Pall Mall Gazette*, 8 Sept. 1886, in an attempt to claim the status of true Pre-Raphaelite membership for Smith, this letter stated, 'I still have a copy of Browning's Poems, given me by the Rossettis when, in 1847, I thought of turning farmer in the Far West, in which is written "To Bernhard Smith, P.R.B. from Gabriel and William Rossetti, P.R.B's. Beneath is the quotation from Browning's "Lost Leader"'. W. M. Rossetti refuted Wise's claim that Smith was 'the missing brother' as follows: 'Mr Smith must have been totally mistaken in saying that the book thus inscribed was given to him in 1847. In 1847 no such affair as the Pre-Raphaelite Brotherhood existed in any sort of way . . . Of course too, Mr. Smith was mistaken in identifying Browning's poems about Waring with his poem entitled *The Lost Leader*.'[1] The confusion regarding the title of the poem quoted and the date of the inscription in the Rossetti brothers' gift of a two-volume set of Browning to Smith was clarified in private correspondence between William Rossetti and Bernhard Smith junior.[2] Now severely damaged, Rossetti's letter provides a brief overview of the Pre-Raphaelite movement and reiterates his high regard for Smith as a person. 'Few indeed have I known to match him, either in geniality of character and bearing, or in the striking manly mould of his face and person.' The letter also provides a Pre-Raphaelite imprimatur for the medium of sculpture. 'The artists of the Brotherhood set to at painting pictures or carving sculpture of which the uncommoness of and after a while the fine and important qualities, were widely recognised.' Despite clarifying Smith's status in regard to the Brotherhood, this letter remained unpublished.

The impetus behind Minnie Bernhard Smith's attempts to prove her father was one of the 'Original Seven' Pre-Raphaelites differed from the views of her siblings, who believed that their father did not want to lay claim to the reputation of Pre-Raphaelitism, as his art career in Australia did not match those of his English associates. He was unhappy to exploit the achievements of others.[3] In the letter of 1881 Smith declared that '. . . It matters not to me now. Leave your friend in his opinion that I was not one of them. . . .' although he equally claimed that '. . . *they* were content that I was one of them'.[4] Minnie candidly admitted in a letter to Amy Woolner, that her father's 'modesty' should not prevent the truth from being published.[5] Her anxiety to establish her father's membership of a renowned art movement may reflect her own position, undermined by a double disadvantage of being a woman artist, and a sculptor, in a country where a cohesive audience and official support for sculptors only emerged after the arrival of abstract formalism in the 1950s and 1960s.[6] Such periods of systematic patronage for sculpture that existed at earlier times in Australia coalesced themselves around the exertions of individual sculptors, for example Charles Summers, Bertram Mackennal, Raynor Hoff and Thomas Woolner and dissipated upon their death

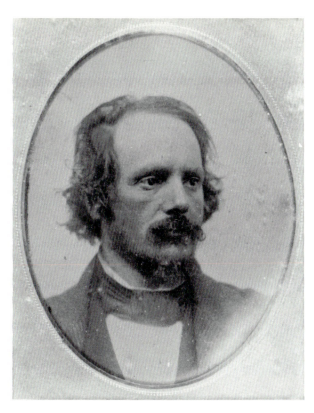
fig.11 Photograph of Bernhard Smith (1820–1885)

or retirement. Minnie Bernhard Smith, as a part-time New Sculptor, by profession a dressmaker[7] was in no position to command the network of contacts that made an impact upon civic authorities and art critics. Minnie's monograph on her father should not be dismissed as a personal crusade. Fascination with Pre-Raphaelitism in Australia, at least in the nineteenth century, was so directly articulated that in 1884 not only was the text of a lecture on Pre-Raphaelitism reprinted in several Melbourne newspapers from the respectable to the raffish, but three local citizens sent letters to *The Argus*, correcting the text, citing as their authority familial connection to the Brotherhood and its associates, through Deverell, F. G. Stephens and Bernhard Smith himself with his copy of Browning's *Poems* signed by the Rossetti brothers.[8]

Bernhard Smith shared a background from the lower reaches of the English gentry with many members of mid-nineteenth-century Victoria's cultural community.[9] Although not a member of the select circle of 'Port Phillip Gentlemen', the pre-goldrush Melbournians, he gained access to this circle, like Woolner, via Bateman. His mother's family, the Voases of Anlaby, outside Hull, had sufficient local importance to be patrons of the parish church of that district, live in a large home and be commemorated in various memorials in the church, including an East Window dedicated to Smith's father.[10] Bernhard's recollections suggest that he grew up in an atmosphere of frugality and self-sufficiency that sustained and shaped him throughout his life. He cheerfully undertook women's housekeeping duties, when a young artist in London, and maintained this habit in Australia even as a husband and father, in the face of Victorian convention, having previously enraged more slovenly tent companions on the goldfields by his neatness.[11] His sister Fanny sewed for him and maintained his wardrobe.[12] Whether this self-help ethos was an advanced social philosophy among the Smith family or simply the result of financial circumstances is not known, but there appears to be a dichotomy between the austere conditions described in his recollections and his family's adherence to cultured and refined values.[13] As an art student living at Blackheath, he rose at 5.30, made a cup of tea, left his home in the dark and walked eight miles to Sass's drawing school. Later in the day he moved to the British Museum, where he modelled and drew until 4 pm and then commenced his walk back to Blackheath.[14] He was known to be drawing from the casts at the Museum in 1838, and was contemplating entering the Royal Academy Schools in that year, although he did not enrol until two years later.[15] Much of Smith's social and cultural activities were centred upon the British Museum. He gained access to the circles of scientists and learned experts working at the Museum, through his uncle John E. Gray.[16] Among these early associates was the notable naturalist and entymologist Adam White.

The ivory disc Smith received on his entry into the Royal Academy Schools is dated 21 April 1840. When drawing at the British Museum, he had longed to gain access to the superior collection of 'heads' at the Academy. Once having entered the Schools, he appears to have grown dissatisfied. By October 1840 he was in Paris with letters of introduction from the Grays, which helped him establish contacts. There he took advantage of the Beaux-Arts system of training, but rejected those aspects of it that did not interest him. His original intention was to enter the atelier of David d'Angers, but a friend of the Grays, a Monsieur Olivier, an artist and engraver, advised Smith that David 'was too political a character and neglected his studio and schools for that passion'.[17] Smith's regard for the work of David d'Angers was not diminished as he classed him as one of France's most talented artists,[18] and particularly mentioned seeing a figure by him in a letter to England. As Smith's intention was 'to develop any genius that I may possess to the utmost' he chose the atelier of the sculptor Etienne-Jules Ramey, renowned as one of the most orderly in Paris. Its reputation was growing as more ex-pupils won prizes at the Beaux-Arts. A number of letters survive to chart Smith's activities in Paris. He emerges as more ambitious and talented than may be assumed from later speculation, as well as giving a lively picture of life under the régime of Louis Philippe. Though he deplored violence and affected behaviour, Smith moved among French associates and students, who actively talked of revolutionary politics.

He also participated in the more benign and hedonistic aspects of Parisian life and describes public fêtes and walking in the parks and palace gardens.

Somewhat to the chagrin of more experienced students, Ramey took note of the young Englishman, and set him to model medallions under his direct supervision, promoting him to a high position in the studio, and acquiring one of Smith's works to be cast. Ramey's taste makes itself directly felt in the little that is known of Smith's œuvre. Considering the subsequent importance of the portrait medallions to Pre-Raphaelite sculpture, it is interesting to note that, as early as April 1841, Smith was modelling 'from medals, casts which [Ramey] made at Rome'.[19] Far from being a diminution of his early talents, Smith's line drawings of fairies leads directly back to his Paris experiences. '[O]ur masters Ramey and Dumahl are always trying to impress on the students to study the antique Poussin and Flaxman'. Smith notes that reproductions of Flaxman's works were available cheaply in Paris.[20]

Smith had a comprehensive knowledge of art history, although more eclectic than identifiably Pre-Raphaelite. He admired Rubens as a colourist, Claude's magnificent landscapes and Jean Goujon 'the Michelangelo of France'.[21] At the same time his interest in Gothic art was emerging, and when not sculpting, he spent much time researching in libraries. In France, he saw engravings of contemporary German art for the first time. In terms of searching for Pre-Raphaelite influences, it is possible, though not certain, from his description that he was viewing works by the Nazarenes: '. . . the Germans are full of everything sweeping [heroic?] . . . there is a dryness a formality perhaps a mannerism in their work, but for all this they seem to be possessed of a sound bottoming and be full of good stuff sound at the core'[22] Most noteworthy is Smith's consistent rejection of the schematised aspects of French academic art, '. . . all interest emotion and pleasing colour is sacrificed to correct drawing of theatric poses . . . an academic cold way of thinking and expressing ideas . . . the same methods of cooking their pictures produces a wearisome monotony . . .'.[23] If he expressed such opinions outside the family, there was more than his 'healthy, hearty English look and manner' to recommend him to the Brotherhood.

Smith was modelling medallion portraits soon after returning to England. He was technically enterprising, making experiments in 1847 with an electroplating bath, which he had constructed himself in the studio at Stanhope Street he shared with Woolner. He described the quality of the casts made by this process as 'most beautiful'.[24] Smith appeared to be most sensitive to finish in sculpture, and Woolner was pleased to receive Smith's approval of a bronze.[25] Smith was dependent upon his family circle and their known associates; for a number of the early portraits exhibited at the Royal Academy including J. E. Gray Esq, 1842; Captain Sir James Clark Ross RN, 1844, a fellow officer with his brother (cat.48); Lieutenant Henry Thomas Smith (his brother), 1845, L. H. Smith Esq, 1848, and possibly Mr Thomas Ringrose, 1849 (his nephew's middle name was Ringrose), as well as other medallions such as Emma A. Smith (fig.13, lower) and Mrs M. E. Gray (fig.12).

A serious claim for Smith can be made with these sculptural portraits of the 1840s. If one accepts the recent identification of the portrait medallion as a genre that has a specific resonance in the circle of sculptors surrounding the Pre-Raphaelites,[26] then Smith's loyalty to this format must be noted, as well as the primacy of his interest in relief portraits in relation to Woolner. Smith's particular influence on Woolner in this genre is apparent. Portrait medallions were later to form a crucial means for Woolner in Australia to earn money to establish his sculptural practice on his return to England, and also helped lay the foundation of critical acclaim for his most successful period as a sculptor. Undoubtedly there was an exchange between the two artists.

Smith's medallions have considerable value as examples of Pre-Raphaelite sculpture beyond their influence on Woolner. Smith sculpted portrait medallions of his uncle and

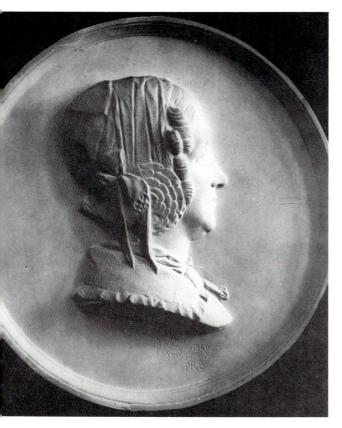

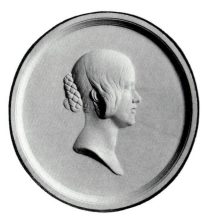

fig.12 Bernhard Smith, *Mrs Maria E. Gray*, plaster, 1849. Location unknown

fig.13 Bernhard Smith, *Frances E. A. Ince* (upper) and *Emma A. Smith* (lower), plaster. Location unknown

aunt John and Maria Gray (fig.12; formerly in his daughter Minnie's possession, present whereabouts unknown). The latter is a particularly significant work, because it is the only sculpture by Smith bearing the initials PRB, which lends some support to his daughter's claims for his membership of the Brotherhood. Since however, he was definitely not an official member of the PRB, these initials may be interpreted as purely support and enthusiasm for the movement, in much the same spirit as Hancock's formal application to use them (see pp.72–3) and Tupper's adding them to his correspondence (see p.67).

These medallions contain elements of true realism, for example Maria Gray wears a bonnet, in which net has been pressed into the wet plaster to suggest the texture of the material. Woolner's medallion of Mrs Ward Cole, 1853, in the La Trobe Library, Melbourne, displays the same technique. Smith's portrait of Emma Smith (fig.13), whereabouts unknown, is also noteworthy, for the austere use of line that sympathises with the earliest Pre-Raphaelite style, seen for example in pen-drawings by Millais of the late 1840s. The influence of profile portraits from the quattrocento, such as those by Uccello, in the solidity and clarity of the forms, seems possible, though unprovable. Woolner's ideal of female portraiture, even at its most refined such as *The Lord's Prayer* (col. pl.4) or the *Portrait of Eliza Orme* (1856; private collection, Australia) is softer and more domestic in character. Known to the Pre-Raphaelite circle, Smith's sculpture *The Schoolmaster* (1848; cat.50) is a genial and whimsical characterisation of a seated man in modern dress. In terms of a sculptural aesthetic based upon Gibson's men in sheets and blankets,[27] its intimate scale and contemporary fashion are radical statements, even if it is not as formalised as Smith's medallions.

Minnie Smith claimed that her father had advised Woolner when modelling his statuette of *Puck* (cats 53a & b), when they shared a studio together. One image of *Puck* by Smith which is known today is an oil painting from a later date (1851–2; private collection, Australia), which shows Puck seizing the tail of a bird and displays a similar characterisation, with Puck represented as somewhat malicious and sinister, half infant and half elderly man. In his *Puck*, Woolner was making an early excursion into the world of fairies and Shakespeare that later dominated Smith's œuvre.

Smith articulated an allegiance to Pre-Raphaelite ideas. The lack of corroborating evidence means that these statements have to be accepted on face value.

'The thing arose from disgust at the sloppy way we used to see the modern painters putting out work. Our motive was to represent conscientiously what we saw. I often assented[?] and desired that the beautiful should chiefly be chosen and faithfully drawn with care. And I was right, though at first my voice was not of weight. I knew nothing would cure eccentricity, so never thrust forward that idea. It was to draw and to paint most carefully and to avoid slummy, sloppy work, and to prove the truth of that idea, that we banded ourselves together....'[27a]

By the 1880s accounts of Pre-Raphaelitism were available in Australia as well as England, so he could have gleaned an awareness of its philosophy at a later date, but as noted, in Paris, Smith was dissatisfied with the superficiality of fashionable art. A sketchbook of pen-and-ink drawings dated 1844 in the La Trobe Library, Melbourne, suggests that he was seeking inspiration through study of Gothic and Saxon monuments and architecture. Identifying virtue in art with pre-Renaissance style is not specific to Pre-Raphaelitism and can be identified broadly with the Gothic Revival in the 1840s, but Smith was considering the notion of artistic decadence and progress and the placement of medieval art in relation to such values, at least in a rudimentary form. He pasted a newspaper clipping denouncing a gravestone carved with 'Anglo Saxon' lettering as 'retrogression' into the sketchbook and repudiates this assertion by surrounding it with sketches for monuments of Celtic and Gothic design. This sketchbook seems to relate to a larger compilation, c.1843, of historic architecture and design referred to by Minnie Smith in her biography. Smith went travelling with a

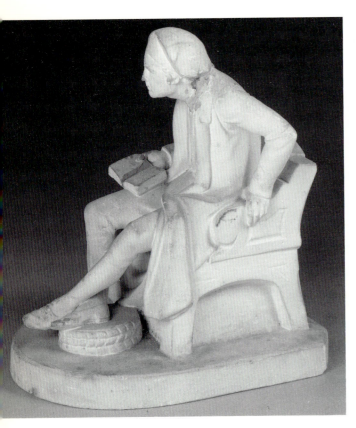

cat.50 Bernhard Smith, *The Schoolmaster*, plaster, 1848. Private collection

Belgian architect in France in 1841, visiting Rouen and observing the 'antiquities' in architecture.

There are also fleeting glimpses of Smith in the Pre-Raphaelite social circles, beyond the claims of his daughter. As late as 1854, Dante Gabriel Rossetti was visiting Smith's brother with Woolner's father.[28] For both Woolner and Smith, Holman Hunt was 'our old friend' and referred to as such in their correspondence. For the Howitt family in Australia, Smith, Woolner, and Bateman were 'Pre-Raphaelites'.[29] Smith appears spasmodically but upon terms of equality in the Pre-Raphaelite journals. It is the value assigned to these documented links to the movement that is variable. William Michael Rossetti left no doubt about Smith's cordial relations to the Brotherhood in the late 1840s, suggesting that 'he was treated with great familiarity by the Pre-Raphaelites and there was some idea that he would finally be elected into the Brotherhood . . .'.[30] To Smith's family, Rossetti further declared that 'my brother and others, in a spirit of artistic sympathy, applied the term PRB to him from time to time: but it is apparently true that when the Brotherhood assumed a certain degree of organic form, the members were seven and no more – Millais, Hunt, Woolner, Stephens, Collinson and the 2 Rossettis'.[31]

By 1849, Smith was already thinking of detaching himself from London and the Pre-Raphaelite circle. The 1849 joint gift by the Rossettis of a volume of Browning's poetry anticipated Smith's imminent departure to take up farming in Canada. As it was, he travelled as far as Yorkshire, but returned to London in January 1850 'disgusted at the total want of intellectual companionship . . . and [meant] to stick to Art'.[32] Painting seems to have formed the greater part of his œuvre over the next two years. He remained in London for two years more, exhibiting a painting of two water elves at the Royal Academy in 1851, and finally travelled to Australia, assisting Woolner with his passage money.[33] The reasons behind his departure are not clearly stated. His daughter interprets the painting of *Puck* as an allegory of his dissatisfaction with Pre-Raphaelitism.[34] Smith's series of portraits in the Royal Academy were not entirely centred on members of his family. Some of the subjects were notables such as Sir Rowland Hill and Sir James Clark, Physician to Queen Victoria, even though in the case of James Clark Ross (cat.48), it was family connections rather than market prestige that brought Smith the commission. He was not unsuccessful, but seemed unwilling or unable to move onto works of a larger scale, although the known fragments of his early œuvre suggest an artist capable of a certain felicitous dexterity, which boded well for its mature development. A sketch for the oil-painting *Two Water Elves* exhibited at the Royal Academy in 1851 survives (private collection, Australia). This drawing suggests that the overall style of his Australian work had already been set in early Victorian London. Two female nudes are seen floating in a miniature boat made from a curled leaf. A number of similar sketches were executed in Australia, of fairies flying on feathers and thistledown, seated on mushrooms and in rosebushes. Smith once described his fairy drawings as memories of his career of many years ago, so he drew a link between his two periods of creativity.[35] The fairy subjects were known to the Pre-Raphaelites and mentioned in William Michael Rossetti's diaries. It would appear that he had studies for a number of fairy works in his studio in 1850.[36] Travelling to Australia may have resolved a lack of impetus in an exhibiting career centred upon small portraits for nearly a decade. Woolner certainly found the idea of temporary emigration an answer to the lack of immediate sculptural prospects.

Smith later admitted to having envisaged Australia as a land of 'brilliantly' coloured wildflowers and butterflies,[37] which in the Colony of Victoria were confounded in his observations, as had been Woolner's dream of a socially equitable muscular Christian adventure on the goldfields. Dante Gabriel Rossetti's spurning of the poetical rewards of gold mining was not heeded by either Smith or Woolner, but both appear to have grown restless by early 1853 after months of fruitless labour. The immediate spur to enlistment in the Gold Commission was the presence of Bernhard's brother Alexander

in the corps, but one notes that Woolner, contemplating abandoning a miner's life, was not unmoved by the relative comfort of the commissioners among the grimy diggers.[38]

Combing through his letters one may find other reasons for Smith's apparently painless abandonment of art. His intense love for his wife and children runs throughout his letters, and in retrospect he rejected the years before his marriage as being unimportant. He advised his son William that friends, outsiders, could never match the love and understanding found in the family circle.[39] Smith also professed a deep trusting Christian faith and passively accepted changing circumstances in his life as the will of the Lord.[40] A small visual reminder of the directness of Smith's faith is found in a detail of his drawing of a rain cloud above the Australian countryside, God's hands penetrate the clouds and lightning radiates from His body (fig.14). This motif is repeated in his later picture *The Soul Set Free* (1880).

Personal circumstances are not the sole reason for Smith setting aside his art. The uncertain income for a trained sculptor in mid-nineteenth century Australia could have influenced his decision to remain in the public service. Smith's disappearance as an exhibiting artist fits into a broader pattern of sculptural experience in Australia. A number of professionally trained sculptors, some even with modest public profiles in their home country, had emigrated to Australia by the 1850s and 1860s, but once arrived, they were rarely employed as sculptors and turned to another trade, setting aside art for extended periods. William Lorando Jones likewise ceased practising for eleven years or more, and some regret was expressed by local critics about the infrequency of his exhibits.[41] Other issues of art ethics influenced Smith. In one letter he claims to have consciously rejected London art circles, angry at the profusion of empty showy work, preferring to work on his own terms in the relative obscurity of rural Victoria than to pursue an uncongenial public career.[42] In some letters this theme of rejecting worldly success is expanded in Smith's mocking of his fellow citizens' desire for professional rank and ceremony, contrasting his own family-orientated viewpoint, but on other occasions he extended his deep sympathy and concern to women and children outside his family.

During the late 1850s and 1860s, Smith partially subsumed his aesthetic interests in an intense natural history study. His careful empirical observation, his rejection of purely analytical science[43] and his strong belief in the details of nature as expressions of God's presence could be seen to harmonise in a general way with Ruskinian attitudes and therefore form a tenuous link with Pre-Raphaelite belief in the years when Smith had contact with the movement. A small sketch of gum blossom executed for his sister in 1860 is somewhat weaker than the confident works that he would produce from the late 1870s onwards.[44] A work from the next year, however, displays the precise line work and decorative, even baroque invention, that characterised his 'mature' work from the 1880s. In 1877 he sculpted a portrait medallion of a fellow Smythesdale resident.[45] More intriguing, but so far untraced, is a sculpted memorial to the wife of Sir Henry Barkly, third Governor of Victoria. Logic suggests that such a memorial would have been erected to the first Lady Barkly, who died in 1857 in Melbourne. One account of the sculpture suggests that the subject was well known for her charitable work in India, suggesting that it in fact commemorated the second Lady Barkly, a Melbourne resident who had grown up in India. The sculptor's daughter suggested that it was erected in Durban, South Africa, where Barkly was posted subsequent to Melbourne. If this were so, it would suggest that Smith and Barkly remained in contact after the latter's departure from Australia.[46] Smith's desire in 1885 to see his drawings reproduced as parian plaques suggests that his thoughts were again turning to a sculpture-related format.[47] His choice of parian as a portrait medium suggests that his tastes remained loyal to the London of the 1840s and 1850s, despite the fact that aesthetic taste and more recent styles were already well established in Australia. Minnie Smith stated that the set of drawings of *Much Ado About Nothing* were intended as studies for high-relief sculpture.

A new opportunity for Smith to begin working as an artist intervened at the lowest point of his career as government official. Summarily dismissed in January 1878, with hundreds of other public servants in Victoria as a retaliation for the blocking of supply to the Barry government, he was ultimately reinstated, but transferred to a new district around Alexandra in the mountainous East of the state. Constantly travelling on the circuit where he sat as magistrate, he turned to drawing as a serious art practice during long evenings spent alone. Sculpture or oil painting would be impossible to practise when constantly changing residences every few days. The nature of magisterial duties effectively prevented Smith from working as a sculptor. He set aside time to work in a disciplined fashion and produced carefully planned series of drawings, from Shakespeare, Longfellow (*Excelsior*) and his own poetry and invention. He began in pencil and then painstakingly inked in the outline. By the mid-1880s he was reproducing earlier themes, in order to improve upon his previous images.[48] Some aesthetic progress can be observed in surviving drawings by Smith. In *The Joyful Rain, The Solemn Rain* (1879; Australian National Gallery; fig.14) a welcome rain cloud above an Australian landscape, is marked by a busy and voluptuous abundance of line and detail, which becomes more focused and austere in the Flaxmanesque works produced in the 1880s. The characterisation of raindrops as beneficient angels falling earthwards in December reflects an Australian perspective. It is not the only Australian reference, for example, a pen-and-ink view of the town of Jameson in the La Trobe Library is undoubtedly by Smith.[49] The fairy drawings are marked by some faults of draughtsmanship and proportion yet they do not undermine the general effect of Smith's images. Smith integrates fantastic details of anthropomorphic plants and beasts, partly drawn from the conventions of Victorian fairy scenes into formal neo-classicism. The illustrations to *Macbeth* fuse neo-Greek figures with a dark evocation of a barbaric world, conveyed through grotesque furniture and settings and elaborate natural ornament. Some of these details curiously parallel the architectural embellishments carved under the general aegis of his former associates in England in the 1850s and 1860s.

To regard Smith as a downunder version of the *Facteur Cheval*, untutored and marginalised in his vision, distorts both the artist and the context in which he worked. Throughout the last seven years of his life, Smith was moving slowly towards professional art practice, prevented firstly by the burden of his magisterial duties and lastly by his untimely death. Woolner's 1880 letter congratulates Smith on his decision to return to art and discusses his plans for publishing his drawings.[50] The 1880 International Exhibition in Melbourne provided a premature 'coming out' for Smith. He only became free to contemplate full-time art practice in 1885, but the award of a second class order of merit for his drawings suggests that his contemporaries regarded them seriously. The 1880 Exhibition provides one of the few independent criticisms of Smith. 'Eight outline drawings by Bernhardt [sic] Smith, of Mansfield, were very original and mystic, with their figures in long flowing, pointed draperies.'[51] He was not entirely pleased when Blakean influences were postulated in his drawings and protested that Blake only became well known in England after he left, suggesting a knowledge of the circumstances of Blake that undercuts his denial of influence. More pertinent for the historian is the cognisance of Blake in nineteenth-century Melbourne, that such criticisms document.[52]

Decorating his home, the drawings were shown regularly to friends and associates by Smith and his son Bernhard Alexander Smith. The opera singer Madame Tasca on viewing them apparently exclaimed that she had despaired of Australians ever producing beautiful art until she had seen them.[53] Smith was in contact with at least four notable artists in Melbourne during the 1880s. James Panton was also a Police Magistrate, and Smith took over his work when he was on leave.[54] Georgiana McCrae saw drawings from Smith's hand and wrote so glowingly to La Trobe Bateman, that he wanted to be advised if any drawings were sent to England so that he could view them.[55] Louis Buvelot declared them to be full of artistic merit. Through Buvelot, Smith

Notes

1 *Pall Mall Gazette*, 10 Sept. 1886

2 Bernhard Alexander Smith to William Michael Rossetti, 8 Sept. 1890, fragments of undated letter, William Michael Rossetti to Bernhard Alexander Smith, La Trobe Coll. Ms 10626 Box 2 25/f. Copy of a letter written by Bernhard [jnr] and Ethel Smith to 'Aunt George', 1 Aug. 1886 on paper 3 Crown Terrace Hull, La Trobe Coll. Ms 9963 Box 1/3. Another copy of B. A. Smith's letter to Rossetti is located in Helen Rossetti Angeli's papers

3 La Trobe Coll. Ms 9963 Box 1/3 Copy of a letter written by Bernhard [jnr] and Ethel Smith to 'Aunt George', 1 Aug. 1886, La Trobe Coll. Ms 10626 Box 2 25/f. Letter from Bernhard Alexander Smith to William Michael Rossetti, 8 Sept. 1890

4 *Pall Mall Gazette*, 8 Sept. 1886, p.3

5 Copy of letter, Minnie Bernhard Smith to Amy Woolner, 22 Jan. 1919, pasted in Scrapbook, La Trobe Coll. Ms 9936 3/3

6 Such factors as the establishment of the Centre Five Group, the Mildura Sculptural Triennial, corporate commissions in the wake of the building boom at this period and the series of lavish art prizes as reflecting the establishment of an avant-garde support network for sculpture in the 1950s and 1960s; see Parr

7 In 1896 Lady Brassey granted vice-regal patronage to Minnie Smith's dressmaking and designing establishment, Letter, F. Freeman Thomas ADC to Minnie Bernhard Smith, 18 March 1896, La Trobe Coll. Ms 9963 3/3

8 *The Argus*, 13 Sept., 23 Sept., 24 Sept., 25 Sept. 1884

9 For details of Bernhard Smith's family background see Smith

10 Letter, J. B. Davies, Vicar of Anlaby, 19 June 1922 in Scrapbook, La Trobe Coll. Ms 9963 3/3

11 Thomas Woolner Australian Diary, BLO Ms facs. d 152, Australian Joint Copying Project, microfilm, 22 Feb. 1853. For Smith as 'househusband' see letter, Bernhard Smith to Willie Smith, 2 June 1885, La Trobe Coll. Ms 9963 Box 1/3

12 Letter, Bernhard Smith to Harry Smith, 2 March 1885, La Trobe Coll. Ms 9963 Box 1/3

13 Bernhard together with several of his brothers and sisters wrote verses, which were gathered in a privately published book *Fugitive Pieces* by 'A Dear Sister' printed by George E. Over The Rugby Press *c*.1885 onwards

14 Undated letter Bernhard Smith to his son William, *c*.1885, La Trobe Coll. Ms 9963 Box 1/3. Letter Bernhard Smith to his son William, 2 June 1885, La Trobe Coll. Ms 9963 Box 1/3 Woolner Diary. Letter Bernhard Smith to his brother Henry Smith, 2 March 1885, La Trobe Coll. Ms 9963 Box 1/3

15 Letter, Bernhard Smith to 'My Dear Old Lady' [presumably a sister], 15 June 1838, private coll.

16 *DNB*, vol.VIII, 1917, p.454

17 Letter, Bernhard Smith to his mother, 21 Oct. 1840, private coll.

18 Letter, Bernhard Smith to Edward Smith, 30 Nov. 1840, private coll.

19 Letter, Bernhard Smith to his mother, 23 April 1841, private coll.

20 Letter, Bernhard Smith to Edward Smith, 30 Nov. 1840, private coll.

21 Letter, Bernhard Smith to his mother, 15 June 1841, private coll.

22 Letter, Bernhard Smith to Edward Smith, 30 Nov. 1840, private coll.

23 Letter, Bernhard Smith to his mother, 15 June 1841, 26 March 1841, private coll. also transcribed by Minnie Bernhard Smith

24 Letter, Bernhard Smith to 'My Worthy Sister', undated, inscribed 1847 by Bernhard Smith in 1885, private coll.

25 Fredeman, p.85, entry for 8 Dec. 1850

26 Read 1984, p.109

27 For a denunciation of Gibson's men in sheets and blankets see

fig.14 Bernhard Smith, *The Joyful Rain, The Solemn Rain*, 1879. Australian National Gallery, Canberra

met Blanche Mouchette, who also regarded his works favourably.[56] She asked why such an artist had come out to Australia. The neo-classical architect Joseph Reed urged Smith to send his drawings back 'home' to show the remaining Pre-Raphaelites.[57]

Smith's impetus towards identifying himself as a professional was galvanised by the emigration from England of his nephew Bernhard Ringrose Wise. Widely regarded at the turn of the century as one of the most original minds of his generation in Australia, Wise was a protégé of Henry Parkes,[58] and had direct experience of radical cultural circles in both London and Australia.[59] Wise and his wife openly admired Smith's drawings, compared them favourably to Rossetti's art and encouraged him to preserve his mementoes of contact with the Pre-Raphaelite Brotherhood.

Had Smith not died before he could return to art full time, he would have come into contact with the artistic mainstream in Australia, if not through Bernhard Wise, then through geographical proximity. In 1885 Smith built a house in Box Hill, where he intended to live after he retired. Had he done so, he could not have failed to notice the Box Hill artists' camp, established in 1886, the year after his death, popularly regarded as the cradle of the nationalist school of the 1880s and 1890s. Far from being immune to Australian subjects, in describing his new property to his son Willie he wrote appreciatively in 1885 of 'such a lovely spot, such a vista . . . from Doncaster Tower, look by Black Spur way'.[60] It was the eastwards view to the hills that was to feature so prominently in the landscapes of Roberts and his associates.

From comments quoted by Smith's daughter, it is easy to assume that Smith witnessed a gradual withering of his artistic sensibility in Australia. On other occasions he believed that his new land provided conditions in which his fairy visions could only flourish:

'. . . even on this Earth, where the Southern cross shines, visions of things beautiful may be seen by a Bushman, after his fashion – and why should not that be? [I]s not our climate fairer than their climate and is not the loveliness of our sunshine a whole power in itself.'[61]

Thomas Woolner, letter to Emily Tennyson, 25 June 1857, repr. in A. Woolner, p.135

27a Letter, Bernhard Smith to his brother J. P. G. Smith, 8 May 1881, quoted in *Pall Mall Gazette*, 8 Sept. 1886, p.3

28 Letter, Thomas Woolner to Bernhard Smith, 13 July [1854], private coll.

29 Howitt, p.2

30 *Pall Mall Gazette*, 10 Sept. 1886, p.6

31 Fragments of undated letter, William Michael Rossetti to Bernhard Alexander Smith, La Trobe Coll. Ms 10626 Box 2 25/f

32 Fredeman, p.42

33 Copy of letter, Bernhard and Ethel Smith to 'Aunt George', 1 Aug. 1886, La Trobe Coll. Ms 9963 1/3 confirmed by letter Thomas Woolner to Bernhard Smith, 13 July [1854], private coll.

34 Puck (the movement) reaches out for a bird, which escapes leaving only its tail feathers, representing an obsession with irrelevant detail. Puck sits down crushing a bee, which represents 'b' for Bernhard

35 Bernhard Smith to Emma Smith, undated, *c.*1883, private coll.

36 Fredeman, pp.74–5, 26 Oct. 1850, p.76, 29 Oct. 1850 'Woolner and I, with Hannay, spent the night at Bernhard Smith's. He has made a sketch in colour for his fairy picture, and showed us also designs of other similar subjects.'

37 Bernhard Smith [Natural history and autobiographical notes *c.*1877] in Scrapbook La Trobe Coll. Ms 9963 Box 3/3

38 Thomas Woolner Australian Diary 1852–1854 *op. cit.*, note 11, especially 6 April 1853 where he dined with the commissioners 'spent a pleasant evening afterwards in Mr Gilbert's [of the Commission] tent'

39 Letter, Bernhard Smith to Willie Smith, 3 July 1885, La Trobe Coll. Ms 9963 Box 1/3

40 Letter, Bernhard Smith to Josephine Smith, 14 July 1874 advising her to 'be my own Grand wife and the more noble because of her submissiveness to the circumstances now surrounding us all', undated letter to Josephine 'God is loving and trust in him to do our best . . . seek not to make your kind miserable with doubts and fears but bravely do our duty and trust the rest to the Great Father, who watches over all of His children'. La Trobe Coll. Ms 9963 Box 1/3

41 *Sydney Morning Herald*, 27 Sept. 1870, National Gallery of Victoria, Press Clipping book p.76 (microfilm copy, Newspaper Collection, State Library of Victoria), Charles Abrahams, Benjamin Law and Emil Todt are further examples of sculptors, who gave up their profession in 19th-century Australia

42 Letter, Bernhard Smith to Fanny [Voase?], undated, Bernhard Smith to Willie Smith, 18 Aug. 1885, La Trobe Coll. Ms 9963 Box 1/3

43 Bernhard Smith [Natural history and autobiographical notes *c.*1877] in Scrapbook, La Trobe Coll. Ms 9963 Box 3/3

44 Letter, Bernhard Smith to Emma Smith, 22 April 1860, La Trobe Coll. Ms 9963 Box 1/3

45 Letter, Minnie Smith to the Art Committee of the Felton Bequest, 11 Jan. 1937, artist files, National Gallery of Victoria Library

46 *ibid.*

47 Letter, Bernhard Smith to Willie Smith, 22 June 1885, La Trobe Coll. Ms 9963 Box 1/3

48 Letter, Bernhard Smith to Josephine Smith, 20 Aug. 1881, letter to Willie Smith, 1 May 1885, letter to Minnie Bernhard Smith, 31 Aug. 1885, La Trobe Coll. Ms 9963 Box 1/3

49 Although this drawing appears in a sketchbook with works by his children, the drawing resembles the Australian landscape in the Australian National Gallery and Jameson was a town Smith visited on his circuit as magistrate. He was not accompanied by his family on these journeys

50 Letter, Thomas Woolner to Bernhard Smith, 8 Aug. 1880, La Trobe Coll. Ms 9963 Box 1/3, possibly the lithographed versions of his drawings are related to this scheme. Woolner thanks Smith for some etchings by him sent from Australia. However the prints of Smith's drawings found so far do not appear to be etchings and lack plate marks and other characteristics of intaglio print processes. Bernhard Alexander Smith in a letter of 6 Oct. 1885 also asks 'when the copies will come out here'

51 Melbourne International Exhibition 1880–1881, *Official Record*, Melbourne, Mason, Firth and M'Cutcheon 1882, p.ci

52 Letter, Bernhard Smith to Josephine Smith, 11 Dec. 1881, cf. letter Bernhard Smith to Emma Smith, *c.*1883, private coll. '. . . they all worry me by saying [the drawings] are filled full of Blake . . .', also Tolley, pp.24, 26, 35, mentions at least two books by Blake, documented as having been owned by mid-19th-century Melbournians

53 Bernhard Alexander Smith letter to Bernhard Smith, 6 Oct. 1885, La Trobe Coll. Ms 10626 25/2f Box 2

54 Bernhard Smith, undated letter to Fanny [Voase?], La Trobe Coll. Ms 9963 Box 1/3. Woolner [and presumably Smith] first met Panton at Bendigo in 1853, where he served as Commissioner. Woolner Australian diary *op.cit.* note 11, 22 April, 24 April 1853

55 Letter, Bernhard Smith to Willie Smith, 18 Aug. 1885, La Trobe Coll. Ms 9963 Box 1/3

56 Letter, Bernhard Smith to Emma Smith, 8 Sept. 1883, La Trobe Coll. Ms 9963 Box 1/3

57 Letter, Bernhard Smith to Emma Smith, undated, *c.*1883, private coll.

58 *The Australasian*, 1 June 1895, p.1032

59 Wise included Robert Louis Stevenson among his London friends, and in Australia was an associate of the radical and important plein-air circles around artists such as Julian Ashton and Tom Roberts. His sister-in-law was famed in England for creating the role of Trilby in the influential 'bohemian' play of the same name

60 Letter, Bernhard Smith to Willie Smith, undated, *c.*1885, La Trobe Coll. Ms 9963 Box 1/3

61 Letter, Bernhard Smith to William Smith, 4 April 1885, La Trobe Coll. Ms 9963 box 1/3

Thomas Woolner: PRB, RA
by Benedict Read

Thomas Woolner was born on 17 December 1825 at Hadleigh in Suffolk.[1] He went to school near Ipswich and then in London where his family moved: as a child he showed talent in drawing, modelling and carving, with the result that aged about thirteen he was sent to study with the painter Charles Behnes. He however soon died, but the young Woolner was evidently already talented enough to be taken on by the painter's brother William Behnes, one of the most eminent sculptors of the time. Woolner remained in Behnes' studio for some six years and clearly became close to his master – we know of a drawing of Woolner in the studio that identifies him as 'Mr B—s Tyger'. His talent was apparent to others: as the painter B. R. Haydon was leaving the studio after a visit, Woolner 'reverently hastened to hold the door open to him as an honoured guest; the painter, not satisfied at simply acknowledging this courtesy, turned and examined the boy's cranium, and based on its bumps words of encouragement as to his future possibilities.'[2]

Working as a junior and assistant in the studio of an established practitioner like Behnes was virtually the only way an aspiring sculptor could receive a thorough training and education in all aspects of sculpture, technical, theoretical and more. 'This was an excellent and honourable arrangement for Woolner, because the master had a very large practice in sculpturing figures and busts in marble, bronze, and stone, while, so far as the workmanship of these objects went in modelling and carving, he could not possibly, at least in London, have had a better teacher than the thoroughly skilful, but rather inert and dull man, who was, it is said, not a little exacting withal, yet who most honourably fulfilled his part of the compact. Behnes made Woolner an admirable executant, or, as the technical phrase is, "a carver" of the highest skill.'[3] Certainly one may see prefigurations of the pupil's later distinctive style if one examines instances of Behnes' treatment of drapery: that in the Mrs Botfield relief monument at Norton, Northamptonshire (post 1825) has a characterful informality and irregularity verging on naturalism, while Behnes' statue in St Paul's Cathedral of Dr Babington, who died in 1837, has a crispness in drapery execution equal to anything the pupil later won credit for.

In 1842, while still working for Behnes, and with his encouragement, Woolner entered the Royal Academy Schools, but he later claimed to have learnt little here, he had already got all that he needed in the way of formal artistic education from his time with Behnes.[4] In 1843 (i.e. aged eighteen, and still a pupil at the RA Schools) he showed his first work in public, at the Royal Academy: *Eleonora sucking the poison from the wound of Prince Edward*; the following year he showed *The Death of Boadicea* at Westminster Hall. These were both what were called Ideal works, that is, works whose subjects were drawn from history, mythology, poetry and so on, which ranked highest in the hierarchy of genres of sculptors at the time. In an early notebook of Woolner's dated 1843[5] but probably in use until the end of the 1840s, he listed a number of Ideal subjects for consideration: some were from history (particularly the life of Alfred the Great), others from English literature (Pope, Goldsmith, Gray, Byron, Milton, Spenser and Shakespeare), with yet another category defined as Universal (*The Marriage of Philosophy and Art* – a group; *The Course of Man* – a series of nine groups).

It was part of a sculptor's thinking at this time to contemplate such works, their design was a sculptor's greatest challenge, the opportunity to realise and express the summit of his skills and art, and their execution in marble or bronze – at a patron's expense – represented the fulfilment of his profession. Unfortunately there was little effective market for them and, as we shall see, Woolner was to be like every other sculptor largely dependent on portrait commissions or funerary monuments for a living. The occasion of his *Boadicea* reflects a classic example of this: it was submitted to a competitive exhibition held to select sculptors to execute historical portrait statues in the Houses of Parliament then being built. It was favourably viewed: 'This is a fine group. The dying Queen, mastered by the anguish of the hour, lies like a royal martyr, in the arms that sustain her. There is great force of hand here:– suffering, moral and physical are powerfully expressed. The treatment is highly dramatic – and the language

fig.15 Thomas Woolner, Model for the *Wordsworth Memorial*, Westminster Abbey, complete original plaster model, 1851. Location unknown (seated figure: see cat.56)

of its drama is pure sculpture.'[6] Another critic later wrote that the work 'occupied a conspicuous place in the great national contest that year . . . It stood quite close to Foley's famous and beautiful *Youth at a Stream*, and even in that neighbourhood did not suffer. This bold venture did not help Woolner to a commission at Wesminster or elsewhere but it affirmed his fellow-students' opinion of him, and drew the attention of wealthier amateurs, who, nevertheless bought nothing . . .'[7] The quality of the Foley may be judged by his obtaining a commission for two portrait statues in St Stephen's Hall;[8] Woolner was not successful.

Woolner continued to show Ideal works at the Royal Academy or the British Institution until the end of the 1840s: *Alastor* (RA 1846) – 'an image, silent, cold and motionless' – came from Shelley, *Puck* (BI 1847; cat.53a & b) and *Titania caressing the Indian Boy* (BI 1848) from Shakespeare. The latter was called 'an exquisite group'.[9] In 1846 he showed his first portrait medallion, *Edwin Adolphus Ashford* at the Royal Academy where the following year he showed a genre piece *Feeding the Hungry* representing a boy feeding chickens. But the Ideal works clearly did not attract commissions and tended to remain with the artist. Both F. G. Stephens and Holman Hunt visited Woolner's studio in 1847 and described *Puck* there.[10] Hunt also mentions seeing another huge figure,[11] identifiable as *The Progress of Nature* from Woolner's Universal category of Ideal work.

Woolner's studio, which he shared with Bernhard Smith, was next to that of John Hancock, which Dante Gabriel Rossetti had been using to paint in. It was Rossetti who brought both Hunt and Stephens to see Woolner; Rossetti had talked much of him as one to whom he had explained the resolution of Millais and Hunt to turn more devotedly to Nature as the one means of purifying modern art, and said that Woolner had declared the system to be the only one that could reform sculpture, and that therefore he wished to be enrolled with them.[12] Hunt recalled: 'the many indications of Woolner's energy and his burning ambition to do work of excelling truthfulness and strong poetic spirit expressed in his energetic talk were enough to persuade me that Rossetti's suggestion that he should be made one of our number was a reasonable one; in due course, therefore, Millais having known him at the Academy, he was approved as a member.'[13] Stephens for his part stated: 'In the style of his ideal works it had from the first been part of Woolner's ambition to embody something of Phidian dignity, simplicity, and naturalness, combined with exhaustive representation of detail. It was this view of the potentialities of sculpture which induced him . . . to join the Pre-Raphaelite Brotherhood – and while it retained its original characteristics to take part heartily in its efforts.'[14]

Over the next five years, when the Brotherhood was at its strongest as a group, Woolner produced six medallion portraits, 'made "to get a living with", as he said, but not the less on that account as thorough, learned and accomplished as they could be made by diligent and studious hands.'[15] He also executed two commemorations of Wordsworth that demonstrate his full-blooded Pre-Raphaelitism. Wordsworth was a poet of nature and great ideas implicit in nature, as well as being a Pre-Raphaelite Immortal. In his wall-monument at Grasmere of 1851 Woolner produced a portrait head carved in profile, with sculptured flowers at either side. The head was recognised as a truthful representation of physical likeness and intellectual character,[16] while the adjacent crocus, celandine, snowdrop and violet are as accurate in natural detailing as anything Hunt or Millais were depicting at the same time in *The Hireling Shepherd* and *Ophelia*. Woolner also produced a more elaborate work for the competition for the national Wordsworth Memorial to be set up in Westminster Abbey (fig.15). This consisted of a central seated figure (cat.56) on a pedestal bearing a relief, with a supporting group on each side. The aim was to embody the poet's 'Individual Mind' and illustrate his principles, and Woolner evolved a series of symbolic designs combining nature and seriousness of unimpeachable Pre-Raphaelitism – and he signed a full manuscript description of the work 'Thomas Woolner PRB'.[17]

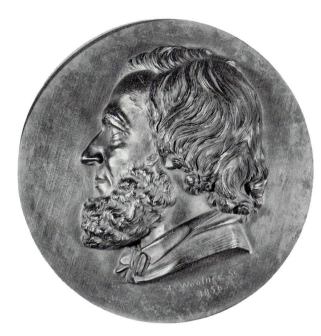

cat.64 Thomas Woolner, *Robert Browning*, bronze, 1856.
City Museums and Art Gallery, Birmingham

Unsuccessful in the Wordsworth competition (and by inference with sculpture generally), plus possibly an affair of the heart, Woolner left for Australia to dig for gold – his departure witnessed by Rossetti, Hunt and Madox Brown generated the latter's emigration picture *The Last of England* (fig.27). But gold turned out to be harder to find than sculpture commissions and Woolner reverted to art. Over two years (1852–4) he built up in Australia an extensive practice in portrait medallions which Stephens claimed were 'remarkable, even among Woolner's portraits, for their vivacity, learning and solidity'.[18] (See Juliet Peers's essay, pp.34–9 & cats 57–63). He was, though, less successful with public statues. A Melbourne Queen Victoria went elsewhere, and when questions arose concerning his capacity to handle a portrait statue for Sydney of W. C. Wentworth (of whom he had done a medallion), he returned to England in 1854 to drum up support and evidence.

The Wentworth commission did not materialise. 'To get a living with' (see above) Woolner continued to produce medallion portraits. The advantage of these was that they were relatively small in size and technically could be reproduced by the artist himself in any number if demand required. Woolner certainly did this, though he was careful to hand finish each casting in plaster or bronze. The wider marketability of these medallions of course depended on the appeal of the person portrayed. Before he had gone to Australia, Woolner had produced medallions of Tennyson and Carlyle. On his return he made entirely new versions, adding also one of Robert Browning to produce a triumvirate of literary lions portrayed which can have done his reputation no harm. His *Tennyson* (cat.66) medallion of 1856 was analysed acutely (and sympathetically) by his Pre-Raphaelite associate-cum-fellow-sculptor-cum-medical-illustrator J. L. Tupper, and granted these many qualifications it is worth quoting at length for the criteria it selects: '. . . being a medallion, it offers to the sculptor temptations to go astray in search of the "pictorial". Yet here we have a disposition of masses strictly sculptural; a variety of surface just sufficient to distinguish the forehead from the hair, and the eyebrow from the forehead, the field of which is tenderly broken by the delicately increasing light and shade attendant on the temporal artery's relief, which itself leads the eye by fine gradations to the shade that plays about the frontal and corrugator muscles, and culminates in the contour of the brow. Then there is no weak hankering for melting away the outline: it is firm, and clear, and keen; that of the neck is almost rigid in its grandeur.'[19]

Woolner's medallion of *Browning* (cat.64) of the same year was analysed by his Pre-Raphaelite Brother W. M. Rossetti, who singled out certain observed doctrines of the group: 'that quality of keenness . . . is strikingly apparent in the bronze medallion by Woolner dated 1856. Here the precise contour of the features is rendered with an exactitude and an emphasis for which a sculptured profile is a more positive document than art of other kinds can readily be; and the well-known precision of the artist is our guarantee for crediting its accuracy in these respects. It is remarkable, considering that this is a work of sculpture that the eye is made the most expressive feature of all; it seems to look, with a steady glance of scrutiny and almost of challenge, into men and things. In this medallion, the physiognomy appears on the whole more penetrating than poetic; this does not diminish its truthfulness, but makes it somewhat less acceptable as an ultimate type of the man.'[20] Woolner's skill and success in this genre can perhaps be gauged by his continuing to produce some forty more over the ensuing thirty years. Some were intimate family portraits (cat.86), others of varying eminences, still others occasionally jumped the genre barrier and formed part of public memorials – a marble medallion by Woolner is set in the Chamberlain Memorial Fountain in Central Birmingham of 1880, another of Sir Edwin Landseer sits above Woolner's relief rendering in marble of the painter's classic tear-jerker 'The Old Shepherd's Chief Mourner' on his memorial in the crypt of St Paul's Cathedral (1882).

The foundations of a wider acclaim and professional success were to come to Woolner soon after the medallions of Carlyle, Browning and Tennyson. Late in 1855, after

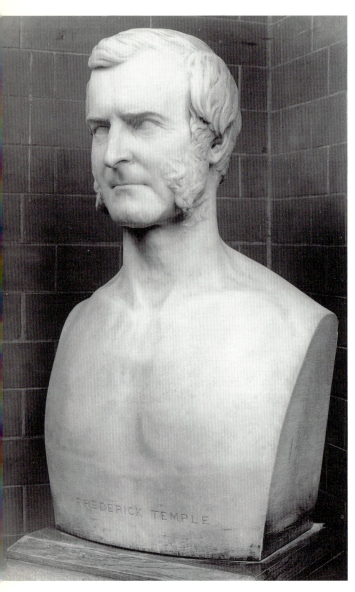

fig.16 Thomas Woolner, *Frederick Temple*, marble, 1869.
Temple Reading Room and Museum, Rugby

correspondence between Woolner and Mrs Tennyson (see below, pp.42–3), Woolner was allowed to proceed to model a bust of the poet. By March 1856 he had prepared a clay model, by mid-April the original plaster was completed and available to view. Critical acclaim for the monument was not universal. Millais went quite into raptures at the sight of it and told Woolner to tell Mrs Tennyson he thought it 'splendid', no other word would express his feeling with regard to it; but Madox Brown noted in his diary: 'Woolner's bust of Tennison is fine but hard & disagreeable. Somehow there is a hitch in Woolner as a sculptor, the capabilities for execution do not go with his intellect.'[21]

Woolner then rather unusually proceeded to execute a version in marble without a specific guaranteed commission, though he probably foresaw little difficulty. He worked on this from autumn 1856 to March 1857; when Brown saw it he commented: 'By the bye, the Tennysson is finished & is a very noble work – & I hope will do Tommy Woolner good.'[22] Various purchasers loomed – Thomas Fairbairn; a buyer from Boston, Mass.; W. M. Rossetti contemplated setting up a project for 100 subscribers to contribute a guinea each and then present the bust to a public institution.[23] Eventually the most long drawn out scheme won the day, a subscription organised by Vernon Lushington to present the bust to Trinity College, Cambridge where it is today (cat.67).

The net effect of the Tennyson bust was considerable. Its placement at Trinity began a succession of works by Woolner for the college over the next thirty or so years; these included his bust of the eminent Professor Sedgwick (cat.72) of 1860 and his two major portrait statues of *Macaulay* of 1866 and *Whewell* (cat.80) of 1873. At the same time the *Tennyson* seems to have instigated the spate of commissions for portrait busts that were to keep Woolner occupied for the rest of his life, producing in the end at least 96 portrait busts during his working career. He sometimes complained about having to do them to earn a living;[24] on the other hand he also questioned whether there was a human countenance that would baffle him.[25] His hope with his 1857 Tennyson was 'to do such a likeness of a remarkable man that admirers of his centuries hence may feel it to be *true* and thankful to have a record which they can believe in'.[26] Though his sitters included many little known today, nonetheless the likes of Tennyson (cat.67), Maurice, Arthur Hugh Clough, Cobden, Newman, Carlyle, Gladstone (cat.75), Darwin (cat.78), Dickens, Keble, Kingsley constitute a record of Victorian heroes almost unequalled: 'this company of the illustrious is so remarkable that it can be compared with the body of portraits of celebrities painted by Mr Watts, and the two groups of likenesses include so many worthies that the artists may be said to have combined their skill for the benefit of posterity.'[27] But there was also a quality in what he produced that was outstanding. Coventry Patmore wrote about the bust of Newman being 'by very much the finest likeness of him in existence . . . I was once in a room containing first-rate busts of all the most famous men of the past generation. That of Newman made all the others look like *vegetables*, so wonderfully was it loaded with the great Cardinal's weight of thought and character.'[28]

One can observe Woolner's accuracy of likeness when there is an obvious physical characteristic recorded: the pock-marks resulting from Rajah Brooke's smallpox (cat.68), the bags below and the lines around Sedgwick's eyes (cat.72), the slow-eye of Professor De Morgan (Senate House, London University), the pursed lips, but different, of Thomas Hewitt Key (cat.83) or Frederick Temple (Rugby School; fig.16) – the latter also sports individualistic side whiskers extending down his neck. But there was more to it than mere detail. He made two different busts of Gladstone, exhibited respectively in 1869 and 1882. Of the first, Mrs Gladstone wrote: 'You have searched deeply and stamped upon it what makes it so valuable, God's gifts written upon that countenance'.[29] Of the second (commissioned by the City of London and unfortunately destroyed in the Second World War) we are told that Gladstone himself insisted on the character of the bust being severely classical, with no drapery whatever. He gave Woolner many sittings, and 'when the model was finished he literally danced round

fig.17 Thomas Woolner, *Francis Bacon*, limestone, 1857. University Museum, Oxford

it in delight and satisfaction. It was just as he desired to go down in posterity he said'.[30] One critic was able to analyse the models of the two works together in Woolner's studio; of the later bust he wrote: 'it bears the minutest possible examination . . . indeed, it must be looked into closely before there can be appreciated not only the beauty and strength of the head and face, but the extraordinary power which the sculptor has bestowed upon them. There is not a superfluous touch, not a line that has not its meaning, and as it stands completed it is a likeness, not of any special mood or character – not of Gladstone the statesman, or orator, or author – but just of Gladstone himself, the whole man'. He then compares the two: 'the head and face of the Gladstone of to-day are different from, and, in some respects, finer than those of . . . 1864. There is great growth visible, growth in every sense of the word. The frown that sat so often on the forehead in those days (but which was a mark, not of a fretful or an "imperious" mood, but of a habit of deep cogitation over problems that have since been solved) has almost entirely disappeared from this new portrait. The brow is no longer bent but uplifted; and the whole countenance is calmer and fuller of repose; though the vigour of intellect still shines throughout.'[31] This identification of the manipulation of a detail, a part, in order to influence the appearance of a portrayal and thus its character is clearly the underlying key to Woolner's practice as a portraitist, with the accretion of such observed detailing making a major contribution to his distinction in this field. Comments from critics who knew him well help bear this out: 'Among the moderns, I do not know anyone who has, for instance, carved with so much exquisite fidelity and skill as Woolner's, the texture of the skin between the temple and the ear of a human face, or given with completer veracity the difference between the cartilaginous base of a nose and the everywhere mobile fleshiness of the lips beneath it. Breath seems to be in his sculptured nostrils, while the eyes he carved may be said to move within and between their differingly yielding lids. Merely to copy nature thus is, with dull labourers, simply a matter of almost mechanic patience and delicate toil; quite otherwise is it to preserve the breadth and freedom of a noble type, while omitting none of the supremely delicate details.' (F. G. Stephens).[32] J. L. Tupper wrote: 'These flowers of Holman Hunt's (sc. in the foreground of *The Hireling Shepherd*) were true to the artistic, not the scientific fact of nature, just as such accessories of hair as we have been noticing are in Mr. Woolner's busts true to the visible effect; the mass of marble employed for these not being the exact equal of so much beard or eyebrow, but a mass commensurable with the impression which these leave upon the eye. Mr. Woolner is one of the few living sculptors who . . . interprets each nicest variety of form truthfully, because not literally; by equivalents, not by equals. This mindfulness of medium, this sense of his art's speciality, Mr. Woolner possesses in perhaps larger measure than any sculptor of our time (with the single exception of Mr. Foley), and this next to the creative faculty, is the most indispensable requisite of true art, though unfortunately the very one that has by sculptors been least possessed, or rather most wilfully discarded, since Michael Angelo aspired to make sculpture pictorial.'[33] As Woolner himself put it rather more succinctly: 'I have striven to show that vitality can be expressed in subtlest detail on the surface of marble.'[34]

In the same year, 1857, that the Tennyson bust marked his break-through into this principal genre of portraiture, Woolner completed the statue of Francis Bacon (fig.17) that was widely held to have been his first major public commission.[35] It was positioned in the Gothic Revival Science Museum at Oxford, designed by Deane and Woodward under the supervision of Dr Acland and Ruskin. A considerable decorative scheme was at various points envisaged for the building including a high level of sculpture.[36] A series of statues of scientists was set against the arcade around the large central hall, and through Ruskin's and Woodward's associations with the Pre-Raphaelite circle, six figures were commissioned from Munro, one from Tupper as well as that given to Woolner.

He started work on the model of Bacon in 1856, but possibly because this was his first large-scale portrait statue, the going was not easy. 'Many a day Woolner, who

was one of the original pre-Raphaelite brotherhood, and particular to a fault, slaved at the face, the hands, the gown, the ruff, the very shoetips of the logician'.[37] Madox Brown recorded: 'Two days I was interrupted by going to see Woolner's statue of Bacon which was very fine in design but looked too short & every one afraid to tell him. The first time I hinted to him pretty plainly what I thought and got him to alter it slightly, but fearing he would not sufficiently I proposed to Gabriel that we should go together & insist upon his head being made smaller or his body longer. Rossetti said he would come but I must be spokesman as he funked it, however while I was looking at the statue & thinking how to begin, Rossetti, who bye the bye had before all along swore the statue was perfect, blurts out, I say that chap's too short I certainly think. In this delicate way he broke the ice & we began in earnest – at last Woolner was convinced & agreed that it was better to loose some of the individuality and truth than risk offending the prejudices of the multitude who certainly never consider Bacon in the light of a dwarf. Today I have been to see it again & it is all right.'[38] During the winter the frost got at the model draped in wet cloths (as clay had to be); one of the hands dropped off and had to be carefully, laboriously redone.[39] The model complete, Woolner had the design transferred to stone: 'I want a man to copy it within a trifle of correctness, and instead of that when I begin to work upon the stone, I find that there is not a piece correct the size of a pins' point and have to begin to work and do the whole thing over again.'[40] No wonder that he complained: 'it is not a thing I can well be congratulated upon, for 2 or 3 more such commissions would lodge me in prison for debt.'[41]

The completed statue went down well. Dr Acland wrote of it: 'Bacon is the best statue – and it shall have on every account the best place.'[42] Queen Victoria was reported to have a very great admiration for it, which was as well, as she had paid for it.[43] And F. G. Stephens's description of it brings out its particular character: 'An example of what I may call Woolner's imagination penetrative occurs in the very fine, broad, and manly statue of Bacon in his Chancellor's robes which seems to speak with the genial, earnest tone of Tennyson's "large-browed Verulam". There appears to be an argument in the action of the hands placed the one upon the other; the light of persuasion beams from the eyes, and the pleasure of one who convinces informs the smiling lips.'[44]

Woolner's next public statue was again for the Oxford Museum, the University's memorial to Prince Albert of 1864. Holman Hunt considered his treatment of Prince Albert in modern costume settled the question of its adaptability for the purposes of sculpture[45] (this referred to a widespread current debate). In 1867 his bronze statue of Godley was set up in Christchurch, New Zealand – when some of Godley's friends came to see the work in Woolner's studio before its departure they said that 'if they had only seen his legs they would have known them for Godley's'.[46] In 1869 his marble statue of David Sassoon (fig.18) was set up in Bombay: it displays a fantastic, almost infinitesimal truth to nature in its treatment of the subject's Parsee costume, rivalled only by that shown by Foley in his statue of Manockjee Nesserwanjee of 1865 – and one should perhaps recall here Tupper's linking of just these two sculptors for their mindfulness of medium, and sense of their art's speciality (see above).

In these and others, Woolner nearly always tried to incorporate something distinctive to liven up, bring animation to his public statues. He was particularly fond of some version of what is described in a very different context as the 'urgent, potent, thrusting-

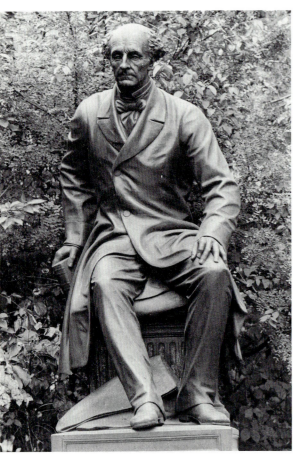

fig.18 Thomas Woolner, *David Sassoon*, marble, 1869. Bombay University, India

fig.19 Thomas Woolner, *John Stuart Mill*, bronze, 1879. Thames Embankment, London

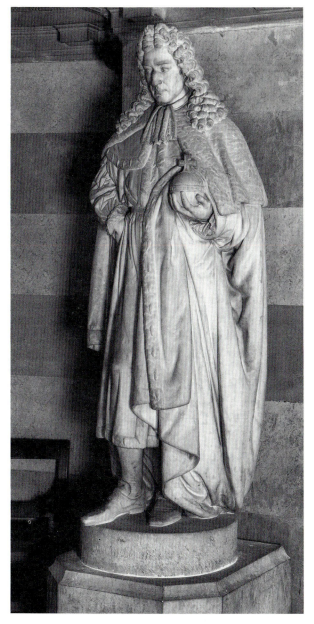

forward gesture implying some urgency in human communication.'[47] *Edwin Field* (1877; Law Courts, London) leans back with legs crossed. *John Stuart Mill* (cat.84; fig.19) (1879; Thames Embankment, London) is about to rise, which can set off a series of possible observations: this 'is the man not only in head and face, but the set of the head, the feeble throat, the falling shoulders, the long weak back, the splay of the hand on the knee . . ., and the forward pose of absorbed and critical but courteous attention, which tell as true a tale both of physical and mental character as ever was cast in bronze or cut in stone.'[48]

Possibly Woolner's masterpiece in the field of public statuary, *Captain Cook* (fig.28) was unveiled the same year in Sydney, Australia. Again his gestures, his formal disposition carry implications: the face implies knowledge, the just lowered telescope signifies land is nearby and so on. It is true though that not all Woolner's public statues were as successful – an 1869 first version of *Lord Palmerston* for Parliament Square, London was rejected, while its successor of 1876 improves on the nearby *Peel* of Matthew Noble of the same date only by virtue of its enhanced realism in detailing. Woolner's *George Dawson* of 1882 in Birmingham, modelled posthumously from photographs, was held to be 'so ludicrously bad that after the deceased's fellow-townsmen had laughed at it for several years they agreed to take it down'[49] – it has however recently been re-erected.

A particular feature of the *Bacon* statue was its close connexion with a Gothic Revival architectural scheme. Woolner was involved with another in 1857 and 1858; the restoration of Llandaff Cathedral near Cardiff had been entrusted to the architects John Prichard and John Pollard Seddon, and Seddon turned to Pre-Raphaelite associates/ friends of his painter brother Thomas for help with the decoration. From Woolner he commissioned four panels to be set in the Gothic pulpit, *Moses with the stone tablets of the Law, veiling his face on the Mount*; *David Harping*; *St John the Baptist in a Camel's hair robe* and *St Paul* (figs 1–4). Woolner prepared plaster models which were sent down for carving on the spot by the mason-sculptor Edward Clarke. He claimed the job was 'most perfectly uninteresting',[50] but a certain typically Pre-Raphaelite quality can be seen in the characterful representations – Seddon certainly thought as much about the *St Paul*, whose right hand Burne-Jones also especially admired.[51] *St John*'s nose though was crushed to pieces during its return from being exhibited at the Royal Academy.[52]

In 1861 Woolner was commissioned to do an extensive programme of sculpture for Alfred Waterhouse's Assize Courts in Manchester; the thirteen figures and three reliefs took him until 1867. In 1868 he completed a statue of *William III* (fig.20), part of a series originally intended to stand in the Royal Gallery at the Houses of Parliament, the Gothic Revival building *par excellence*; others involved included Alexander Munro and eminent names in British nineteenth century sculpture, such as Henry Weekes, Thomas Thornycroft and William Theed. The original commissions were given in 1860, but when the first figures (by Thornycroft) were ready, it was discovered they were too large for the designated positions. This was par for the course in the Palace of Westminster, when figure sculpture designated as part of the building was selected by a committee and not the architect. Though John Birnie Philip's replacement figures fit well enough (fig.21), they lack a certain swagger, not to say the imposing presence of Woolner's.[53] It would be a mistake to interpret Woolner's occasional reservations about his architectural sculpture work as in any way anti-Gothic. He had doubts about

fig.20 Thomas Woolner, *William III*, marble, 1867. Old Bailey, London

fig.21 John Birnie Philip, *William III*, 1869. Royal Gallery, House of Lords, London

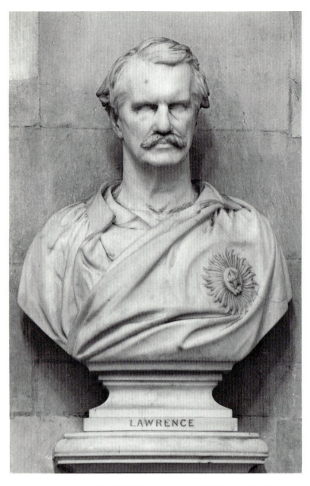

red-hot young Ruskinites at Oxford and 'the wild enthusiasm they all and each fluster into at Gothic Sculpture, indiscriminately, good or bad'.[54] But it was a lack of judgement, seen also in their wholesale condemnation of classical sculpture that he objected to. Indeed, when it came to building his own studios behind 29 Welbeck Street, in 1862, he described these as 'all Gothic, with nice wood and iron and tile work, and much prettier than any of the rooms in the house itself' which he dated to the eighteenth century.[55]

As we have seen, Woolner was involved in the field of funerary monuments from early in his career, viz. the Grasmere *Wordsworth*. He returned to these at intervals – many were done for friends and were limited in scope. Occasionally greater elaboration was entailed (possibly for financial reasons). The *Peel* monument of 1867 (Wrexham; cat.76) incorporates certain of his special sculpture ideas of that time (which I shall examine later) as do the four reliefs of *The Acts of Mercy* on the exterior Moore Memorial Fountain at Wigton (1872), but further examples of this particular style appear only in projected monuments such as the *In Memoriam*s or *The Listening Boy*. A greater scale only really comes in with the major monuments of the 1880s – *Landseer* (St Paul's Cathedral), *Lord Frederick Cavendish* (Cartmel) and *Bishop Jackson* (St Paul's Cathedral). Undoubtedly the liveliest of Woolner's church monuments is his national memorial to *Lord Lawrence* of the Punjab in Westminster Abbey of 1881 (fig.22). But here it is hard not to conclude the life comes from the use in the monument of Woolner's most successful sculpture genre, the portrait bust.

A particular variation in commemorative monuments which Woolner developed was the memorial cross. The first of these, the *Palmer Cross* was designed in 1860. The following year he became involved in a potentially more prestigious scheme for a memorial to be set up at Cawnpore in India in honour of the British women and children slaughtered there and thrown down a well during the Indian Mutiny (fig.23). The 2nd Earl Granville wrote to Lord Canning on 10 July 1861 that he had asked Woolner 'a young artist of great imagination and good workmanship' to send a sketch; 'he has lately made a magnificent statue of Lord Bacon (not altogether a pathetic subject) . . . Woolner instead of a sketch has made a very pretty model; a woman leaning against a cross, a dead infant at her feet, a sword worked into the cross, (an old English one, not very intelligible to a superficial observer)'. This answered a remonstrance from Canning about a rumoured monument of 'a woman clinging to a cross with the bodies of murdered children near her'. This was not what Canning envisaged: it would be painful to English families, provocation to fellow-countrymen-soldiers and not desirable to put before the natives for all time so literal a picture of the horrors of 1857.[56] Woolner did not receive the commission – it went to Marochetti. Other memorial crosses followed though – the *Simeon Cross* of 1873 (Isle of Wight) and the *Percival Cross* of 1882 (Oxford) perhaps more typical: simple structures decorated with non-figurative, vegetal carving, all in the best Pre-Raphaelite truth to nature tradition.

This is all, of course, a long way from a sculptor like Woolner's ultimate expression of his art, the Ideal work, upon which as we have seen he had expended so much energy and imagination in his earlier years. In 1856 he showed at the Academy the figure of *Love* (cat.65). This had originated in a drawing circulated among friends before he left for Australia; this ostensibly represented 'Spring' but with a second meaning, in this case Love or a dream of love.[57] The work was admired by Woolner's friends: 'very

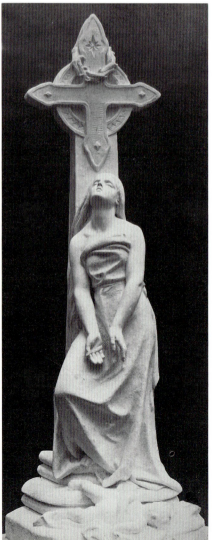

fig.22 Thomas Woolner, *Lord Lawrence*, marble, 1881. Westminster Abbey, London

fig.23 Thomas Woolner, Model for the *Cawnpore Memorial*, plaster, 1861. Location unknown

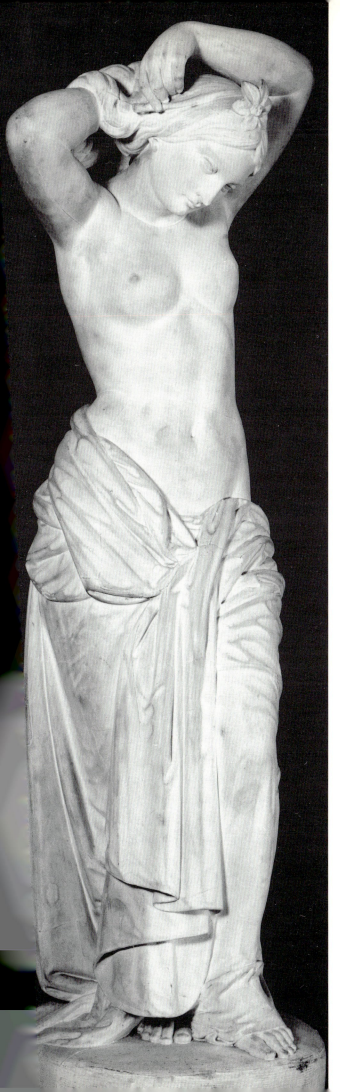

beautiful and finished'[58] (W. M. Rossetti), 'a lovely piece of finished modelling and chaste, dreamy expression' (F. G. Stephens).[59] But it did not attract a buyer for some time, and Woolner did not repeat this sort of work for some years. There were other problems involved: '. . . one of my chief difficulties is the obtaining of suitable models, for really those one can get are so ugly that all ideas of beauty are driven away at a single glance of the denuded horrors. I wish art was in such a high spiritual state that lovely ladies could sit for their figures without entailing any scandal upon themselves, for it really does seem almost a crime that women of beauty nearly divine should never let it be seen so that available use could be made of it – "They waste their sweetness on a blank chemise". You see I grow poetical.'[60]

Woolner's next strictly Ideal work was not exhibited until 1866 and even this was not a new creation but a bronze version of his *Puck* of 1847 (cat.53b). A reason for this scarcity in addition to the general lack of patronage for the genre was Woolner's undertaking at this time two of the major works of his entire career, the *Fairbairn Group* (fig.24) and *The Lord's Prayer* (col. pl.4) The first of these, known also as *Constance and Arthur*, *Brother and Sister* and *Deaf and Dumb* is really a double portrait group of two of the Fairbairn children. Woolner met the children in August 1857 and began work on a sketch of the group soon after; the marble was completed in time for the 1862 International Exhibition. The work can be taken almost as a manifesto of Woolner's particular artistic ideas and skills. It is not just a portrait, it is a portrait seeking to express the physical condition (deaf and dumb) of the two children. Their pose is replete with tactile emphases, their lack of marked facial animation is to be expected in a soundless world. They are nonetheless clearly together, communicating in spite of their disability. Woolner is here contributing to an accepted, established category, the possibly sentimental child portrait that verges on genre. Millias in painting excelled at this (*My First Sermon*, 1863 and others), Joseph Durham produced sculptures such as *On the Sea Shore* (alias Sir Savile Crossley as a boy) of 1865 and others – the Durhams though are less evidently sentimental. To convey the messages and reinforce them, Woolner employs the vein of naturalism and realism already established in his portrait busts: the children's feeling for each is confirmed by the total naturalism of their pose, and every detail (even in the naked child) is represented realistically. The group provoked widespread admiration, a poem from Browning, and J. B. Waring stated: 'this work of Mr. Woolner's places him at the head of the Realistic school.'[61]

The Lord's Prayer (also known as *Mother and Child* or *The Trevelyan Group*) occupied Woolner from 1856 to 1867. A mother is teaching her child to pray, above a base depicting scenes of savagery (eating people, burning them alive etc.). This is the triumph of Christianity over paganism in a modern-life context, the principal figures represented naturally and truthfully. This can be seen as a truly Pre-Raphaelite idea, echoing the ideal moralising projects of Woolner's younger days (the Westminster Wordsworth programme or *The Progress of Nature* group) and quite matching paintings by Woolner's brother-in-law Holman Hunt such as *The Awakening Conscience* or *The Light of the World*. One should note though, in addition, regarding both of Woolner's groups the multiplicity of their titles. It is not quite the equivalent of Albert Moore's retort to a potential patron enquiring about the name of a painting ('you can call it what you like'), but Woolner did write to Sir Walter Trevelyan: 'Concerning a name for the group I have never yet seriously thought upon the matter . . . I am rather of W. B. Scott's opinion in this respect, that if you can give a work of Art, either picture, statue or poem, a distinctive name it matters little whether the name be descriptive or not; and he cites the titles of some of Shakespeare's dramas in confirmation of his view.'[62] It

cat.65 Thomas Woolner, *Love*, plaster, 1856. Christchurch Mansion, Ipswich

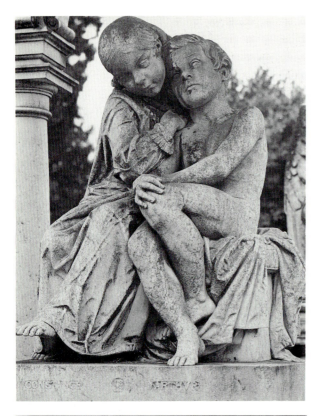

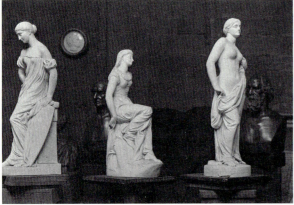

fig.24 Thomas Woolner, *Constance and Arthur*, marble, 1862. Private collection

fig.25 Photograph of Thomas Woolner's studio at 29 Welbeck Street, London

fig.26 Thomas Woolner, *Virgilia bewailing the banishment of Coriolanus*, marble, 1871. St Mary's College, Strawberry Hill, Twickenham

is possible to see here Woolner, and Scott, participating in that movement of the time where the specificity of the work of art was being dematerialised ('Art for Art's Sake') and which involved such close erstwhile colleagues of Woolner's as Millais and D. G. Rossetti.

Woolner's completion of these two substantial works was not trouble-free. The supply of adequate blocks of marble became problematic in the early 1860s,[63] while a financial crash in 1866 not only further restricted what limited market there was for Ideal works, it caused considerable delays in the settling up of more modest commissions for busts etc . . .[64] This may partly explain the new direction in Ideal work that Woolner took from the late 1860s, a series of half life-size statuettes of female figures from literature (fig.25): *Elaine* 1868 (Tennyson), *Ophelia* 1869 (cat.77) (Shakespeare), *Guinevere* 1872, *Godiva* 1878, *Enid* 1881 (all from Tennyson);[65] Tennyson subjects were no doubt aimed to take advantage of Woolner's friend's substantial reputation. F. G. Stephens considered the *Godiva* one of Woolner's three supreme works of the 1870s. Taken from the Tennyson poem of that name, it is possible to see (in spite of other verses quoted in the Royal Academy catalogue entry) that the sculpture illustrates a particular moment (my italics) in the poem before the heroine becomes entirely nude:

'Then fled she to her innermost bower, and there
Unclasp'd the wedded eagles of her belt,
The grim Earl's gift; *but ever at a breath*
She linger'd, looking like a summer moon
Half-dipt in cloud: anon she shook her head
And shower'd the rippled ringlets to her knee;
Unclad herself in haste; adown the stair
Stole on . . .'

For the literate who know what will happen next, this choice of a moment in time, suspended before something deeply dramatic happens, creates a representation fraught with tension, and this use of the implicit to heighten the effect can only really be paralleled in Victorian art of this period in the immediately contemporary paintings of Frederic Leighton that deal with both the implicit future and the implicit past (see *Jonathan's Token to David* RA 1868; *Captive Andromache* RA 1888). One should perhaps also note that Godiva had been treated as a subject both by Holman Hunt in his illustration to the Moxon Tennyson (1857) and even earlier by William Behnes at a time when Woolner was working in his studio.[66]

At the same time as Woolner was evolving a new type of Ideal work, a quite distinctive and new stylistic element came into his work. Having modelled the Gladstone bust for Oxford, he designed three reliefs to go on its base illustrating themes from Homer (see cat.73). They reflect Gladstone's expert knowledge of the Greek poet, of which Woolner gained first hand experience while considering the reliefs on the occasion late in 1865 when he entertained Gladstone, Tennyson, Dr Symonds and others for dinner;[67] they were also 'a compliment to Mr. Gladstone's study and knowledge of Greek art'.[68] The reliefs are lively in composition, using action and gesture to animate the potentially dramatic scenes portrayed. What is distinctive about them also is their use of a much more classically-inspired drapery style and they usher in what can be seen as a definite classical phase in Woolner's work. The major work of this category is his relief of *Virgilia bewailing the banishment of Coriolanus* (fig.26), commissioned by Lady Ashburton and completed in 1871. It was highly regarded at the time,[69] but the most perceptive critical description was that of Tupper, which again is worth quoting at length for the precise technical standpoint he brought to bear: 'Let us take, then the "Virgilia", the wife of Coriolanus (Shakespeare not Niebuhr for historian), and we shall find that the heart-sick longing for her absent lord is told not only in the face (the one pathognomic exponent with our now-a-days sculptors), but in the yearning of the forward neck and head dropped back, in the huddled-up, self-abandoned posture wherein she sits, in the clutched feet, and, most pathetically, in the outstretched

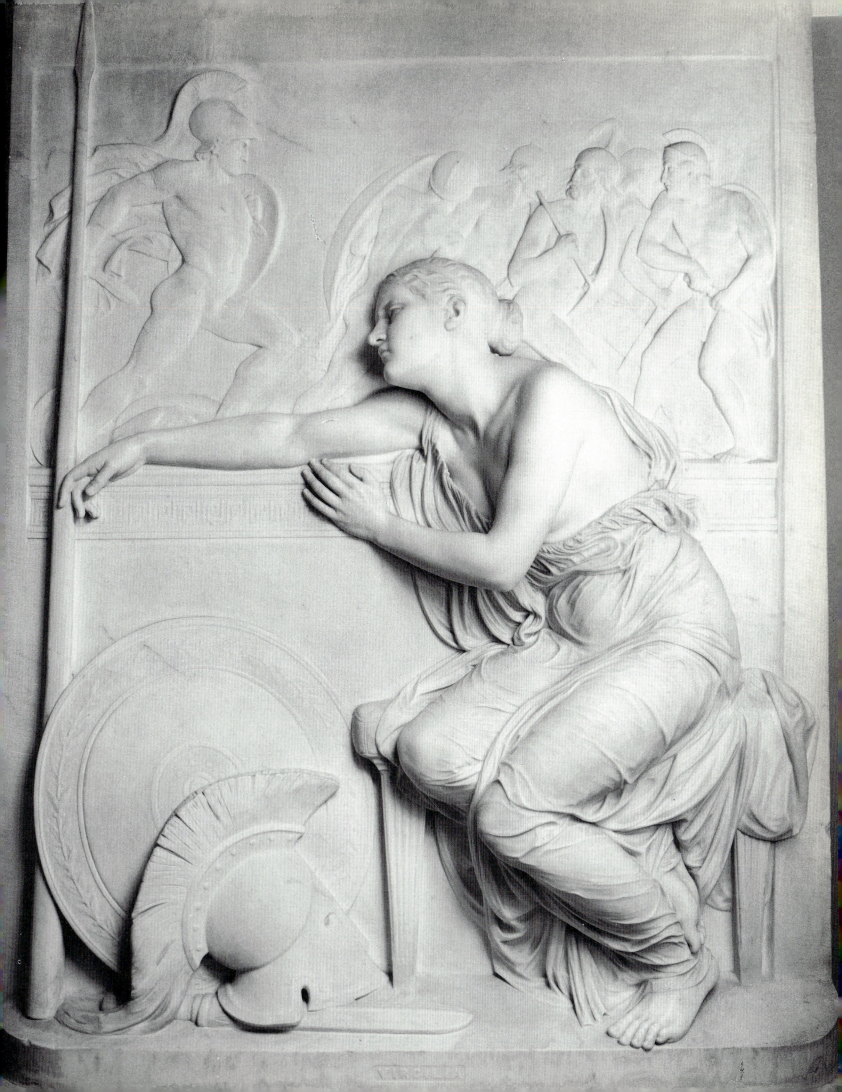

unconsciously exploring arm . . . Coriolanus alone (probably shut in Corioli) charges a group of Volscians, of which the nearest is killed, the next in full retreat, the hindmost looking back half resolute but still retreating, while the furthest off only prepares to fight. Herein we have found psychologic machinery indispensable in all groupings of human beings : and all this is intelligible criticism : it is what we can write and explain. But what shall we say about that which we can neither explain nor put in words, the mysterious exponency and significance of the arrangement of *lines* in the composition; their exsurgency, or, so to speak, polarity in the figure of the fate-fraught hero, their flutter, decline, and collapse in the forms of the scattered Volscians? By theorists (on art's threshold) we may be told that, the mind once rightly expressed in the attitude, harmonious composition must follow, or that what we have called psychologic machinery will ensure this result . . . All this background is in low relief, while the form of Virgilia is in alto; and if it may be doubted whether high and low relief can be judiciously mixed, there can be doubt that the complete isolation of the background, which in this case represents not the fact itself, but its ideal embodiment [Coriolanus and the Volsci are portrayed on a relief within the relief], is triumphantly effected by the delicate expedient of interposing a course of key-fret ornament, which, with its ever-pronounced shadow, draws the desired line of severance between the real and the ideal upon the same slab. The "mere points of material arrangement" as we are apt to think them, are to sculpture just about what the bass is to music.'[70]

Further classical themes or treatments can be seen in the Wigton reliefs of *The Four Acts of Mercy* (1872), the Lucas medal (1872), the repeat of *Achilles Shouting from the Trenches* (cat.73) from the Gladstone reliefs that Woolner submitted to the Royal Academy as his diploma work in 1876, as well as to some extent in the drapery treatment of the *In Memoriam* reliefs of 1870 (cat.79) and 1872 and the *Listening Boy* of 1874. It is possible to see this phase of Woolner's work as fitting in with the sudden classical revival in British painting from the mid 1860s (Albert Moore's *The Marble Seat* 1865, Frederic Leighton's *Daedalus and Icarus* of 1869 and others). But there had also been always a hint of the classical at intervals throughout Woolner's œuvre. Stephens referred to his 'supple and elastic quality of the human skin' as Phidian, 'the skin of the Theseus or Ilissus is only finer in degree than Woolner's best statues show',[71] it was the same who claimed 'in the style of his ideal works it had from the first been part of Woolner's ambition to embody something of Phidian dignity, simplicity, and naturalness, combined with exhaustive representation of detail', which was part of the inducement he felt to join the Pre-Raphaelites,[72] while even in 1857, when castigating the redhot young Ruskinites, it was for Woolner in part for their lack of judgement revealed in 'the very great contempt they all feel and express towards the Greek sculpture however good . . .'.[73] There was moreover Woolner's developing admiration for the work of John Flaxman whose drawings he was acquiring certainly by 1876,[74] and it is possible to see stylistic analogy between the drapery treatment of Flaxman's RA Diploma work *Apollo and Marpessa* and that shown in Woolner's *Peel* monument of 1867, or more general Flaxman kinship in *The Four Acts of Mercy* reliefs on the Moore Memorial Fountain of 1872.

It might perhaps seem that after these adventures of the late 1860s and 1870s, Woolner's career began coasting to a successful end. He had been elected ARA in 1871, full Academician in 1874 and was briefly Professor of Sculpture at the Royal Academy between 1877 and 1879. Major public statuary commissions still came his way in the late 1880s – *Raffles* for Singapore in 1887, *Bishop Fraser* for Manchester in 1888. There is evidence that he did not like the new movements coming into British Sculpture in the 1880s, an antipathy possibly heightened by a certain dull inflexibility coming into his own work of the period. But his swan-song revealed the old spirit of adventure was alive. *The Housemaid* (cat.88) shown in 1893 was a subject Woolner had long wished to do, it is an observation of real, everyday life and in its way a last statement of Pre-Raphaelite principle, a work of art based on Truth and Work and Beauty.[75]

Woolner died on 7 October 1892. A constant *motif* among those who had known him was a certain trenchancy of personality and expression about him – Madox Brown refers to Woolner's 'fumes sulfureous', to his being 'fierce as ever', to Tommy Woolner entertaining us 'with many highly wrought annecdotes, one of which as I had witnessed it myself although he did not seem to remember, I had an opportunity of testing the quantity of coloring matter superadded which seems to be considerable. To another I declare He superadded comments which I remember myself having made at a former hearing of the narration . . .'[76] Mr Callander Ross, a friend of later days, wrote in *The Times* along these lines: 'In life, as in art, he was the uncompromising foe of shams, of claptrap, and of superficiality.'[77] Obviously this did not go down well with everyone, and Brown (again) describes how Ruskin 'a sneak' hated Woolner, 'because he is manly & strait forward' (like himself, Brown, whom Ruskin also hated).[78] But as F. G. Stephens pointed out, Woolner had a life of constant professional frustration through which certain qualities and successes that I have noted were achieved. Perhaps the last word should go to William Michael Rossetti, writing to F. G. Stephens after news of Woolner's death: 'For many years (as you know) he and I were like affectionate brothers: but I grieve to say that I had not so much as seen him for perhaps 12 to 15 years. I never felt alienated from him in spirit: but family circumstances, combined with my own pretty blameable habit of never going anywhere, had made us lose sight of each other. Peace and praise be with his memory.'[79]

Notes

1 The fullest accounts of Woolner's life and work, especially his early days, are in A. Woolner; Stephens 1894, pp.80–86

2 Hunt, vol.I, pp.116, 118

3 Stephens 1894, p.81

4 See *Report of the Commissioners Appointed to Inquire Into the Present Position of the Royal Academy in relation to the Fine Arts; together with the Minutes of Evidence Presented to Both Houses of Parliament by Command of Her Majesty*, London 1863, paragraphs 2364–7

5 Private coll.

6 *Athenaeum*, 20 July 1844

7 Stephens 1894, p.81

8 For further details see Read 1982, pp.82–4

9 *Art Union*, March 1848

10 Stephens 1894, p.82; Hunt, vol.I, p.114

11 Hunt, vol.I, p.127

12 *ibid.*, pp.112–13

13 *ibid.*, p.128

14 Stephens 1892, p.522

15 *ibid.*

16 See *Spectator*, XXIV, 2 Aug. 1851, p.740

17 For fuller details and discussion of both Wordsworths, see Read 1984, pp.106–7

18 Stephens 1892, p.522

19 Tupper 1871, p.99

20 Rossetti 1890, p.187

21 See Tate Gallery 1984, pp.165–6; Surtees 1981, entry for 11 April 1856, p.169

22 *ibid.*, 16 March 1857, p.195

23 See his letter to William Bell Scott, 17 Feb. 1857 in Peattie, p.77

24 Letter to Sir Walter Trevelyan, 10 Nov. 1860, Trevelyan Papers

25 Letter to William Bell Scott, 24 May 1859, Troxell Coll.

26 Letter to Lady Trevelyan, 8 March 1857, Trevelyan Papers

27 Stephens 1894, p.84

28 Published letter to the Editor of the *Spectator* – date unknown

29 Letter Mrs Gladstone to Woolner, 14 Sept. 1863, A. Woolner, p.238

30 Temple, p.43

31 'Mr Woolner's Studio'

32 Stephens 1892, p.72

33 Tupper 1871, p.98

34 Letter to Lady Trevelyan, 8 March 1857, Trevelyan Papers

35 See *Town and Country Journal*, Sydney, 15 March 1879, p.497; 'his first important production'; Justin H. McCarthy, *The Portrait*, No.5 (date unknown): 'his first important work'; Stephens 1892, p.522: 'his first important commission'.

36 See Blau, pp.74–5; also, for the sculpture, Acland & Ruskin, pp.34–8, 73–81, 103, 111

37 'E', *The Bookman*, Dec. 1892, p.79

38 Surtees 1981, entry for 1 Sept. 1856, pp.185–6

39 'E', *The Bookman*, Dec. 1892, p.79

40 Letter to Lady Trevelyan, 6 April 1857, Trevelyan Papers

41 Letter to Mrs Tennyson, 16 Aug. 1856, A. Woolner, p.115

42 A. Woolner, p.123

43 Woolner letter to Lady Trevelyan, 23 Dec. 1860, Trevelyan Papers

44 Stephens 1893, p.72

45 Woolner letter to Lady Trevelyan, 8 March 1863, Trevelyan Papers

46 Woolner letter to Lady Trevelyan, 26 Oct. 1863, Trevelyan Papers

47 See Moore, 'Introduction', p.7

48 Greenwood, p.475

49 Read 1982, p.14

50 Letter to Lady Trevelyan, 6 April 1857, Trevelyan Papers

51 Letter to Lady Trevelyan, 2 Dec. 1857, Trevelyan Papers

52 Letter to Mrs Tennyson, 3 Aug. 1858, A. Woolner, p.158

53 See Walker, pp.100–1, 107

54 Letter to William Bell Scott, 17 Dec. 1857, Troxell Coll.

55 Letter to Constance Hilliard, 7 Feb. 1862 (location unknown)

56 Fitzmaurice, vol.I, pp.396–7. I am very grateful to Dr Philip Ward-Jackson for this reference

57 'E' *The Bookman*, Dec. 1892, pp.78–9

58 Letter to William Bell Scott, 14 April 1856 in Peattie, p.66

59 Stephens 1894, p.83

60 Letter to William Bell Scott, 18 Nov. 1858, Troxell Coll.

61 See Tate Gallery 1984, pp.194–5

62 Letter to Sir Walter Trevelyan, 24 Dec. 1860, Trevelyan Papers

63 Letters to the Trevelyans, 5 Aug., 10 Nov., 24 Dec. 1860, Trevelyan Papers

64 Letters to Sir Walter Trevelyan, 21 July 1867, 19 Feb. 1868, Trevelyan Papers

65 Marble versions of *Elaine*, *Ophelia* and *Guinevere* featured in the sale of Jonathan Nield, Rochdale at Christie's 3 May 1879, lots 96–8

66 A. Woolner, p.2

67 Letter to Lady Trevelyan, 12 Dec. 1865, Trevelyan Papers

68 A. Woolner, p.237

69 See A. Woolner, p.279; Stephens 1894, p.84

70 Tupper 1871, pp.100–1

71 Stephens 1893, p.71

72 Stephens 1892, p.522

73 Letter to William Bell Scott, 17 Dec. 1857, Troxell Coll.

74 A. Woolner, p.305

75 See Read 1982, p.212

76 Surtees 1981, pp.119, 138, 185

77 A. Woolner, p.334

78 Surtees 1981, p.197

79 Letter of 16 Oct. 1892 in Peattie, p.560

Beyond Captain Cook:
Thomas Woolner and Australia
by Juliet Peers

Although Thomas Woolner found many supporters and commissions throughout his life in England, his Australian connections have a special importance in his œuvre. Woolner's finest works, in his daughter's opinion, the *Captain Cook* (fig.28) in bronze and the 1876 bust of Tennyson in marble were in Australia. The Australian medallion portraits drew attention to Woolner's merits as a portraitist in the mid-1850s, and this was recognised in England.

Even in the first phase of his Australian visit, Woolner was toying with portraiture in Melbourne, sketching Charley Howitt, and intending to draw the Governor, C. J. La Trobe.[1] His choice of the latter sitter suggests that he had some thought of potential commissions. Through Bateman, nephew of Governor La Trobe, Woolner gained access to a suprisingly cohesive circle of art and cultural patronage in Melbourne.[2] La Trobe, various members of the Howitt family, the MacCrae family and their cousins the Ward Coles are among Woolner's Melbourne sitters. Only missing from this group of prominent art lovers is Redmond Barry, of whom Woolner was later to sculpt a marble bust, presented by subscribers to the National Gallery of Victoria, Melbourne. Barry was an advocate for art and learning, who supported the function of sculpture as a celebration of 'great men', in his use of plaster busts of historic and literary notables to decorate the public library.[3]

Despite the story, circulated by Holman Hunt, that Woolner needed the portraits of his celebrated London associates to establish his bona fide credentials as a sculptor, the connections with the Howitts and La Trobe Bateman were more relevant to Melbourne patrons than the Pre-Raphaelites in distant London.[4] Melbournians recognised that Dr Godfrey Howitt 'has done his best to bring Mr. Woolner's talents to the knowledge of the Victorian world'.[5] Woolner had no need to trade on the reputation of other artists, as his own English reviews, especially of the Wordsworth Memorial, judiciously circulated to the local press, caused sufficient excitement. His connection with the Howitt family established a pattern for Woolner in seeking sponsorship in Australia. He relied upon friends and satisfied patrons to circulate his name and recommend him to appropriate committees. To this end he corresponded with a number of Australians, including Henry Parkes, Edward Wilson, Sir Thomas Elder and also Bernhard Smith — the latter correspondence being for friendship rather than influence. Less naive than Parkes, Wilson appears to have upbraided Woolner for singing his own praises; Woolner believed such a practice was acceptable and proceeded unabashed to give an account of his recent success with *Constance and Arthur* (fig.24).[6]

Even in the relatively secure period of the 1870s, Woolner seemed acutely conscious of the transience of critical acclaim. It would appear that an extensive colonial practice in public monuments had its drawbacks. Firstly many of his finest works were erected overseas, and he had few chances to familiarise English authorities and connoisseurs with these works. Woolner therefore was grateful for the opportunity to exhibit his completed *Captain Cook*, in London, on a temporary plinth outside the Athenaeum Club, for some months prior to shipping. According to Woolner, this was an accustomed practice for British sculptors sending works out of the country, although circumstances decreed that many of his works were sent abroad in haste without such an opportunity to bring them to public notice.[7]

The reputation, established with the works that he sent out from London, was not sufficient in itself to withstand the wild cards of local politics and influence, let alone claims by local talent which, in the case of Australia, Woolner did not regard favourably.[8] With Parkes he pleaded to be given commissions, deploring the waste of sculptural work on 'native roughness'.[9] Such uncertainties had to be prudently countered by keeping his name before potential patrons half a world away, a task to which Woolner devoted much attention. To obtain a commission for a statue of Queen Victoria, later awarded to Joseph Edgar Boehm, the documentation which Woolner sent to support his claim, included an inventory of major commissions and tributes from

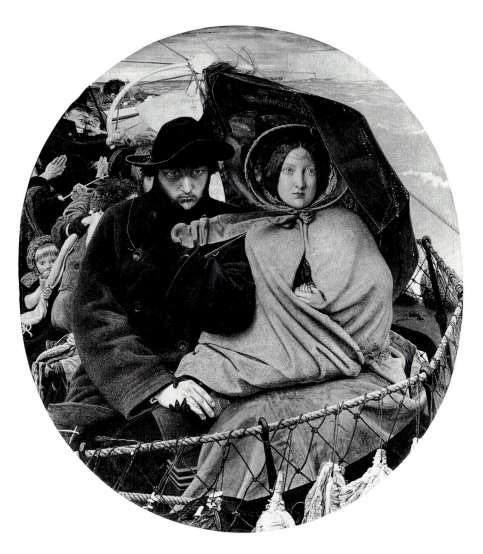

fig.27 Ford Madox Brown, *The Last of England*, oil on panel, 1855. City Museums and Art Gallery, Birmingham

referees as eminent as W. E. Gladstone.[10] On one occasion Woolner was too ardent, even for his loyal friend and appears to have caused some problems by lobbying for a commission, the monument to Governor Phillip, which Parkes had already entrusted to another sculptor.[11]

The success of Woolner's Melbourne portraits (cat.57) led him to be associated with a scheme to erect a statue of Queen Victoria.[12] Jane Lennon has identified the collapse of this plan, which had provided both publicity and hope to Woolner in late 1853, with the change of Lord Mayors in Melbourne. Subscribed funds were to be handed back.[13] This reversal was prophetic, as both the *Cook* statue and the series of portrait busts of British Prime Ministers were jeopardised by changes in colonial ministries. Woolner's last major commission, for three over life-size statues of Sydney politicians, was aborted for the same reason. Smaller portrait busts, such as those of Edmund Wilson, Redmond Barry and Dr Bayer, funded by the subjects' admirers and supporters, seemed less at risk.

Having played out Melbourne with reasonable success, Woolner turned to Sydney and in February 1854 executed the work that especially would make his career in Australia, the Wentworth medallion (cat.62).[14] In Australia, at least, it appears to have been the primary target for pirated copies and re-casts, a backhanded compliment to its popularity. Widely praised in the papers, it was exhibited at the office of *The Empire* newspaper. Woolner advertised his intention of taking subscriptions, through a stationer, and then casting the medallions in London. Wentworth was pleased with the likeness and permitted his letter of congratulations and support to be used as advertising copy for gathering subscribers.

During his stay in Sydney Woolner met Henry Parkes, who immediately publicised his sculpture through the columns of his newspaper *The Empire*.[15] Surprisingly Parkes is not mentioned in Woolner's 1854 accounts of Sydney. To his father he credits Charles Nicholson with introducing him to Sydney society, and to Bernhard Smith he credits a Mr Dyer of *The Empire* with performing the same service.[16] Parkes was in the earlier stages of his climb from working-class penury, and may not have been able to afford to be sculpted by Woolner.

However, Woolner's interests in 1854 did not lie so exclusively with Parkes, as they would in subsequent decades. Some of his sitters, such as William Fanning, actively opposed Parkes and by the 1870s Sir Charles Nicholson was identified firmly as an enemy of Woolner.[17] On the other hand, it is certain that Woolner provided a crucial entrée for Parkes, during his visits to England, into the High Victorian culture that he admired.[18] Therefore the sculptor partially facilitated Parkes's construction of himself as poet, connoisseur and 'Australia's Grand Old Man' – the penniless emigrant made good. When English weather and artistic ostracism made Woolner feel bleak, he entertained himself with reveries about the climate and abundance of New South Wales. Woolner even asked Parkes to find a piece of land suitable for settling his family on.[19]

In 1854 Woolner intended to stay for a length of time in Sydney, confident that he had promises of portrait work in hand to the value of £200. He advised Smith to leave the Gold Commission, move to Sydney and take up the waiting circle of patrons.[20] Only the hope of obtaining a commission for a statue of Wentworth caused Woolner to abandon the lucrative commissions still unfulfilled. Doubts had been raised over his relative inexperience with monumental work, necessitating his return to London to demonstrate his skill on a larger format than the portrait medallion. A 'London'

cat.61 Thomas Woolner, *Sir James Martin*, bronze, 1854.
Private collection

reputation was an advantageous factor in influencing local committees commissioning monuments.[21]

On his return to London in October 1854, Woolner began looking for a studio, 'cleaning up my casts' and visiting friends and useful contacts. Australian curiosities, such as the quartz stones he gave to Mrs Tennyson, no doubt initially opened doors to the returned traveller.[22] Australians in London also played a part in establishing him. Fitzroy gained an entrée for Woolner with a dealer in Pall Mall.[23] Woolner finally lost the much delayed commission for the Wentworth statue. The completed figure by Pietro Tenerani is now at the University of Sydney. Wentworth himself fell out of Woolner's favour when he turned to Baron Marochetti and Alexander Munro as potential sculptors of his monument. Woolner sneered that Wentworth 'knows nothing of art and will not understand my sketch . . .'.[24] He finally had a chance to sculpt a statue of Wentworth for Sydney in 1890.

From the start Woolner circulated multiple copies of his portraits. In a letter to Smith, he stated that he received £20 for a likeness and £3 for subsequent casts. These Australian casts were in plaster, and his practice was extensive enough for him to establish fixed arrangements with plaster suppliers and frame makers.[25] Woolner took a number of these plaster portrait-medallions including those of Wentworth and Fitzroy, back to London for casting. His *Queen of the South Journal* records his consternation, when he believed that his 'case' of medallions had not been shipped. Woolner hoped that these Australian portraits would establish him in London. He described them as 'the means of doing what is an important part of my business . . . Without my medallions I should be like a man in an uninhabited district with but little food and having lost the stock of seed that he meant should serve him in times to come'.[26]

It is difficult for Australians now to approach *Captain Cook* (1879; Hyde Park, Sydney; fig.28) in the optimistic spirit in which it was commissioned and created by Parkes and Woolner. It could be argued that the symbolic values which its sculptor saw Cook representing were those of opportunity not oppression. Cook represented the self-made man, a pragmatic hero with the common touch. Although Australian commentators have been hard pressed to trace 'Pre-Raphaelite' influences in the appearance of the work,[27] especially if defined in terms of Rossetti, *Captain Cook* was the focus of deep and pure emotions for Woolner. 'My six months in Sydney partly from the lovely scenery, and in part from the great amiability of everyone towards me, was one of the most enjoyable periods of my life.'[28] Not only personal feelings were embodied by the Cook statue, but Woolner saw it as a potent symbolic figure. 'My idea is . . . to make an animated figure filled with wonder and delight at the moment of discovering a new country. Smitten by the sun he would always stand a shining welcome to all comers to the fair Australian land.'[29] If approached in such a manner, *Captain Cook* may seem a little closer to the aesthetic of *The Lord's Prayer*, than would otherwise be assumed from a purely visual comparison. Cook's overtly rhetorical gesture is relatively unique in Woolner's œuvre. As with *The Lord's Prayer*, the documentation behind the production of the Cook statue is extensive. As well as progress reports, the basic issue represented in the often anguished exchanges of letters, at both government and private levels, show the precariousness of working in England.

A change of government meant that Woolner who had been given, in correspondence with Parkes, the commission for sculpting a figure of Captain Cook for a base already erected for some years in Hyde Park, Sydney,[30] found himself placed in the hands of a new Agent General in London. Having seen Woolner's models and sketches, products of nearly two years' work, William Forster, the New South Wales Agent General, began openly negotiating with Charles Summers, and possibly others[31] to tender against Woolner. Problems arose because whilst money had been voted for the sculpture, and an additional sum granted following Woolner's advice, there was no official record of

fig.28 Thomas Woolner, *Monument to Captain Cook*, 1878. Sydney, Australia

Notes

1 Thomas Woolner, Australian Diary 1852–1854, BLO Ms Facs d. 152, Australian Joint Copying Project microfilm no.1926, photocopy of complete MS in Australian National Library, Ms 2939, 31 Oct. 1852

2 Clementi, pp.40–57

3 For the Woolner bust of Barry see letter, Thomas Woolner to Henry Parkes, 8 Dec. 1878, Parkes Papers A930. For Barry's sculptural collecting see The Age, 12 Dec. 1985 and Galhally, pp.28–49

4 Stephens 1894, also R. Ormond 1967

5 Melbourne Morning Herald, 13 July 1853

6 Letter, Thomas Woolner to Edmund Wilson, 9 Oct. 1863, La Trobe Coll. Ms. 303.4 (g): '. . . your implied rub as to the impolicy of giving explanations of one's works happily does not touch me . . .'

7 Letters, Thomas Woolner to Henry Parkes, 22 Aug. 1875, 17 Oct. 1875, Parkes Papers A722. Letter, William Forster to John Robertson, 18 Oct. 1877, New South Wales Colonial Secretary: Special Bundles Captain Cook's statue 1876–1879 (A.O. N.S.W. ref. 4/859.1)

8 Lennon notes Woolner's description of himself as the 'only sculptor' in Sydney was at the expense of local artists such as W. G. Nicholls who had a relatively well-established English career

9 Letter, Thomas Woolner to Henry Parkes, undated, c.1883, Parkes Papers A722

10 Letter, W. E. Gladstone to Henry Parkes, 26 Oct. 1883, Parkes Papers A30

11 Letter, Thomas Woolner to Henry Parkes, 3 May 1890, Parkes Papers A722

12 Melbourne Morning Herald, 13 July 1853

13 The Argus, 7 March 1854 and Jane Lennon op. cit., note 8. In a letter to his father, Woolner declared that there were not sufficient funds collected, 24 Jan. 1854, repr. in A. Woolner, p.65. The Argus describes it as a £2,000 monument.

14 The Empire, 22 Feb. 1854. Wentworth's letter enclosing payment for the medallion is dated 28 Feb. 1854, BLO, Ms. Eng. Lett. d.293, Australian Joint Copying Project microfilm 1926

15 Martin, pp.90–1, 196

16 Letter, Thomas Woolner to Bernhard Smith, 13 July 1854, private coll. Letter, Thomas Woolner to his father, 24 Jan. 1854, repr. in A. Woolner, pp.64–6. Letter, Thomas Woolner to Henry Parkes, 23 Nov. 1874, Parkes Papers A722

17 Illustrated Sydney News, 29 April 1854, list of supporters of Charles Kemp against Henry Parkes, Legislative Council Election. For Charles Nicholson as advocate for Charles Summers see letter, Thomas Woolner to Henry Parkes, 29 June 1876, Parkes Papers A930

18 Martin, p.91. For an English discussion on Parkes and Victorian culture see C. Tennyson & Dyson

19 Letter, Thomas Woolner to Henry Parkes, 13 April 1879, Parkes Papers A722

20 Letter, Thomas Woolner to Bernhard Smith, 13 July [1854], private coll. Smith visited Sydney in 1857 as his sister Maria Wise lived there.

21 English sculptors regularly received many prestigious commissions in Australia up to the First World War. Sergeant Jagger's bronzes of First World War soldiers, Wipers and The Driver, now decorating the forecourt of the State Library of Victoria are major late examples of English work imported into Melbourne.

22 Letter, Thomas Woolner to Emily Tennyson, 23 Oct. 1854, repr. in A. Woolner, p.105

Woolner as the chosen sculptor, beyond Parkes leaving recommendation to his successors. Forster brushed aside Woolner's objections. He refused to be bound by mere 'trade union' rules,[32] as he described arguments based upon accepted practices of sculptors and patrons in England, and rejected legal depositions that Woolner's solicitors had submitted to him, with terse notes.

Like the better-known Belt vs Lawes libel case[33] detailed information on the organisation of Victorian sculptors' working life emerges as a sideline of the dispute. 'It is an invariable custom with sculptors to consider a commission as given when instructions have been given to prepare designs'[34] The only reason for withdrawal from such an engagement is when a design has been submitted and pronounced as incompetent and the artist has refused to furnish another.'[35] William Calder Marshall stated that it was 'utterly impossible to mix up the two ways of obtaining designs for approval', i.e. direct commission or open competition, the latter being 'a breach of faith' when 'Designs [were] received from one artist'.[36] However, memoranda regarding British sculptural ethics, Parkes's anxious lobbying to the Governor and Premier, and questions on the floor of the house, did not guarantee the commission, so much as the new Premier's tactful acknowledgements of his responsibility to the artist. When quibbles arose over the timing of contractual payments he 'was unwilling even to appear to drive so hard a bargain with an artist'.[37]

Examining the dates on letters and notices, suggests that his decision to support the artist crossed Woolner's legal documents in the mail.[38] The source of the problem lay in Parkes's method of commissioning art works. He preferred to keep the negotiations on an informal, personal level, rather than ratifying them on an official basis. Woolner insisted that he be given a written order for the series of busts of British Prime Ministers, Parkes's second commission. Even then the commission was never recorded in the Colonial Secretary's office and Parkes had to plead with his successor to ensure the completion of the work and make excuses as to why he had not concluded the negotiations through official channels.[39] Parkes was not a wholly beneficial or discriminating patron. He never seems to have recognised the essential difference between the sculpture of Woolner and, for example, 'the Four Seasons in Carrara Marble by Signor Elgisto del Panta of Florence',[40] one of the many sculptures, paintings, mosaics and decorative objects that decorated the Colonial Secretary's offices. The Prime Ministers' busts in bronze were a consolation prize. Parkes had already given three prominent full-length figures in the same building, the Queen, the Prince of Wales and New South Wales to Giovanni Fontana, a London-based sculptor, whose works were conventional by the standards of 1880s British sculpture. Far from aesthetic criteria, Woolner 'was selected to execute these busts because he had been personally acquainted with all the five statesmen, and on terms of friendship with two of them'.[41] Parkes also believed that the portrait of Russell would be 'the finest yet produced'.

Despite his limitations of taste, mitigated by his genuine enthusiasm for sculpture and his sculptor protégés, Parkes deserves credit. Few collectors of this era, even in Britain, showed such a consistent preference for sculpture. He promoted all aspects of sculptural production, decorative pieces, public monuments, figures, portraits, garden ornaments and architectural sculpture.[42] Woolner's busts of the Prime Ministers document this early attempt at systematic public connoisseurship in Australia. They survive in an interior,[43] which still holds many of the objects, somewhat old fashioned in taste by the 1880s, collected by Parkes for adorning the Colonial Secretary's offices. Parkes seemed entranced by the showier European exhibits from International Exhibitions and employed a buying agent, Signor Oscar Meyer, manager of the Italian court at the 1879 exhibition. Woolner was not above acting in a similar capacity to Meyer. He helped Parkes to buy a 'Turner' and touted on behalf of a dealer wishing to sell a Frith to the Art Gallery of New South Wales.[44]

23 Letter, Charles Fitzroy to Thomas Woolner, 27 Sept. 1856, BLO, Ms Eng. Lett. d.292. Australian Joint Copying Project microfilm 1926

24 Letter, Thomas Woolner to Emily Tennyson, 25 June 1857, repr. in A. Woolner, p.135

25 T. Woolner 1854

26 ibid.

27 Dolan, pp.88–91

28 Letter, Thomas Woolner to Henry Parkes, 23 Nov. 1874, Parkes Papers A722

29 ibid., an early copy of this letter, not in Woolner's hand and with variant punctuation, is found in the State Archives of New South Wales: New South Wales Colonial Secretary: Special Bundles Captain Cook's statue 1876–1879 (A.O. N.S.W. ref. 4/8859.1)

30 Nicholls had sculpted an elaborate figure of some merit depicting the same subject. It had been intended to place this figure on the Hyde Park, Sydney, site. Letter, Henry Parkes to Thomas Woolner, 16 Sept. [?] 1874, Parkes Papers A722 promises to send photograph of the pedestal. Letter, Alfred Stephens to Henry Parkes, 26 Sept. 1874, New South Wales Colonial Secretary: Special Bundles Captain Cook's statue 1876–1879 (A.O. N.S.W. ref. 4/859.1)

31 Copy of letter, William Forster to Thomas Woolner, 27 June 1876; letter, Thomas Woolner to Henry Parkes, 29 June 1876, Parkes Papers A930; also letter, Alex Campbell to Henry Parkes, 24 Dec. 1872, Parkes Papers A879, putting forward a German sculptor for the Cook monument. Charles Summers also was showing interest in the commission at this stage

32 Copy of letter, Thomas Woolner to John Robertson, 28 June 1876, Parkes Papers A930

33 Read 1982, pp.66–7

34 Letter, Thomas Woolner to Henry Parkes, 18 Nov. 1875, Parkes Papers A722. Copy in letter Coode, Kindom and Cotton to William Forster, 1 June 1876, Parkes Papers, A879

35 ibid.

36 Copy of letter, William Calder Marshall to Thomas Woolner, 12 Feb. 1876 in letter Coode, Kindom and Cotton to William Forster, 1 June 1876, Parkes Papers, A879

37 The scheme advocated by N.S.W. differed from that described by Read 1982, p.59, as typical, with payment divided between approval of design, completion of full-size model and completion of statue. The government wanted to pay Woolner on the completion of the full-size model, then on completion of the statue and finally on erection in Sydney. Woolner wanted four payments 1) on approval; 2) completion of the full-size model; 3) completion of the statue; 4) erection in Sydney. The two schedules of payment appear in a memorandum of 6 Jan. 1877, New South Wales Colonial Secretary: Special Bundles Captain Cook's statue 1876–1879 (A.O. N.S.W. ref 4/859.1)

38 Letter, John Robertson to Forster, 5 Aug. 1876 and memos for letters John Robertson to Thomas Woolner, 29 June 1876 and John Robertson to William Forster in ibid.

39 Letter, Henry Parkes to Thomas Woolner, 12 May 1882, 28

Parkes's art buying was constantly attacked by his political opponents and throughout the 1880s a succession of questions regarding art works and art prices were tabled in parliament. No other individual in Australia appears to have supported Woolner to the extent of Parkes, although his English portrait reliefs were sent out to Australia in the 1850s and 1860s, to relatives of the sitters; an interesting record of the function of Woolner's portraits. They include *Eliza Orme, Mrs Coventry Patmore* and *Robert Browning*, the latter sent out to his cousin, Mrs Cyrus Mason of Melbourne, wife of a prominent graphic artist.[45] Busts of British poets and writers found a certain favour. Bronzes of *Dickens* and *Tennyson* were presented to the Government of New South Wales, and the marble *Tennyson* to the Art Gallery of South Australia, plaster and bronze casts of the Australian medallions were being acquired by Australian art galleries in the late 1880s and 1890s.[46] Woolner's Ideal works were (and are) virtually unknown in Australia, apart from illustrations.[47] The sculptor himself showed a half-life-size *Ophelia* (see cat.77) at the Garden Palace in 1879 and it is telling that out of his three exhibits *Ophelia* inspired no public-spirited gesture. Only a plaster study for *In Memoriam* (see cat.79), in the National Gallery of Victoria, a significant and graceful work, gives the Australian public access to Woolner's creative and poetic imagination, beyond the medallions, portrait busts and *Captain Cook*.

July 1882, letter Saul Samuel to Alexander Stewart [?], Feb. 1883, Parkes Papers A722

40 Listed in 'Catalogue of Pictures and other Works of Art in the Chief Secretary's Office as on 1st January 1913', Sydney, Government Printer 1913. I am grateful to Richard Neville for drawing this source to my attention.

41 Letter, Henry Parkes to Sir Alexander Stewart, 4 July 1883, Parkes Papers A916

42 Giovanni Fontana also hailed Parkes as patron and friend and openly lobbied him to gain commissions, letters to Henry Parkes, 11 Aug. 1885, 13 March 1891, 2 Sept. 1892. He also pleads with Parkes not to divulge his ideas to his other artistic associates, Oscar Meyer and Achille Simonetti, letter 12 April 1889, Parkes Papers A883. Other Australian-based sculptors supported by Parkes include Simonetti, William Lorando Jones, Charles Frances Summers and Tommaso Sani.

43 Now with restored wall finishes and furnishing textiles.

44 Letter, Thomas Woolner to Henry Parkes, 3 Oct. 1885, Parkes Papers A930. Woolner's advocacy of the artist contradicts his earlier condemnation of Frith as an 'artificial man' and the prices gained by his work as 'folly', quoted in Trevelyan 1978 (2), p.202

45 Now in the Australian National Gallery, Canberra.

46 The National Gallery of Victoria purchased a bronze medallion of La Trobe (now in the La Trobe Library) in 1888, and were presented with a small-size medallion of the same subject in 1889 and with a plaster medallion of the Rev. James Crow in 1891. The Art Gallery of New South Wales was presented with a relief of P. P. King in 1891 and purchased a bronze of Wentworth in 1897

47 A photograph of *Elaine* sent out by Woolner is held by Smith's descendants and a marble statuette of a woman is held in an Australian private collection. Woolner also sent Parkes photographs of English works, mostly public commissions

Thomas Woolner
and the Image of Tennyson
by Leonée Ormond

In 1855, when he was in his middle forties, Alfred Tennyson grew a beard, transforming himself from a Late Romantic to a High Victorian. Tennyson's 'annus mirabilis' had been 1850, the year when he married, published *In Memoriam* and became Poet Laureate. From that date, his physical image became increasingly familiar to the public at large, until, by the time of his death, more than forty years later, his head was a commonplace, like those of royalty and statesmen. This icon, still so familiar to us, did not, however, represent the Tennyson of 'The Lady of Shalott' or 'The Lotus Eaters', nor even the poet of *The Princess*, *In Memoriam*, and *Maud*. The man with the wispy beard, the high domed forehead and straggly hair was the 'later' Tennyson, who wrote *The Idylls of the King* and 'Enoch Arden'. Images of his mysterious predecessor, the beardless Tennyson, are comparatively rare. Samuel Laurence's oil portrait, touched up and toned down by Edward Burne-Jones at the behest of the Laureate's widow and son, is the best-known example (National Portrait Gallery, London). The other major images are two medallions and a bust, all the work of Thomas Woolner, who fortunately worked on them in the 1850s, just before the onset of the beard.[1]

Woolner first met Tennyson in the late 1840s. Through the poet, Coventry Patmore, he begged to be allowed to model a medallion. Tennyson agreed, but Woolner found it hard to carry through the project. In the years before his marriage, the poet was a rootless and peripatetic figure, unpredictable in his comings and goings, and Woolner was always missing him. He finally pinned his quarry down in the Lake District, where Tennyson was enjoying a lengthy honeymoon near Lake Ullswater. In these relaxed surroundings work on the medallion continued. By 8 December 1850 it was cast in bronze, with some washing 'blue' rubbed into it 'to improve its color'.[2] One copy went to the Tennysons, and others to Patmore and to a Lake District friend, Mrs Eliza Fletcher. Woolner may have presented the medallion to the sitter in person, as Patmore reported that Tennyson 'has taken a great liking to him and has had him to stay with him and Mrs Tennyson'.[3]

Woolner's admiration for Tennyson was entirely genuine. He recognised, however, that a portrait of the poet could forward his career, telling William Bell Scott later that he had made his first medallions of Tennyson and Thomas Carlyle 'for love', but that no new commissions had resulted.[4] Portraits rather than imaginative compositions provided the bread-and-butter work of most sculptors, and 'connections' were of vital importance in securing commissions. When Woolner put his name forward to work on the Wordsworth Memorial in Westminster Abbey, he used Tennyson's name as one of his referees. The commission went elsewhere, and the sculptor, disappointed in this and other projects, decided to try his luck in the Australian goldfields.

Shortly before leaving in 1852, he spent two days with the Tennysons at Chapel House in Twickenham. While there he 'acknowledged' a 'fault' in the medallion, already noted by Tennyson's old friend, James Spedding. As Tennyson put it, 'The face and forehead are not in their proper relation to one another. The face is too forward. Woolner, poor fellow, said he would alter it when he came back. It certainly needs this alteration.'[5] Eliza Fletcher also commented on a marked division between the upper and lower parts of the face, but interpreted it more generously: 'though the forehead is pre-eminently masculine, the lower part of the face is full of tenderness and pity.'[6] Judging by other images of Tennyson, the medallion was too bland, not sufficiently characterful; it was the modelling of the mouth and jaw which created this effect.

Woolner returned to England in October 1854, having done well with portrait medallions, though not with gold-digging. The Tennyson medallion, which had been left in England, had aroused interest in Australia, and Woolner was soon in touch with Emily Tennyson, sending her a lump of quartz, and suggesting that he begin work on a new medallion. For all her saintly appearance, Emily Tennyson was a shrewd woman, well able to discern the vulnerability beneath Woolner's brash manner. Much of their correspondence survives, demonstrating a warm and long-lasting friendship. Woolner

cat.66 Thomas Woolner, *Alfred Tennyson*, bronze, 1856.
Private collection

was one of the rare friends with whom Emily felt able to share anxieties about her husband. Tennyson himself made continual attempts to help the younger man on his way, including putting Woolner's name forward, without success, for a monument to Emily Tennyson's uncle, Sir John Franklin, and for work on more than one memorial to the Prince Consort.

In February 1855, Woolner was a guest at Farringford, the Tennysons' home in the Isle of Wight, where the new medallion was begun (cat.66). 'The present one', Woolner told Emily, 'could easily be altered but the size I strongly object to: a head or a figure should never be more than half size unless full life sized, and this is nearly $\frac{3}{4}$.'[7] The sculptor was welcomed into the family. On leaving, he told Emily:

'your innumerable kindnesses, darling Hallam's fascinating little ways, the great poet's wisdom and music all singing in my memory: I felt a sense of splendor about me as if the sun were brighter on the earth. I never in my life enjoyed a fortnight more and shall always look back upon my visit as an isle of light in the general gloom of things.'[8]

The poet was 'very pleased'[9] with the copy of the medallion sent to Farringford, but some 'unlucky accident' occurred, presumably to Woolner's original.[10] The Tennysons' medallion was returned to Woolner, and arrived back in Farringford in April 1856. Emily thought the nose too long, and Woolner slightly shortened it. Later in 1856, after studying Tennyson's face for his work on the first bust, Woolner decided that the medallion made the poet look too severe: 'I . . . have put a slight touch of sweetness which I think is of golden value, and now I consider it the *very best* med: I have done. I have a cast for you when you please to claim it.'[11] Numerous copies of the medallion were made, both in plaster and bronze, some being presented to friends of the sitter and the sculptor, among them Robert Browning, Coventry Patmore and W. E. Gladstone. The bronze exhibited at the Royal Academy in 1857 may have been the cast shown in this exhibition, one retained by the sculptor himself. An engraving from it was used as the frontispiece for the illustrated edition of Tennyson's *Poems*, the so-called Moxon edition of 1857, which is well known for its Pre-Raphaelite illustrations.

Woolner's second Tennyson medallion is cast in the heroic mould. As a relief profile portrait, it follows in the traditions of Renaissance medallic sculpture, which, in its turn, drew upon the form of the Roman medal. Such images came to Tudor England through the work of Pietro Torrigiani, and remained a traditional element in tomb sculpture and in ceramic or enamel portrait plaques. During the early nineteenth century, the French sculptor, David d'Angers, had made a series of medallions of famous men and women, including several English sitters. Though more expressive and romantic than Woolner's staid images, the success of David d'Angers' medallic portraits must have influenced the younger sculptors in their choice of this particular form.

Woolner himself has left no record of his reasons for the choice. His first known medallion dates from 1846, two years before he became a founder-member of the Pre-Raphaelite Brotherhood. He had trained initially with the well-established sculptor, William Behnes, before joining the Royal Academy Schools in 1842. Here he became friendly with Bernhard Smith, a sculptor five years older than himself. Smith was closely associated with the Pre-Raphaelite circle, even signing a portrait medallion of 1849, 'PRB'. Two plaster medallions by Smith are in the National Portrait Gallery, one of Sir John Richardson (1842), and another of Sir James Clark Ross (1843). Both Richardson and Ross were explorers, and the sittings seem to have been arranged through Smith's brother, a lieutenant on one of Ross's expeditions. Versions of the two medallions were shown at the Royal Academy in 1844. Later in the decade, Smith sculpted portraits of a number of philanthropists, but the fact that he was Woolner's companion on the voyage to Australia suggests that he too was short of work in Britain.

Smith's choice of the medallion form must have influenced Woolner. William Michael Rossetti noticed that Woolner, having just completed the first Tennyson medallion,

prided 'himself not a little on Bernhard Smith's approval of the execution'.[12] But, as Benedict Read has pointed out, Woolner's 'accuracy in modelling realistic detail' was 'without parallel, in contemporary sculpture', differing markedly from Smith's 'smooth generalisation'.[13]

In later years, Woolner made further medallions of both Alfred and Emily Tennyson. Emily was initially unwilling to sit: 'I cannot feel it right to let you waste your time on my lean face which should have been drawn ten years ago at least if at all.'[14] Woolner, however, insisted; 'tho' probably your face was rounder then, I know the expression was no better and I think not so good: the expression of persons whose minds are fixed upon high and holy things grows better every instant of their lives, thro' growing in fact nearer to that perfection they contemplate.'[15] Emily sat to Woolner in February 1856, and a version was sent to Farringford in May. 'I feel sure', Woolner told her, 'there is some of your character, for various persons who have seen it remarked upon the extreme sensitiveness it displayed.'[16] The medallion shown in this exhibition is a later one, modelled over Christmas 1858 and cast in January of the following year (cat.71).

A third medallion of the poet was made in 1864, a year for which Woolner's diary survives. By now the sculptor was a busy man, and, departing from his earlier practice, he worked from photographs taken at the London Stereoscopic Company on 29 November. Some of these are in a Woolner album in the Bodleian Library in Oxford. Woolner worked on this medallion for a week or so after Tennyson had left London, a very different matter from the year or more spent on the second medallion. The diary lists various assistants employed in making and marketing the new portrait. The frame came from a Mr Tate, and Woolner's studio assistant, Luchesi, worked on the reproductions of the original. Woolner himself took 25 copies, presumably for sale and for presentation. One finished cast was sent to the Stereoscopic Company to be photographed. Meanwhile, 'Payne promised to run the risk of A. T. Med: – I to have £50 or guis: first profits, and afterwards to share equally'.[17] This third medallion shows the poet bearded. Woolner abandoned the striking pose of the earlier medallions, and the head is three-quarter face rather than in profile. The effect is less challenging and less idiosyncratic than the earlier versions.

Through his network of literary friends, Woolner was established as a portraitist in the world of letters. This represented his regular income, but he was always on the look-out for larger commissions. Woolner's master, Behnes, had been a notable sculptor of portrait busts, and the talented pupil is known to have helped him. Not surprisingly, he conceived the idea of making a bust of Tennyson. Writing to Emily Tennyson after his visit to Farringford in 1855, Woolner made an oblique suggestion:

'How sorry I am I did not model a bust of him instead of a medallion when I was at Farringford, it would not have taken me any longer and would have escaped the accidents the other met, and been a fifty times better work and more important. I shall never have such a fine head again, and it is a grievous pity not to have made the best of it.'[18]

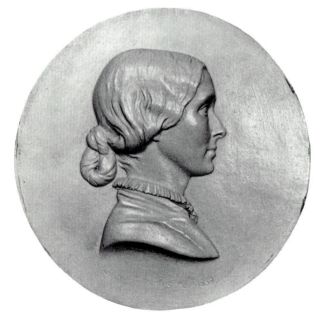

cat.71 Thomas Woolner, *Emily Tennyson*, plaster, 1859.
Private collection

Emily immediately responded to this praise of her husband's appearance, warning Woolner that William Brodie was to model a bust of Tennyson, 'but I cannot help wishing it were you who had to do it and to say also, that if you still wished it you should have an opportunity of fulfilling your wish'.[19] Both Woolner and Emily were determined to carry through this plan, whatever Tennyson's own wishes might be. The sculptor saw it as 'a duty I owe myself and country'[20] and disregarded the fact that Tennyson anticipated 'the operation with shoulder-shrugging horror'.[20] Emily was almost conspiratorial: 'We must catch him as we can for the few sittings you will want. I hope it may be warm enough for us to be in the drawing-room for I fear the study would not be so good a light for you.'[21]

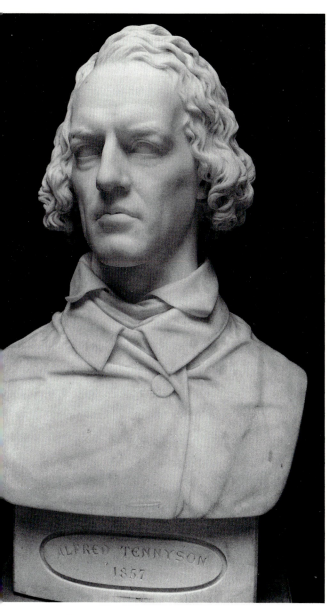

cat.67 Thomas Woolner, *Alfred Tennyson*, marble, 1857.
Trinity College, Cambridge

Woolner arrived in Farringford on 7 February 1856, and worked on both the first medallion of Emily and the bust of her husband for five weeks. In her journal for 28 February, Emily wrote: 'Difficult work for Mr Woolner as A. is not at all fond of having his face copied & will only spare a little while at night when Mr Woolner has to take a candle in one hand & model as he can.'[22] The plaster was completed by 10 March and Woolner left on 15 March. A mould was then made by Luchesi, sent down from London for the purpose. 'I asked him to cast the forehead of the original and just the tip of his nose', Woolner wrote, 'for if I do the bust in marble they will be an assurance to me.'[23] Luchesi made a cast of both Alfred and Emily's noses, as well as of Alfred's forehead and hand.

Because of the delay between modelling and casting, it was essential to keep the bust moist. Emily reported that 'Alfred watered it sedulously on Tuesday & Wednesday'.[24] When he began work on the marble, Woolner found the carving particularly arduous. On 10 December, he told William Allingham that he had 'more than a month's work' still to do,[25] and, when writing to Robert Browning on 5 January 1857, he seemed no nearer his goal:

'I have scarcely done anything since I saw you but work upon my bust of Tennyson, which takes so long that I am almost out of patience with it; but having begun to work it up to highest pitch I must finish in the same way. As it is I have worked upon it closely for nearly 9 weeks and have fully a month's work yet before it can be completed. In a wholesome state of art such a time would be thought nothing to bestow in producing a respectable work, but art, particularly sculpture, is made such a commonplace business of that work is knocked off much after the manner of bricks or muffins, and the consequence is such productions are respected about as much as bricks.[26]

The bust was at last finished by 8 March 1857 (cat.67). It was shown at the Manchester Art Treasures Exhibition during the summer where it was well received. As yet, however, there was no purchaser, and the sculptor became increasingly gloomy about the prospects of finding one. F. D. Maurice believed that it should go to the new National Portrait Gallery: 'if they do not have him who will they have?',[27] but at that date the Gallery could not admit portraits of living subjects. By February 1858 Dr Bellows (?Fellows) of Boston had expressed a wish to buy the bust, but the Tennysons were unhappy about its leaving the country. Emily wrote:

'We have heard that Trinity College had offered £200 for it. I do not know what the price fixed on it is but I have the feeling for Trinity that as far as feeling goes I would rather have it there than elsewhere, though I know it ought to be in London . . . Alfred says "Tell him not to part with that to America. He is sure to find a purchaser in England."'[28]

Woolner replied with some acerbity: 'You were mistaken in supposing Trinity College had offered £200 for my bust; if they had, the bust should have been in their Library long ago.'[29] He told Alexander MacMillan that the Trinity rumour had 'caused me to lose the *selling* of the bust; for Mr Fairbairn of Manchester wanted it, and . . . was very grieved to miss it, he wanted something as a memorial of the Art Treasures Exhibition and was hard driven to find a piece he cared anything for.'[30] Woolner himself now tried to persuade Lord Ashburton to buy the work.

Meanwhile, a group of younger Trinity men, led by Montagu Butler, and strongly supported by Vernon Lushington, a friend of both Tennyson and Woolner, set out to raise the money to buy the bust for the college. According to Woolner, Lushington 'placed so many restrictions in the way of subscribing that I think it never can succeed'.[31] Although the money was raised by May 1859 the Master and Senior Fellows then decided to decline the offer: 'chiefly because he is a *Living* Poet.'[32]

The rejection of the bust probably had more to do with Trinity College politics than with the ostensible cause. Cambridge was in a ferment over reform proposals embodied in an act of Parliament of 1856, and the Master of Trinity, the autocratic William

Whewell, was fighting attempts to make his college more democratic, and to break the power of the seniors, the all-powerful group of Master and eight Fellows. It was the younger men opposing Whewell who put up the Tennyson bust. The counter-attack began at once, with the bust's supporters demanding that it should be placed somewhere in the college, if not in the Wren Library, for which they had intended it. In the meanwhile, the bust was left with Alexander MacMillan, whose publishing house was then established in Cambridge. On 11 October, it was suggested that the bust should be placed on the library staircase, and, on 1 November, Woolner finally heard that it had been accepted, and would be placed in the vestibule to the library. He was reasonably happy with the compromise: 'The light . . . will be favourable: and altho' not in so dignified a position as if it were in the Library itself, still it will be in a much better light, and I shall be perfectly satisfied.'[33]

Woolner's *Tennyson* is perhaps his finest portrait bust. Tennyson's concentrated frown, his huge forehead and his clenched jaws all give a powerful impression of tension. The delicately worked curls, the coat with a button unfastened, the collar with one corner turned up, these touches, while in one sense naturalistic, are also appropriate to a romantic poet, notorious for his untidiness. Yet the whole effect is brooding, not careless. Woolner himself said of it:

'I have striven to show that vitality can be expressed in subtlest detail on the surface of marble as it can be by means of color etc. and likewise what I hoped was to do such a likeness of a remarkable man that admirers of his centuries hence may feel it to be *true* and thankful to have a record which they can believe in.'[34]

Woolner's contemporaries confirm this sense of the work's importance. Emily Tennyson writes of its 'grandeur', where she referred to the 'delicate yet lofty beauty of the medallion'.[35] John Millais 'went quite into raptures at the sight of it, and told me . . . he thought it "splendid"'.[36] Holman Hunt 'often instanced' the bust 'as distinctly better than any male head Marochetti had ever done, and no one ventured to dispute the point'.[37] Another of Woolner's admirers, W. E. Gladstone, believed it to be 'one of the most wonderful things he had ever seen in art'.[38] The bust soon became a popular image of Tennyson. In December 1860, Arthur Munby noted with pleasure that a cast had been placed in the hall of Mudie's Lending Library.

Not everyone liked it, however. Ford Madox Brown expressed two different opinions. He thought the original plaster 'hard & disagreeable. Somehow there is a hitch in Woolner as a sculptor. The capabilities for execution do not go with his intellect.'[39] A year later, however, he described the marble as 'a very noble work, and I hope will do Tommy good. No one deserves it more'.[40] John Ruskin's attitude was even more confusing. To Woolner he was 'in a vast state of delight' about it, he 'shook me by the hand enthusiastically several times', saying that 'he was very glad to know that such a thing could be done' and 'I consider that bust to be a triumph of Art'.[41] However, not a fortnight later, lecturing on sculpture at the Working Men's College, Ruskin mentioned neither Woolner nor the bust, and praised Alexander Munro and Baron Marochetti. Dante Gabriel Rossetti concluded that Ruskin did not care for Woolner's direct manner and plain speaking.

After Tennyson's death, the 'beardless' bust was chosen to stand over his tomb in Poet's Corner. His son, Hallam, decided to place the marble version originally made for Charles Jenner there, and to commission a copy from Mary Grant for the National Portrait Gallery. The President of the Royal Academy, Frederic Leighton, told the Director of the Gallery, 'entre nous, I don't *much* like the original',[42] but the bust found its way into the Gallery none the less. Woolner himself made at least one further version, for Charles Buxton, now in the Ipswich Museum. That in the church at Somersby, where Tennyson's father was rector, may be a later copy.

Notes

I am grateful to the Publications Committee of the Tennyson Society for permission to reproduce material taken from my Tennyson Society Monograph, *Tennyson and Thomas Woolner*, 1981. Miss Susan Gates, the research librarian of the Tennyson Research Centre in Lincoln was, as always, particularly helpful. I am also indebted to my husband, Richard Ormond, for discussing this project with me. His National Portrait Gallery catalogue of *Early Victorian Portraits*, 1973, vol.I, pp.446–58 contains the best general discussion of the portraiture of Tennyson

1 The exact timing of Tennyson's beard poses something of a problem. He has a new-looking beard and moustache in Dante Gabriel Rossetti's drawing of September 1855, full-grown by the time of Dicky Doyle's drawing of January 1856. Did Tennyson shave before the Woolner bust was modelled in February 1856, or did Woolner rely upon earlier studies of his chin?

2 Fredeman, p.85. A version of this first medallion is in the Usher Art Gallery, Lincoln

3 Champneys, vol.II, p.175

4 Scott 1892, vol.I, p.296

5 Lang & Shannon, vol.II, p.55

6 A. Woolner, p.11

7 ibid., p.105

8 Letter of 22 March 1855, Tennyson Research Centre, Lincoln

9 Letter of 12 Nov. 1855, TRC

10 Letter of 28 April 1856, TRC

11 A. Woolner, p.115

12 Fredeman, p.85

13 Read, entry no.30 in Tate Gallery 1984, p.82

14 Letter of 21 Nov. 1855, TRC

15 A. Woolner, p.108

16 ibid., p.113

17 Woolner Diary entry of 17 Dec. 1864. A copy of this medallion is in the Usher Art Gallery, Lincoln

18 Letter of 8 Oct. 1855, TRC

19 Letter of 21 Nov. 1855, TRC

20 A. Woolner, p.109

21 Letter of 1 Jan. 1856, TRC

22 TRC

23 A. Woolner, p.111

24 Letter of 20 March [1856], TRC

25 Allingham & Williams, p.291

26 Trinity College Library, Cambridge

27 A. Woolner, p.132

28 Letter of 25 Feb. 1858, TRC

29 A. Woolner, p.145

30 Letter of 12 March 1858, Berg Collection, New York Public Library

31 Trevelyan 1979, p.11

32 Bursar's Minute Book, Trinity College Library, Cambridge

33 A. Woolner, p.178

34 Read 1982, p.179

35 Letter of 11 Nov. 1856, TRC

36 A. Woolner, p.112

37 Hunt, vol.II, p.162

38 Woolner to Emily Tennyson, 12 April 1862, TRC

39 Journal for 11 April 1856, quoted in Hueffer, p.121

40 Journal for 16 March 1857, ibid., p.150

41 A. Woolner, pp.130—1

42 Letter of 1 Dec. 1893, National Portrait Gallery Archives, London

43 H. Tennyson, vol.II, p.152

44 Metcalf, p.250

In 1873, nearly twenty years after his work on the Trinity portrait, Woolner produced the first of his 'bearded' busts of Tennyson, now in the Art Gallery of Southern Australia in Adelaide. The new work was originally made for the 'Hall of Worthies' in Albert, Baron Grant's new Kensington House, built for him by Tennyson's friend, James Knowles. Grant wanted his hall decorated with busts of the famous men of the day, and Knowles persuaded Tennyson, who had made up his mind to sit to no more sculptors, to let Woolner model him once more. Hallam Tennyson reports that his father was 'daily at Mr. Woolner's studio because of the new bust'[43] but, in the event, Grant objected to the work for which he had paid, and sent it back with the complaint that it 'was too classical, and that he thought the bare shoulders not quite proper'.[44] Bare shoulders or not, the bust is sadly lifeless in comparison with the earlier portrait.

Perhaps influenced by this rejection, Woolner then worked on his third and final bust of Tennyson, the 'cloaked bust', for which he had sittings at the poet's second home, Aldworth, in July 1874. This is still untraced. By then, Woolner had exhibited two Tennysonian statues, both female subjects from the *Idylls of the King*, *Elaine* of 1868 and *Guinevere* of 1872. An engraved version of *Guinevere* served, like that of the second medallion, as frontispiece to a Tennyson volume, the complete edition of *The Idylls*.

Woolner's association with Tennyson had many facets. Tennyson was a regular and often demanding guest at Woolner's London home both before and after the sculptor's marriage in 1864. As a practising minor poet himself, Woolner fell heavily under the Laureate's influence. As a friend to be consulted about the visual arts, he supplied photographs and casts of classical and Renaissance works for display at Farringford, and accompanied Tennyson on visits to art galleries and exhibitions. Emily, believing that her husband was easier when writing, asked Woolner to send ideas for new poems. Two which fell on fertile ground inspired narrative works of the 1860s, 'Aylmer's Field' and Tennyson's 'best-seller', 'Enoch Arden'. Both stories came from East Anglia, and it may be that their common background in the Eastern counties formed a bond between these two men. Whatever the chemistry between them, the relationship was a fortunate one, leaving us, as Woolner rightly expressed it, 'with a likeness of a remarkable man'.

Alexander Munro: Pre-Raphaelite Associate

by Katharine Macdonald

Alexander Munro came to London in 1844 at the age of eighteen, 'a poor Highland lad, who evinces a strong predilection for the fine arts'.[1] His headmaster, the Rector of Inverness Academy, had however not only fostered his talent but given him a sound classical education and a lively interest in literature. He also introduced him to the well-educated and influential élite of the North East, and they in turn gave him a starting-point for his career and contacts in intellectual, artistic and journalistic circles in London. It was Harriet, Duchess of Sutherland, who paid his fare to London and asked Charles Barry to find him work on the new Houses of Parliament.

At Westminster, working under John Thomas, Munro was in the thick of the medievalising influence of Pugin, so much deplored (at least in retrospect) by Hunt. But for Munro, this chimed in with an early enthusiasm for Walter Scott. It is not surprising that one of his earliest works, a chimney-piece commissioned by his patrons, the Sutherlands, and carved in 1847/8, was of two knights in full armour below the Duke's heraldic arms. This work is obviously derivative but it illustrates two aspects of Munro's development.

Firstly, it was made to fit the Scottish baronial style of Barry's re-building of Dunrobin. His next commission for the Sutherlands was *The Seasons* (1853), intended as another chimney-piece, but eventually carved in Caen stone for the terrace at Cliveden. This is in a totally different style, matching the classical, Italianate building designed by Barry. These works are examples of Munro's early practice in sculpture closely linked with architecture – a link which William Rossetti and Ruskin insisted was of prime importance.

Secondly, the chimney-piece showed his particular skill. At school, his talent was discovered through his carving of the thick slate pencils then in use and at Westminster he was employed as a carver. It is on record that he was hesitant about changing from carving – cutting away to reveal a form – to modelling – building up to create a form.

Munro's ambition was to train at the Royal Academy Schools. His first attempt to gain entry (1846) was rejected, probably on grounds of his lack of experience in modelling, which he himself recognised. The only sculptor on the board, E. H. Baily, supported his application and undertook to remedy this in his own studio. Munro's work on the Houses of Parliament (at a salary of '£62 per annum – very good for 5 or 6 hours a day easy carving and holidays besides')[2] gave him free time which he devoted mainly to modelling. Until 1849, he had only a large bed-sitting room, but Patric Park allowed him to use his studio. These two, Baily and Park, had a considerable influence on him. Baily, himself a pupil of Flaxman and his sculptural executor, kindled Munro's enthusiasm for Flaxman's work and writings. Park's best work was in portrait busts and this must have helped Munro's early efforts. Both sculptors produced 'colossal' statues – Baily had recently completed his *Nelson* for Trafalgar Square. Their example encouraged Munro in an early and uncharacteristic attempt at the 'colossal': his head of Peel for the Oldham Memorial (1854).

In 1847, Munro was accepted at the Royal Academy Schools, having become sufficiently proficient in the method of sculpture prevalent at that time: clay model, plaster cast, then carving in marble or stone, or permanent casting. Some of his work was cast in bronze and in 1863, he exhibited at the Royal Academy a group cast in aluminium (now lost), an early innovative use of this element. It had first been recognised by Davy and a cheaper method of extraction had been discovered in 1854, but aluminium did not come into general use until after 1886. However, most of his work is in marble or stone, or in the earlier stage of plaster casts. He came to love the feel of clay in his hands, but throughout his life he carried in his pocket some slate pencils, which he would whittle into small classical heads or figures as he chatted with friends. The idea that direct carving is morally and artistically superior lay far ahead in the twentieth century and as he became more prosperous, he was able to employ

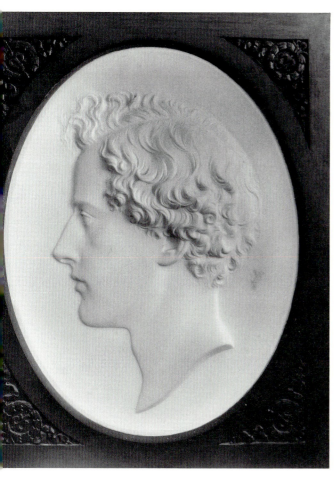

fig.29 Alexander Munro, *John Everett Millais*, marble, c.1855. Private collection (Before 1973, when in the possession of the Millais family, the surround was unpainted)

two or three assistants in the processes of casting and of pointing – roughing out the final marble version. He was himself small and slight and in later years often racked with pain and away from his London studio. Their help was therefore invaluable; but his letters are full of injunctions not to allow them to go beyond their brief. To some extent, the attitude was that of writer towards the actors interpreting a play or a composer towards the musicians performing a work. He reserved the final carving for himself, and his estimate of the value of his sculpture was based on original execution as well as original conception. In some cases, especially in later years when more of the carving had to be left to assistants, he considered the cast superior to the marble.

At the Royal Academy Schools, Munro very soon met Gabriel Rossetti. By January 1848, Gabriel was writing to Deverell: 'I shall see you and the rest of our friends at the Club on Saturday, whither I hope this time to drag Hancock and Munro.'[3] Although three years younger, Rossetti's was the ebullient, dominant personality. Both were aliens in the parochial, insular England of the 1840s and both were consequently regarded with some reserve or even suspicion. They shared a love of poetry, but Munro was fired by Gabriel's deeper knowledge of Dante and Goethe and infected by his admiration for Blake and for Keats. He and Gabriel also shared an enthusiasm for the Middle Ages – Rossetti covering sheets of paper with quick drawings of knights and ladies. As it took shape, the Pre-Raphaelite principle of absolute truth to nature, combined with poetic truth, was filtered to Munro through Rossetti's interpretation.

The circles in which Munro already moved were not lacking in intellectual stimulus; but there can be no doubt about the surge of fresh interest in the arts and poetry when he entered the Royal Academy Schools and met Gabriel's family and friends. It shines out from the commonplace books which he kept in the 1840s and early 1850s. To Homer, Shakespeare, Milton, Scott are added less obvious poets: George Herbert, Vaughan, Herrick; more modern ones: Coleridge, Wordsworth, Keats, Tennyson, the Brownings; and even closer: Allingham, Rossetti. Cuttings of engravings are replaced by pencil sketches by Gabriel, Millais and later Arthur Hughes. From 1850 on there are quotations from *The Germ*: 'Ellen Alleyn' (Christina Rossetti), Woolner, Tupper, Gabriel again.

Arthur Hughes has described how he was drawn into the Pre-Raphaelite orbit one day at the Schools, when Munro came in with *The Germ*, defending it against the jeering students.[4] In fact, Munro's copy of *The Germ* still exists, decorated with what must be one of Hughes's earliest surviving drawings: a rough sketch of Munro. From 1852 to 1858, Hughes shared Munro's studio and house, with the status of a favourite younger brother. They served as models for each other – notably, Alex Munro in *April Love* and *Benedict in the Arbour*, and his sister Annie in *The Eve of St Agnes*, while Hughes may have been the model for *Paolo and Francesca*. There are obvious similarities in their approach and both have been accused of the same fault: tenderness toppling into sweetness.

Munro kept in touch, at least intermittently, with Millais, with Bell Scott and with Allingham, all of whose heads he modelled in the early 1850s (fig.29), and with some of the later adherents. He was at first on friendly terms with Woolner and he probably shared the general admiration for Hunt, but never felt that he was the greatest or the sole true PRB. Munro and Rossetti became the objects of Hunt's indignant censure when Gabriel supposedly disclosed the meaning of the initials to Munro and he passed it on to Angus Reach, who tossed off a casual but sarcastic 'filler' for *The Illustrated London News*.[5] Hunt never forgave this. It is clear that Munro's affinity was with Rossetti, not Hunt; as William Michael wrote, 'Gabriel never had a more admiring or attached friend than Munro'.[6]

Munro's work includes portraits, posthumous busts and monuments, historical statues, and works of imagination – though these categories are not as sharply divided as might

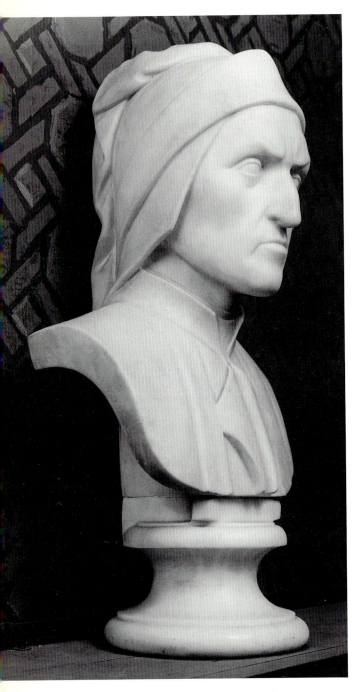

fig.30 Alexander Munro, *Dante Alighieri*, marble, 1856.
Girton College, Cambridge

be assumed. The bent of an artist's mind is most clearly seen in imaginative works; and it is therefore useful to consider these first. Although his 'doodling' – carving the ends of slate pencils – often resulted in a classical, helmeted head, Greek and Roman history and myth did not give him the inspiration it gave Woolner, in sculpture and in poetry. There are echoes of classical mythology in his *Boy with a Dolphin*, in Rorie Matheson as an infant Bacchus, and in his fountain nymphs. But the earliest of these, his *Egeria* (RA 1853), illustrates a poem by Charles Mackay; and it was poetry or poetic prose from Dante to Browning which fired his imagination.

Munro's best-known imaginative work is his *Paolo and Francesca* (frontispiece & cat.21), which dates from the time of his closest involvement with the PRB (1851). Benedict Read has already tackled the tangled question of the relationship between Rossetti's drawings and Munro's sculpture of this group.[7] Certainly Munro would have been the last person to deny the influence of Gabriel and of his father, Gabriele. He used the latter's death-mask of Dante to model and carve various likenesses: a full-length statue and heads in the round and in high relief. His enthusiasm, kindled in these early years, lasted throughout his life. In 1856, he exhibited his marble bust of *Dante* (fig.30); in 1857, a marble head of *Beatrice*; in the late 1860s he gave a small high relief of Dante's head, paired with one of Shakespeare, to the potter, Clément Massier, to be reproduced in terracotta at Vallauris.

It would have been impossible for Munro to have embarked on the *Paolo and Francesca*, in about 1850, without exchanging ideas with Rossetti, discussing preliminary sketches, whether in pencil or clay, and possibly sharing models; but the sculpture is not a direct translation of a Rossetti drawing and Rossetti's was not the only influence. Munro already knew and admired the Flaxman illustrations to the *Inferno*. The two engravings of *Paolo and Francesca* had inspired drawings and paintings by Koch, Ingres, Delacroix and Dyce; he may have known the latter's picture. He was probably also aware that Flaxman had intended to use the line drawings for 'groups of bas relieves'. Munro was at pains to make the details of his group historically accurate; for instance, he consulted an expert about the Malatesta arms on Paolo's badge.[8] But he was concerned with the wider truth – in Ruskin's words, the 'fact as it really was likely to have happened'. He made at least two models of *Paolo and Francesca*. In one, Paolo is half-reclining, curled round Francesca with the easy intimacy of an established lover. He chose instead a more restrained version, which seizes the very moment before the first, tremulous kiss. The sculpture conveys the full intensity of that fatal moment of love and death and this 'inner truth' illustrates a Pre-Raphaelite principle.

All this is in the Rossetti line of Pre-Raphaelitism and Rossetti's influence was always strong. Munro thought of following up the *Paolo and Francesca* with a group of *Faust and Margaret*, another of Rossetti's favourite subjects. In the event, nothing seems to have come of this project, though it might be connected with another of Munro's early works. He modelled a group (known only from photographs) of an angel bending protectively over a crouching girl, enfolding her in his wings; this may perhaps be a repentant Margaret. In 1857, Munro did translate Rossetti's design of *King Arthur and the Round Table* into a relief for the tympanum over one of the Oxford Union entrances. Later still, in 1863, Lewis Carroll photographed Helen Beyer and described her as 'a model of Mr Munro's and of Mr Rossetti's'.[9] Munro had made two busts of her: the first, simply entitled *A German Girl's Head*; the second, in armour, *Joan of Arc* (exh. RA 1862; whereabouts unknown). Apart from the identity of the sitter, there is little resemblance between Munro's heads, gazing heavenward, with luxuriant hair cascading over the shoulders, and Rossetti's various versions of *Joan of Arc*, kissing her sword (drawn and painted in 1863, 1864 and 1881).

Munro's Dante group was in tune with the preoccupation natural to his age-group, and in 1855 he reverted to the theme of love. He tried out various versions of an interpretation of some lines by William Allingham:

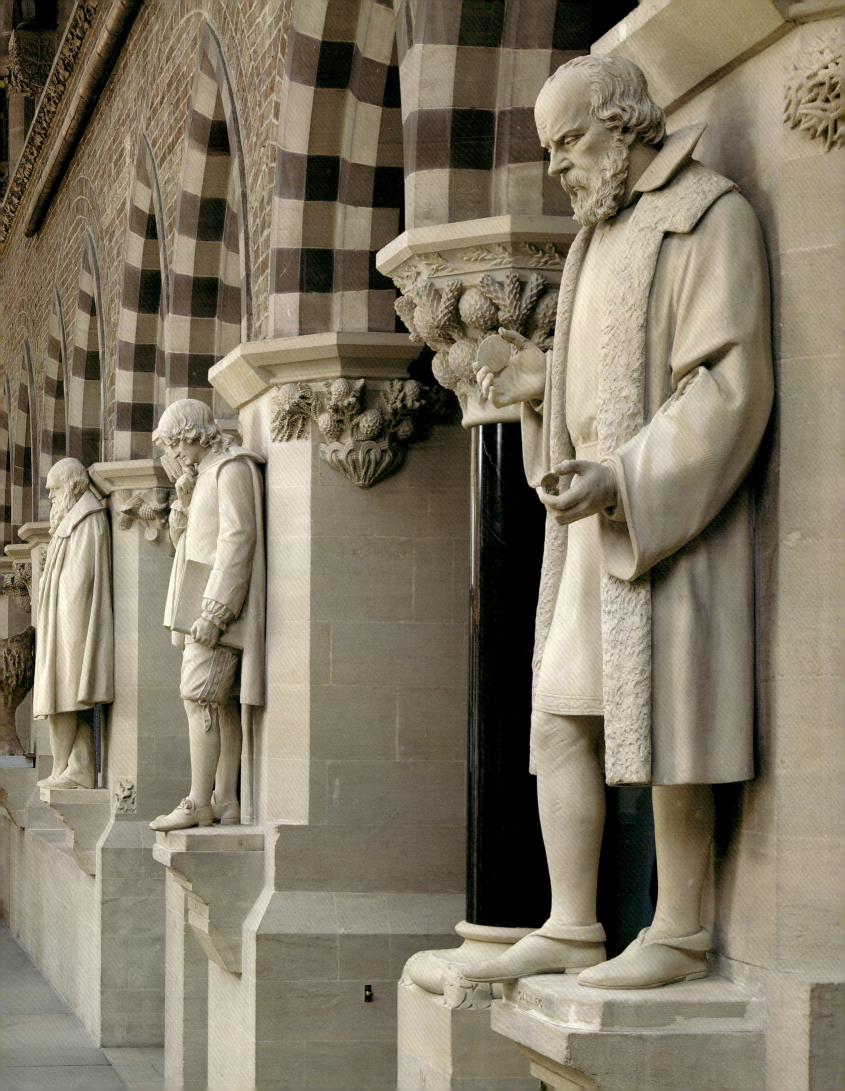

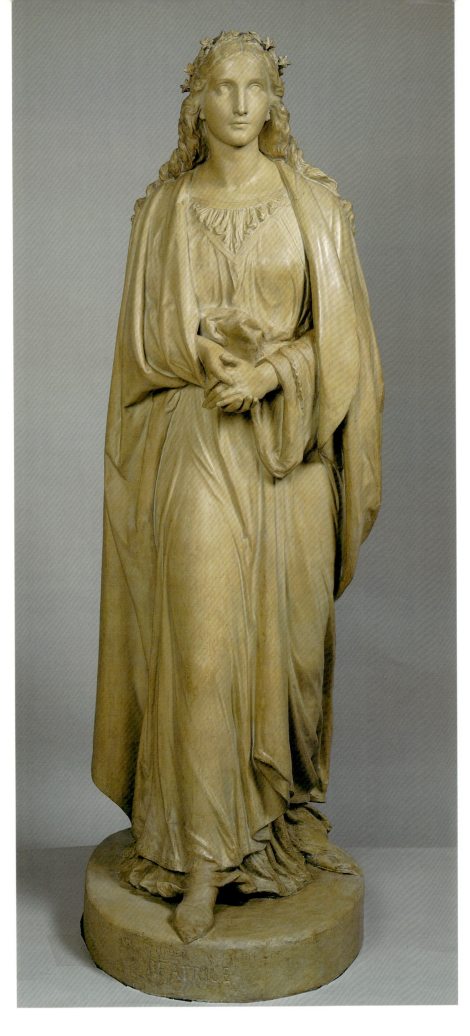

on previous page
Plate 1 View of Interior, Oxford University Museum

Plate 2 John Hancock,
Beatrice,
c.1851, painted plaster,
The Victoria and Albert Museum, London, cat.16

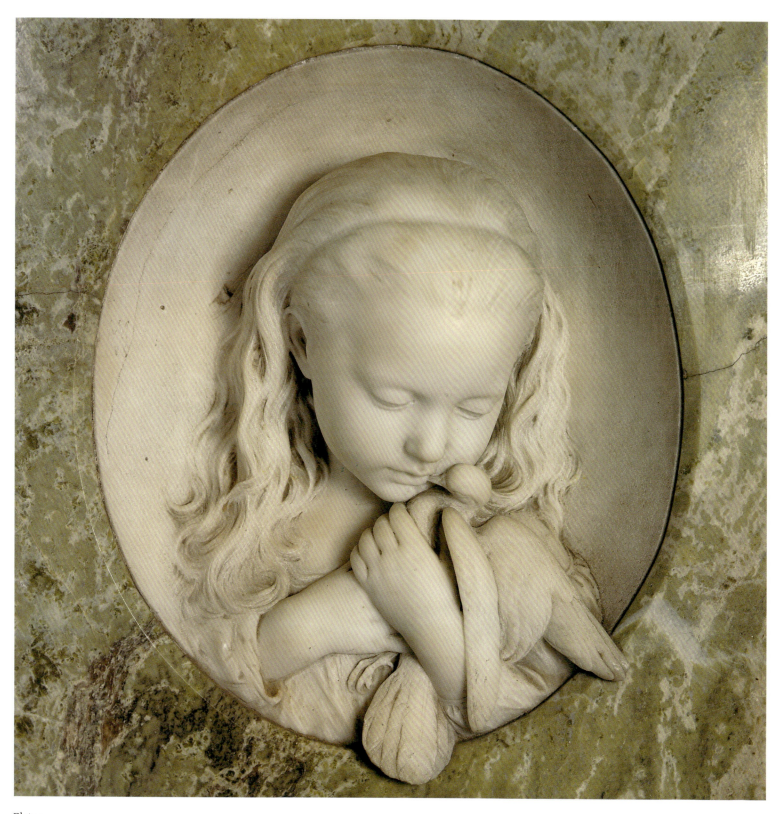

Plate 3
Alexander Munro,
Eva Butler with Live Dove,
*c.*1864, marble set into green serpentine, cat.39

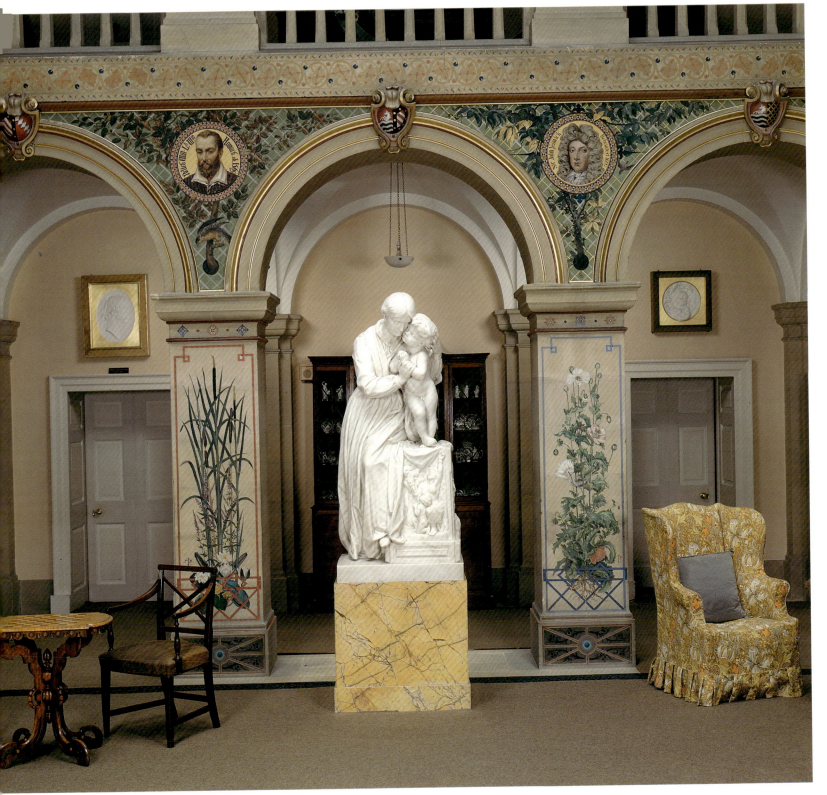

Plate 4 View of the Main Hall,
Wallington, Northumberland

opposite
Plate 5 Alexander Munro,
detail of full-length statue of *Undine*,
*c.*1869, marble, Cragside, Northumberland

overleaf left
Plate 6 Edward Burne-Jones,
The Hand Refrains,
1878, oil on canvas, Birmingham City Museums
and Art Gallery, cat.5

overleaf right
Plate 7 William Ernest Reynold-Stephens,
detail, relief from pole-screen,
Happy in Beauty, Life and Love and Everything,
1896, Copper, bronze, inset with mother-of-pearl
and precious stones, cat.43

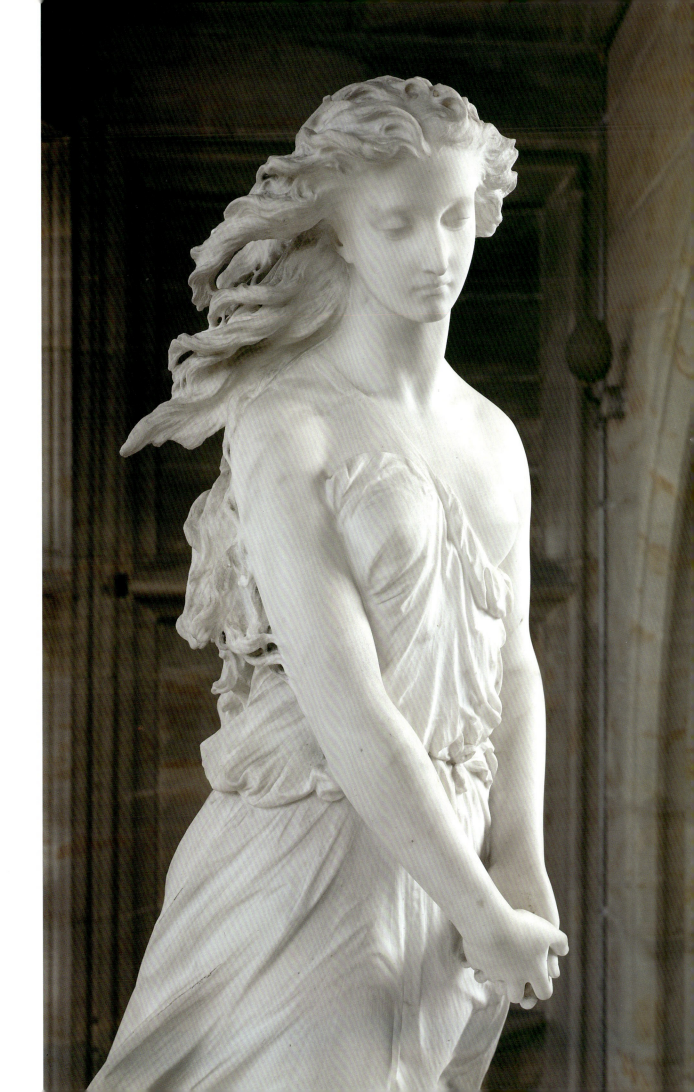

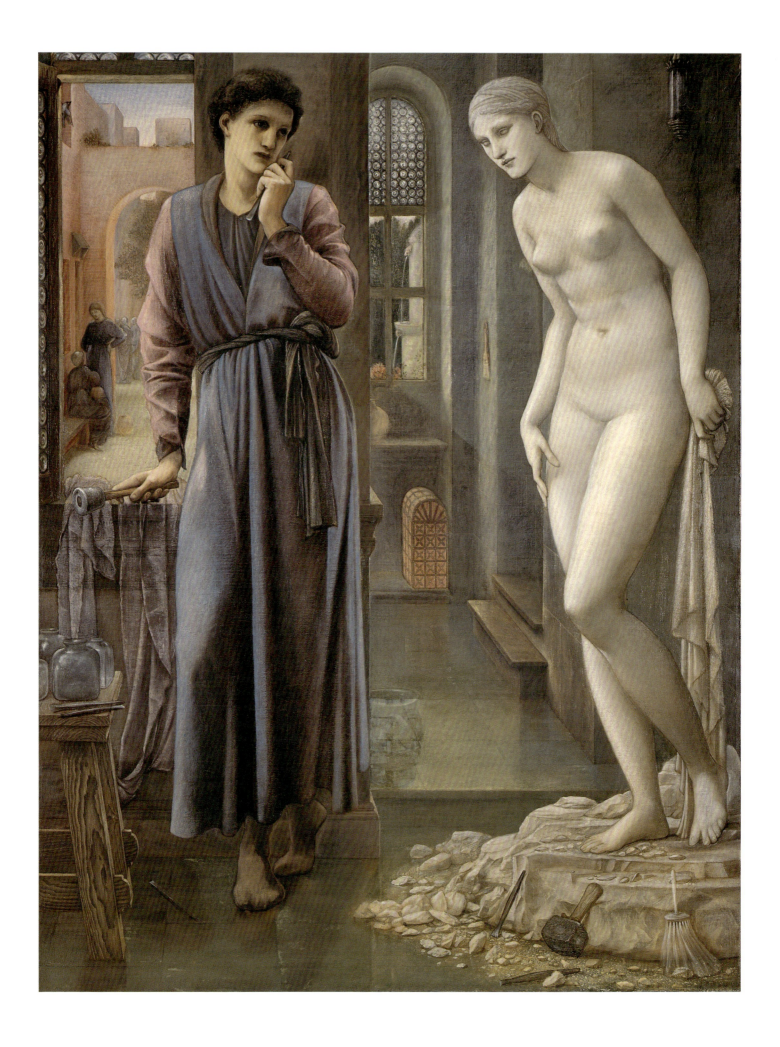

HAPPY IN BEAUTY LIFE AND
LOVE AND EVERYTHING

GOLD MEDAL VIENNA 1900

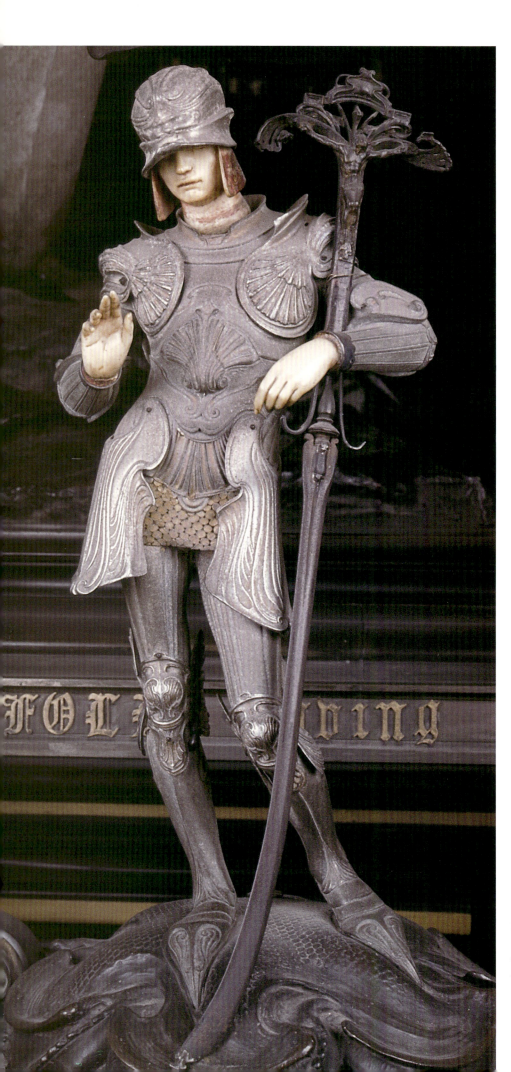

Plate 8 Alfred Gilbert,
St George (detail from the *Memorial to the Duke of Clarence*),
*c.*1896, aluminium and ivory,
Albert Memorial Chapel, Windsor

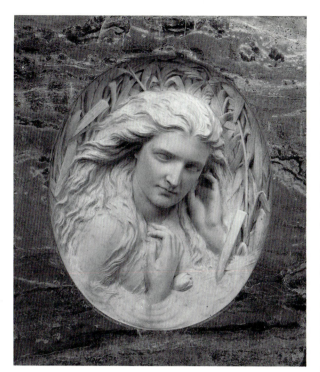

fig.31 Alexander Munro, *Sabrina*, marble, *c.*1860?. Ackland Art Museum, North Carolina, USA (gift of the Matthiesen Gallery)

'Sweet shall fall the whisper'd tale –
Soft the double shadow.'

Two lovers walk, arms round each other and heads bent close together. Munro had himself photographed in this pose, with his sister, and has drawn a faint sketch of the back view. What seems to have been his first clay model was in modern dress, nearer to the photograph, but the final version, executed in marble and exhibited at the Royal Academy in 1858, was in medieval dress. It has some similarities with Arthur Hughes's illustration of *Lady Alice*, for the 1855 edition of Allingham's *Music Master*, and the two artists probably worked on this theme together, though the poem does not include the relevant lines. The only known copy of this group is in parian marble, with added details (cat.30). Certainly, though full of tenderness, the photographs of *Lovers' Walk* give no hint of the intensity of *Paolo and Francesca*.

Some of Munro's early works foreshadowed themes which were to recur again. In 1850, he exhibited a sketch of a child with a dog (plaster, exh. BI). This has disappeared; it may have been purely 'genre' or may have been connected with one of his constant themes: a boy with a deer-hound. The impetus came from Wordsworth's story of the legend of Bolton Abbey. Young Romilly ranging through Barden woods stirred Munro's memories of his own youth, running along the wooded banks of the Ness to read in the library at Aldourie, eight miles away, jumping between tussocks of wood-rush and brushing through dark-green fronds of shield-fern. Already in the *Seasons* of 1853, Munro expressed his love of nature, and of children: in the four panels, three children are shown in different landscapes, from the burgeoning of spring through the richness of summer and autumn to the bare windswept boughs of winter. In a free-standing statue, the landscape can only be indicated: Romilly is a young boy, springing onto a rocky ledge, among ferns and grasses, and holding his leaping, shaggy deer-hound as they gaze across the Strid. *Young Romilly* was exhibited at the Royal Academy in 1863 (cat.38); it was executed in marble for Lady Ashburton. A related work, *The Young Hunter*, was exhibited at the Royal Academy in 1862, and much the same theme inspired the later sculpture of a boy running with a deer-hound, again among ferns: *Gillie and Hound* (exh. Dublin 1865).

Munro's statues for fountains show less exuberance of natural forms. The *Egeria* was followed by the *Boy with a Dolphin*, on which Munro was working in the summer of 1860, with Greville MacDonald as model, when Lewis Carroll paid one of his visits to the studio. The group was set on a base of rough rock and the interest is concentrated on the shapes of the naked boy and the dolphin. Nor is there any vegetation in the next fountain: a nymph at the base of a memorial statue to Herbert Ingram (Boston, Lincs 1863), which survives also as a 'fragment', an incomplete plaster cast (cat.37). For the nymph of the drinking fountain in Berkeley Square, commissioned by the Marquess of Lansdowne (1865), Munro carved a clump of reeds round the base of the pitcher, echoing the folds of drapery which fall from her waist. There is a small version of this nymph in Oxford.

Water and wind fascinated Munro. *Comus* struck an answering chord; and two versions of Munro's *Sabrina* still exist. One is an oval marble alto-relievo set in a serpentine rectangle (fig.31);[10] the other is a terracotta, probably by Clément Massier after Munro and exhibited in Paris in 1878 (private collection). Both are fundamentally the same composition, showing the river goddess rising from the 'glassie, cool, translucent wave' to listen by 'the rushy-fringed bank', her hair gently waving in the breeze. There is obvious delight in the modelling and carving of the rushes, sedges and water-lilies, of the hair, and of the formalised swirl of water. This is true also of Munro's *Undine*, of which he made at least two versions over the years (1856 and 1869; col. pl.5). Munro's vision of her was not like Hancock's nymph or Dyce's bonnie lass perched on Huldebrand's horse. For him, she was an elusive water-sprite, scarcely assuming human form and hovering tiptoe on the water.

Munro's other Ideal sculpture is known only from photographs or written records. An angel, flying serenely across the chancel wall of one of the English churches in Cannes, was destroyed in 1944. Munro, true to the Pugin tradition, gave it a background wash of pure blue. His mood was not always so sunny: he was haunted by a dark image of a distraught woman fleeing with her two children from some disaster. The group has disappeared and so has a marble head of *Pippa* (exh. BI 1863). This was, however, an impossible choice of subject. The essence of Browning's poem is the juxtaposition of Pippa's artlessness and the wheeler-dealing, adultery and murder in the houses she passes – a theme which would have defied even Gabriel Rossetti's imaginative painting (though Elizabeth Siddal attempted a drawing of it).

For Munro, as for others, sculpture of the imagination was a luxury and private commissions for portraits or memorials were a vital source of income. It is impossible to believe that, where he felt an empathy with the sitter, he did not enjoy modelling his or her head, but he had no interest in the public image, the pomp and ceremony of status. His only contributions to the statuary of civic squares are the colossal head of Peel; a statue of his patron, Herbert Ingram, standing beside the bound volumes of *The Illustrated London News* (1862; Boston, Lincs); and the statue of James Watt (1868; Birmingham), which arose from his Oxford University Museum commission.

Munro's most important contribution to 'public' sculpture is the series of six of the historical statues of scientists in the Oxford Museum: Hippocrates, Galileo, Newton, Leibniz, Davy and Watt. The existence of the Museum was mainly due to the persistence of Dr Henry Acland, later Professor of Medicine. His project was enthusiastically supported by his friend John Ruskin and by George Butler. Munro must have heard a good deal about their successes and setbacks when he stayed with the Aclands in 1854. The foundation-stone of Woodward's building was laid in 1855 and the statues were commissioned and begun soon afterwards. By 1857, Munro was able to exhibit at the Royal Academy his model for *Hippocrates* (cat.25), presented by Ruskin's father.

It was not all plain sailing. Munro wrote: 'I want to hunt up every detail regarding Galileo whose statue I have undertaken for Oxford Museum – I wish to make it as worthy as I am able of the grand old Florentine'.[11] However, soon he was hesitating whether to bother Dr Acland about 'the height of the Museum figures – Galileo is got up to six feet high when, last week, Butler writes saying it should be *five* and Dr. Wellesley tells me "yes *five*" and now this afternoon the Architect in Dublin says *no* – five and a half feet – is to be the height –! this would really be amusing if it did not lead to the destruction of so much work with terrible loss of time . . .'[12] He invoked the patience of Galileo to prevent his giving up the series, and he completed all six.

The statue of *Hippocrates* was commissioned by Mr Ruskin; those of *Galileo, Newton* and *Leibniz* by the Queen; *Davy,* by the Marquis of Lothian; and *Watt,* by M. P. W. Boulton. Munro tried to incorporate into these works as much historical accuracy as he could and to fuel his imagination with all known biographical details. The pursuit of James Watt was probably the start of his connection with Birmingham. His first source would naturally have been M. P. W. Boulton himself. Not only was he the grandson of Watt's partner but his brother-in-law was Watt's biographer. Boulton would have directed Munro to his fellow Scot and Watt enthusiast, W. C. Aitken, who had come to Birmingham as an 'improver' in the brass foundry trade and stayed to make a number of inventions, to promote education in, and exhibitions on, science and art and to write on subjects from art to railway bolts. His interest in the Birmingham and Midland Institute was shared by the first Recorder of Birmingham, Matthew Davenport Hill. Munro formed lasting friendships not only with these three but with their families. The success of Munro's *Watt* in the Oxford Museum also led to his selection when, by public subscription, a statue of Watt was erected in Ratcliff Square (1868).

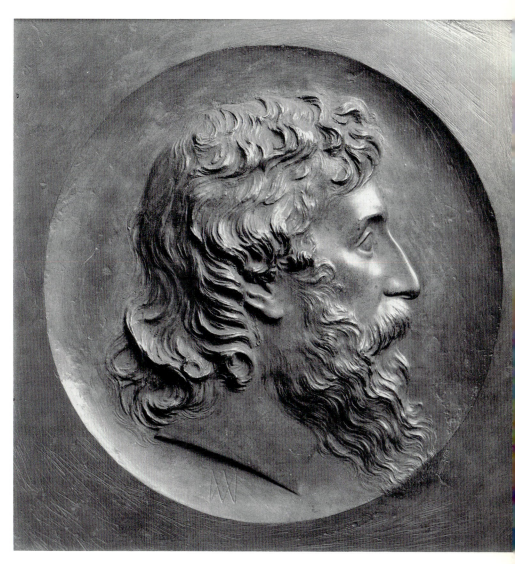

The challenge of this type of sculpture, combining careful historical research with a leap of the imagination, had a special appeal for Munro. He strove to re-create the truth about his subjects and the statues form an impressive body of sculpture. He had already worked not only on his bust of Dante but on a full, free-standing statue (now lost) and he intended to do one of Michelangelo. In the event, his only other historical work is his *Queen Mary II* (1868; Old Bailey, London).

In the 1850s, Munro spent a good deal of time in Oxford, staying with the Aclands or the Butlers, and working both on the Museum statues and on the tympanum for the Union. This brought him a number of other commissions. He made low-relief heads of Mrs Acland (1854), of Master Harry Acland and of Dr Henry Wellesley. When Dr Acland had a narrow escape from a shipwreck, his friends clubbed together to present his wife with his bust by Munro (1857; cat.26). This somewhat formal and bland marble is not Munro's most successful work. He made portraits of various Oxford notables and in the course of time, three portraits of Josephine Butler and three of her daughter Eva. These and the marble bust which he called 'the pensive Mrs Butler' came later, but the low-relief and the earlier bust date from about 1855.

This bust (cat.23) demonstrates some of the characteristics of Munro's style. It is of course the portrait of a friend, done with affection and complete informality. It shows her as a frank and intelligent, as well as a beautiful, woman; her hair tumbles down her back, decorated only with a band of seven small stars. As he said, without her name there might be 'a likely enough supposition that it is only an "ideal" subject.'[13] Munro was perfectly capable of producing an uncompromising male portrait: his *William*

fig.32 Alexander Munro, *George MacDonald*, bronze, c.1859. Scottish National Portrait Gallery, Edinburgh

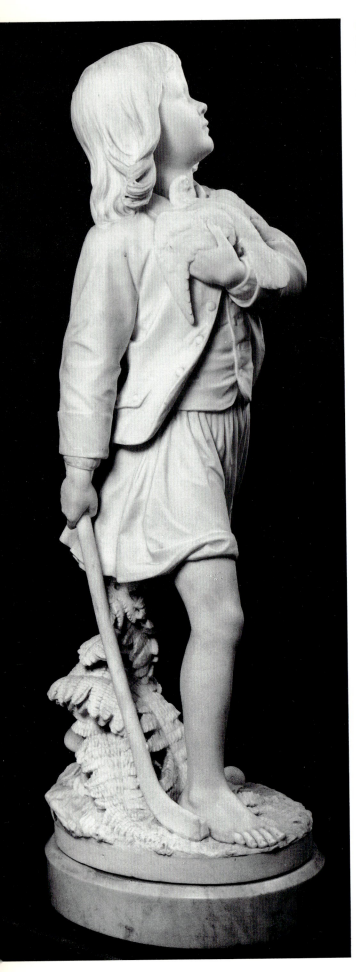

(Bird's Nest) *Hunt* (1862; cat.35) and his *Victor Cousin* (1867) surely prove this. But he revelled in the freedom from formality given in portraying women and children. His early low-relief head of Lady Alwyne Compton (1854), the respectable wife of a very dull bishop, is decorated with vine-leaves and was consequently catalogued until recently as 'Bacchante – Italian', and he must be the only Victorian British sculptor who portrayed a duchess with hair flying all round her head (marble alto-relievo, *Duchess of Vallombrosa*, 1867; cat.42). A somewhat similar male portrait, but earlier, is that of George MacDonald (?1857/9). Munro was visiting Hastings when MacDonald 'coming indoors upon a windy day with his thick curling hair blowing all about him, arrested the sculptor's eye. Then and there he modelled the medallion of him, two replicas of which were later cast in bronze (fig.32).'[14] Some of his portraits of boys (*Henry Gladstone, Master Dunbar*, both known only in photographs) have this look of having just come indoors, hair slightly tousled, tie awry. Another characteristic of his portraits is a tendency to break out from the confines of their round or oval perimeter. This can be seen in the alto-relievo of Eva Butler (cat.39), and in those of Pauline Trevelyan (fig.36) and Honora Glynne, where a softly draped collar interrupts the frame.

'Wings', Munro wrote, 'are such beautiful creations that I think they should be ever thought of with flowers and stars'.[15] He could not resist introducing birds, flowers and stars into some of his portraits. In his low-reliefs, honeysuckle twines round Mrs Robb, morning glory into Josephine Butler's hair; and little Eva Butler watches a butterfly. There are stars in the early marble of Josephine Butler and round Agnes Gladstone's head, in alto-relievo. The high-reliefs of Eva Butler show her fondling a dove and Ronald Munro-Ferguson is portrayed gazing defiantly up at the invisible hawk which threatens his pet dove.

This statue has a title: *The Baffled Hawk* (fig.33). Munro was fond of children, and was often called on for their portraits, singly or in a group, to which he sometimes gave a general title. *The Brothers' Little Pet* (1853), later called *Child Play* (1855) was primarily a portrait group of three Ingram children; Munro rewrote some lines by Walter Scott to fit their names and actions. *Measurement by Foxglove* (1859) shows Edith Gathorne Hardy measuring the height of her sister Emily in an exuberant swirl of foxglove, skirts, hair and ferns. Another group of Kenneth and Mary, the children of Alexander Matheson, was entitled *The Sound of the Shell* (1860). These groups were all of living children, but the group of Arthur and Edmund Hardy, the sons of Charles Hardy, was made posthumously (1862; fig.34). They are reading together, a battledore and shuttlecock lying beside them, and there is no reason to guess that they were not alive. The group was only placed in the church when the Hardys left Chilham Castle.

Munro often had the task of making a portrait of the dead or dying, and this again raises the question of truth. In some cases, it was made easier by being someone he had known and liked. He seems to have sent one of his versions of little Eva to the Butlers spontaneously and soon after her tragic death (1864; cat.39). When Ruskin's father died, a death-mask was taken and Munro used this as well as his memories of Mr Ruskin to start on a bust. John Ruskin's emotion and his sensitivity about his own appearance, made him prevent Munro from completing this and a bust of himself – though he paid a generous sum for 'the trouble and deeply feeling care that Alic had given to that work'.[16] One of Munro's best high-relief portraits is also posthumous, but again based on recollection of a friend, Benjamin Woodward, the architect of the Oxford Museum and the Union, who died in 1861. As part of a memorial to him, Acland and Ruskin commissioned the relief, 'the expressive record of a guileless contemplative nature' (cat.33).[17]

fig.33 Alexander Munro, *The Baffled Hawk*, marble, 1868.
Private collection

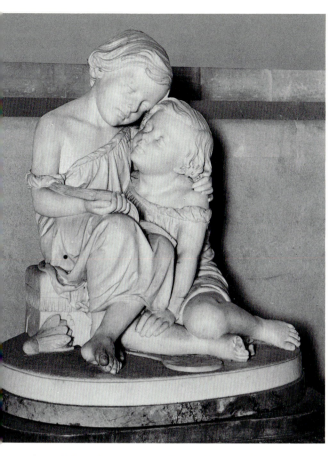

fig.34 Alexander Munro, *Arthur and Edmund Hardy*, marble, 1862. St Mary, Chilham, Kent

For a monument to Julian, the two-year-old son of William Vernon Harcourt (*c*.1862), Munro was able to make use of a death-bed drawing by G. F. Watts, 'a sketch from the cold clay which Perugino might have envied' which 'really is my little darling as he lived'.[18] And Munro's Julian looks like his other living babes, asleep among a profusion of bluebells and woodland plants (fig.35). The luxuriant foliage of the Harcourt tomb has been described by one art-historian as 'bringing Victorian clutter into sculpture'. But Munro was also capable of economy, e.g. in the M. D. Hill family headstone (Arnos Vale, Bristol) which he designed with two simple fronds of palm arching over the inscription. A more difficult and less successful commission was the monument to Sir John Gladstone and his wife in Fasque church. Munro produced a genre low-relief, reminiscent of some of Coventry Patmore's verse, of the couple praying together. His patron (Sir Thomas) dictated a larger size than he had wanted and a change in the composition to show the lady full-face.

From 1865, Munro spent his winters in Cannes and inevitably many of his sitters were invalids. The accounts make painful reading in this squeamish and sceptical century. Frequently he could have only two or three sittings. It might be argued that in these circumstances the death-mask was the true portrait; but Munro tried to realise the living person from whatever material was available. This was a similar exercise to historical sculpture and could result in a good portrait and a deeper truth.

A rare surviving example of these late marble busts is the simple and dignified portrait of the eager, affectionate, young Mrs Edward O'Brien. Of it her uncle, Henry Taylor ('Philip van Artevelde') wrote: 'It accomplished, perhaps, all that sculpture could accomplish, and the effect is fine in its way; but her face was a fitter subject for a painter than a sculptor; there was a richness and variety of transitional expressions which neither art could render, but of which the one might have afforded a better indication or suggestion than the other'.[19] The treatment of eyes is always one of the difficulties of sculpture. Munro often left them blank (e.g. Josephine Butler, Acland) but sometimes gave a slight indication of the iris (e.g. Emily Hamilton, W. Hunt). He had had this argument long before, in the early 1850s. He had made a first cast of Allingham's bust; it had to be 'worked up to a higher finish', and then moulded, re-cast and sent off. 'The Rossettis think it as like as sculpture can give likeness, but they don't believe much in such possibility and Stephens believes less, for he vows its *not* like and that only painting can give a resemblance of you: which, though it savours of *shop* from *him*, I'm myself half inclined to believe – nevertheless there are times when sculpture speaks to us with infinitely greater power than painting can – in the twilight-evening – more suggestive hours when paintings are really flat – perhaps too "stale and unprofitable" – at such times your bust may tell more effectively than all the painted eyes of pictures – at times when Aeolian Harp influences touch us.'[20] Allingham thought the head 'most admirable as a work of art' – but was 'the last person' to judge the likeness. 'People think them [the casts] a great deal too handsome; yet it is not on this account that I feel abashed by the presence of this white ideal of myself, but because it has the look of commemorating something and also seems to be making ever so many fine promises. To say the least, it was like drawing a bill upon Fame at twenty years' sight, to put myself into a sculptor's hands, – and what a number of such bills are dishonoured!'[21] Munro promised that when Allingham's poems 'reach a tenth edition I shall tell you your sculpture debt'.[22]

Allingham's bust remains a plaster cast; but of the two, very different, low-reliefs of Bell Scott and of Millais, one was cast in bronze and the other carved in marble. Millais wrote to Munro from Brig o'Turk, where he was painting his portrait of Ruskin and falling in love with Ruskin's wife. He passes on a message from Ruskin: 'that he will like you to model his wife's profile like mine, upon his return to Town'. So, he adds, 'you will have hers and mine to exhibit at the R.A. next year, *and a very pretty couple they will be*'.[23] But the portrait of Effie was never made.

By now, Munro's circle of patrons had widened. In 1853 he made a marble 'medallion' of Lady Constance Grosvenor, the daughter of his original benefactors, the Sutherlands (cat.22); and they were probably responsible for his making the relief of Lady Alwyne Compton in 1854. But his *Paolo and Francesca* had drawn him into a different sphere. The plaster cast was exhibited at the Great Exhibition of 1851. It was seen by a rising young politician, who on those warm summer evenings was exploring 'the dangerous edge of things', testing his marriage vows and risking his career in rescue work among prostitutes, and who confided his temptations to his diary in the language of one of his favourite poets, Dante. *Paolo and Francesca* had a powerful impact on William Ewart Gladstone. He wrote to Munro to find out whether he could afford a marble version – 'in any case he cannot avoid complimenting Mr Munro upon the manner in which he appears to have seized and embodied the beautiful conception of the poet'.[24] They agreed on the execution of a marble, smaller in size, for £150. An additional excuse for this expenditure was that it would be a kindness to Munro; he meanwhile reported the commission to the Sutherlands, who promptly invited Gladstone to their house. 'Killing', writes Catherine Gladstone, 'the Stafford House invitation – so clear they are enchanted at your patronizing their sculptor.' And her husband replies: 'Mr Munro as you truly say is our patron not we his.'[25] Their warm friendship lasted twenty years, until Munro's death.

In 1869, Gladstone still denied that Munro was 'under any sort of obligation to me',[26] but Munro would have insisted that he was. On his frequent visits to Hawarden, and in London, he made a bust of Gladstone and one of his son Henry; a high-relief and a more demure low-relief of his daughter Agnes (cat.24); a high-relief and a free-standing group of Agnes with her baby brother Herbert; and a high-relief of his niece Honora Glynne. Munro also made (for Gladstone's elder brother) the monument to their parents at Fasque (1854); in 1863, a bust of Adam Steuart Gladstone; a bust of Gladstone's close friend, the Duke of Newcastle (1863/4) and low-reliefs of the two children of another close friend, Walter James. In addition, Munro had the pleasure of hearing his 'Dante group' praised by various distinguished guests in the Gladstones' house.

In about 1856, Munro gave the plaster cast of the group to his friend, Dr Acland. He gave or lent a number of casts to him, including one of *Undine*. But this was regarded as a mixed blessing by Mrs Acland who presumably was responsible for seeing that they were dusted but not broken. About 1868, Munro wanted the *Undine* back 'as I know Mrs A. wd. grudge £5 for it and their house is already too full she thinks of my things, though costing nothing'. He goes on to say that Acland gave the *Paolo and Francesca* 'to please Mrs A. to the *poor* Trevelyans' (the ironic emphasis is Munro's).[27]

Pauline Trevelyan visited Munro's studio in January 1855 and his first visit to Wallington was in the autumn of that year. He obviously enjoyed the days he spent there, and between visits wrote to her about his work, that of the PRBs, and his travels. In 1856 he brought Woolner to stay; they fished and walked and Sir Walter took them to visit old Sir John Swinburne and see his Turners. Then they went on by foot to Jedburgh and by train to Edinburgh. On another occasion, Munro was hoping to come via Newcastle, collecting Scott for a joint visit. These invitations, and at least one to Seaton, showed the Trevelyans' concern for his health. They were also concerned about his 'poverty' and Sir Walter generously lent him a 'big sum', which he was conscious of owing 'so long'.[28] They gave him various commissions: the most notable, the marble high-relief of Pauline's head (1855; fig.36). He made a low-relief profile of Sir Walter and Pauline bought a cast of his *Sleeping Babe* (1857; cat.27). There is also a cast of his bust of Acland at Wallington. It is possible that the Trevelyans were the connecting link with Sir William Armstrong. Munro sent Pauline a photograph of his head of Armstrong, 'which some people consider the best Bust I have done' (1860).[29]

fig.35 Alexander Munro, *Julian Harcourt*, marble, c.1862. All Saints Old Church, Nuneham Courtenay, Oxon

SUFFER · LITTLE · CHILDREN · TO · COME · UNTO · ME

MARCH 2 JULIAN 1862

THEM · NOT

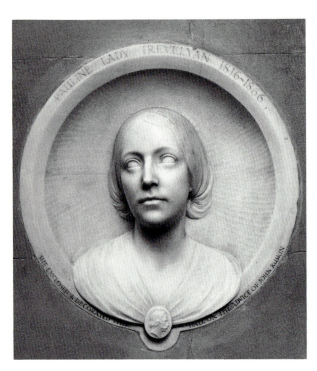

fig.36 Alexander Munro, *Pauline Trevelyan*, marble, *c.*1856. Wallington, Northumberland

William Bell Scott made much of losing Munro's friendship by his supposed promotion of Woolner, which led to the Trevelyans giving him the commission for *Mother and Child* (or *The Lord's Prayer*). There is no sign of any resentment in any of Munro's letters to, or about, the Trevelyans and Scott. No doubt he felt disappointment and he must sometimes have got the feeling that Woolner was trying to displace him here, at Hawarden and at Castle Ashby.

Munro presumably met Pauline's favourite, 'Loo', Miss Louisa Stewart Mackenzie, at Wallington. In the late 1850s, he went to 'a great gathering of fashion and beauty at her house' and met 'that wonderful old lady her mother', who still kept 'the air of grandeur that impressed Walter Scott.'[30] This led to various commissions: he made a marble bust of the Hon. Mrs Stewart Mackenzie of Seaforth (RA 1861) and a medallion of her daughter-in-law, the widowed Mrs George Stewart Mackenzie (RA 1860). In 1860, he also exhibited his bust of Lord Ashburton, who had married Louisa (cat.28). Soon, however, the latter swung right round. Under her influence, Jane Carlyle described this bust as 'quite contemptible'.[31] Woolner became the reigning favourite and made his posthumous bust of Ashburton (cat.74).

It was at this period that a scandal broke out over F. T. Palgrave's intemperate attack on Marochetti and Munro and unstinting praise of Woolner in the catalogue of the 1862 Exhibition. A great deal of heat was generated by this and a great deal of nonsense has been written about it. Munro's reputation was said to have been irreparably damaged, and he has, even recently, been described as having 'crawled away to Cannes and died in humiliation'.[32] (It is not clear where the author would have crawled to with a terminal cancer, before the days of chemo-therapy). Munro's reaction is known only from a letter to Mrs Hill, the wife of M. D. Hill. He thanks her for her sympathy which, however, was 'less required for the *abused* than the *abuser*, upon whom the heavy hand of "Jacob Omnium" did very damaging execution'; he is sure that Palgrave's abuse and praise are wrong 'and you may imagine which I prefer to be subjected to'; he recalls Jerrold's remark that 'the bark of a cur is preferable to his slaver'.[33] Whatever he may have thought of Palgrave, he seems to have kept no animosity against Woolner. In 1869, when he was selling up his London studio, he asked Arthur Hughes 'to tell Woolner of my pointing instrument and lever bars and the large turn-table' and 'especially tell him of the round rosewood-topped banker [sculptor's stool] with J. F. stamped on it. *Flaxman's* it was and perhaps valuable in Woolner's estimation – 30/- he may get it for.'[34] A few weeks later, Hughes reported that 'Woolner in a note from his wife excused himself getting the Flaxman from want of room'.[35]

It is difficult to know what is meant by the damage done by Palgrave to Munro's reputation. The cognoscenti presumably had their own views anyway; friends and acquaintances of the three sculptors divided fairly predictably; and the general public paid little attention. Any decline in Munro's creativity or skill after 1865 was due to his illness, with its recurring pain and weariness and enforced absences, which kept him from being always able to supervise casting and pointing or to do final carving. Even so, as he said 'I feel better when I am at the clay';[36] he continued working until late in 1870, and this gave him the will to live. Worldly success was not lacking and commissions abounded. On coming to France, he made portraits of a well-known writer (Prosper Mérimée), a well-known lawyer and politician (Odilon Barrot) and a well-known philosopher (Victor Cousin, whose bust was commissioned by the Empress Eugénie for the Institut de France). He made a bust of the Grand Duchess Alexandra of Russia, and the English Princess Royal called on him in person. Edward Lear wrote wryly to Woolner that, though numbers came to visit his studio, 'no one bought a pennyworth, nor gave a single commission. It was the fashion, on the contrary, to do 2 things with their money: first to have a bust done by Munro: 2dly to buy each other's drawings at Church Bazaars'.[37] (This somewhat acid opinion, and his friendship with Woolner, had not prevented him from visiting the Munros, where he kept Alex from work by 'singing endless songs').

Notes

Letters to the Munro family are in private collections

1 Letter from Robert Carruthers, editor of Pope's works and owner/editor of the *Inverness Courier*, to Charles Mackay, author, journalist and poet, 19 May 1844 (National Library of Scotland)

2 Letter to Walter Carruthers, 26 Oct. 1845

3 Doughty & Wahl, vol.I, p.34

4 Hill, p.69; see also Bornand, pp.xix, xx

5 *ILN*, 4 May 1850

6 Bornand, p.39

7 Tate Gallery 1984, p.102

8 Letter to S. Grimaldi, British Library

9 Green, vol.I, p.205

10 Given by the Matthiesen Gallery to Ackland Art Museum, North Carolina, USA

11 Letter, Alexander Munro to Pauline Trevelyan, n.d. [1857], Trevelyan Papers

12 *ibid*. [1857/8)]

13 Letter, Alexander Munro to George Butler, n.d. [1855], Fawcett Library, City of London Polytechnic

14 MacDonald, p.301

15 Trevelyan Papers, ?1857/8

16 Letter, John Ruskin to Mary Munro, Venice 18 June 1869

17 Acland & Ruskin, p.112

18 Letter, William Vernon Harcourt to Tom Hughes, March 1862, quoted in Gardiner, vol.I, p.115

19 Taylor, vol.II, ch.XVIII, p.249

20 Allingham & Williams, pp.236/7. The actual letters are in the Henry E. Huntingdon Library, San Marino, California

21 *ibid*., pp.239/241

22 *ibid*., p.241

23 Letter, John Millais to Alexander Munro, 10 Sept. [1853]

24 Letter, W. E. Gladstone to Alexander Munro, 15 July 1851

25 Gladstone letters, July 1851. Clwyd Record Office

26 Letter, W. E. Gladstone to Mary Munro, 25 May 1869

27 Letter to Annie Munro (?1868/9). Trevelyan 1978 (1) states on the contrary that Pauline Trevelyan 'bought his [Munro's] plaster group that had been shown at the Great Exhibition, the "Paolo and Francesca"' (p.111)

28 Letter, Alexander Munro to Pauline Trevelyan, 5 Feb. 1861, Trevelyan Papers

29 *ibid*.

30 *ibid*. [?1857/8]

31 quoted in Surtees 1984, p.102

32 Amor, pp.183/4

33 Letter to Mrs M. D. Hill [1862]

34 Letter to Annie Munro [1869]

35 Letter, Arthur Hughes to Alexander Munro, 1 Aug. 1869

36 Letter to Annie Munro, 24 April 1868

37 Quoted in Noakes, p.271 [1 May 1870]

38 Lessing, p.109

39 Letter to Annie Munro, 4 Feb. 1868

Not only did Munro have a constant stream of new commissions. There was also a demand for casts or copies of his past work. He gave his friend Clément Massier at Vallauris casts to be reproduced in terracotta or pottery. At the very end of his life, he seems to have sold casts, moulds and copyrights to professionals in London. One of his assistants, Wallace Martin, had by now set up his own pottery, the well-known Martin Brothers. With or without permission, in the year after Munro's death he made a version of *Maternal Joy* (now in the V&A). This dispersion led to a multiplication of works which are more-or-less but not-quite Munro's. But the best of his sculpture, 'the very work of *my own hands*', has survived the test of time.

In assessing Munro's sculpture, there is the difficulty of accessibility: most of his work was essentially private and not designed for public display. Moreover, in the case of those sculptures intended for open spaces, a further obstacle arises. They have suffered the common fate of marble, stone, and even bronze: a slow decay, blunting, streaking, whittling away, disfiguring and eventually destroying the work, perhaps leading to its replacement by a copy. It was surely this distortion, re-inforcing her twentieth-century sensibility, which led Doris Lessing to dismiss the *Boy with a Dolphin* (now in Regents Park, London) as 'cruel'.[38] The same distortion has inevitably affected other works: *The Four Seasons* (Cliveden), *David Scott* (Dean Cemetery, Edinburgh), the *King Arthur* tympanum, after Rossetti's design (Oxford Union), the *Fountain Nymph* (Berkeley Square, London), *Gillie and Hound* (Thornton Hough) and the over-life-size statues of *Herbert Ingram* (Boston, Lincs) and *James Watt* (Birmingham). His 'colossal' head of Peel has found shelter indoors, towering unregarded in the entrance lobby of the Oldham Swimming Pool. Other works have unfortunately made their way into the open: e.g. the *Fountain Nymph* (Park Town, Oxford), the low-relief medallion heads of Prosper Mérimée (Cannes) and of the Chevalier de Bunsen (Bonn) or the small free-standing group of the Gladstone children, which has dwindled to a stump. Munro was fully aware of the difference between 'the best marble' and 'sculpture marble wh[ich] decays soon outdoors'[39] but no marble can contend with pollution; studio photographs show how much of his fine carving has been lost.

Alexander Munro died on 1 January 1871, at the age of forty-five. A year later, he was honoured by a special exhibition at the Birmingham and Midland Institute. In the hundred and twenty years since then, it has been impossible to see and judge the range of his work until now.

The Sculpture of John Lucas Tupper: 'The Extremest Edge of P.R.Bism'

by Joanna Barnes and Alexander Kader

It is difficult to assess Tupper's contribution to Pre-Raphaelite sculpture, because so little of his sculptural output has survived.[1] Apart from his major life-size statue of *Linnaeus* (fig.39) in the Oxford University Museum, only two typically Pre-Raphaelite portrait medallions have been traced (cats 51 & 52). However a contemporary comment in *The Crayon* of 1857 demonstrates the significance of his sculpture and its relevance within the Pre-Raphaelite movement: 'John L. Tupper . . . adopted in a modified form some of the Pre-Raphaelite principles, and carried out his convictions in several sculptures, which exhibit great care and profound scientific knowledge of a kind seldom brought to the aid of sculpture.'[2]

From an early age, Tupper was resolved to become an artist and was encouraged in this direction by his father, a lithographic and general printer in the City, who taught him about optics and perspective. In his diaries Tupper describes his initial efforts at modelling his fat cat in dough and mud, moving on to chalk portraits of the family, landscapes, still-lifes and modelling statuettes of satyrs. He copied from Old Master prints and gradually learned about more complex graphic techniques.[3]

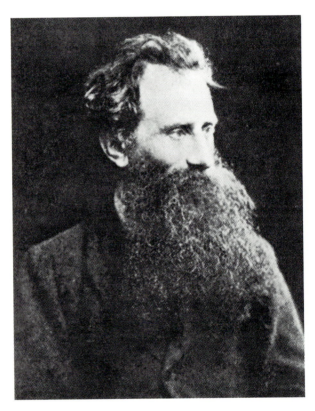

fig.37 Photograph of John Lucas Tupper (*c.*1823–1879)

Tupper enjoyed working directly from nature, but his tutor discouraged this, advising him instead to copy casts after classical sculpture. This guidance encouraged him to enrol as a student at the British Museum, with the support of an introduction from the painter Henry Howard RA. He studied first from Roman and then Greek sculpture, but strongly rejected the former for 'its deficiencies of skin and mal-administration of muscle'. He declared: 'I dissected, and would have vivisected, my country men, to refute the anatomy of Rome.'[4] He admired the antique figure of *Theseus* and in 1838 prepared a model of this work to submit for entry to the Royal Academy Schools. The rules, however, required a complete figure, so he revised his plans and submitted a relief of the *Discobolus* in its place. In July of that year Tupper was admitted as a probationer for three months and in December succeeded in becoming a fully-fledged student. Even in these early days Tupper seems to have favoured sculpture, but also practised as a painter. He found the Academy 'dismally other than I had anticipated' since most of his work was confined to copying from casts. He further complained that the students hindered him with 'breadshots, asking about chalks and papers – where I got them, why I used the stump, and drew so much with one eye'.[5]

While still a student Tupper had moderate success as a sculptor. In 1840 he was paid ten guineas for a portrait medallion of a lawyer, and then modelled another of the lawyer's daughter and one of an unnamed doctor. Despite this, Tupper's diary at this period displays much of the uncertainty and a degree of self-doubt which was to dog his later life. His anxieties about the practicality of pursuing a career as a sculptor are voiced for the first time: 'if only I could be sure of getting a sufficient number of medallions to do, I think . . . it would make me lay that [painting] aside altogether . . . in favour of sculpture'. He continues 'sculpture at every change of the observer's position, has an infinite variety of light and shade upon it, and moreover NATURE'S OWN ILLUSTRATIONS of form, viz, *real* light and shade, which the painting wants . . . this . . . might seem to argue the superiority of sculpture . . . [but] . . . we do at intervals sicken of pale form and gladly take refuge in colour . . .'[6] Words that were to become ironic, when one considers that the next generation of sculptors under various influences including that of Burne-Jones were to introduce colour regularly into their sculpture with the use of mixed media.

At this time Tupper made designs based upon a poem by Robert Burns and a relief inspired by Shelley's *Witch of Atlas*, in which 'the quaint costume gives a wonderful individuality to the subject and makes it look like some old Egyptian dream'. These works are now lost, but the subject-matter and attention to realistic detail suggest that already Tupper's interests were turning in a Pre-Raphaelite direction. In his reminiscences Tupper recalled that in March 1841 his view had been that 'the painters before Raffaêlle's time were better, i.e. more Christian, than Raffaêlle himself, and that he introduced the heathen element into modern art'.[7]

PLATE II

Fig. 1. Fig. 2.

Fig. 3.

Tupper, del. & lith. G.F Tupper. Lith. Imp.

fig.38 John Lucas Tupper, Illustration to John Hilton's article 'Two Cases of Dislocation', *Guy's Hospital Reports* 1857, f.p.104

At the Academy Schools, Tupper first met F. G. Stephens and William Holman Hunt and through the latter came into contact with the Rossettis. William Michael Rossetti described Tupper in his *Reminiscences*, as 'a meagre young man, hardly up to middle height, with pale visage, abundant dark hair, vivid dark eyes, and very mobile eyebrows; his play of feature in talking was unusual. He was not handsome, but got wonderfully improved and not a little picturesque by growing, as he was approaching middle age, a very copious beard.'[8] (fig.37)

William Michael writes in the prefatory notice to the volume of Tupper's poems which he edited and published in 1897 after the sculptor's death, that by 1849 Tupper had 'shunted himself off into a special line of work, being installed as anatomical draughtsman at Guy's Hospital – an employment for which he was exceptionally well qualified'.[9] Here Tupper was able to pursue his passion for scientific truth to nature and it was perhaps a natural progression, since his ideas as a student seem to have been dominated by an academic and scientific inclination. In his opinion: 'archaeologists, palaeontologists, microscopists, histologists, anthropologists, pyschologists and transcendental anatomists [were] all ready to run into the arms of the artist if he is strong enough to bear the embrace'.[10] Tupper's anatomical drawings were lithographed by his father's firm and reproduced in the *Guy's Hospital Reports* from 1847 to 1864 and he applied himself with characteristic intensity to this work. 'He would rigidly draw what was put before him, and if you asked him to portray a particular part in order to display some special feature in the case, he would regard it as an affront, as if he had been requested to tell a lie.'[11] His works were, however, much admired and Dr John Hilton, of whom he made a portrait medallion (cat.51), employed him to illustrate his book *On the Influence of Mechanical and Physiological Rest and The Diagnostic Value of Pain* (1863). Fig.38 demonstrates the keen observation typical of Tupper's graphic work.

Although working at Guy's, Tupper still kept in close contact with the Pre-Raphaelites and on the very evening *The Germ* was decided upon, was present at a large gathering at the studio of Gabriel Rossetti. W. M. Rossetti recalled 'the company consisted not only of the seven members of the Brotherhood, but also of the painters, Madox Brown, Cave Thomas, and Deverell, the sculptor Hancock, and two brothers Tupper. One of these, John Lucas, who had been an Academy-student well known to Hunt, and aiming at sculpture rather than painting . . . a very capable conscientious man, quite as earnest after truth in form and presentment as any P.R.B., learned in his department of art, and with a real gift for poetry . . .'[12]

Tupper's poetry was frequently read at Pre-Raphaelite gatherings. He was enthusiastic about the movement; a noteworthy example appears on a letter to F. G. Stephens on 19 June 1850 which he signed with a flourish 'P.R.B. hurrah!!'.[13] His father and two brothers, George and Alexander, became involved with the movement and their firm printed *The Germ*, and bore some of the financial losses which the publication incurred. Tupper made several contributions to *The Germ* including a rather complicated two-part essay on 'The Subject in Art', which advocated that art should represent natural things. In 1850 Tupper wrote the poem 'A Quiet Evening' describing the members of the circle and when the fourth issue of *The Germ* failed Tupper wrote a mock elegy 'Dedicated to the P.R.B. On the Death of "The Germ"'.[13a]

It is not without significance that Tupper's first major piece of sculpture was based on a medieval text, that it was rejected by the Royal Academy and that it was regarded as the '*introductory*' sample of Pre-Raphaelite sculpture. In May 1851 William Michael Rossetti recorded: 'We saw Tupper's bas-relief, which the Academy rejected. It is illustrative of the *Merchant's Second Tale*, by, or ascribed to, Chaucer, and represents the chessplaying between the Merchant and the old man he meets in a strange city. It is at the extremest edge of P.R.Bism, most conscientiously copied from Nature, and with good character. The P.R.B. principle of uncompromising truth to what is before

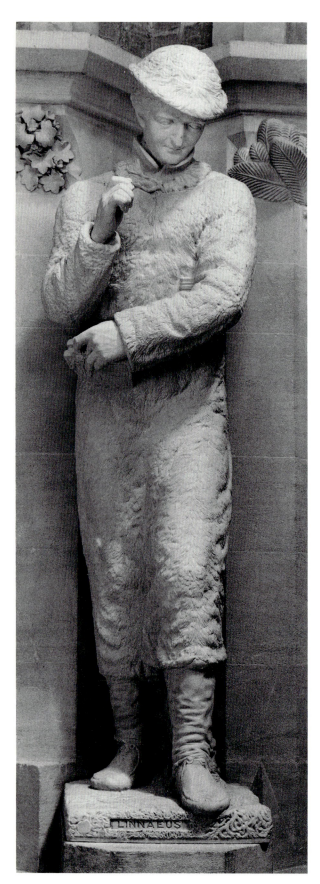

fig.39 John Lucas Tupper, *Linnaeus*, limestone, 1856–8. University Museum, Oxford

you is carried out to the full, but with some want of consideration of the requirements peculiar to the particular form of art adopted. According to all RA ideas it is a perfect sculpturesque heresy, whose rejection – especially seeing it is the *introductory* sample of P.R.B. system in sculpture – cannot be much wondered at, though most unjustifiable.'[14] This work which was almost certainly a plaster and has probably perished, was placed by Tupper at St George's Chess Club, which was host to the first international chess tournament that year.

Tupper was more successful in having his portrait medallions accepted by the Royal Academy and exhibited examples of them regularly between 1851 and 1868. These mainly represented doctors from London hospitals. At least one of these works was in marble, but most were probably in the more vulnerable medium of plaster. In 1857 he executed a medallion of Holman Hunt (RA no.1301) and in 1869 a medallion of W.M. Rossetti, both of these works are untraced. Tupper's medallion portraiture connected him closely with the other Pre-Raphaelite sculptors, who worked in this genre.

It was through Dante Gabriel Rossetti that Tupper obtained the commission for his most important and largest sculptural work, the limestone statue of the eighteenth-century Swedish botanist, Carl Linnaeus, for the Great Hall of Oxford University Museum (1856–8; figs 39 & 40). In April 1856 D. G. Rossetti wrote to Tupper: 'Have you heard that a Museum is building at Oxford in connection with the University? The architect, Mr. Woodward, is a friend of mine, and a thorough thirteenth century man. Among the features of the interior decoration are a goodish number of statues of celebrated men.' Rossetti further urged Tupper to contact Woodward about doing a statue, for although the pay was only to be £70, he thought that 'on the score of connection and repute it struck me you might be willing to think about a commission . . . The sculptor of one statue would probably, I suppose, if he pleased have subsequent opportunities of doing others . . .'.[15] Hunt later mentions Tupper's work on this commission with the observation that all the sculptors involved on the project were 'working in the hope of future patronage for the pay was less than meagre'.[16] The statue of *Linnaeus* was paid for by the entomologist and benefactor of the Museum, the Rev. F. W. Hope, a Fellow of the Linnean Society.[17] W. M. Rossetti regarded *Linnaeus* as 'a work of the most conscientious order in realism of intention and unsparing precision of detail'.[18] The statue is not only part of one of the most complete Pre-Raphaelite interiors, but also expresses an adherence to Pre-Raphaelite principles in its faithful depiction of the botanist's fur coat (probably modelled from a goatskin jacket belonging to D. G. Rossetti), hat, boots and the intricate plants on the base. The statue is signed: 'Designed and Carved by J. L. Tupper LONDON' (fig.41) which indicates a strong Pre-Raphaelite belief in the idea of the artist-craftsman.

Unfortunately more commissions were not forthcoming; Tupper never succeeded in attracting influential patrons in the same way as Woolner and Munro. His health was beginning to fail and he was unable to continue in his post at Guy's Hospital. It is poignant that after executing what was to be his major sculptural work Tupper wrote to Hunt: 'Here comes a turning point with me. Evidences accumulate that God will not have my sculptural offering, that I may not serve in *that capacity* the brotherhood of Christians . . . a conclusion I don't wish to arrive at'.[19]

Tupper's friends rallied round to help him find work. D. G. Rossetti attempted to obtain for him the commission for his father's memorial in Florence, but this came to nothing. Although Hunt encouraged him to apply for the post of professor of drawing at University College London, he was not successful. It was Hunt, however, who eventually helped him to achieve a permanent post. He recalled 'Dr. Sewell in earlier years, when founding Radley, had consulted me about an art master for the school, one who could awaken and also satisfy interest by his lectures, and teach drawing. I had introduced to him my fellow student, John L. Tupper, who was invited down to

learn the duties and the prospects of the intended post.' This appointment had to be indefinitely postponed. In 1864, Hunt met Dr Temple [headmaster of Rugby; fig.16] at a country house, who enquired if he knew of any artist qualified to fill the post of drawing-master at Rugby. Hunt suggested Tupper, but explained 'he would not be content to fulfil the ordinary routine of pencil drawing, but would strive to accomplish something much more through his teaching'.[20]

In March 1865, Tupper took up the appointment as master of scientific drawing at Rugby school, where he dedicated himself to the development of art teaching. He remained in regular contact with the Pre-Raphaelites writing to Stephens frequently enquiring from time to time after Woolner and his work, to which he devoted a perceptive critical essay in 1871. He also visited Thomas Bell, of whom he had made a portrait relief (cat.52). Bell was not only a dental surgeon but also a keen natural historian. It is perhaps significant that while at Rugby Tupper gave a lecture on 'The Fossil' reproduced in *The Report of Rugby School Natural History Society*. Bell also had a particular interest in fossils and had published the *Palaeontographical Society Monograph on Fossil Malacostracous Crustacea* in 1857 and 1862.

As late as 1868 Stephens was still suggesting alternative posts to Tupper, 'your letter containing advertisement for a master at Derby, came too late to take effect',[21] but Tupper's correspondence gives the impression that in any case by this date he was relatively content at Rugby. In 1869 he visited Florence with William Michael Rossetti and Holman Hunt, but was taken seriously ill and nearly died.

On his return his health rallied and he embarked upon plans for the Museum and Art Gallery at Rugby. After much preparation, during which time he frequently sought Stephens's advice, the Museum was opened. Tupper regretted the breadth of subject-matter it was decided the museum should include, and would have preferred it to have

fig.40 John Lucas Tupper, *Linnaeus*, detail

fig.41 John Lucas Tupper, *Linnaeus*, detail

Notes

The most recent sources for J. L. Tupper's life and works are: James H. Coombs, Ann M. Scott, George P. Landow and Arnold A. Sanders (eds), *A Pre-Raphaelite Friendship. The Correspondence of William Holman Hunt and John Lucas Tupper*, UMI Research Papers, Ann Arbor, Michigan 1986; Sushma Kapoor's unpublished Master of Arts thesis in the Department of English at Brown University, *John Lucas Tupper. The Life and Works of a Minor Pre-Raphaelite*, June 1982; and her two articles 'John L. Tupper, to 1863: "King of the Cadaverals"', *The Journal of Pre-Raphaelite Studies* 1984, IV, no.2 pp.70–86 and 'John Lucas Tupper, 1865–79: The Rise of "Outis"', *The Journal of Pre-Raphaelite Studies*, 1986, VI, no.2, pp.37–43

Extracts from J. L. Tupper's diaries were published by *The Crayon: A Journal devoted to the graphic arts and the literature related to them*, II–III (1855–6); the title then changed to *The Crayon, An American Journal of Art*, IV (1857). *The Crayon* was reprinted as an A.M.S. Edition, New York 1970. It is important to note that the date given by Tupper for his entry to the Royal Academy Schools (1840) in his diaries does not correspond with documents held by the Royal Academy, which record his admittance in 1838. In this essay 1838 has been taken as the year he entered the Royal Academy; all other dates in Tupper's diaries have been accepted.

1 List of documented sculptures:
Pre-1838: Models of cats and satyrs; Model of Theseus; Model of the Discobolus
1841: Medallion of a lawyer; Medallion of lawyer's daughter, Miss 'A'; Medallion of Dr 'S'; Model of Dancing Faun; Model of Germanicus; Model of Antinous; Relief of a scene from Shelley's *Witch of Atlas*; Design based on a poem by Burns
1851: Bas-relief of *Merchant's Second Tale* (Chaucer) Chessplaying, formerly in St George's Chess Club
1854: Medallion portrait of J. Hilton, surgeon at Guy's Hospital, Exh. RA, no.1522; Medallion portrait of J. Callaway, Assistant at Guy's Hospital, Exh. RA, no.1525
1855: Medallion portrait of Dr Gall, Assistant Physician at Guy's Hospital, late Prof. of Physiology to Royal Institution, Exh. RA, no.1487; Marble Medallion portrait of Edward Cock, Senior Surgeon at Guy's Hospital, Exh. RA, no.1488
1856: Prof. Bell, President of Linnean Society, VPRS, Exh. RA, no.1277; A Portrait, Exh. RA, no.13711
1856–1858: Marble statue of *Linnaeus*, Oxford University Museum
1857: Medallion portrait of W. H. Hunt, Exh. RA, no.1301; Medallion portrait of a young lady, Exh. RA, no.1362; Medallion portrait of J. Patient, Surgeon-Dentist at St Thomas', Exh. RA, no.1364
1862: Relief entitled *The Image of Pity*
1867: James Salter Esq., FRS., Exh. RA, no.185
1868: Dr Hyde Salter, FRS, Physician at Charing Cross Hospital, Exh. RA, no.1164
1869: Medallion of William Michael Rossetti
nd.: Medallion of Mrs Annie Tupper
2 *The Crayon* 1857, vol.IV, part XII, p.363
3 *The Crayon*, II (1855), no.XI, pp.159–60 & no.XVIII, pp.271–2
4 *The Crayon*, II (1855), no.XXIV, pp.368–9
5 *The Crayon*, III (1856), pp.45, 102
6 *The Crayon*, IV (1857) part V, p.146

been confined to key areas, particularly sculpture. Rugby school was however extremely proud of its achievement, and in *The Meteor* recorded: 'Let it be handed down to generation after generation that on 24th June 1879, was opened at Rugby the first Art Museum possessed by any School in England. We may be forgiven a tone of triumph in looking back on this greatest of all our achievements'[22] There was an inaugural exhibition in which the work of Tupper was represented by pencil drawings of *Arthur Durham* and *Leigh Sotheby* and two portrait medallions of Holman Hunt and Tupper's wife Annie. Sculpture by Woolner was also exhibited, *In Memoriam* (cat.79), *Bust of Lord Lawrence* (fig.22), and *Achilles Shouting from the Trenches* (cat.73) and in addition he lent a self-portrait by Flaxman and several Old Master paintings (probably the results of his foray into picture collecting at this period).[23] Tupper died on 25 September of that year, having seen his dreams for Rugby realised. A further exhibition was mounted the following year, which contained a *Lion* by Julius Haehnel, possibly from Tupper's own collection, presented to the school by his wife in his memory and still on display there today.[24]

In 1897, W. M. Rossetti summed up Tupper's contribution to sculpture as follows: 'As a young man he exhibited a few sculptural works at the Royal Academy, and perhaps elsewhere – works showing advanced studentship and the severest tenets of truthful rendering – but nothing of his ever fixed the public attention. The tendency of his mind was certainly quite as much scientific as artistic; and, though I conceive him to have been fully capable of producing sound works of art, had circumstances been favourable, he did in fact pass through life without realizing anything considerable in sculpture, if we except the life-sized statue of Linnaeus.'[25]

Tupper, however, contributed more than sculpture to the Pre-Raphaelite movement: his articles on art, his poetry and his concern for art education are other tangible reminders of his work. Perhaps the most apt tribute was made by Woolner who wrote to Tupper's wife Annie of 'his unswerving devotion to art.'[26]

7 *The Crayon*, III (1856), p.235
8 Rossetti 1906, vol.I, p.161
9 Rossetti 1897, p.viii
10 *The Crayon*, III (1856), p.43
11 Wilks & Bettany, p.421
12 Rossetti 1895, vol.I, p.151
13 MS BLO
13a Fredemann, pp.124, 127
14 Fredeman, p.96
15 Rossetti 1899, pp.132–4
16 Hunt, vol.II, p.158
17 Acland & Ruskin, p.103
18 Rossetti 1897, p.ix
19 Coombes et al., p.234
20 Hunt, vol.II, p.247
21 Letter, F. G. Stephens to Tupper, MS BLO
22 *The Meteor*, 29 July 1879, no.139
23 Rugby 1879
24 Rugby 1880, no.233
25 Rossetti 1897, pp.viii–ix
26 Coombes et al., p.107

John Hancock:
Pre-Raphaelite Sculptor?

by Thomas Beaumont James

Following John Hancock's death on 17 October 1869 *The Athenaeum* recorded that Britain had lost an artist of the highest potential.[1] Today, apart from useful though incomplete entries which relate to his life and work in reference books, John Hancock is all but forgotten.[2] This essay is an attempt to draw together what is known of a man who, from his earliest days, was a close associate and friend of the members of the PRB.

On Thursday 24 May 1849 William Michael Rossetti recorded in the *P.R.B. Journal* that Millais made 'highly successful' portraits on that 'most glorious' summer's day of (Thomas) Woolner, (John) Hancock and (William Holman) Hunt.[3] It is a great pity that these portraits have not survived. Indeed, apart from a recently discovered photograph of his studio showing two men, of whom he is no doubt one, and a woman, no certain likeness of John Hancock is known (fig.42).[4] Although no details of his early life are available, recent research has done much to reconstruct his family background and this evidence has much to offer about the artistic milieu in which he grew up. Not least among his attractions to the members of the PRB were Hancock's financial support, not to mention his beautiful sisters. These were to forward his association with Dante Gabriel Rossetti and his friends.

John Hancock's grandfather, James (b.1753), a cabinetmaker of Marlborough, Wiltshire, died in 1821 some years before the sculptor's birth in 1825. The Hancocks were prolific: the sculptor's father John Hancock (1788–1835) was one of eleven children, and the sculptor was the sixth child of a family of nine. John Hancock, senior, moved to London and worked with Sir Humphry Davy. He is said to have been the originator of the lamp which now bears Davy's name. He later left London and moved with his family to a job connected with a mining project in Cornwall, where he died in 1835 at Marazion and is buried hard by an informative monument at Ludgvan. He entrusted his family to his brother Thomas Hancock, and the 1841 census finds the young sculptor resident in his uncle Thomas's house at Stoke Newington, North London. It was at this house, modestly called Marlborough Cottage (both as an act of homage to his birthplace and also lest it be confused with Marlborough House), that Thomas Hancock discovered the process of the vulcanisation of rubber. His patents brought him considerable wealth, especially when the products of his process began to pour off the production lines of factories set up in partnership with Charles Macintosh, for previously rubber had only been used for pencil erasers. Thomas Hancock, a bachelor, seems to have relished the large family of which he unexpectedly found himself head in 1835. John Hancock's children moved into Marlborough Cottage which became their home until the sculptor's last surviving sister Harriet died there in 1909 in her eighty-fifth year. It can be argued that it was the money resulting from Thomas's enterprises which made possible a relatively carefree career for John Hancock as a sculptor.

The sculptor's father and other uncles were more or less involved in the newly introduced rubber business. Walter Hancock (1799–1852) had a brief association with Thomas in business, but made his name as the patentee and originator of steam road carriages which ran from his works in Stratford, East London to the Bank, and more widely in the 1830s. The sculptor's father John established a factory in Fulham for producing rubber and rubber commodities for medical purposes. Another uncle, Charles Hancock (1800–1877) effectively combined science and arts. He too was involved in the rubber business patenting, among a variety of other things, the *gutta percha* sheath for the cable which was manufactured for the Atlantic telegraph, eventually successfully laid by Isambard Brunel's *Great Eastern*. He was also a painter, trained in London and Norwich and enjoyed a particular association with the Norwich School artist James Stark, senior. Charles went on to work in Reading and London painting race-horses, cattle and sporting scenes. In later life, though, his entrepreneurial enthusiasm drew him away from art and from his middle years onwards he painted no more.[5]

fig.42 Photograph of John Hancock's studio

fig.43 John Hancock, *Dante Gabriel Rossetti*, 1846. Location unknown

The business success of his uncle allowed the young John Hancock relief from financial expediency. A small reversible oil painting by John Hancock depicting a dog on one side and a calf on the other survives from the mid-1830s, when the artist was about ten years old. Clearly he was able to develop this interest in painting and sculpture in the years following his father's death. Though Hancock was largely self-taught he was for a short time at the Royal Academy Schools in 1842; the same year as Thomas Woolner.[6] He showed an early interest in medieval subjects, exhibiting a statue of *Geoffrey Chaucer* in Westminster Hall in 1844.

It was about this time too that he came to know D. G. Rossetti of whom he made a portrait-medallion in 1846 (fig.43). D. G. Rossetti must have become a visitor to John Hancock's family home at Marlborough Cottage. Here no doubt he met the sculptor's sisters, especially Harriet Hancock (1824–1909) to whom Gabriel presented a book and also a button from the British seaman's uniform in which disguise his father had escaped from Italy.[7] Trifles such as these indicated D. G. Rossetti's interest in Harriet, although suggestions that their relationship might become permanent were not in the least acceptable to uncle Thomas. However, like the Pre-Raphaelite men as a group, the solid middle-class background of John Hancock made him at once acceptable to, and at home with, the embryonic PRB.

As is well known, several artistic societies preceded the formation of the PRB. These included the Sketching Club, which D. G. Rossetti joined in 1843, and the Cyclographic Society, which was destroyed by the secession of the PRB members in September 1848.[8] The scanty records which survive from 1848 show that Hancock was a member of the Cyclographic Society. The three surviving criticism sheets – all of D. G. Rossetti's work – include Hancock's comments on two works, *La Belle Dame Sans Merci* and *Faust: Gretchen and Mephistopheles in Church*. Of the first Hancock wrote 'a most admirable subject, well treated, sunny, wild, like Spenser'.[9] The *Faust* he described 'as a most beautiful sketch'.[10] Hancock's close association with D. G. Rossetti and the Society is confirmed in a letter from Rossetti to Walter Deverell of January 1848 in which he says that he looks forward to seeing Deverell 'at the Club [presumably the Cyclographic Society] on Saturday as usual, whither I hope this time to drag Hancock and Munro'. In the same missive he states 'I shall now be at Hancock's for sometime until the exhibition all day and everyday'.[11]

When the *P.R.B. Journal* begins in 1849 it is not surprising to find Hancock, now some twenty-four years of age, already a familiar figure to the group. While it seems Hancock got on well with D. G. Rossetti, his relationship with Gabriel's brother, William Michael, was less close. Indeed there seems to have been some antagonism, possibly because W. M. Rossetti had not been a member of the Cyclographic Society, while Hancock had been included. The formation of the PRB saw the position reversed. W. M. Rossetti described Hancock as 'an ungainly little man, wizened, with a long thin nose and squeaky voice'.[12] The high-pitched voice was immortalised by Gabriel Rossetti in his poem *St Wagnes' Eve*, 1851:

'. . . and Hancock there
Has laboured to repeat, in accents screechy,
"Guardami ben, ben son, ben son Beatrice";
. . . And Hancock, hard on twelve,
Showed an engraving of his bas-relief.'[13]

Apart from knowing D. G. Rossetti, Hancock was a close associate of Thomas Woolner with whom he shared a studio in the late 1840s.[14] It was through Woolner that Hancock made his only recorded attempt to join the PRB. According to the *P.R.B. Journal* on 16 May 1849 Woolner told Gabriel Rossetti that Hancock had visited his studio requesting to know whether he might put 'PRB' to his works. Woolner had promised to put the proposal to the Council, but pointed out that he had only one vote. On

hearing this Hancock 'withdrew in considerable reverence' according to W. M. Rossetti.[15] In view of the long-standing association of Hancock with both Woolner and D. G. Rossetti, this description seems somewhat surprising.

Although denied the accolade of putting 'PRB' to his works, Hancock remained on the scene. While on holiday in the Isle of Wight in September 1849, W. M. Rossetti heard from his brother that through a printer friend of Hancock, Gabriel had met some publishers and had discussed financial aspects of the production of a magazine, then to be called 'Monthly Thoughts'.[16] Hancock initially agreed to give support to the proposed magazine of the fraternity as a co-proprietor, proposed by D. G. Rossetti. Indeed according to W. M. Rossetti the Brotherhood found some difficulty in 'keeping back the ardor of our new proprietors'.[17] However, the ardour clearly cooled over the next two months so far as Hancock was concerned and in November he informed D. G. Rossetti that circumstances had brought about the necessity of withdrawing from any such proprietorial arrangement.[18] No doubt the Hancock money would have been very useful and the PRB journalist records ruefully 'this is unpleasant so far as convenience in money is concerned' but hoped nonetheless to hold the sculptor to his pledge at least for the first issue.[19] Perhaps his uncle was less than happy that the sculptor should commit funds to such an airy scheme. Hancock seems to have stayed with the project at least for the time being. In December 1849 he was present at a meeting of the whole PRB together with four other non-members in Gabriel Rossetti's study at which the assembled company decided by a vote to call their magazine *The Germ*.[20] Hancock was among the majority who voted in favour.

In March 1850, Ford Madox Brown, concerned that an etching of his own would not be ready for the forthcoming third edition of *The Germ*, suggested that Hancock, D. G. Rossetti and Woolner should each prepare an etching as an alternative;[21] whichever was finished first should go in. In the event Hancock and Woolner never completed theirs and D. G. Rossetti defaced his.[22] In any case *The Germ* was dead in mid-1850 leaving the Brotherhood and their supporters with an unpaid bill of £33.[23] Hancock's change of mind over the support for the venture was perhaps thus justified.

Hancock had other fish to fry and had been rewarded when, in December 1850, Woolner reported to the PRB, meeting with the exception of Millais 'at Stephens's', that Hancock had been appointed as one of the commissioners to decide on sculpture for the Great Exhibition planned for 1851. W. M. Rossetti writes that there was 'astonishment' at this revelation and concludes his entry with two exclamation marks (in brackets).[24] For the exhibition Hancock set to work to produce a statue for display. This statue of *Beatrice* was among his most successful works (cat.16). Hancock was not alone in his family in showing at the Great Exhibition: his guardian Thomas had a range of products from his rubber manufactories, as did his uncle Charles, whose son, C. F. Hancock, a noted silversmith, also exhibited. Two of Hancock's sisters also exhibited, as did his brother-in-law John Nunn.[25] We do not know how John Hancock himself viewed his background, but it may be noteworthy that W. M. Rossetti later described him as 'related to the old-established family engaged in the business of silversmiths and jewellers',[26] which seems to be a description related more to his cousins than his forebears. Certainly silversmiths would have more artistic cachet than rubber manufacturers and provincial cabinetmakers, however prosperous they were! Indeed C. F. Hancock's Greek vase exhibited in 1851 has recently been most highly praised as a 'feat of sustained craftsmanship'.[27]

In 1852 Woolner departed for Australia. His fellow-sculptor's temporary removal to the other side of the globe does not, however, seem to have severed Hancock's links with the PRB. In 1853 Hancock completed a companion work to his *Christ's Journey to Jerusalem* of 1849, for the Art Union of London. This time it was *Christ led to Crucifixion* (cat.15). The International Exhibition in Paris in 1855, where *Beatrice* was shown for the second time, also saw the display of another statue, *Maidenhood*. The

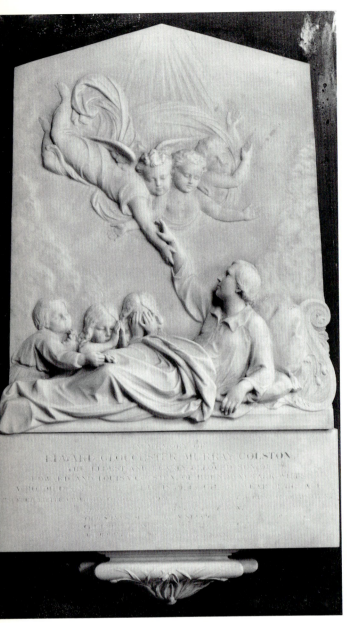

fig.44 John Hancock, *Monument to Edward Colston*, marble, 1859. St James the Great, Southbroom, Devizes

latter received some mixed comments from one French critic who said firstly that the 'expression and movement in it are remarkable' but added that it was 'covered by a thick coat of paint which is barbarous'. Another French critic praised both statues: they 'possessed what Gibson's works require – life'.[28]

Queen Victoria had taken an interest in the work of members of the PRB, on one occasion sending for a painting from the Academy exhibition, which she had been unable to attend because of a confinement. Hancock himself received the royal approval in 1857 when Prince Albert purchased a bust of *Penserosa* (1857; Royal collections, Osborne House) as a Christmas present for the Queen. Another bust by Hancock, referred to in the family memoir as 'a copy of John Hancock's bust of Milton's Penserosa', was to be seen at Marlborough Cottage as late as the turn of the century, although its whereabouts is now unknown.[29]

Around 1859 Hancock carved his only known funerary monument (fig.44), the marble relief to the memory of Edward Gloucester Murray Colston, the ten-year-old son of Edward and Louisa Colston, at the church of St James the Great, Southbroom, Devizes. The monument has particularly strong links with the work of other Pre-Raphaelite sculptors. The three mourning children are reminiscent of child groups by Munro such as the *Arthur and Edmund Hardy* (fig.34), but there is an even closer and more interesting precedent for the naturalistic foliage and flowers on the scroll behind the dead boy's head and on the corbel beneath the reliefs in Woolner's monument to William Wordsworth erected in 1851.

During the last decade or so of his life Hancock continued to produce work for exhibition and to engage in other projects. In 1861 he contributed the *Penserosa*, one of sixteen figures commissioned by the Corporation of London from the most eminent sculptors of the day to adorn the Egyptian Hall at the Mansion House (see cat.18).[30] The £70 paid to each sculptor was but a tiny fraction of the £10,000 set aside for the adornment of the Mansion House. The series depicts significant figures from English literature, and Hancock's early effort at Chaucer in 1844 may have led to this commission. Henry Weekes, who had made such enthusiastic comments about *Beatrice* (cat.16) at the Great Exhibition of 1851, was also a contributor to this series.

A second important commission for sculpture for a City institution came from the National Provincial Bank, now the National Westminster Bank, for its building in Bishopsgate, London. The architect was John Gibson and the six Hancock sculptures date to 1864–5 (fig.45).[31] They are in the form of rectangular relief panels (metopes) and in each panel an angel, flanked by appropriate scenes, holds symbols relating to an allegory. The series includes *Agriculture* (an angel stands by a cornucopia holding a sickle and a sheaf of corn, with a ploughing scene, including oxen and a ploughboy), *Navigation* (here an angel holds a rudder), *Science and Engineering*, *Cottage Industries*, *Commerce*, and *The Arts*. They remain the largest monument to Hancock's work. They may also represent his swan-song. After 1864 he ceased to exhibit at the Royal Academy and the details of his life are unknown. A clue exists in the brief and somewhat acerbic account of Hancock's life and career recorded by W. M. Rossetti, where it is stated that after some initial success following on *Christ's Journey to Jerusalem* (1849) and 'owing partly to unfortunate circumstances into which it is not my affair to enter, he gradually sank out of observation and died in middle age'.[32] Virtually nothing is known of Hancock's last four or five years. On uncle Thomas's death in 1865 Hanock was left £4,000, although it was noted in a codicil he had already had £1,000. On 5 December 1864, Woolner had noted in his diary that Hancock had borrowed 10 shillings from him making a total of £3 owing to him. This together with the codicil suggests that Hancock was in financial difficulties.[33] He lived the later years of his life in South Norwood, but died at 35 Grafton Street, Tottenham Court Road on 17 October 1869. Administration of his goods was by his widow described as Eliza Jane, otherwise Hancock, about whom nothing else is known. The assets altogether amounted to only £20.[34]

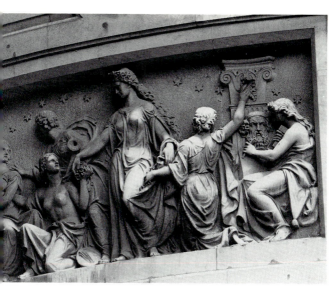

fig.45 John Hancock, *The Arts*, 1865. National Westminster Bank, Bishopsgate, London

What conclusions can be drawn about his career and life in general and his association with the Pre-Raphaelites in particular? Hancock, like Alexander Munro, was closely associated with D. G. Rossetti in the 1840s and like John Lucas Tupper, Hancock attended deliberations of the PRB *c.1850*, as we learn from the *Journal*. Hancock clearly wanted to be a member of the PRB, and asked for that distinction to be bestowed upon him, though unlike Bernhard Smith, another sculptor rebuffed by the Brotherhood, Hancock did not, so far as is known, actually sign any of his work 'PRB'. To use Benedict Read's felicitous phrase, Hancock and other sculptors, apart from Woolner, existed 'within the Pre-Raphaelite penumbra'.[35]

There is plenty of evidence that Hancock from his earliest activities as a sculptor subscribed to the ideals which were later embraced by the PRB, which as an organisation lasted only a very few years. Medievalism is illustrated by his statues of *Chaucer* (1844) and *Beatrice* (cat.16) and he produced a number of portrait medallions, a genre found in Italy from the fourteenth century onwards and practised also by Smith, Woolner, Munro and Tupper. In his portrait of D. G. Rossetti (fig.43; recorded at Wightwick Manor, Wolverhampton) the subject provided a happy admixture of the medieval and the modern both in the medium and lineage. The painted sculpture of *Maidenhood* shown in the Paris International Exhibition of 1855 may be a testament to a further excursion into the realistic and natural representations beloved of the PRB.

In certain of his later works he turned briefly to literary figures. Hancock's *Ariel* (RA 1858) takes up a Shakespearean theme in a single figure as does Woolner's *Puck* and *Ophelia* (cats 53a & b & 77). The parallels between Hancock and Woolner are not far to seek, and the link between their careers are yet stronger still. They were contemporaries at the Royal Academy Schools in 1842 when in their mid-teens and worked closely together in the mid-1840s. Both Hancock and Woolner suffered difficulties in their early careers and both exhibited medieval subjects at Westminster Hall in 1844, Hancock – *Chaucer* and Woolner – *Queen Eleanor Sucking Poison from Prince Edward's Wound*. Woolner seems to have supported Hancock in his bid to join the PRB, and Hancock also knew D. G. Rossetti well in this period.

On his return from Australia in 1854, Woolner's career took off. It was at this time that the Pre-Raphaelites gained recognition in artistic circles and Woolner became increasingly an establishment figure. He gained many commissions for public statues and monuments, became a Royal Academician in 1874 and finally was made Professor of Sculpture at the Academy in 1877. Hancock's career showed great promise in the late 1840s and 1850s. His design *Christ's Journey to Jerusalem* won the Art Union of London premium in 1849 (cat.14); in 1851 Hancock became a commissioner of the Great Exhibition and his statue of *Beatrice* at the Exhibition gained wide praise. His works also seem to have been well received when shown at the Royal Academy.[36] In the early 1860s too Hancock gained certain important commissions (notably those for the Mansion House and the National Provincial Bank), but his career mysteriously seems to peter out, just when Woolner, in the 1860s, was beginning to establish himself as one of the leading sculptors of the day.

The reasons for the termination of Hancock's career are uncertain, but may in part have been connected with the death of his generous uncle Thomas in 1865. W. M. Rossetti's innuendo about 'unfortunate circumstances' is all we have to go on along with *The Athenaeum*'s comment that Hancock's career was 'somewhat suddenly stayed and not renewed'.[37] Who was Eliza Jane, otherwise Hancock, his widow and administratrix of his goods? And who was Edward Collier, present at Hancock's death in Grafton Street and witness on his death certificate? From a family point of view Hancock may, like his uncle Charles, have tired of art as a profession. He seems to have made little money out of it and after his uncle Thomas's death, support from his former guardian of thirty years standing ceased. It has been said that had he lived Hancock would have been among the greatest sculptors Britain has ever known.[38] Such claims cannot be easily

Notes

I wish to acknowledge the help of Martin Greenwood whose scholarly insights into nineteenth-century sculpture have been invaluable. Hugo Hodge generously gave time searching in Somerset House, which made the exercise much more enjoyable. My brother Francis and my mother have made available the fruits of their extensive researches into the Hancock family and I thank them most sincerely for their help.

1 *The Athenaeum*, no.2191, 23 Oct. 1869, p.535

2 The main sources for John Hancock are Gunnis, pp.186–7, *DNB* and Read 1984, pp.97, 98, 100, 109. A short biographical note is also contained in Rossetti 1906, vol.I, p.150 (repr. in Fredeman, p.189). Information about the Hancock family is principally from an unpublished memoir of his friends by the Rev. J. L. B. James, *c*.1948, in particular the chapter 'The Great Aunts'

3 Fredeman, p.6

4 Though John Hancock's elder sisters Harriet and Maria are recorded in later life in oil paintings of the mid-1890s by C. Collies and J. Horsburgh of Edinburgh

5 See James 1979, pp.190–3. The considerable success of his nephew as a sculptor together with the need to provide for ten children may have contributed to Charles Hancock's retreat from the easel

6 Gunnis, pp.186, 443

7 James, 1948

8 see Fredeman, Appendix 3, pp.108–12

9 *ibid.*, p.109

10 *ibid.*, p.111

11 Doughty & Wahl, vol.I, pp.34–5

12 Fredeman, p.189

13 *ibid.*, pp.122–3. These lines refer to Hancock's statue of *Beatrice* which was shown at the Great Exhibition of 1851, and to his bas-relief design *Christ's Journey to Jerusalem* (1849) (cat.14)

14 Fredeman, p.189, Holman Hunt, however, claims Hancock's studio was next to Woolner's, Hunt, vol.I, p.113

15 Fredeman, p.3

16 *ibid.*, p.15

17 *ibid.*

18 *ibid.*

19 *ibid.*

20 *ibid.*, p.34. The four other non-members were George Tupper, John Lucas Tupper, Walter Deverell and William Cave Thomas

21 Fredeman, p.62

22 *ibid.*, p.226

23 *ibid.*, p.70

24 *ibid.*, p.85

25 1851 *Official Catalogue*, cxlvi; certificates among family papers

26 Fredemen, p.189

27 Wright, p.32 & fig.xivb

28 Gunnis, p.186–7

29 James, 1948

30 Gunnis, p.187; V. Knight, p.339

31 See Read 1982, p.222 & figs 288, 290: According to the Schedule of the Historic Buildings and Ancient Monuments Act, the carvers of these metopes were Messrs Colley. The two reliefs of *Shipbuilding* and *Mining* were added in 1877 and were modelled by Mabey and carved by John and James Underwood

32 Fredeman, p.189

33 Woolner diaries 1864

34 Information from John Hancock's death certificate, St Catherine's House, London; administrations and wills, Somerset House, London

35 Read 1982, p.179

36 From 1845–60 Hancock's works are regularly reviewed in the *Art Journal* and *The Athenaeum*. See for example *AJ* 1845 (*Comus*), 1858 (*Ariel*), 1859 (*Maidenhood*); *The Athenaeum* 1849 (*Christ's Journey to Jerusalem*), 1856 (*Maidenhood*), 1858 (*Angel's mission*)

37 *The Athenaeum*, 1869, no.2191, p.535

38 James, 1948

39 The only other works by John Hancock known to be in circulation are parian ware figures, of which three have been identified: *Una* (which bears a striking resemblance to the *Penserosa*; cat.18), and *Christ and John the Baptist* which may be a version of his Royal Academy sculpture of 1852, *The First Impulse of Love*; *An Angel teaching two Children to Kiss* and *Undine* (cat.17) – see Atterbury, figs 591, 882, 843.

substantiated. What is clear is that he did gain some recognition, particularly in his early career, and that he did produce some fine and well regarded sculptural works. His close relationship with the Pre-Raphaelite artists and his adoption, in common with them, of certain types of subject, assures him of a place in the history of the movement.[39]

There is still much research to be done on John Hancock: many of his works, if they still exist, are unaccounted for at present, although recent discoveries lead one to believe they are likely to be unacknowledged rather than no longer in existence. Further research into Hancock's life, for example through a search of post-1841 censuses (he had left Marlborough Cottage by 1851) might show some details. Of his marriage nothing whatever is currently known other than the name of his wife. We do not know where he is buried, although as he died after his uncle Thomas, his remains may lie with those of his elder sisters in the shadow of the great obelisk which marks Thomas Hancock's grave in Kensal Green Cemetery.

Burne-Jones and Sculpture

by John Christian

Reviewing the Grosvenor Gallery's summer exhibition in 1878, Henry James complained that Burne-Jones's figures were 'too flat, . . . they exist too exclusively in surface. Extremely studied and finished in outline, they often strike one as vague in modelling – wanting in relief and in the power to detach themselves'.[1] Many have commented on Burne-Jones's tendency to think in terms of line (for Ruskin 'an outline by Burne-Jones is as pure as the lines of engraving on an Etruscan mirror');[2] and it is a commonplace of art history that while he was inspired by that master of line, Botticelli, his own art was a source for Art Nouveau.

Yet Burne-Jones was far from unaware of plastic values. After his death, his friend Lady Lewis recalled: 'He once told me the best saying about art was one of Michelangelo's: the nearer painting to sculpture, the better for painting; the nearer sculpture to painting, the worse for sculpture. "Then", said I, "you place sculpture higher than painting?" "I think I do . . .," [he said.] I asked had he ever thought of being a sculptor himself. "Often", he replied, "if ever my eyes grow dim . . . I will give up painting and take to sculpture"'.[3]

Until recent times, artists have generally gained their first notions of sculpture by drawing from casts as students, but this was not true of Burne-Jones. 'I know', he wrote in 1880, 'that if there had been one cast from ancient Greek sculpture . . . to be seen in Birmingham when I was a boy, I should have begun to paint ten years before I did'.[4] In fact such casts existed, having been given by Sir Robert Lawley to the Birmingham Society of Arts on its foundation in 1821, and Burne-Jones must often have seen them when he attended evening classes at the local School of Design in the late 1840s. But they evidently made no impact on him, the School's uninspired teaching and the lack of any taste in his own home background effectively rendering them invisible. Even when he paid his first visit to the British Museum in July 1850, and went into 'ecstasies' over the Greek and Egyptian sculpture,[5] its appeal was not so much to his aesthetic sense as to the imagination of a sixteen-year-old who was passionately interested in ancient history and intended to go into the Church.

The first to show him that sculpture was something more than an interesting record of the past was Ruskin, whom he was reading by the time he went up to Oxford in 1853. For Ruskin, of course, sculpture was a subject of vital concern, an essential adjunct to architecture if not the chief agent through which architecture achieved the high moral ground he claimed for it. By the summer of 1854 Burne-Jones had absorbed this concept. He visited the Crystal Palace, recently reconstructed at Sydenham, and, in a passage steeped in *The Stones of Venice*, dismissed it as a mere 'hot-house', remote from the Ruskinian ideal of 'an architecture in . . . enduring stone . . . covered . . . with carving and bright colour'.[6] A year later Burne-Jones and his inseparable friend William Morris made a tour of the cathedrals of northern France. Ruskin was again the moving spirit and sculpture again loomed large, even when, as at Nôtre-Dame, they found it 'half taken down and lying in careless wreck under the porches'[7] as part of Viollet-le-Duc's restoration. We know the impression it made from two pieces written by Morris on his return for the *Oxford and Cambridge Magazine*: an article entitled 'The Churches of North France: Shadows of Amiens', which contains many descriptions of sculpture, and 'The Story of the Unknown Church', a romance in which the narrator is a sculptor responsible for decorating a great French abbey church. About the same time, sharing rooms with Burne-Jones in Red Lion Square, Morris himself made experiments in 'clay-modelling, [and] carving in wood and stone'.[8] These do not, apparently, survive, but they can easily be imagined – expressions, like Morris's contemporary poetry and Burne-Jones's early pen-and-ink drawings, of the friends' intense medievalism. Even Morris's notion of holding his woodcarving tools in the loops of an evening tie nailed to his bedroom wall was probably inspired by Dürer.[9]

In January 1856 Burne-Jones had met D. G. Rossetti, and as a result left Oxford, determined to become an artist. The impact of Rossetti on his career can hardly be

overstressed, but did it deepen his perception of sculpture? Rossetti was certainly alive to sculpture; indeed as protégés of Ruskin, he and his fiancée Lizzie Siddal were currently involved in Ruskin's programme of architectural reform. Miss Siddal had made 'lovely designs', including one of 'an angel with some children', for a building in which Ruskin took a keen interest, Benjamin Woodward's new library at Trinity College, Dublin; while for the same architect's University Museum at Oxford, 'I hope . . .', Ruskin told Henry Acland, 'to get Millais and Rossetti to design flower and beast borders – crocodiles and various vermin . . ., and we will carve them and inlay them with Cornish serpentine all about your windows'.[10] Although this scheme came to nothing, Rossetti did design the relief of King Arthur and his knights which Alexander Munro carved above the entrance to yet another of Woodward's buildings, the Oxford Union. A further piece of sculpture to his design, a group of the *Pelican in her Piety*, formed part of J. P. Seddon's restoration of Llandaff Cathedral.[11]

Here was a precedent for Burne-Jones, who, as we shall see, was to undertake designs of a similar type in the future. But Rossetti set another example of more immediate value: that of an artist using sculpture for his own creative ends. The records of his visit to Paris and Belgium in 1849 contain no ecstatic references to sculpture, as they do to Van Eyck and Memlinc, sundry pictures in the Louvre, and Flandrin's murals in St-Germain-des-Prés. But he must have seen Gothic sculpture in the Musée Cluny and elsewhere, and its influence seems to be traceable in his early figure style, especially his standing figures with their 'closed' poses and pipe-like drapery folds. There is also the complex relationship between his *Paolo and Francesca* drawings and Munro's famous sculpture of 1851–2 (cat.21). Whoever originated the design (which in any case relies on Flaxman), it seems that Rossetti ultimately took as much as he gave; and he certainly had a cast of Munro's group in his studio (where, incidentally, it must have been seen by Burne-Jones) long before he had finished re-working the subject in pictorial terms. What all this seems to amount to is that, despite the opacity of the external evidence, Rossetti's early work contains a strong sculptural element, resulting from his tendency to conceive figures or groups which were either derived from, or, in the case of the Munro connection, capable of inspiring, sculpture. Presumably this was what Sargent recognised when he based a small bronze group on one of his early designs (cat.47).

Well into the mid-1860s Burne-Jones was to study northern Gothic sculpture.[12] It found many reflections in his contemporary paintings and stained-glass cartoons, and to this extent the sculptural influence of Ruskin and Rossetti may be seen as complementary. There, however, the parallel ends. Rossetti tended to confirm his inability to 'see' classical sculpture, discouraging him from studying the antique on the grounds 'that such study came too early in a man's life and was apt to crush out his individuality'.[13] Ruskin, on the other hand, offered him the access to the antique so long denied by others.

In his account of the Crystal Palace, Burne-Jones had included 'Grecian statues' among the things the Palace was 'fit' for, together with 'fragrant shrubs, trickling fountains, . . . eau-de-Cologne, . . . strawberry ices and brass bands'. If this means that at this early date he thought that Ruskin's passion for Gothic implied a distaste for classical art, he was mistaken. Ruskin was certainly contemptuous of modern neo-classicists like John Gibson and Hiram Powers, but he had the highest respect for the art of ancient Greece. Of all the qualities he looked for in art, none rated higher than a sense of peace, equilibrium and order which he called 'repose'. It was, he wrote in *Modern Painters II* (1846), 'the Type of Divine Permanence, . . . the especial and separating characteristic of the eternal mind and power; . . . no work of art can be great without it, and . . . all art is great in proportion to the appearance of it. It is the most unfailing test of beauty'.[14] Sometimes he used other phrases, such as 'perfect grace and quiet truthfulness', or 'classical grace and tranquillity'; and, as the latter suggests, he associated it particularly with fifth-century Greek sculpture, the example given in *Modern Painters* (and frequently elsewhere) being the Parthenon 'Theseus'.[15] But the

Greeks had no monopoly of 'repose'; on the contrary, Ruskin cherished the idea that it was passed on, torch-fashion, from one peak to another in Western art. The first to inherit it were the great Gothic workmen of Italy; 'Nino Pisano and Orcagna', he wrote in *The Stones of Venice*, 'could have understood the Theseus in an instant, and . . . received from it new life';[16] while a procession by Giotto reminded him of 'a portion . . . of the Elgin frieze'.[17] By the late 1850s, when a radical change in his religious beliefs had caused him to re-evaluate Titian and Veronese, they in turn came to be seen as heirs to the great tradition.

By about 1858 Ruskin was seriously concerned about the medievalising excesses of Rossetti and his circle. He thought Arthurian subject-matter frivolous (by comparison with the Bible or Dante), while the self-indulgent quaintness and other stylistic eccentricities offended his sense of 'repose'. Typically, he felt he must intervene, not least because he knew he was partly to blame; but since his relations with Rossetti were increasingly strained, he focused his attention on Burne-Jones, whom he had met in November 1856, greatly admired as an artist, and valued as a sympathetic friend. All the evidence suggests that during the next decade he tried to reform Burne-Jones's style in accordance with his concept of a great tradition, meeting with far more success than usual when he embarked on ventures of this kind.[18] In the autumn of 1859 Burne-Jones visited northern Italy, 'Ruskin in hand', and copied those medieval artists who would have 'understood the Theseus'. Most, admittedly, were painters, but he drew at least one piece of sculpture, Nanni di Bartolo's *Judgement of Solomon* on the north-west corner of the Ducal Palace in Venice.[19] There are clear reflections of the journey in the work done on his return, and he continued to study early Italian sculpture, copying pieces by Nicola Pisano and others from Cicognara's *Storia della Scultura* (1813–18).[20] Ruskin, however, was not satisfied, and in 1862 he took him to Italy himself, making him copy pictures by the great Venetians who by this time had supplanted the 'primitives' as his ideal. Once again the experience proved fertile, bringing to a climax a distinctly 'Venetian' phase in Burne-Jones's early development. Meanwhile he was working his way back to the source of Ruskin's tradition, classical sculpture itself. Of his numerous copies,[21] many were taken from books such as Visconti's *Museo Pio-Clementino* (1788) and Bouillon's *Musée des Antiques* (1821–7), but many were made direct from sculpture in the British Museum. This was facilitated by the fact that from 1861 to 1865 he lived opposite the Museum at 62 Great Russell Street, although he continued to draw at the Museum for several years after he had joined the mid-Victorian migration of artists from Bloomsbury to Kensington. Ruskin's belief that artists should treat noble subjects, the source of his other complaint about the medieval style, also had the effect of deepening Burne-Jones's awareness of the ancient world. Having lost his Christian faith in 1858, Ruskin came to regard classical myths as fountains of revealed truth. In 1863, almost certainly to consolidate the formal principles he was working so hard to instil, he commissioned Burne-Jones to design a series of mythological figures to illustrate *Munera Pulveris*, the controversial papers on political economy which he had begun to publish in *Fraser's Magazine* the previous year.

Ruskin was not alone in encouraging Burne-Jones to look at classical sculpture. He had an ally in G. F. Watts, whose own art-historical perceptions were remarkably similar. Watts had revered the Elgin marbles ever since, as a boy, he had been introduced to them by his master, the sculptor William Behnes. Like Ruskin, moreover, he found affinities in the great Venetians, the marbles being 'eminently pictorial' while Giorgione and Titian were 'wonderfully Pheidian in texture of flesh and drapery'; and he even saw Giotto as a sort of half-way house, quoting a surmise of Benjamin Robert Haydon's that 'some wandering artist had made him acquainted either with some fragments or some drawings from the Panathenaic procession'.[22] Furthermore, just as Ruskin allowed this notion to influence his criticism of modern art, so Watts applied it to himself, seeking a synthesis of Pheidian form and Venetian colour in his own painting.

We know that Ruskin and Watts discussed the crisis in Rossetti's circle (Watts's pupil Val Prinsep was involved as much as Burne-Jones), and there was probably more to Burne-Jones's prolonged stay at Little Holland House in the summer of 1858 than Mrs Prinsep's kindly concern for his health. Certainly Burne-Jones came to regard Watts, his senior by sixteen years, as something of a guru, finding it, as he told him in 1874, 'a real comfort to run over to Little Holland House and grumble myself out to you'.[23] It was about this time that he recalled how Watts had 'compelled me to try and draw better',[24] advice which undoubtedly included a strong recommendation to study the Elgin marbles.[25] He would have known the casts of classical sculpture which Watts kept in his studio, and seen Watts's own experiments in sculpture, begun in Italy in the 1840s and renewed on a more serious basis in 1867, when a special sculpture studio was built for him at Little Holland House. Above all there was Watts's example, far more conscious and sustained than Rossetti's, in reaching an accommodation with sculpture in his paintings. Two of these, both in the Faringdon collection at Buscot, are particularly relevant. *The Wife of Pygmalion*, subtitled 'a translation from the Greek' because it was based on one of the Arundel marbles in the Ashmolean Museum, of which Watts had a cast, appeared at the Royal Academy in 1868 and was extravagantly praised in a review by Swinburne for the way in which it made 'painting and sculpture . . . sister arts indeed'.[26] This almost certainly echoed the views of Burne-Jones, who was so close to Swinburne in the 1860s. His opinion of the second picture, *The Judgement of Paris*, is in no doubt at all. Again one of Watts's most classical conceptions, it omits the figure of Paris in order to focus on the three goddesses, magnificent nudes of truly 'Pheidian' form. Two were copied by Burne-Jones about the time the picture was finished in 1874.[27]

Perhaps after all Ruskin and Watts need not have fussed so much. Even without their promptings, Burne-Jones would probably have moved towards classicism since this was the general trend for imaginative figure painting in the 1860s. The phenomenon is seen most clearly in artists whose roots lay deep in the academic, usually the European academic, tradition, moving across the whole spectrum from the excessively fact-conscious Alma-Tadema, through the progressively more idealising Poynter, Leighton and Albert Moore, until it reached the extreme point of aestheticism in Whistler. Pre-Raphaelite reactions were more complex. Madox Brown, Millais and Rossetti were all influenced, but the chief exponent was Burne-Jones, who, while younger than them, was of a similar age to the artists who had experienced continental apprenticeships. He was closest socially to Poynter, who became his brother-in-law in 1866, but artistically his strongest links were with Moore, whose 'subjectless' compositions he often approaches in paintings and drawings of the later 1860s. There is no record of their meeting but they were almost certainly acquainted since they moved in the same circles and Moore worked briefly for Morris about 1864. To all this, of course, there was also a literary dimension, represented particularly by Swinburne and Morris. Different as they are in style and mood, Swinburne's *Atalanta* (1865) and Morris's *Jason* (1867) and *Earthly Paradise* (1868–70) all mark a profound shift towards classicism away from the Pre-Raphaelite intensity of their authors' earlier productions. Burne-Jones was not only a close friend of both poets but intimately associated with the *Earthly Paradise* in his role as illustrator.

Turning the pages of the sketchbooks Burne-Jones used in the British Museum, it is easy to see him teaching himself certain lessons. A careful drawing of one of the Parthenon metopes, with a heroic figure of a lapith fighting a centaur, or a sketch of the so-called 'Westmacott Athlete', a Roman copy of a fifth-century Greek original, were clearly made to learn the ideal proportions of the male nude, while studies from the Nereid Monument, a Graeco-Roman relief of a Dionysiac procession, and others, show him absorbing the image of a moving figure in fluttering or flying drapery which appealed so strongly to his powerful sense of line. Sometimes a sketch ties up with a particular picture. The well-known relief of a charioteer from the Mausoleum at Halicarnassus[28] seems to have inspired the crouching pose of Circe in *The Wine of Circe*

fig.46 Edward Burne-Jones, *The Lament*, watercolour, 1866. William Morris Gallery, Walthamstow

fig.47 Edward Burne-Jones, Study for *The Lament*, 1866. City Museums and Art Gallery, Birmingham

(private collection),[29] an important watercolour based on one of the designs for Ruskin's *Munera Pulveris* which did much to establish his reputation when exhibited at the Old Water-Colour Society in 1869. The Mausoleum reliefs had been acquired in 1846, although the site of the building was not discovered by Charles Newton until a decade later, when G. F. Watts took part in the excavation.[30] Burne-Jones also drew from the main relief showing a battle between Greeks and Amazons, quoting it in his painting of *St George Slaying the Dragon*,[31] one of a set of canvases illustrating the legend of the Saint which he carried out for Birket Foster in the mid-1860s. These paintings are full of such references. In another, the group of the Princess and her attendants lining up to draw lots[32] is clearly derived from the maidens in the Panathenaic procession on the Parthenon frieze. True, they also reflect the Gothic sculpture which Burne-Jones was still copying, but then Ruskin and Watts had always maintained that the friezes anticipated Giotto.

The Elgin marbles were undoubtedly the crucial 'text' for Victorian neo-classicism. If Ruskin used them as the basis for a theory of art-history and Watts as a key to solving the problem of style, they supplied Albert Moore with a *leitmotif*, a group of seated women, and every self-respecting academic artist had casts of them in his studio. Leighton's can still be seen at Leighton House, while his 'official' self-portrait as PRA shows him dressed in his Oxford DCL gown against the famous figures of horsemen which form another section of the Panathenaic procession.[33] Official recognition of the status of the sculptures could go no higher. Burne-Jones made another small but significant contribution to this consort of taste when he sketched the figure of Ares in the group of seated deities[34] and used it in composing *The Lament*, a particularly Moore-like watercolour of 1866 (fig.46). The link is established by a study for the right-hand figure (fig.47) showing her in a pose obviously inspired by the Ares, seated in an upright position with her hands clasped on her knees. In the picture she bends forward in an attitude more expressive of grief, giving the whole composition the character of a Greek 'stele' or tombstone.

About the same time Burne-Jones embarked on a different act of homage. As early as 1861 he had painted the subject of a sculptor at work. He was King René of Anjou, and the panel, made to embellish a massive plan-chest designed by J. P. Seddon in the Gothic taste, was appropriately medieval in feeling, perhaps even incoporating a reminiscence of Morris working on his neo-Gothic sculpture in Red Lion Square (fig.5).[35] Now Morris's decision to include the story of Pygmalion in the *Earthly Paradise* offered him the chance to treat Greek sculpture from a narrative standpoint. Perennially fascinating to artists, and currently, as we saw, preoccupying Watts, the legend perhaps had a special appeal for Burne-Jones, with his intense concern to project a world of his own imagining. At all events, he made twelve illustrations in 1867 and subsequently turned four into a set of pictures in which we see not only Pygmalion's ideal image, Galatea herself, but other works in his studio (cat.5 & figs 8–10).

Greek sculpture of the classic period never lost its appeal for Burne-Jones. That the swaying movement and clinging drapery of Nimue in *The Beguiling of Merlin* (1872–7; Port Sunlight) have a classical origin is confirmed by preparatory studies in which the figure is drawn like an antique statue which has lost its arms (fig.48).[36] *Venus Concordia*, evolved for the Troy triptych in 1871, includes a group of the three Graces not unlike one which appears in Pygmalion's studio; and since this was a design Burne-Jones continued to work on till the end of his life, there are drawings for these figures as late as the 1890s.[37] Meanwhile, like so many Victorian artists, he was in daily contact with casts. The head of the Demeter of Cnidus[38] adorned his studio, while small plaster versions of the Parthenon 'Theseus' and 'Ilissus' can be seen in a painting of the drawing-room at The Grange, his house in Fulham from 1867.[39] In the 1880s, his reputation by now well established, he campaigned to get casts for Birmingham of the kind he wished he had seen there as a boy. Having in 1880 urged the building of an 'Art Museum' displaying casts 'that would open the eyes and the hearts of . . .

fig.48 Edward Burne-Jones, Study for *The Beguiling of Merlin*. Fitzwilliam Museum, Cambridge

students',[40] he returned to the theme when a new School of Art was opened in Margaret Street in 1885. Speaking as President of the Birmingham Society of Artists, he suggested that the authorities should consult his friend William Blake Richmond, who had 'selected for Oxford, when he was Slade Professor, a most admirable set of perfect examples', and begged them not 'to have casts of the late vulgar brutal Pergamus sculptures in preference to the Athenian'.[41] The rhetoric of Hellenistic sculpture repelled him. 'It is Winckelmann, isn't it', he observed, 'who says that when you come to the age of expression in Greek art you have come to the age of decadence? . . . of course it is true'.[42] There is irony in this since he also loathed that cynosure of Winckelmann, Lessing and others, the Laocoön. 'I always judge of a set of school-casts by the absence of Laocoön', he said on another occasion, 'if Laocoön's there, all's amiss'.[43] Once again one is struck by how faithful he had remained to the vision of Greek sculpture revealed to him by Ruskin so many years before. If the 'Theseus' is the hero of the chapter on 'repose' in *Modern Painters*, the Laocoön – 'a subject ill-chosen, meanly conceived, and unnaturally treated' – is definitely the villain.

For all this residual interest, the fact remains that Burne-Jones, like Whistler but unlike Moore, had outgrown the concept of aesthetic classicism by about 1870. It was replaced by an increasing commitment to the Italian Renaissance, growing by 1867, when we find him asking Fairfax Murray to 'mention Mantegna to me',[44] consummated during two further visits to Italy (1871, 1873), when the emphasis, previously on Venice, was firmly on Florence and Rome. This did not, however, lessen his interest in sculpture, which continued to figure prominently among his visual sources. He copied a number of pieces in the South Kensington Museum: a bust by Antonio Rossellino, an *Assumption* by Luca della Robbia, and terracotta groups of putti by Tribolo and Pierino da Vinci, the influence of which is traceable in his own studies of children.

Above all, he was a passionate admirer of Michelangelo's figures of slaves or captives. A sketchbook kept in Italy in 1871[45] contains hurried memoranda of the unfinished examples in the Accademia in Florence, and he would have known the *Dying* and *Struggling Captives* in the Louvre, which he visited in 1855, 1862 and 1878. He owned a small plaster version of the *Dying Captive*,[46] and similar reductions of the *Dawn* and *Evening* in the Medici Chapel in S. Lorenzo were placed over the fireplace in the drawing-room at The Grange. The chief expression of his devotion to Michelangelo (which of course extended also to his paintings) is *The Wheel of Fortune*, particularly the definitive version exhibited at the Grosvenor Gallery in 1883 (fig.49). Fortune herself recalls the Sibyls of the Sistine ceiling, while the nude figures of a slave, a king and a poet bound to the wheel have the agonised poses and massive torsos of the captives. Perhaps what appealed to him most about these sculptures was the way they achieve an overwhelming sense of tension within a restricted outline. Lady Lewis, whose recollections in this context have already been quoted, wrote: 'He loved another saying of Michelangelo's dearly, [that] a piece of sculpture ought to be thus composed, that you could roll it down a hill without chipping off a bit of it.' It is paradoxical that he should have thought so highly of Michelangelo while hating the Laocoön, since Michelangelo was present at the discovery of the Laocoön in 1506 and was greatly influenced by it. Ruskin was more consistent when he launched an attack on Michelangelo in a Slade lecture in 1871, much to Burne-Jones's dismay.

Considering Burne-Jones designed everything from stained glass to shoes, pianos to garden seats, it is not surprising that he made designs for sculpture. In 1879 he supplied Joseph Edgar Boehm with designs for small reliefs of the *Nativity* and the *Entombment*, commissioned by his friend George Howard, later Earl of Carlisle (cats 6a & 6b; figs 54 & 55). They were followed in 1882 by a larger composition representing the Battle of Flodden Field, also carried out by Boehm for Howard, this time for the library at Naworth Castle.[47] In 1894 he designed yet another work in relief, the seal of the new University of Wales, with which his son-in-law, the classical scholar J. W. Mackail, was involved (fig.50). It was executed by the modellers in wax Nelia and Ella Casella, who, like Boehm, belonged to his wider circle.

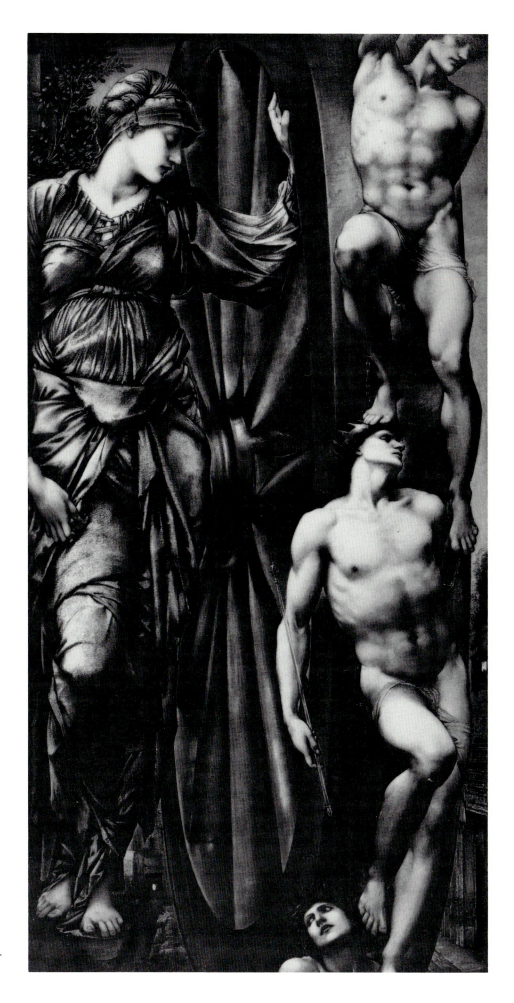

fig.49 Edward Burne-Jones, *The Wheel of Fortune*, 1875–83.
Musée d'Orsay, Paris

fig.50 Edward Burne-Jones, Study for the Seal of the University of Wales, 1894. National Museum of Wales, Cardiff

fig.51 Edward Burne-Jones, *The Garden of Hesperides*, gesso relief, 1882. Victoria & Albert Museum, London

Burne-Jones himself made a number of gesso reliefs. In 1875 he was commissioned by Arthur Balfour to decorate the music room at his London house, 4 Carlton Gardens. The subject chosen was the story of Perseus, already treated by Morris in the *Earthly Paradise*, and it was originally intended that four of the designs should be carried out in plaster relief, painted in gold and silver, on oak panels.[48] One, *Perseus and the Graiae*, was executed in this way and exhibited at the Grosvenor Gallery in 1878.[49] It was severely criticised and the idea was abandoned, but Burne-Jones did not lose interest in the medium itself. The same year his work record shows that he 'designed three panels for low relief of woodnymph, waternymph and Hesperides'.[50] The first two seem to have been taken no further as reliefs (although they were re-cast as easel paintings) but the Hesperides design exists in two versions, dated 1882 (fig.51) and 1888. In 1880 another design, *Cupid's Hunting Fields*, was carried out 'in raised work, gilded and stained', and in 1886 he embarked on a memorial to Laura Lyttelton, the captivating elder sister of the future Margot Asquith, who died, aged twenty-four, in May that year. An upright panel eight feet high, with a design of a peacock, symbol of the Resurrection, standing on a laurel bush growing out of a tomb, this was his most ambitious essay in the medium (fig.52).[51]

Even some of these reliefs were executed by others,[52] but the references to them in the early sources strongly suggest that most were carried out by Burne-Jones himself. What he never appears to have done is any free-standing sculpture, like his friends Watts, Leighton, W. B. Richmond or Henry Holiday.[53] He does not even seem to have emulated them in making models for figures in his paintings. The only time when he showed some intention of working 'in the round' was in connection with the Troy triptych, conceived in 1870, planning to have bronze figures of naked boys sitting or standing at the bases of the columns which framed the main panels. The triptych, however, was never completed as an entity, and we only have drawings for the figures of boys (cat.4), which were no doubt inspired by those terracotta groups by Tribolo and Pierino da Vinci already mentioned. Given Burne-Jones's concern with sculpture at so many levels, this failure may seem surprising, but in fact it is not as anomalous as it appears. Whether or not we agree with Henry James that his work 'exists too exclusively in surface', line had always been the basis of his style and ultimately it proved a limitation from which he was unable to break free. We should also remember that, painting apart, he showed a curious reluctance to become totally involved with any medium, designing innumerable illustrations but never cutting a woodblock,

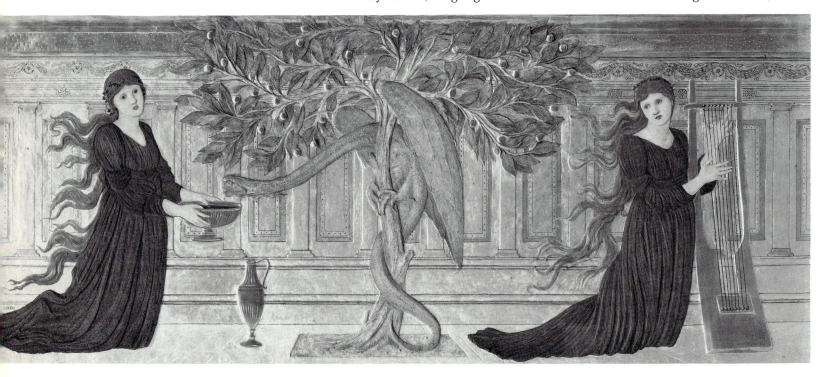

fig.52 Edward Burne-Jones, *Memorial to Laura Lyttelton*, gesso relief, 1886. Victoria & Albert Museum, London

producing stained-glass cartoons by the hundred but never actually making a window himself. His relationship with sculpture follows this pattern in a more general form.

So much for what Burne-Jones had said about one day 'taking to sculpture', a remark which never quite had the ring of truth.[54] Others, however, were to achieve what he was unable to accomplish, translating his aesthetic values into true sculptural terms. One might have imagined that the first to do so was his mistress Maria Zambaco, but her career as a sculptress did not start until the early 1880s, some ten years after their affair ended, and her masters were Legros and Rodin.[55] She may have picked up certain ideas about sculpture in Burne-Jones's studio, but if anything, as a Greek girl of outstanding beauty, she must have contributed to *his* sculptural perceptions, giving life and substance to the Pheidian ideal which loomed so large for him at the time of their liaison.

Evelyn De Morgan has better claims for consideration, being very much a Burne-Jones follower in her painting. However, her two essays in sculpture look only to related sources. A half-length *Mater Dolorosa* in terracotta[56] is based on Renaissance prototypes, while a bust of *Medusa*, executed in Rome about 1876 when she was only twenty-one, is principally indebted to her other great mentor, Watts. The over-life-size scale and a certain Michelangelesque *terribilità* suggest she had studied his bust of *Clytie* (first marble version 1867–8). No doubt she was also aware of his own head of *Medusa* (Watts Gallery, Compton), carved in alabaster in the 1840s (again, as it happened, in Rome) and repeated in marble for his patron C. H. Rickards as recently as 1870–1.

It was not until the so-called 'New Sculpture' emerged in the 1880s that Burne-Jones became a primary source of sculptural inspiration. He was not of course the only force involved. The French influence was crucial, whether mediated through the electrifying presence of Dalou in London or the studio system in Paris. Leighton set a shining example in his *Athlete Struggling with a Python* (1877; Leighton House), and continued to foster the movement with all the resources open to him as PRA. Watts, too, was an important figure, notably for Bates, Thornycroft and Gilbert, who made a bust of him in 1888 and found his comments on art of 'infinite value'.[57] Burne-Jones's contribution was analogous to Watts's; although he himself had learnt from Watts, to this new generation they were both grand old men of British symbolism, whose work not only exemplified the fusion of realism and idealism which the New Sculpture sought to achieve but provided a fertile mine of imagery. Nonetheless, the special nature of Burne-Jones's symbolism and his capacity to evoke a world of poetry and romance expressive of a certain state of mind and hinting at layers of hardly articulated meaning, made him uniquely relevant to a movement which prided itself on going beyond physical appearances to explore the spiritual dimension. Nothing demonstrates this better than his relationship with Alfred Gilbert.

This was a true meeting of minds. Gilbert's own romanticism was innate, and long before they met, the groundwork for a fruitful association was established. As a student at the Royal Academy Schools in the early 1870s Gilbert had studied the Elgin marbles and admired Burne-Jones's *Love among the Ruins* (private collection), exhibited at the Dudley Gallery in 1873. (Was part of its charm that the 'ruins' include a high-relief frieze of putti?) That year he entered the Fulham Road workshop of Edgar Boehm, and he might have met Burne-Jones sooner than he did if he had still been there when Boehm carried out reliefs from Burne-Jones's designs in 1879 and 1882. However, in 1876 Gilbert became the first of the New Sculptors to continue his training in Paris, entering the Ecole des Beaux-Arts to study under P-J. Cavelier. He was to remain abroad eight years, settling in Rome in 1878 and visiting Florence, Padua and Venice around 1880. These travels made him a devotee of Renaissance sculpture; in Paris he found that admiration for Michelangelo, almost unknown among English sculptors with the exception of Alfred Stephens, was highly developed, while in Florence he was fired with enthusiasm for Donatello's *David* and (with certain reservations) Cellini's *Perseus*

and Medusa. The results were seen in three bronzes which he exhibited in London: *Perseus Arming* (Grosvenor Gallery, 1882; cat.12); *Study of a Head* (RA, 1883) and *Icarus*, commissioned by Leighton (RA, 1884).

These pieces were highly acclaimed and we can well imagine that Burne-Jones was among their admirers, recognising characteristics that were common to his own vision. Like him, Gilbert was clearly a student of Renaissance sculpture. His use of the lost-wax method of casting gave his bronzes an astonishing pictorialism, while their mood of brooding introspection, resulting from Gilbert's view of his subjects in terms of personal symbolism, was almost uncannily like that of Burne-Jones's paintings. Reinforcing these general correspondences were certain specific motifs. Burne-Jones himself was currently concerned with the subject of Perseus (although this was not known to Gilbert), and a notable feature of the *Study of a Head* and *Icarus* was a Michelangelesque bandeau, such as Burne-Jones had given to his own figures of *Fortune* (fig.49), exhibited the same year as the *Study*.

Gilbert returned to England in the autumn of 1884, lured by Leighton with promises of major commissions, and on 22 October he and his wife dined with the Burne-Joneses.[58] Burne-Jones was clearly impressed. 'Gilbert the sculptor is a gain', he reported, 'I go warily, taught by old follies — but I think he will be a comfort on the way down'.[59] As for Gilbert, the meeting was nothing less than a revelation. So long out of touch with developments in English art, he had come prepared for pictures of the calibre of *Love among the Ruins*. 'Instead, I found myself in the presence of his greatest work . . . "King Cophetua and the Beggar-maid". It roused mingled feelings of wonder and joy, and I felt . . . a rush of enthusiasm and sympathy with the artist and his aims . . . From that moment I became a humble proselyte . . . of . . . Burne-Jones.'[60]

He was soon proving as good as his word, exploring a world of high romance peopled by characters of chivalry and expressed in terms of a rich bronze polychromy. To achieve these effects every possible technique was exploited — alloys, enamel, ormolu, damascening, contrasts with ivory, brass and aluminium, inlay with semi-precious stones and shells. It was not of course accidental that the picture which made such an impact on him was *King Cophetua* (Tate Gallery), since the themes and colouristic tendencies he derived from Burne-Jones are present here in a particularly telling form.[61] The first work by Gilbert to show Burne-Jones's influence was the row of Virtues on the monument to Henry Fawcett in Westminster Abbey, commissioned in 1885 and unveiled two years later. Elaborately patinated and originally inlaid with turquoises and garnets, the figures included a 'knight in armour' (Fortitude), a 'damsel in distress' (Sympathy), and three 'saints in heavy drapery' (Zeal, Justice and Industry).[62] They were followed by the St Albans Cathedral reredos, commissioned in 1890, which, as Richard Dorment has shown, is Burne-Jonesian both in its symbolism and its technical dependence on the mosaics the artist designed in the 1880s for the American Church in Rome.[63] Even in the context of portraiture there is a link between Burne-Jones and Gilbert if we accept that the sculptor's bust of one prominent 'Soul', Nina Cust, owes something to the painter's portrait of another, Lady Windsor.[64]

But the outstanding expression of Gilbert's 'proselytism' is his masterpiece, the tomb at Windsor of the Duke of Clarence (col.pl.8), who died in January 1892. The key source here is the *Briar Rose* paintings, which Gilbert had also seen, unfinished, in Burne-Jones's studio; they were, he wrote, 'a revelation of the power of human genius to assert . . . imagination over material effort',[65] and which, completed, had been exhibited to rapturous acclaim at Agnew's in 1890. They had already suggested the treatment of 'Sympathy', entangled in briars, on the *Fawcett Memorial*; now they provided not only an overall programme for the tomb, reading it as a sleeping figure awaiting resurrection within an enveloping thicket, but details of the guardian saints — notably the roses that wind their way round the body and halo of the Virgin and the fantastic armour of

St George (cat.13). The nature of Burne-Jones's art made an emphasis on armour inevitable, and he would often design it himself, 'expressly in order to lift [it] out of association with any historical time'. It features particularly in the *Briar Rose* paintings, the Perseus series (cats 7 & 8), and the designs he made for Comyns Carr's play *King Arthur*, staged by Irving at the Lyceum in 1895. Many of the pieces, as well as the crown held by the King in *Cophetua*, were executed by the metalworker W. A. S. Benson, and it is amusing to trace their influence both in the table-lamps, chandeliers and firescreens which became Benson's stock-in-trade and in the knights on the *Fawcett Memorial* and the *Clarence Tomb*.

In the relationship between Burne-Jones and Gilbert the debt Burne-Jones owed to sculpture was repaid in full. Gilbert for his part saw nothing strange in taking so much from a painter; on the contrary, when he lectured on sculpture at the Royal Academy in the early 1900s and the Council complained that he talked too much about painting, he replied loftily: 'I know of only one art.'[66] But perhaps the bridge between painting and sculpture was harder to cross than he realised. For some time Burne-Jones continued to take a keen interest in his development. 'We are such friends that we are shy of meeting . . .', he wrote in 1885, 'I hear that he talks about me and I know that I think about him a great deal'.[67] To Lady Lewis, who accompanied him to see the *Fawcett Memorial* in 1887, he worried that Gilbert might get 'spoilt' by society: 'I couldn't stand anything hurting his career.'[68]

But at some unknown date before his death in 1898 Burne-Jones's attitude changed and he declared himself 'disappointed' with Gilbert's work – 'he cares too much for detail'.[69] Considering it was precisely this tendency, the 'goldsmith' element in Gilbert, that Burne-Jones had encouraged, this may seem strange; indeed perhaps what irked him most was not so much the 'detail' itself as some of the commissions on which Gilbert lavished it – Queen Victoria's Epergne (1887–90), the Preston Mayoral Chain (1894), and others. However, Burne-Jones was the first to admit that his influence on painters could be harmful, so perhaps he was making the same point in relation to Gilbert. Certainly Gilbert did lose much when, in his 'enthusiasm' for Burne-Jones, he abandoned his early Donatellesque idiom. But perhaps the most sinister aspect of Burne-Jones's influence was one that had nothing to do with style. It can hardly be doubted that his habit of re-working his pictures over many years (the Perseus series, still unfinished at his death, is the outstanding example) encouraged the chronic dilatoriness that led to Gilbert's financial and professional ruin.

Gilbert too may well have had moments of doubt. It is true that he later wrote of his 'sincere friendship' with Burne-Jones 'which lasted to the day of his death, a friendship of which the memory has cheered me in hours of despondency',[70] but when, as a bankrupt and exile in Bruges, he was interviewed in 1907, 'he spoke about . . . the unwholesome influence of Burne-Jones'.[71] Was he thinking specifically of himself, or of young painters and sculptors in general?

For Burne-Jones's influence on the New Sculpture did not stop at Gilbert. As Benedict Read has shown, many of its exponents were responsible for figures of armoured knights, St Georges or Sir Galahads, often in the context of war memorials.[72] Other subjects to which Burne-Jones had given memorable expression were also re-examined. Bates did a *Story of Psyche* (1887), Mackennal a *Circe* (1893), Reynolds-Stephens a *Sleeping Beauty* (1897) and Pomeroy (like Gilbert) a *Perseus* (1898). Drury's *Griselda* (1896) refers to Chaucer and Boccaccio, Frampton made a bust of Chaucer (1902–3), and he (cat.9), Reynolds-Stephens and Goscombe John were inspired by Malory. More generally, New Sculptors often reflected the taste for the early Renaissance that Burne-Jones had done so much to create, while many, following the path first suggested to Gilbert by his study of *King Cophetua*, continued to explore the role of colour in sculpture. In addition to subject-matter and style, Burne-Jones indicated areas of activity which became closely associated with the New Sculpture and saw some of its greatest

triumphs. His Howard and Lyttelton Memorials showed that memorial sculpture need not be bound by overworked convention.[73] His readiness to design stained glass and mosaic foreshadowed the movement's preoccupation with the relationship of sculpture to architecture. It was as if, late but wholeheartedly, New Sculptors gave life to the Ruskinian concept of architecture which had moved Burne-Jones but never received from him more than tangential expression. The great appeal of architectural sculpture was that it enshrined the principle of art in everyday life, and the movement found two other forms for this, the commercially reproduced bronze statuette and the multiple plaster relief. Once again Burne-Jones was a pioneer. He had not only made plaster reliefs but shown a consistent interest in the subject of cheap reproduction, his preferred medium being wood-engravings based on his designs.

Many of these strands come together in the careers of three more artists included in the exhibition: George Frampton, Robert Anning Bell and William Reynolds-Stephens. Frampton probably met Burne-Jones, and certainly had numerous opportunities to study his work. If he was, as seems likely, one of the New Sculptors who began their careers working for the monumental masons Farmer and Brindley in the Westminster Bridge Road (Harry Bates and C. J. Allen were others), then he could have encountered Burne-Jones there since the artist frequented the firm to study the marble which features in many of his later paintings.[74] In 1881 Frampton entered the Royal Academy Schools, and in 1887 he went to Paris as a pupil of Antonin Mercié; but in 1889 he visited the Exposition Universelle (where, incidentally, the New Sculpture was well represented) and saw *King Cophetua*, enchanting the public and winning its painter the cross of the Legion of Honour. Later that year he returned to London, where he was already a member of the Art Workers' Guild and thus a confrère of Morris, Walter Crane, T. M. Rooke and other members of the Pre-Raphaelite circle. Burne-Jones himself did not join the Guild until 1891 and resigned two years later; but in 1890 Frampton began to show with the Arts and Crafts Exhibition Society, which Burne-Jones had supported since its foundation in 1888. Two more events are relevant: in the winter of 1892–3 a large Burne-Jones retrospective was held at the New Gallery, and in 1893 Frampton married Christabel Cockerell, whose cousin Sydney Cockerell was secretary to William Morris and the Kelmscott Press.

Frampton's most overtly symbolist works are the series of frontal female busts which he began to produce when still a student in Paris. Starting with *Christabel* (Paris Salon, 1889), they take a more occult turn in *Mysteriarch* (1892) and reach a bizarre climax in *Lamia* (1899–1900; cat.10). As scholars have observed, these astonishing pieces owe much to contemporary French polychrome sculpture, much to European symbolist painting, and much to the portrait busts of Renaissance sculptors (a parallel here with Evelyn De Morgan's *Mater Dolorosa*).[75] But equally strong is a late Pre-Raphaelite element for which the most obvious sources are Rossetti's half-length female figures and certain Burne-Joneses, whether early essays in Rossetti's 'Venetian' manner or later works such as *Flamma Vestalis* (1886; private collection) and *Vespertina Quies* (1894; Tate Gallery), in which young girls, again half-length, are seen in romantic settings. Like these paintings, Frampton's busts are full of a brooding melancholy or seem to embody some withdrawn yet fatal power. Like them, too, they are 'fantasy portraits', playing with the portrait form. Such emphasis is placed on decorative detail and mood (partly established, as in their Pre-Raphaelite prototypes, by their titles) that the form is divorced from portraiture as such and assumes a life of its own. On the other hand, just as Rossetti's half-lengths are portraits of Fanny Cornforth or Jane Morris, and *Flamma Vestalis* and *Vespertina Quies* represent respectively Margaret Burne-Jones and the model Bessie Keene, so sitters were important to Frampton; his fiancée presumably posed for *Christabel*, and he used the same formula for 'straight' portraits when the sitters – his wife and child (1894–5), the sibylline Marchioness of Granby (c.1901–2)[76] – lent themselves to symbolist interpretation. Not surprisingly, Frampton's busts, wherever they come on the scale from independent art object to portrait, had many derivatives, Alfred Drury's *Griselda* (1896) and *Prophetess of Fate* (1899–1900)[77] being among the more distinguished.

fig.53 Edward Burne-Jones, *A Sea-Nymph*, 1880. Location unknown

The quest for a sculptural equivalent to painterly values, pursued so tenaciously by Gilbert and by Frampton in his symbolist busts, led inexorably to the relief; as we have seen, Burne-Jones himself had gone so far down the road to sculptural expression. Of all the New Sculptors, Frampton was the most closely involved in architectural decoration, and much of his finest work in this field takes the form of high or low reliefs. When his subject is a group of 'Pre-Raphaelite' girls, as in the friezes for Lloyd's Registry of Shipping in Fenchurch Street, or the spandrels of the north porch of the Glasgow Art Gallery, all dating from the turn of the century,[78] the results are as near as we shall get to what Burne-Jones himself might have produced if he had adorned buildings with sculpture instead of stained glass or mosaic. Indeed it has been suggested that one of his most important designs for the mosaics in the American Church, the 'Tree of Life' shown at the Arts and Crafts Exhibition of 1888, inspired the decorative tree motif which Frampton developed in the mid-1890s and which, through him, became popular with other sculptors working in relation to architecture.[79] The relief of *Alis la Beale Pilgrim* (cat.9), one of nine representing Arthurian heroines which Frampton modelled for the door of the Great Hall at Astor House, Westminster, in 1895–6, may be further evidence of Burne-Jones's influence on him in this area. It seems unlikely that he would have chosen such an obscure heroine, rating only one appearance in the *Morte d'Arthur*, without knowing that Burne-Jones had portrayed her in one of his early pen-and-ink drawings.[80]

Frampton also made reliefs in coloured plaster, working in close collaboration with Anning Bell. Near contemporaries, they had experienced similar training (Royal Academy Schools and Paris), and by 1889 were sharing a house and studio off Camberwell Green. The climax of their collaboration was the altarpiece in St Clare's Roman Catholic Church, Liverpool, a version of which was the first item either showed with the Arts and Crafts Exhibition Society, in 1890. Bell in fact was a more consistent exponent of the coloured relief than Frampton, producing a series of charming examples up until about 1907, when he included a group in his one-man exhibition at the Fine Art Society in London.[81]

Like Frampton's busts, his and Bell's plaster reliefs are the product of forces among which Italian Renaissance and Burne-Jonesian elements are readily identifiable. Both artists visited Italy about this time, Frampton with a party of Art Workers who toured northern Italy under the auspices of the Guild in 1891. During Bell's spell of teaching at Liverpool University School of Architecture (1895–9), he became involved with Harold Rathbone's newly-established Della Robbia Pottery at Birkenhead; the firm, whose very name indicates the context within which Rathbone and Bell were working, not only made ceramic versions of some of Bell's designs for plaster reliefs but panels based on Burne-Jones's *Days of Creation*. Similarly, Bell's contemporary book illustrations pay tribute to the woodcuts of the *Hypnerotomachia*, that evergreen source which had inspired Burne-Jones's *Earthly Paradise* designs in the 1860s. The reliefs of Bell and Frampton were sometimes seen alongside Burne-Jones's work in this field at the Arts and Crafts Exhibitions. He showed the *Hesperides* in 1888, an unidentified 'gesso panel, coloured in oils', in 1893, and his seal for the University of Wales in 1896. The gesso panel shown in 1893 was executed by Matthew Webb, who collaborated with Frampton on an article 'On Colouring Sculpture' published by the *Studio* in May 1894. One of Bell's reliefs, *The Mermaid* (cat.1), may owe something to Burne-Jones's painting of a *Sea-Nymph* (fig.53), which, as we saw, began life as a design for a 'panel in low relief'. But possibly the influence was not all one-sided, the flurry of interest in relief sculpture (Walter Crane was another prolific exponent) inspiring Burne-Jones himself to make one further experiment. During the last years of his life he devoted much time to drawing groups of figures in metallic paint on coloured paper, and some of these were worked in hammered silver by the versatile Robert Catterson-Smith, who was also busy translating his pencil drawings for the Kelmscott Press into pen-and-ink outline suitable for wood-engraving. Three of these plaques, one of them a book-cover, were shown at the Arts and Crafts Exhibition of 1896.[82]

Notes

1 Sweeney, p.164

2 Cook & Wedderburn, vol.XXXIII, p.301

3 Unpublished notes by Lady Lewis (private coll.). He also told her: 'It is the fate of all pictures and books to be burnt, it is only a matter of time; but sculpture has a chance of living in some form or other'.

4 GB-J, vol.II, p.100

5 *ibid.*, vol.I, pp.45–7

6 *ibid.*, vol.I, p.101

7 *ibid.*, vol.I, p.114

8 Mackail, vol.I, p.106

9 A similar device appears in the background of Dürer's engraving of *St Jerome in his Study*. Dürer was a major influence on Burne-Jones and his circle during their medieval phase

10 Cook, vol.I, pp.445–6

11 Repr. Read 1982, p.260, pl.324. Two of Rossetti's drawings for the project survive (Surtees 1971, 707 and 797A)

12 e.g. two north German limewood reliefs of SS. Matthew and Luke, acquired by the South Kensington Museum in 1858; see Victoria & Albert Museum, sketchbook E.3 – 1955, pp.41–2

13 GB-J, vol.I, p.149

14 Cook & Wedderburn, vol.IV, pp.113–7

15 Now identified as Heracles, form the east pediment

16 Cook & Wedderburn, vol.IX, p.188

17 *ibid.*, vol.XXIV, p.65

18 For a fuller account of this complex subject, see Christian, pp.184–205

19 Fitzwilliam Museum, Cambridge, sketchbook 1084, f.16

20 Victoria & Albert Museum, sketchbook E.1–1955, pp.298–302

21 Victoria & Albert Museum, sketchbooks E.2–1955 to E.6–1955, datable *c.*1863–70.

22 M.S. Watts, vol.I, pp.146–7

23 GB-J, vol.II, p.2; original (microfiche) in Tate Gallery archive, Watts correspondence, letter 41

24 Carr, p.72

25 Watts's pupil J. R. Spencer Stanhope wrote of him in 1851: 'He seems to approve of few besides the Elgin Marbles as lessons to study from' (M.S. Watts, vol.I, p.137)

26 Swinburne, p.360

27 Victoria & Albert Museum, sketchbook E.10–1955, pp.55–7. For the two Buscot paintings, see Whitechapel Art Gallery, nos 23 & 27, both repr. in cat.

28 British Museum, no.1037. Burne-Jones's copy is in the Victoria & Albert Museum, sketchbook E.5–1955, p.41

29 Tate Gallery 1984, no.244, repr. in cat.

30 Burne-Jones would have been well aware of Newton, who was a friend of both Ruskin and Watts. His copy of a Greek bronze relief of Boreas and Oreithyia (V&A, sketchbook E.2–1955, p.3) was probably made from Newton's *Travels and Discoveries in the Levant*, 1865, vol.I, p.330, pl.15, since the piece did not enter the British Museum until 1873

31 Now in the Art Gallery of New South Wales, Sydney. The British Museum has a finished composition drawing (Arts Council 1975–6, no.89, repr. in cat.)

32 Painting lost, finished drawing in British Museum (repr. Wood, pl.13)

33 Uffizi, Florence; L. & R. Ormond 1975, pl.147. Other expressions of the phenomenon are Alma-Tadema's painting of Pheidias working on the Parthenon frieze (1869; Birmingham) and Henry Holiday's painting *The Panathenaia* (begun 1884, never finished).

34 Victoria & Albert Museum, sketchbook E.3–1955, p.16. Ares is seen in Slab IV of the frieze, fig.27

35 The chest, to the decoration of which Rossetti, Madox Brown, Morris and others also contributed, is in the Victoria & Albert Museum. Burne-Jones's design of King René sculpting is at Birmingham (528'04; repr. Harrison & Waters, fig.51)

36 A group of these studies is in the Fitzwilliam Museum, Cambridge, sketchbook 962

37 Carlisle Art Gallery and Birmingham (22'98)

38 British Museum, excavated by Sir Charles Newton in 1858. Burne-Jones's cast of the head was included in Arts Council 1975–6, no.349

39 Arts Council 1975–6, no.376

40 GB-J, vol.II, p.100

41 *ibid.*, p.157

42 *ibid.*, p.140

43 *ibid.*, p.158

44 *ibid.*, p.305

45 Arts Council 1975–6, no.345

46 *ibid.*, no.348

47 Casts at Naworth and in the Carlisle Art Gallery. Burne-Jones's design is reproduced in Vallance, p.27

48 Watercolours showing this scheme are in the Tate Gallery (3456–8); see Löcher, figs 19–21

49 Collection of the Earl of Balfour; Löcher, fig.37

50 The record, now in the Fitzwilliam Museum, Cambridge, also lists under 1878 a 'golden panel of Triumph of Love for Duke of

Aesthetic values are often most clearly perceived in the work of minor artists, and this is true of William Reynolds-Stephens. Aptly described by Susan Beattie as 'essentially an illustrator',[83] he was much influenced by Gilbert and Frampton, respectively eight and two years his senior, and reflects many of their ideas and priorities. A painter as well as a sculptor, he saw his sculpture in pictorial terms, making great play with coloured materials and often working in relief. He liked poetic subjects, notably the Arthurian themes re-worked by Tennyson, and identified closely with the Arts and Crafts movement, seeing art as an integral part of everyday life. If his masterpiece is the furnishings of St Mary, Great Warley, he was not above designing a yachting trophy, a bonbonnière, a photograph frame or electric light fittings. The *Happy in Beauty* relief (cat.43) 'was intended not as a self-sufficient work of art for display in sterile isolation, but as a piece of furniture, to take its place among the paraphernalia of private life'.[84] Inevitably Burne-Jones was a component of his style. As we saw, he did a *Sleeping Beauty* in 1897.[85] A low-relief panel designed as an overmantel for a chimney-piece by Norman Shaw, it clearly echoes Burne-Jones's *Briar Rose* series, revealed so dramatically seven years before. The reredos at Great Warley (*c.*1903) employs the 'Tree of Life' motif and includes small reliefs of the Nativity and Lamentation (see cat.45) which seem to betray knowledge of Burne-Jones's *Howard Memorial* (cats 6a & 6b).

But Reynolds-Stephens's illustrational approach also involves a fundamental change of emphasis. For him, as for many artists of his generation, Pre-Raphaelitism, far from being the vital, re-orientating force that it had been even for Gilbert, was essentially a style to play with, a vocabulary of picturesque images whose use implied no deeper creative significance. Nothing shows this better than *Happy in Beauty* (cat.43), with its Keatsian title, its 'aesthetically' garbed figure, and its circular mirror, a motif that runs like a refrain through Pre-Raphaelitism, being borrowed by Holman Hunt from Van Eyck in the 1850s, taken up by Burne-Jones in an early watercolour (1862) and a famous portrait of his daughter (1886), and enjoying a sort of afterlife in the work of Ricketts and Shannon, Burne-Jones's Birmingham follower S. H. Meteyard, and Reynolds-Stephens himself. Charming, self-conscious, and academic in spirit, the relief clearly marks the end of a line. There could not be a better tailpiece to the exhibition.

Westminster'. According to other early sources, this too was a gesso relief

51 Versions in the Victoria & Albert Museum and in Mells Church, Somerset

52 The 1888 version of *The Hesperides*, on the front of a cassone, was by Osmund Weeks (who also worked in this medium with Walter Crane), and Matthew Webb was responsible for a gesso panel designed by Burne-Jones which was shown at the Arts and Crafts Exhibition of 1893, no.281

53 Two letters in his correspondence with Watts (Tate Gallery, microfiche) are relevant in this context. In one (letter 43) he discusses a life-size sculpture by Holiday; in another (letter 68) he urges Watts to exhibit sculpture at the New Gallery, which was soon to open

54 Even though his eyes did 'grow dim' in old age, (see GB-J, vol.II, p.317)

55 See Attwood, pp.31–7

56 Repr. in the *Studio*, XIX, 1900, p.230

57 M.S. Watts, vol.II, p.134

58 Autograph notes by Lady Burne-Jones (private coll.). Gilbert himself mistakenly dated the visit to 1886, when he was exhibiting *An Offering to Hymen* at the Grosvenor Gallery (McAllister, p.144; repeated by Beattie, p.144)

59 GB-J., vol.II, p.147

60 McAllister, p.147. The fact that he saw *Cophetua* is further evidence that the meeting took place in 1884. The picture was exhibited at the Grosvenor that summer and bought by the Earl of Wharncliffe. Gilbert presumably saw it after it had returned from exhibition but before it went off to its owner

61 Benedict Read quotes a passage from Fernand Khnopff's reminiscences of Burne-Jones which is highly relevant in this context; see Read 1989, cat.p.59

62 See RA 1986, cat.pp.124–6

63 *ibid.*, p.20

64 See Manchester 1978–9, cat.p.171, under no.88, and RA 1986, cat.pp.172–3. Gilbert's bust was executed in 1894. Burne-Jones was working on his portrait in 1893 but did not finish and exhibit it until 1895. One other debt to Burne-Jones is worth considering. Gilbert's statuette *An Offering to Hymen*, shown at the Grosvenor Gallery in 1886, is comparable, in theme and title if not in composition, to Burne-Jones's *Sacrifice to Hymen* or *Hymenaeus*,

exhibited at the New Gallery two years later. Although there is some evidence that Gilbert began his figure in Rome, he certainly worked on it in London, using a model popular with Millais, Leighton and others (see RA 1986, cat.p.112, no.18). Equally, although Burne-Jones's painting had been executed for the dealer Murray Marks as early as 1875, it could well have been back in his studio and seen there by Gilbert when he was working on his statuette

65 McAllister, p.147

66 Ganz, p.7

67 GB-J, vol.II, p.147

68 Unpublished letter (private coll.)

69 Unpublished notes by Lady Lewis (private coll.)

70 McAllister, p.145

71 Ganz, p.6

72 Read 1989, pp.58–61

73 The *Lyttelton Memorial* was exhibited at the Grosvenor Gallery in 1887; the studies for the *Howard Memorial* (cats 6a & 6b) were seen in the Burne-Jones retrospectives at the New Gallery in 1892–3 and 1898–9. Also worth mentioning in this context is the tomb in Brompton Cemetery for F. R. Leyland (d.1892) which he designed with W. A. S. Benson. Two 'models' were shown at the Arts and Crafts Exhibition of 1893, nos 325, 328

74 GB-J, vol.II, pp.222–3

75 See Beattie, pp.157–62; Read 1989, pp.56, 59

76 Beattie, figs 154, 172

77 *ibid.*, figs 170–1

78 *ibid.*, figs 74, 76–9

79 *ibid.*, p.76

80 The drawing is mentioned in Bell (1st ed.) 1892, but does not seem to have been exhibited until it was included in the exhibition of Burne-Jones's drawings held at the Burlington Fine Arts Club, 1899, no.18

81 For a fuller account, see P. Rose, pp.16–23

82 Nos 109–110A. They are reproduced in a review of the exhibition in the *Studio*, IX, 1897, pp.119–20, together with reliefs by Frampton and Anning Bell

83 Beattie, p.167

84 *ibid.*, p.193

85 Repr. in the *Studio*, XVII, 1899, p.82

Robert Anning Bell
(1863–1933)

Bell entered the Royal Academy Schools in 1879, having already undergone two years' architectural training with his uncle. While at the Royal Academy he also studied at Westminster School of Art under Professor Fred Brown. Bell spent a year in Paris working with the painter Aimé Morot and later studied in Italy. Around 1887 he shared a studio with George Frampton in Camberwell and it was at this time that he started to make the coloured plaster reliefs which became his most distinctive sculptural work. He exhibited at the Royal Academy from 1885 and joined the New English Art Club in 1888. He worked as a painter, mainly in watercolour; modeller; book illustrator and as a designer of stained glass, mosaic and other decorative work. Bell had a successful teaching career: for four years from 1895 he taught painting and drawing at the School of Architecture, University College, Liverpool; from 1911 he was Professor of Decorative Art at Glasgow School of Art and from 1918 Professor of Design at the Royal College of Art, London. Bell was elected a member of the Royal Society of Painters in Watercolour in 1904, ARA in 1914 and RA eight years later. He became the Master of the Art Workers' Guild in 1921 and was deeply involved in the Arts and Crafts movement, organising exhibitions in London and all over Europe with the Arts and Crafts Exhibition Society. His international reputation was recognised by medals in Vienna, Milan, Barcelona and Turin.

A.K.

1 Mermaid, 1900

Plaster relief, coloured and gilt, 37 × 31cm (14½ × 12¼in)
Signed: R. A. Bell 1900

PRIVATE COLLECTION

This is a version of one of a series of panels which Bell made for 'Le Bois des Moutiers', a house designed by Edwin Lutyens for Guillaume Mallet at Varengeville near Dieppe. A banker and anglophile, Mallet commissioned the panels by way of giving names to the rooms of the house, having them fixed beside each door. Still *in situ*, they are dated 1899, and all show female figures gracefully disposed within frames. The *Studio* featured the scheme (XIX, 1900, pp.264–7), reproducing the original of the *Mermaid*, which differs from the present version in having a purple background.

J.C.

2 Mother and Children, 1906

Plaster relief, coloured and gilt, 37 × 28cm (14½ × 11in)
Signed: R. An. Bell '06 no.2

Lit: P. Rose, p.22

PRIVATE COLLECTION

Mothers and children or female figures in some friendly
relationship are characteristic subjects of Bell's plaster reliefs.
This is a late example, dating from only a year before his
exhibition at the Fine Art Society in 1907, after which he
tended to move on to other forms of decorative art such
as stained glass and mosaic. Unlike his early reliefs, c.1890,
which are bright and clear in tonality, these later pieces are
in a rich sombre palette, often achieved, as here, by glazing
transparent colour over a gold ground.

In the catalogue of the Fine Art Society exhibition, Bell
wrote: 'The reliefs can be repeated, the issue being limited
to fifteen examples of each subject, worked upon, coloured
and numbered by the Artist.' They would be dated at the
time of colouring, and even within an edition the colouring
varied widely. As the inscription on the present example
shows, it was the second cast in the edition to be thus
completed. Another was included in the 1907 exhibition
(no.49), and the *Studio* reproduced this in colour, observing
that 'Mr. Anning Bell has at times expressed himself through
this medium with much beauty of result and with great
advantage in interior architecture' (XLII, 1908, pp.308–9).

J.C.

John Brett
(1831–1902)

Eldest son of an army veterinary surgeon, Brett attended drawing classes at Dublin and entered the Royal Academy as a student in 1853. He was introduced into the Pre-Raphaelite circle by Coventry Patmore and began to come under the influence of Ruskin. Brett first exhibited at the Royal Academy in 1856 and the following year in the Pre-Raphaelite exhibitions at Russell Place, London and in New York. In 1858 he joined the Hogarth Club and showed *The Stonebreaker* at the Royal Academy, which received an enthusiastic reception from Ruskin. Gradually Brett turned from figure painting to landscapes and travelling in Italy and Switzerland painted the *Val d'Aosta*, which Ruskin acquired for himself. From this time on Brett continued to produce a series of landscapes in the same meticulous vein, displaying a scientific love of detail. By the late 1860s he had turned exclusively to seascapes and after 1870 his subjects most frequently were the coasts of southern England and North West Scotland. Science was his particular interest and he was elected a Fellow of the Royal Astronomical Society in 1871. Brett became an Associate of the Royal Academy in 1881.

J.B.

3 Alexander Munro, 1861

Pencil on paper, 19.5 × 14.5cm (7¾ × 5¾in)
Signed: JB/Florence/Dec.ʳ 6. 61

PRIVATE COLLECTION

This drawing was made during Munro's honeymoon in Florence in 1861. It is not known if Brett also made a pendant portrait of Mary Munro (cat.36). The sculptor wrote home from Florence to his sister Annie, 'Brett is here – we see each other every day' (letter 1 Dec. 1861 private coll.). In a further letter to Annie written on 17 Dec. from Rome, Munro recounted 'I am sitting for my cameo. Brett made a good drawing of my profile at Florence, for it – & Mary says you will be sure to want it.' The finished cameo was given to Annie and remained in the family until it was stolen and is now untraced.

A.K.

Edward Burne-Jones
(1833–1898)

The son of a frame-maker, Burne-Jones was born in Birmingham. In 1844 he entered the local grammar school and planned to go into the Church. At Oxford, however, he and his friend William Morris came under the influence of Ruskin and the Pre-Raphaelites, especially D. G. Rossetti. Burne-Jones's early work, strongly influenced by Rossetti, consists mainly of small pen and ink drawings and watercolours. In 1861 he became a partner in the firm of Morris, Marshall, Faulkner and Co., 'Fine Art Workmen', becoming deeply involved with the design of stained glass and other forms of decorative art. In 1859 he paid his first visit to Italy, returning in 1862 (with Ruskin), 1871 and 1873; these visits were of great importance for his later style. In 1867, by now married with two children, he moved to The Grange, a large Georgian house in Fulham which remained his London home until his death. Meanwhile, in 1864, he had been elected an Associate of the Old Water-Colour Society, but resigned six years later. During the early 1870s Burne-Jones scarcely exhibited, relying on the support of private patrons, however, in 1877 he was invited to exhibit at the newly opened Grosvenor Gallery and the eight large paintings he showed there caused a sensation. From then on he continued to show major works every year at the Grosvenor until 1887, thereafter at its successor the New Gallery. In 1886 he exhibited one picture at the Royal Academy during an unhappy nine years as an Associate. The twin peaks of his later career were the exhibition of *King Cophetua and the Beggar Maid* at the Grosvenor in 1884 and of the four *Briar Rose* paintings (Buscot Park) at Agnew's in 1890. In 1894 he accepted a baronetcy. During the 1890s he also enjoyed an international reputation, being especially fashionable in Symbolist circles in Paris, where *King Cophetua* was received with great acclaim at the Exposition Universelle of 1889 and where he continued to exhibit until 1896. At the end of his life he saw his popularity decline, and his last pictures, withdrawn and abstract, seem to be painted essentially for himself.

J.C.

4 Two Nude Children, *c.*1871

Watercolour with bodycolour on brown paper,
39.3 × 90.2cm (15½ × 35½in)

Exh: Arts Council 1975–6 (no.128)
Lit: Birmingham 1930, p.32 (no.186'22)

BIRMINGHAM CITY MUSEUMS AND ART GALLERY

Burne-Jones conceived the idea of painting a triptych to illustrate the story of Troy in 1870. It was to include a predella as well as the three main panels, and have an elaborate Renaissance-style frame topped by a massive entablature. A large canvas in the Birmingham Art Gallery, unfinished and mainly by assistants (repr. Arts Council, 1975–6, cat.p.49), shows the complete scheme with the frame drawn in perspective, but opinions differ as to whether this is a sketch to show how the finished work would look or the triptych itself in an unfinished form.

The present drawing is one of three at Birmingham for the bronze figures of children who appear in the painting at the bases of the columns which frame the main panels. According to Burne-Jones's assistant T. M. Rooke, the children were added to the canvas at the suggestion of Fairfax Murray 'to diminish the peril . . . that the whole would be cut up for the sake of the separate subjects, as his experience of ancient work told him had often happened' (Birmingham 1930, p.31). This certainly suggests that the painting was seen as an end in itself. However, illusionism

of this kind was so uncharacteristic of Burne-Jones that it still seems possible that the purpose of the work was to give an impression of a yet-to-be-realised three-dimensional scheme. In this case the children would presumably have been cast in bronze and fixed to the frame as Burne-Jones's only essay in free-standing sculpture.

J.C.

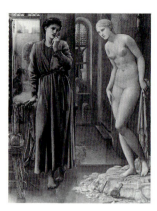

(see page 10)

5 Pygmalion and the Image – The Hand Refrains,
completed 1878
colour plate 6
Oil on canvas, 97.5 × 75cm (38¾ × 29½in)

Exh: Grosvenor Gallery 1879 (no.168); Arts Council 1975–6 (no.137b; see cat. for lit. and other exh.)

BIRMINGHAM CITY MUSEUMS AND ART GALLERY

William Morris's *Earthly Paradise* was originally to have been lavishly illustrated by Burne-Jones. The plan came to nothing, but the numerous designs that Burne-Jones made in the late 1860s provided a bank of compositional ideas on which he was to draw for pictures to the end of his life. The four Pygmalion paintings were based on a set of designs made in 1867 for the tale of 'Pygmalion and the Image'. There are two complete versions, the more important of which is at Birmingham (figs 8–10; for the other, see Harrison & Waters, pls 20–3), and a third version of the first subject (1871) exists. The present painting is the second canvas in the Birmingham set, showing Pygmalion looking longingly at the statue he has created in the image of his own ideal.

The Birmingham paintings were exhibited at the Grosvenor Gallery in 1879 and are in the pale chalky tones Burne-Jones favoured at this time, seen again in *The Golden Stairs* of 1880 (Tate Gallery). Their first owner was Frederick Craven, a Manchester patron, described by Rossetti as 'a very good paymaster' but a 'rather stupid enthusiast of the inarticulate business type, with a mystic reverence for the English watercolour school'. In the context of this exhibition the pictures are interesting in showing Burne-Jones dealing narratively with the subject of Greek sculpture which played so crucial a part in his own development and that of many of his fellow artists in the 1860s. The model for the head of Pygmalion was W. A. S. Benson, who made armour and other studio properties for Burne-Jones to the artist's own design (see cats 7 & 8).

J.C.

6a The Nativity, 1879
6b The Entombment, 1879

Each watercolour with creta laevis, 25.1 × 40.6cm (9 × 16in)

Exh: New Gallery 1892–3 (nos 154, 159); New Gallery 1898–9 (nos 200, 204)
Lit: Bell, p.89; De Lisle, pp.153, 192

THE SYNDICS OF THE FITZWILLIAM MUSEUM, CAMBRIDGE

These are designs for a pair of reliefs forming part of a memorial to the Hon. Charles Howard (1814–79) and his wife Mary Parke in Lanercost Priory, Cumberland. They were commissioned by their son George Howard, later 9th Earl of Carlisle, whose mother had died at his birth. An amateur painter himself, Howard was a close friend of Burne-Jones, who also, among other commissions, designed a relief of *The Battle of Flodden Field* for the library at Howard's Cumberland seat, Naworth Castle, in 1882. Both this and the *Howard Memorial* were executed in relief by Sir Joseph Edgar Boehm, who was appointed Sculptor in Ordinary to Queen Victoria in 1881 and had many patrons among the aristocracy. A Hungarian by birth, Boehm was only a year younger than Burne-Jones. Their relations were warm and Boehm was among those who persuaded Burne-Jones, against his better judgement, to accept Associateship of the Royal Academy in 1885 (see GB-J, vol.II, pp.120, 153).

Burne-Jones has conceived the reliefs in a primitive 'Romanesque' style which Boehm was to translate into a more naturalistic idiom (figs 54 & 55). Boehm's naturalism has caused him to be seen as a precursor of the New Sculpture on which Burne-Jones was to have such an influence; indeed he was the master and promoter of Alfred Gilbert, although Gilbert had left his studio by the time Boehm came to work in collaboration with Burne-Jones.

Preparatory drawings for the two designs are in a sketch-book in the V&A, London (E.7–1955).

J.C.

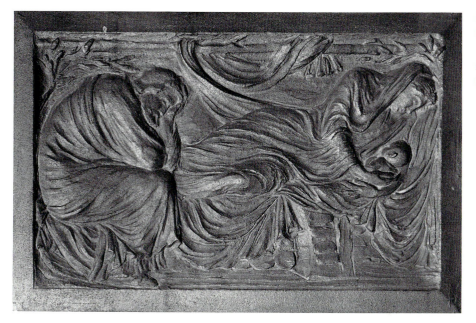

fig.54 Joseph Edgar Boehm, *The Nativity*, bronze, 1879. Lanercost Priory, Cumbria

fig.55 Joseph Edgar Boehm, *The Entombment*, bronze, 1879. Lanercost Priory, Cumbria

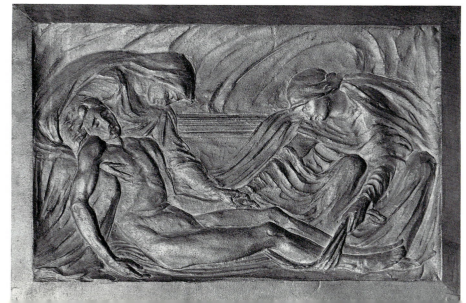

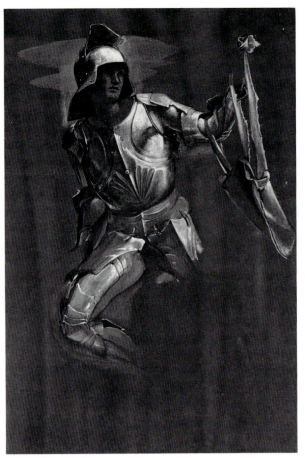

7 Study for Perseus in 'The Finding of Medusa', *c.1881*

Watercolour with bodycolour, 53.3 × 36.2cm (21 × 14¼in)

Exh: Tate Gallery 1933 (no.57); Arts Council 1975–6 (no.165)
Lit: Ironside & Gere, p.47 & pl.86; Löcher 1973, no.4t & fig.64

THE SYNDICS OF THE FITZWILLIAM MUSEUM, CAMBRIDGE

A study for the fourth scene in the Perseus series, commissioned by Arthur Balfour to decorate the music room at his London house, 4 Carlton Gardens, in 1875, but still not finished at Burne-Jones's death twenty-three years later. The related paintings are at Stuttgart (unfinished 'final' oils) and Southampton (full-scale gouache cartoons).

Burne-Jones made many studies of armour, both for the Perseus paintings and the *Briar Rose* series, exhibited in 1890. Some were made from real armour, including pieces in the collection of Sir Coutts Lindsay, the proprietor of the Grosvenor Gallery of which Burne-Jones had been the 'star' since its opening in 1877; others were based on armour he designed himself and had made by the young metalworker W. A. S. Benson 'expressly in order to lift them out of association with any historical time' (GB-J, vol.II, pp.145–6). The present drawing seems to show an authentic suit of late medieval plate-mail. Generally regarded as one of Burne-Jones's finest armour studies, it was specially selected from his studio in 1909 by Sydney Cockerell, the former secretary to the Kelmscott Press who had become Director of the Fitzwilliam Museum the previous year.

J.C.

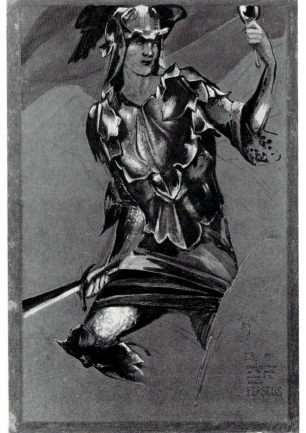

8 Study for Perseus in 'The Finding of Medusa', 1881

Watercolour with bodycolour, 35.5 × 24cm (14 × 9½in)
Signed and inscr: EBJ 1881 / study of armour / for the fourth / picture in the / series of / PERSEUS

Lit: Birmingham 1939, p.100 (no.46'98); Löcher, no.4u & fig.65

BIRMINGHAM CITY MUSEUMS AND ART GALLERY

The armour worn in cat.7 clearly dissatisfied Burne-Jones, with the result that he made the present study from the armour he designed himself and had made by W. A. S. Benson to dissociate it from any historical period. It remains unchanged in the painting at Stuttgart, thus bearing out Burne-Jones's comment on his specially designed studio properties that 'what finally gets onto the canvas is a reflection of a reflection of something purely imaginary' (GB-J, vol.II, p.261). A photograph of Perseus' helmet is reproduced in Vallance, p.29 & fig.46.

The two studies together give a good idea of the type of image that inspired Alfred Gilbert's *Fortitude* on the *Fawcett Memorial* in Westminster Abbey (1885–7) and *St George* on the *Clarence Tomb* (commissioned 1892), as well as many other figures of armoured knights created within the context of the New Sculpture. There are also close parallels in the work of contemporary painters like Frank Dicksee, Arthur Hacker, Frank Cadogan Cowper and G. W. Joy.

J.C.

George Frampton
(1860–1928)

Frampton began work in an architect's office, before being apprenticed to a firm of architectural stone-carvers. He trained at the Lambeth School of Art under W. S. Frith and entered the Royal Academy Schools in 1881. He studied in Paris with Antonin Mercié (1888) before returning to London in 1889. From 1891 he showed a unique and remarkable series of Ideal works – *St Christina* (shallow bronze relief, Liverpool) and *A Caprice* (mixed materials, statue) in 1891, *Mysteriarch* (tinted plaster bust) in 1893; *My Thoughts are My Children* (relief) in 1894. In these symbolist thinking and technical experimentation merge with a formal language relating to certain types of Italian Renaissance sculpture. His practice extended to architectural sculpture (Ingram Street, Glasgow, reliefs 1896–1900; Lloyds Registry and Electra House, London, reliefs 1899–1902) as well as memorials (Queen Victoria, from 1897 for Calcutta, Leeds, St Helen's, Southport, Winnipeg; Mitchell relief, Newcastle upon Tyne 1893; Howitt relief, Nottingham 1900–2). He also executed more straightforward portrait busts, reliefs and statues, especially after 1900, though continuing with Ideal works. He exhibited at the Royal Academy from 1884, at the Arts and Crafts Exhibition Society from 1893 and in Brussels, Vienna and Munich. He taught sculpture at the Slade and was joint head (with W. R. Lethaby) of the Central School of Arts and Crafts. He was a member of the Art Workers' Guild, becoming Master in 1902, Royal Academician, founder-member and President of the Royal Society of British Sculptors. He was knighted in 1908.

B.R.

9 Alis La Beale Pilgrim, *c.*1896

Bronze, 25 × 18cm (9¾ × 7in)
Signed: G.F.
Inscr: ALIS LA/BEALE/PILGRIM

JOANNA BARNES FINE ARTS, LONDON

Alis La Beale Pilgrim is one of a series of nine reliefs representing heroines from the *Morte d'Arthur* designed by Frampton in about 1896. The series was commissioned as silver-gilt panels for the door of the Great Hall at Astor House, 2 Temple Place, London, which was built in 1895 to the designs of J. L. Pearson as a residence and estate office for William Waldorf Astor (now the head office of Smith & Nephew; the panels are still *in situ*).

Frampton exhibited the plaster models of seven of the designs at the Royal Academy in 1896 (no.1839); the other subjects included the *Lady of the Isle of Avelyon, The Lady of the Lake, Lyonors, Enid* and *La Beale Isoule* (Beattie, pp.89, 257, n.61).

The series was one of Frampton's earliest commissions for decorative relief sculpture, an area in which he was later to achieve wide recognition. Another bronze version of *Alis La Beale Pilgrim* is in the Birmingham Museums and Art Gallery; this was formerly in the Handley-Read collection and is a slightly larger cast.

M.G.

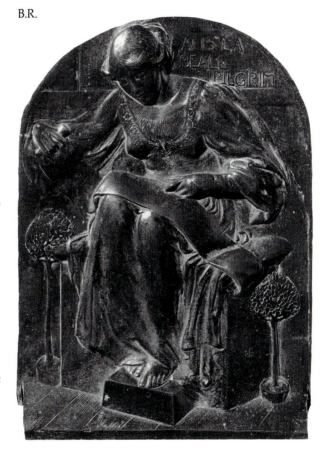

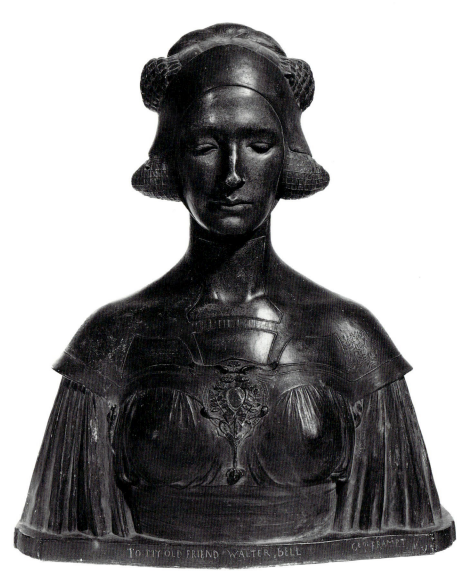

10 Lamia, *c.* 1899

Painted plaster, H 63cm (24¾in)
Signed: Geo Frampton
Inscr: TO MY OLD FRIEND-WALTER BELL

Lit: RA 1972 (no.F15); Beattie, pp.106, 160–2; Birmingham 1987 (no.112); Read 1989, p.145

BIRMINGHAM CITY MUSEUMS AND ART GALLERY

Frampton first developed the female quarter-length figure in works of the late 1880s and early 1890s, notably *Christabel* (1889) and *Mysteriarch* (1892; Walker Art Gallery, Liverpool). *Lamia* was probably modelled in 1899 and, like the *Mysteriarch*, employs intricate plaster working and rich surface patination to create a delicate, jewel-like appearance. Frampton exhibited the multi-media version of *Lamia* at the Royal Academy in 1900 (no.1970), a bust in bronze, ivory and opals (London, Royal Academy of Arts). The use of mixed materials and the decorative approach to sculptural modelling, to be seen in the latter bust, owes much to contemporary French sculpture, notably the work of J. L. Gérome and Antonin Mercié (with whom Frampton trained in Paris). The formal source for the work though is to be found in Italian Renaissance bronzes, particularly the work of Donatello and sculptors such as Francesco Laurana and Antonio Rossellino.

Keats was a favourite source for Pre-Raphaelite artists though Frampton has chosen to portray an unusual subject, the snake-enchantress of Keats's poem *Lamia*, in part 'palpitating snake . . . of dazzling hue, vermillion spotted, golden, green and blue . . . at once some penanced lady elf / some demon's mistress, or the demon's self . . . Her head . . . serpent, but ah bitter-sweet! / She had a woman's mouth with all its pearls complete'. Susan Beattie has described *Lamia* as a 'threatening, highly charged' image. The present model was given to Walter Bell who was the brother of Robert Anning Bell, with whom Frampton collaborated in the 1890s; it later passed into the Handley-Read collection.

M.G.

11 Enid the Fair, 1907

Bronze, H 51cm (20in)
Signed: GEO FRAMPTON 1907, with seal, LOVE AND LABOVR
Inscr: 'ENID/THE FAIR'

Lit: Beattie, p.232, 243–4

MATTHIESEN FINE ART LTD, LONDON

After 1900 Frampton produced a number of idealised bronze heads depicting heroines from Arthurian and medieval legend. They included *The Lady of the Isle of Avelyon* (RA 1902); *Lyonors* (RA 1902, version in City Museum and Art Gallery, Stoke-on-Trent); and *The Madonna of the Peach Tree*, from a modern short story by Maurice Hewlett set in medieval Verona (RA 1910; version in Bradford Art Galleries and Museums). *Enid the Fair* was exhibited in bronze at the 1908 Royal Academy (no.1930).

The subject of Enid was first treated by Frampton in his series of reliefs for Astor House (see cat.9) and Frampton's interest in Arthurian subjects continued in the latter part of his career (Enid was also the subject of one of Tennyson's 'Idylls of the King', from Arthurian romance). The contemplative mood of his early Ideal busts such as the *Mysteriarch* and *Lamia* (cat.10) is retained in his later bronzes though works such as *Enid* are more decorative than the early busts, as seen in the detailing of the head garment and plaited hair of the bust.

Another bronze version is in the collection of the Aberdeen Art Gallery.

M.G.

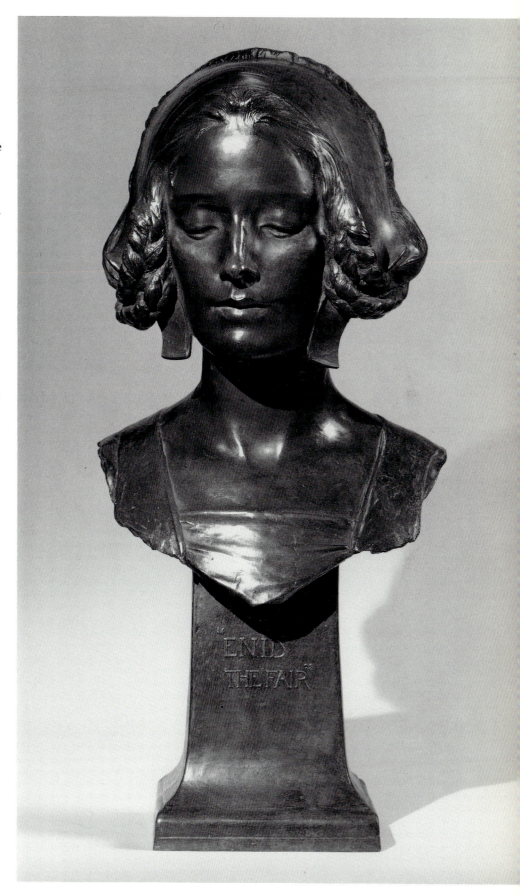

Alfred Gilbert
(1854–1934)

Gilbert intended to become a surgeon, but after failing his entrance examination he entered the Royal Academy Schools in 1873 and became assistant to J. E. Boehm on whose advice he went to Paris to study at the Ecole des Beaux-Arts (1875–8). In Italy from 1878–1884, he there learned the lost-wax technique of casting bronze. Using this he sent back to London *Perseus Arming* in 1882, the first of a series of major works that singled out Gilbert as the leader of his generation in sculpture. There followed *Icarus* (1884), *An Offering to Hymen* (1886) and other Ideal works, plus public memorials to Henry Fawcett (1885–7 Westminster Abbey) and Queen Victoria (Winchester 1887), which all have a technical mastery of materials as well as layers of symbolism both overt and personal. In 1888 Gilbert became a member of the Art Workers' Guild.

In 1892 Gilbert was elected a Royal Academician and was made Professor of Sculpture in 1900. The 1890s saw no let-up in his work: in addition to portrait busts and public statues (*Joule*, Manchester 1890–4; *Howard*, Bedford 1894) Gilbert finished his Shaftesbury Memorial alias *Eros* (Piccadilly Circus, London 1886–93) and started the *Clarence Memorial* (Windsor 1892–9). Problems with the latter led to Gilbert's bankruptcy in 1901 and exile in Bruges two years later. He returned in 1926 to complete the *Clarence Memorial* and execute his swan-song, the *Queen Alexandra Memorial* (Marlborough Gate, London 1928–32). He was knighted in 1932.

B.R.

12 Perseus Arming, *c*.1881–2

Bronze, H 61cm (24in)

THE FINE ART SOCIETY, LONDON

Gilbert modelled *Perseus Arming* in Rome during the winter of 1880, inspired by Benvenuto Cellini's *Perseus and Medusa* which he had seen on a visit to Florence. It is Gilbert's first bronze statue and the first in his series of autobiographical bronzes, which includes *Icarus* and *Comedy and Tragedy*; in *Perseus Arming* Gilbert refers to his need to master his artistic skills: 'As at that time my whole thoughts were of my artistic equipment for the future, I conceived the idea that Perseus before becoming a hero was a mere mortal and that he had to look to his equipment.' (Dorment, p.38). Gilbert was living in difficult circumstances in Rome and could not afford to have his model cast in bronze, until commissioned to do so by Sir Henry Doulton when he visited his studio early in 1881. This commission led to another from Doulton's travelling companion James Anderson Rose and was a significant turning-point in Gilbert's career. The statue was cast by the lost-wax method, in 29-inch casts, probably at the foundry of Sabatino de Angelis in Naples. In 1882 Gilbert exhibited it at the Grosvenor Gallery and a year later at the Paris Salon. It received immediate critical acclaim at both exhibitions, establishing Gilbert's reputation at home and abroad. Perseus' pose is derived from *The Kiss of Victory* on which Gilbert was working at the same time. This rare large cast was owned by the enameller William Soper.

A.K.

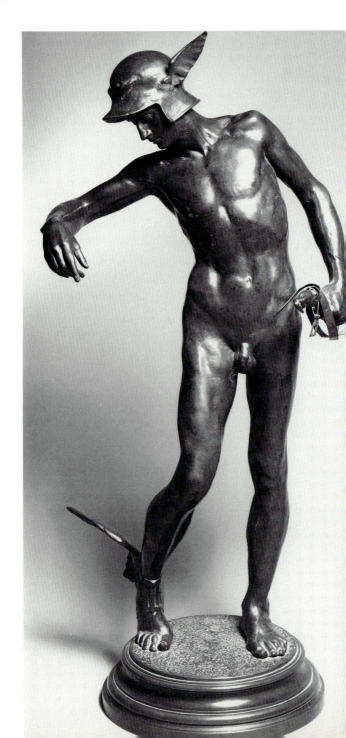

13 St George, 1898–9

Aluminium, H 45.7cm (18in)
Founder: Compagnie des Bronzes, Brussels

Exh. and Lit: RA 1986 (no.71; see cat. for lit. and other exh.)

The first statuette of *St George*, which Gilbert cast in 1895
in white metal with ivory details was a private memorial for
Sandringham. A further cast in aluminium and ivory was put
on the Tomb of the Duke of Clarence in 1898. The present
statuette is one of two, which Gilbert cast entirely in
aluminium. It was in the collections of Sir William Agnew
and then Charles Handley-Read, before being purchased by
the Cecil Higgins Art Gallery.

The armour of *St George*, which was designed in pattern
sections for casting (see RA 1986, no.68), has obvious debts
of inspiration to the designs of Burne-Jones (cats 7 & 8). The
St George is also a continuation of Burne-Jones's taste for
Arthurian and chivalric themes. One source for Gilbert's
armour was Burne-Jones's costumes for Henry Irving's 1895
production of J. W. Comyns Carr's *King Arthur* and Gilbert
maintained that if made to scale, *St George*'s armour could
be worn (RA 1986, p.162).

J.B.

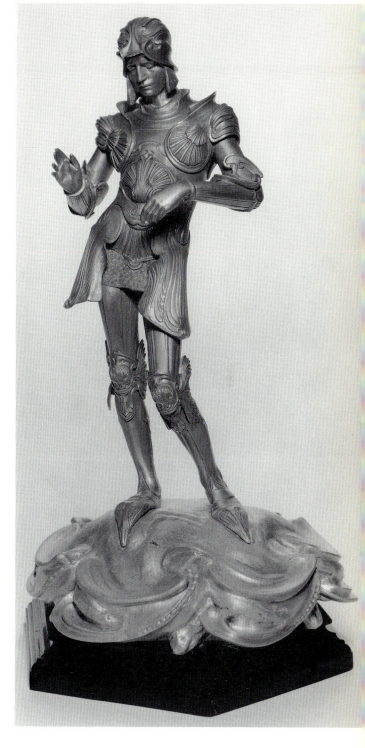

John Hancock
(1825–1869)

Born in Fulham, London, his father and uncles were involved with the manufacture of rubber. After the death of his father in 1835 he was brought up by his uncle Thomas at Marlborough Cottage, Stoke Newington. He was largely self taught as a sculptor though he attended the Royal Academy Schools for a short time in 1842. In the mid-1840s Hancock became friendly with D. G. Rossetti and Thomas Woolner: he worked in a studio next to Woolner's and Rossetti was an occasional visitor to Marlborough Cottage. In 1848 Hancock was a member of the Cyclographic Society, which included Rossetti, Millais, Holman Hunt and Alexander Munro among its contributors. He was involved with setting up *The Germ* in 1849–50, but soon afterwards withdrew his financial support.

His first public success was the bas-relief *Christ's Journey to Jerusalem*, which won the Art Union of London's premium in 1849. He exhibited his statue of *Beatrice* at the 1851 Great Exhibition and was made a commissioner for sculpture at the Exhibition. He also showed works at the 1855 Paris Exposition Universelle and the 1862 London International Exhibition and was a contributor to Royal Academy exhibitions from 1843–64.

Hancock's most important commissions were the statue of the *Penserosa* for the Mansion House, London (1862) and the series of bas-reliefs for the former National Provincial Bank in Bishopsgate, London (1864–65). His only known church monument is that to Edward Colston at St James the Great, Devizes (c.1859).

Hancock's last few years remain a mystery: no works are known from this period and he died in penury. In his career he designed many Ideal works though few portraits, an unusual combination for a nineteenth-century sculptor. Relatively little of his total output survives and it is unlikely that many of his works were produced beyond the plaster stage, though a few of his designs were reproduced as engravings and in parian ware.

M.G.

14 Christ's Journey to Jerusalem, 1849

Engraving, 21.5 × 61cm (8½ × 24in)
Signed: J.H./1849

Lit: *Art Union Reports* 1850, p.5, 1851, pp.5–6; *Art Journal* 1849, pp.115, 176, 272; *The Athenaeum* 1849, pp.281, 843; Fredeman, pp.3, 123

PRIVATE COLLECTION

Hancock's design *Christ's Journey to Jerusalem* (or *The Entry into Jerusalem*) won the £100 premium of the Art Union of London in 1849, offered in the previous year for 'the best design in basso relievo', from which an engraving would be made to be issued to all subscribers (*Report* 1850). Twenty-five plaster casts were sent in to the competition, of which Hancock's was adjudicated the winner.

The *Art Journal* described the successful work as 'simple in conception' though 'full of movement . . . The Saviour occupies the centre of the composition, being preceded by a crowd of people, and followed by his disciples'. It thought though that the representation of one or two figures in alto-relief almost excluded the work from the terms of the competition.

The plaster relief was shown at the Annual Exhibition of Prizes of the Art Union of London held in the Rooms of the Society of British Artists in August 1849 and also at the Royal Academy of that year (no.1207). As promised, engravings of the design were delivered to the subscribers in 1850 (*Report* 1851) and at the same time it was decided to reproduce one of the other competing bas-reliefs, Armstead's *The Death of Boadicea*, in bronze editions by the electrotype process and to produce Hancock's design in the same medium 'in some future year'. It is not known if Hancock's work was ever made in bronze though the sculptor did prepare for the Council a companion bas-relief, *Christ led to Crucifixion* (cat.15).

Christ's Journey to Jerusalem was designed around the time the PRB was formed in September 1848. In the second entry in the *P.R.B. Journal* of 16 May 1849 Hancock was recorded as having come into Woolner's studio and requested whether he might put 'PRB to his works' (Fredeman, p.3). The relief was to appear at the Academy in the following month and it is tempting to conjecture that Hancock might have put the initials to this work had he been given the go-ahead.

The relief has certain features in common with Pre-Raphaelite work: a 'serious' subject (representing Christ, the PRB's chief 'Immortal'), the pictorial detailing and the placing of the disciples as a series of receding profiles is similar to pictures by D. G. Rossetti and Millais (for example Millais' drawing of *Lorenzo and Isabella*, 1848) and, like those works, the figures were probably drawn from friends of the artist. As a sculptural composition too the work is unusual in its rejection of conventional low-relief modelling and simple outline composition.

Christ's Journey to Jerusalem was described by W. M. Rossetti as one of Hancock's most successful works and it (or its companion) appears in Gabriel Rossetti's satirical poem 'St Wagnes' Eve' (1851; 'And Hancock, hard on twelve, / Showed an engraving of his bas-relief') (Fredeman, p.123).

M.G.

15 Christ Led to Crucifixion, 1853

Engraving, 22 × 63cm (8¾ × 24¾in)
Signed: JOHN HANCOCK/1853

Lit: *Art Union Reports* 1851, p.6, 1853, p.5, 1854, p.6

PRIVATE COLLECTION

Christ Led to Crucifixion was made as a plaster bas-relief for the Art Union of London, the companion work to *Christ's Journey to Jerusalem* (cat.14; *Reports* 1851–3). It was subsequently issued as an engraving to subscribers of the Art Union, probably in 1853, and the relief itself was exhibited at the Royal Academy in 1853 (no.1456).

Christ Led to Crucifixion is less detailed than its companion, though the lively characterisation of the figures and the pictorial effect of the composition are retained. As appropriate to a companion piece the figures face in the opposite direction to its pair (suitable for their being hung together on a wall).

The present work is labelled on the back 'engraved by the anaglyptograph from the original bas-relief by John Hancock'. The anaglyptograph was a mechanical device used to translate contours on a bas-relief into two dimensions, the lines of the engraving (sometimes known as a 'ruled engraving') corresponding to the modulations of the relief. The earlier engraving appears also to have been produced in this way although there is no similar inscription.

M.G.

16 Beatrice, c.1851
colour plate 2

Painted plaster, H 183cm (72⅛in)
Signed: JOHN HANC[OCK] S[C] LONDON
Inscr: GUARDAMI BEN BEN SON BEN SON/BEATRICE

Exh: 1851 Great Exhibition (no.25)
Lit: Weekes, p.101; Parris, p.100

THE TRUSTEES OF THE VICTORIA AND ALBERT MUSEUM,
LONDON

'Last All-Saints holiday even now gone by,/I met a gathering of damozels;/She that came first, as one doth who excels,/Had love with her bearing her company:/A flame burned forward through her steadfast eye,/Most like the spirit in living fire that dwells . . .'

Beatrice was first shown at the Royal Academy in 1850 (no.1303) and exhibited in the following year at the Great Exhibition (the present work). A bronze statuette was shown at the Royal Academy in 1854 (no.1416) and a marble bust at the Royal Academy in 1862 (no.1054). The present work is the only known version although a marble statue is said to have been made for Baroness Burdett Coutts (unlocated; Gunnis, p.180).

The statue was exhibited with the above passage from a sonnet entitled *Of Beatrice de'Portinari, on All Saints' Day,* written to accompany *La Vita Nuova* which describes Dante's early encounter with Beatrice as she walks by the Arno in Florence with a 'gathering of damozels'. The inspiration of D. G. Rossetti must have been important to Hancock's choice of subject: Hancock had become friendly with Rossetti in 1847 and Rossetti completed his translation of *La Vita Nuova* in 1848 and made his first drawings of Dante and Beatrice in the late 1840s. Earlier treatments of Dante subjects in British sculpture are rare; among the few known are a group of *Count Ugolino and his sons* by John Gallagher (RA 1835) and Munro's contemporary group of *Paolo and Francesca* (cat.21). Some of the details of the *Beatrice* – the pointed slippers and the floral garland – appear in Rossetti's drawings as well as in sculpture by Munro (cat.21) though, ultimately, *Beatrice* is an independent creation modelled with skill and sensitivity (particularly the drapery and the small, clasped hands of the figure); the 'poetic' subject and conception were to be important features of Hancock's Ideal work (see cat.18). The sculptor Henry Weekes, who saw the work at the 1851 Great Exhibition, wrote: 'Will he [the visitor] not stop before the beautiful spiritualised figure of Beatrice . . . and become for a moment absorbed in expression as is the plaster itself?' (Weekes, p.101).

The present model seems to have returned to the sculptor after the 1851 Exhibition as it is visible in an old photograph of Hancock's studio (fig.42).

M.G.

17 Undine, *c.*1855

Parian ware, H 43cm (17in)
Signed: John Hancock/Sculptor
Inscr: UNDINE

Lit: Atterbury, fig.843

JOANNA BARNES FINE ARTS, LONDON

A statuette representing the water sprite in Friedrich de la
Motte Fouqué's fairy romance *Undine* (1811). In the story
Undine is brought up by a poor fisherman and falls in love
with the knight Huldebrand, who later deserts her. Undine
returns to the water but one day she sees Huldebrand and
accidently drowns him in her embrace. Hancock's *Undine*
was exhibited at the Royal Academy in 1851 (no.1263). The
figure represents her seated on Huldebrand's tomb,
lamenting his loss.

The work shown at the Royal Academy was almost
certainly the full-length plaster version which can be seen
in an old photograph of the sculptor's studio (fig.42). Parian
ware models were produced soon after the work was
exhibited, probably *c.*1855, though the manufacturer of the
present model is not known. Hancock exhibited a marble
medallion of the subject at the Royal Academy in 1853
(no.1459).

M.G.

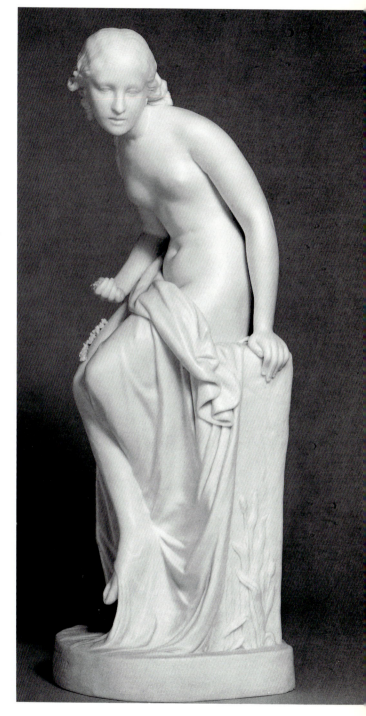

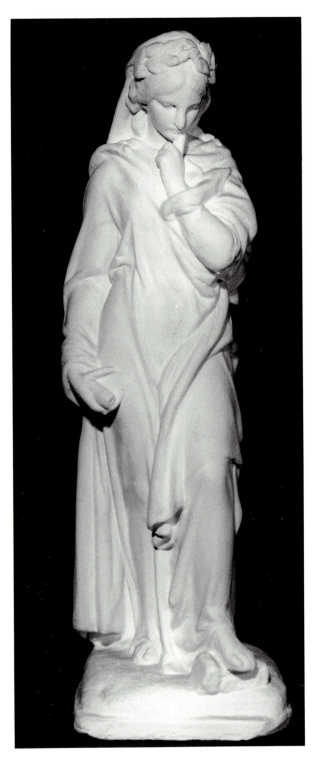

18 Penserosa, *c.1861*

Plaster, H 68.5cm (27in)

Lit: *Art Journal* 1861, p.127, 1864, p.168; *Sculptors' Journal*, Feb. 1863, pp.37–8; V.Knight, p.339; Read 1982, p.206

GUILDHALL ART GALLERY, CORPORATION OF LONDON

Between 1856 and 1861 the Corporation of London commissioned from fourteen British sculptors a series of marble statues for display in the Egyptian Hall of the Mansion House, London. The subjects were to be from British history and literature (taking up the theme of the 1844–47 Westminster Hall competitions to choose sculpture for the decoration of the new Houses of Parliament).

In preparation for the commissions sculptors were required to submit plaster models to the committee representing the Corporation and the present work is Hancock's model which was submitted in 1861. By the middle of the following year Hancock had completed his full-length marble statue of *Penserosa* and it was installed in the Egyptian Hall in January 1863 (*Sculptors' Journal*, Feb. 1863). The marble statue was exhibited at the Royal Academy in 1862 (no.1053) and another version shown at the Royal Academy in 1864 (no.899).

Hancock had produced the *Penserosa* a few years earlier, as a plaster bust. This had been purchased in 1857 by Prince Albert and given to Queen Victoria as a Christmas present in that year (1857; Royal Collection, Osborne House). Hancock also exhibited a 'bust in terracotta' at the Royal Academy in 1858 (no.1209) while a bust is recorded as having been at one time in the Hancock family collection (see p.74).

The *Art Journal* described *Penserosa* as a work of 'the school that seeks to cast poetry into plaster or aspires to carve beauty in marble' (*Art Journal* 1864, p.168) and Milton's poem *Il Penseroso*, which celebrates the virtues of the contemplative life, was the perfect vehicle for a work of 'poetic' sculpture (as well as being an English source as required by the Council of the Corporation). Along with the *Beatrice* (cat.16) it is Hancock's most important surviving Ideal work.

All the plaster maquettes which were submitted for the commission remain in the collection of the Corporation of London.

M.G.

Alphonse Legros
(1837–1911)

Born in Dijon, Legros attended the Ecole des Beaux-Arts there, before going to Paris to study at the Petit'Ecole under Lecoq de Boisbaudran. He first exhibited at the Salon of 1857 and following this, joined a group of painters called the 'Realists'. In 1863, encouraged by James Abbott McNeil Whistler, Legros went to England, where he was befriended by D. G. Rossetti and G. F. Watts. The following year he exhibited for the first time at the Royal Academy and continued to exhibit there regularly until 1874. He taught etching with great success at the South Kensington School of Art which led to his appointment as Slade Professor of Art at University College, London from 1876 until 1892. In 1877 he introduced the French sculptor Aimé-Jules Dalou to the South Kensington School of Art to give demonstrations in clay modelling. Legros had always been interested in sculpture and, influenced by the work of Alfred Stevens, in the early 1880s began to produce sculpture himself. The range of his work was wide and included many historic and contemporary portraits, medals, drawings and etchings.

J.B.

19 Thomas Woolner, 1874

Oil on canvas, 86 × 59cm (33$\frac{7}{8}$ × 23$\frac{1}{4}$in)
Inscr. top left: T.WOOLNER/sculptor

Exh: SFA 1874 (no.66)
Lit: *Art Journal* 1874, p.58

IPSWICH BOROUGH MUSEUMS AND GALLERIES

Enjoying the fruits of his success, in 1874 Woolner had his portrait painted by Alphonse Legros. The portrait is first referred to in Woolner's diary entry for 3 October that year, when he recorded, 'wrote to A. Legros – portrait of self'. Several sittings are subsequently noted and finally a payment of £50 was made to Legros on 12 November. The painting was completed just before Woolner left with his Greek friend Stavros Dilberoglue for a European tour. Woolner wrote proudly to Henry Arthur Bright (the merchant and author): 'I am drawing all my affairs together to try and be off in a week or fortnight . . . Legros is just finishing an excellent portrait of me which you will see when you come to town' (MPL MS).

The painting was exhibited at the end of the year by the Society of French Artists and the *Art Journal* commented: 'Among the notable pictures here are three by Legros, of which perhaps the finest is a portrait of Mr Woolner R.A. The artist has a firm grasp of the solid facts of character.'

The portrait was purchased by the Ipswich Borough Museums from Woolner's daughter, Amy. A pencil sketch by Legros for the portrait is also recorded.

J.B.

John Everett Millais
(1829–1896)

Born in Southampton to a prosperous family from Jersey, in 1838 Millais went to London where he attended Sass's drawing school. He entered the Royal Academy in 1840, as its youngest ever student, and won various medals, including a gold one in 1847 for his painting of *The Tribe of Benjamin Seizing the Daughters of Shiloh*. At the Royal Academy Millais became friendly with Holman Hunt and, with the latter and D. G. Rossetti, contributed to the Cyclographic Society, and helped form the Pre-Raphaelite Brotherhood in the autumn of 1848. His first Pre-Raphaelite painting *Isabella* was praised at the Royal Academy in 1849, but the following year his *Christ in the Carpenter's Shop* received hostile reviews. In 1853 he was elected ARA and around this time fell in love with Effie Ruskin, whom he married following the annulment of her marriage to John Ruskin. The couple went to live in Perth, Scotland where Millais painted a series of non-narrative works on the theme of mortality, exemplified in *Autumn Leaves*. These did not prove to be sufficiently commercial and by 1860 he had reverted to more popular themes. In 1857 Millais took lodgings in London, and settled there in the early 1860s, although he returned to Scotland every year. From 1855–64 he made illustrations for numerous publications notably Moxon's Tennyson (1857), *Parables of Our Lord* and Trollope's novels. In the latter part of his life Millais enjoyed great wealth and from the early 1870s was active as a fashionable portrait painter. He was created a Baronet in 1885 and elected President of the Royal Academy in 1896.

J.B.

20 Alexander Munro, 1853

Pencil on paper, 36.5 × 28.3cm (14⅜ × 11⅛ in)
Signed: John Everett Millais/April 12th 1853

Exh: RA 1967 (no.289)
Lit: Millais, p.81; Hunt, vol.1, p.200; R. Ormond 1967, p.27, pl.4; A. Rose, p.72; Macdonald, p.190 (ill.)

WILLIAM MORRIS GALLERY, LONDON BOROUGH OF WALTHAM FOREST

On 12 April 1853 D. G. Rossetti organised a meeting with Holman Hunt, Stephens, W. M. Rossetti and Millais, in the latter's studio, to make portrait sketches of each other to send to the homesick Woolner in Australia. Arthur Hughes has left an account of how Munro came to be there and have his portrait drawn by Millais:

'While Woolner was in Australia his Pre-Raphaelite Brothers agreed to draw one another and send the drawings out to him; and one day, when two or three of them were about this at Millais' house, Alexander Munro, the sculptor, chanced to call. Millais, having finished his Pre-Raphaelite Brotherhood subject, got Munro to sit, and drew him and afterwards accompanied him to the door with the drawing in his hand, to which Munro was making some critical objection that Millais did not agree with. There happened to be passing at that time a couple of rough brick-layers fresh from their work – short pipes and all. To them Millais suddenly reached out from the doorstep and seized one, to his great surprise, and there and then constituted them judges to decide upon the merits of the likeness, while Munro, rather disconcerted, had to stand in the street with his hat off for identification. A most amusing scene.' (Millais, p.81).

This drawing of Munro, unlike Millais' of Stephens, or Holman Hunt's of Dante Gabriel Rossetti and Millais, is not inscribed with a dedication to Woolner, so it seems unlikely that Rossetti actually sent it to Australia with the others on 16 April 1853. The drawing was given to the Museum in 1935 by the artist, Sir Frank Brangwyn.

A.K.

Alexander Munro
(1825–1871)

Alexander Munro was born on 26 October 1825, the son of a dyer in Inverness. He was educated at the local Academy, where his headmaster discovered and fostered his talent for carving and encouraged his wider education. During his school years, he made his first attempts at portraiture and modelling in clay. One of his early patrons was Harriet, Duchess of Sutherland (née Howard), who was then rebuilding Dunrobin Castle with Charles Barry. In 1844, Barry found employment for Munro, working on the new Houses of Parliament under John Thomas. After an unsuccessful attempt to enter the Royal Academy Schools in 1846, E. H. Baily took him into his studio. In 1847, he was accepted at the Schools, where he met Gabriel Rossetti, Millais and other members of the Pre-Raphaelite circle. From 1852 to 1858 he shared his house and studio with Arthur Hughes. Over these years, both he and Woolner taught sculpture at the Working Men's College, thus coming into the orbit of F. D. Maurice and Ruskin. He first exhibited at the Royal Academy in 1849 and continued to do so until his death.

His work was deeply influenced by the Pre-Raphaelites. He developed a decorative style of his own, in busts and high- and low-relief medallion portraits, round or oval, and typically about 15 to 18 inches in diameter; also in portrait groups of children. His main work in historical portraiture is in the Oxford Museum: six statues of scientists (1856 on). The best known of his imaginative works, inspired by poetic subjects, are *Paolo and Francesca* (plaster cast 1851, Wallington; marble, 1852, Birmingham City Art Gallery), *Sabrina* (marble, 1860s, Ackland Museum, North Carolina) and *Undine* (various versions; marble, 1869, Cragside). He also made two fountains for London: *Boy with a Dolphin* (1861; now in Regents Park) and the *Fountain Nymph* (1865; Berkeley Square). His other public works include statues of Herbert Ingram (1862; Boston, Lincs.), James Watt (1868; Birmingham) and Queen Mary II (1868; Old Bailey).

He liked travelling and explored the North of England in the 1840s. In 1855, he went abroad to Paris with Rossetti and after this, on occasional 'rambles' to Normandy or Ireland. He visited Italy three times, in 1858, 1861 (on his honeymoon) and in 1863, with Hughes. From 1865, he fought a losing battle with cancer and spent the winter months in Cannes. He continued to work, mainly at portraits, there and, in the summer, in England and Scotland. He died on 1 January, 1871.

Many of his works are untraced; some exist only in derived or debased forms: copies in ceramics or terracotta. His sculpture is sometimes unsigned, sometimes signed with his name or with his monogram: ⋉⋈

K.M.

21 Paolo and Francesca, 1852

Marble, 66 × 67.5cm (26 × 26½in)
Signed: Alex. Munro. Sc. 1852
Inscr: 'Quel giorno più non vi leggemmo avante'

Exh: RA 1852 (no.1340)
Lit: *Spectator* 1852, p.593; Gere, pp.509–10; Tate Gallery 1984 (no.44); Birmingham 1987 (no.216)

BIRMINGHAM CITY MUSEUMS AND ART GALLERY

The scene is from Dante's *Inferno*, v, 122–3, in which Paolo and Francesca are reading of the love of Lancelot for Guinevere: '. . . Our eyes were drawn together, reading thus, / Full oft, and still our cheeks would charge and glow/ . . . Then he who nought may sever from me now / For ever, kissed my mouth all trembling –/ A pander was the book, and he that writ –/ Upon that day, we read no more therein' (the final line of this quotation is inscribed in Italian on the base of the statue).

Munro's group was first exhibited in plaster at the Great Exhibition of 1851 (no.41). This entered the collection of H. W. Acland and was given by him to the Trevelyans for Wallington Hall, Northumberland. It was commissioned in marble by W. E. Gladstone, MP. The marble was shown at the Royal Academy in 1852 and lent by Gladstone to the 1855 Paris Exposition Universelle (no.1158) and to the 1862 London International Exhibition.

The subject is closely related to a number of drawings and watercolours representing Paolo and Francesca by D. G. Rossetti (Surtees 1971, 75A–75E), of which two at least date to the late 1840s. One of the drawings (Surtees 1971, 75D) is particularly close to Munro's group, though it has not been established whether it preceded Munro's designs for the subject. It was not until 1855 that Rossetti produced a finished watercolour version of the subject, a tri-partite design, one of the sections of which shows Paolo and Francesca embracing (Tate Gallery, London). What is clear though is that both artists were working along the same

lines on a subject of common interest: Munro presented a plaster cast of his work to Rossetti around 1852–3 and four of the sketches of *Paolo and Francesca* by Rossetti were owned by Munro, one of which is inscribed: 'to his friend Alex. Munro' (Surtees 1971, 75A).

Munro's work conveys the 'lyrical sentiment, poetic overtones . . . jewelled and highly burnished detail' to be found in the work of Rossetti and other Pre-Raphaelite artists (Gere, p.509); The *Spectator* wrote of the 'passionate feeling' in the work, 'a burning tenderness in Paolo, a yielding sweetness in Francesca, worth any amount of those merely classical and respectable traditions with which we are so familiar' (similar passions are to be found in works such as Millais' *Lorenzo and Isabella*, 1849 and Holman Hunt's *The Hireling Shepherd*, 1851). The details too are characteristic: the medieval costumes, the pointed shoes and plumed hat, the flowing locks and Italianate features of Paolo.

The subject was treated by earlier artists: Flaxman's illustrations to Dante's *Divine Comedy* (1793) includes the engraving *The Lovers Surprised* showing Paolo and Francesca reading; the subject also appears in drawings and paintings by Ingres (1845), Delacroix (1824), Joseph Anton Koch (1807) and William Dyce (1834) and, in sculpture, by Félicie de Fauveau, in the *Monument to Dante* (1834). Munro himself executed a marble bust of Dante (1856; fig.30).

A small pencil sketch of *Paolo and Francesca*, probably contemporary to the sculpture and almost identical in design, exists (private collection) while a small variant plaster model of the group can be seen in a contemporary photograph of Munro's studio.

M.G.

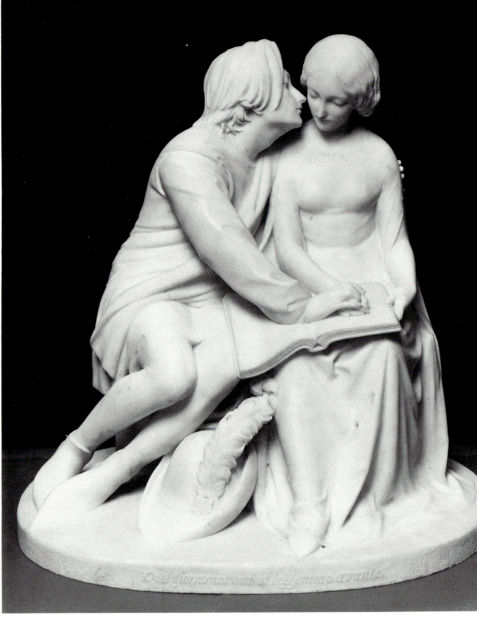

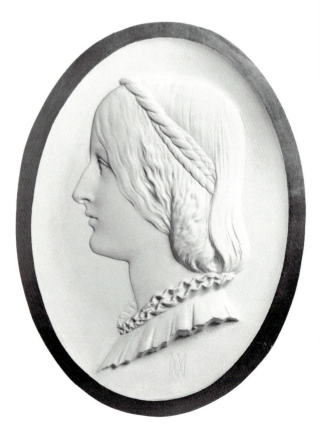

22 Lady Constance Grosvenor, 1852–3

Plaster with original gilt border, 62 × 40.5cm (24⅜ × 16in)
Signed: ALEX MUNRO.SC
Incised with monogram: ⋉

JOANNA BARNES FINE ARTS, LONDON

Lady Constance Gertrude Grosvenor, née Leveson-Gower (1834–1880) was the fifth daughter of George Granville, 2nd Duke of Sutherland, one of Munro's first patrons. In 1852 she married Hugh Lupus Grosvenor, 1st Duke of Westminster (1825–1899).

Munro exhibited a marble version of this relief at the Royal Academy of 1853 (no.1460) and it therefore seems probable that she sat for Munro at the time of her marriage. A Minton parian figure of Lady Grosvenor by Albert-Ernest Carrier-Belleuse of similar date reputedly represents Lady Constance in her wedding dress (see Atterbury, fig.111). The marble relief was formerly at the Sutherland home, Cliveden,

Berkshire, but its present whereabouts is unknown. This plaster relief was undoubtedly cast at the same time. Two further examples are known in a private collection and at Inverness Art Gallery; both are damaged. The posthumous uncatalogued exhibition of Munro's work at the Birmingham and Midland Institute in 1872 included an example of this relief, which belonged to W. C. Aitken, who was instrumental in organising the exhibition.

William Bell Scott remarked of Munro's portrait reliefs that they have 'an elegance and sweetness, united with high breeding, that made them much prized' (Scott 1872, p.134).

J.B.

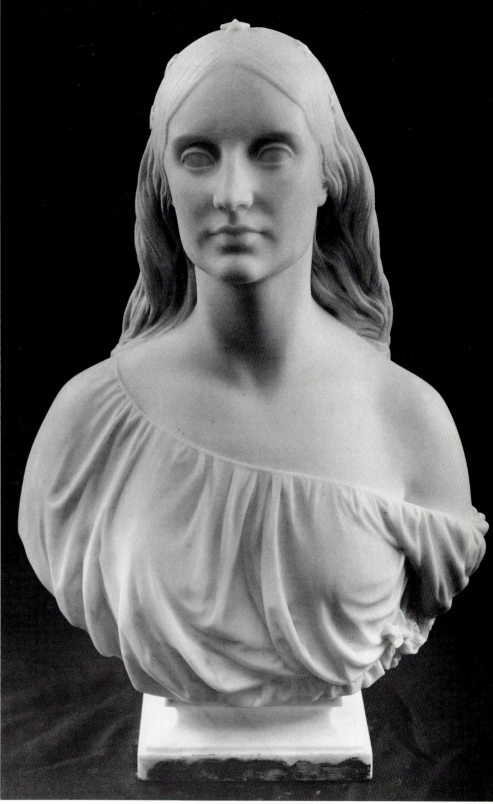

23 Josephine Butler, 1855

Marble, on rectangular socle, H 51 cm (20⅛ in)
Signed behind: ALEX MUNRO. SC.

Lit: Bennett 1988, p.166

THE MISTRESS AND FELLOWS, GIRTON COLLEGE, CAMBRIDGE

Josephine Elizabeth Butler, née Grey (1828–1906) married George Butler in 1852. She was a zealous social reformer and regarded her calling as a spiritual one. Influential in the repeal of the Contagious Diseases Acts, she vigorously attempted to suppress the white slave trade and prostitution. Her writings are prolific and include several

pamphlets, memoirs and the *Life of St Catherine of Siena*. Her husband, who held educational and ecclesiastical appointments, staunchly supported her.

This youthful portrait bust with its loose hair braided with a chaplet of stars was executed while the Butlers were living in Oxford. Munro first met the Butlers when he was working on the statues for the Oxford Museum, for which George Butler was a committee member. Josephine records that 'Munro worked in our house, not infrequently on the clay models of portrait busts he was engaged with' (Butler, p.113). There is also a plaster version of this bust in a private collection.

There are two further portraits of Josephine by Munro at the Walker Art Gallery, Liverpool: a plaster relief in profile with morning-glory entwined in her hair, probably of about the same date as the present bust (Bennett, no.9026) and a more mature and pensive bust executed slightly later, which was exhibited at the Royal Academy in 1861 (no.1072) (Bennett, no.8782; the date of execution is uncertain, but Woolner referred to it in a letter to Pauline Trevelyan, 10 February 1857. Trevelyan Papers).

This bust was presented to Girton College by the wife of the sitter's brother-in-law, Dr Henry Montagu Butler.

J.B.

24 Agnes Gladstone, *c.*1855

Plaster, 40 × 30cm (15¾ × 11¾in)
Monogram: ⋈

PRIVATE COLLECTION

Munro executed two different portrait medallions of W. E. Gladstone's daughter, Agnes (b.1842), one in high relief in a surround with eleven stars and this, more formal, low relief of her at the age of about twelve or thirteen. A copy of the high relief is known to have been in the collection of Dr Henry Acland, but is now untraced. Two versions of the low relief cast still exist.

The first work commissioned by W. E. Gladstone from Munro was the marble version of *Paolo and Francesca* (1852; cat.21). In 1855, Munro exhibited at the Royal Academy a marble bust of Gladstone himself and a high-relief medallion of his niece, Honora Glynne (nos 1481 & 1557). In the following year, he exhibited a high relief of Agnes with her baby brother Herbert (no.1352); he also made a small, free-standing marble of these two. The Gladstones owned copies of Munro's portraits of Millais, Josephine Butler and Sarah James and (after his death) the marble bust of the Duke of Newcastle.

Agnes grew up to be a beautiful woman, but did not marry until she was in her thirties. Before this, she attempted to take up nursing, but met with unexpected opposition from her mother. In 1873 she married Edward Charles Wickham, MA DD (1834–1910), who had just left his fellowship at New College, Oxford to become the headmaster of Wellington College. He was known as the editor of Horace and later became Dean of Lincoln (1894–1910). They had several children.

A.K.

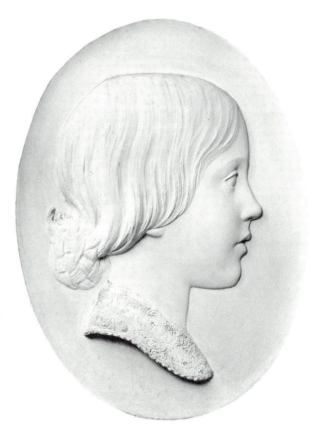

25 Hippocrates, *c.1855*

Plaster, H 59cm (23¼in)

The sculpture of the Oxford University Museum, and Munro's part in it, is discussed elsewhere (see p.58). Of the six statues he contributed, the first to be completed was *Hippocrates*, presented by J. Ruskin (senior). A model (for the final version in Caen stone) was shown at the Royal Academy in 1855. It may have been this cast, or one from the same mould, or a slightly different one illustrated in a studio photograph. The latter was possibly a larger version; it has a much thicker base, on which the sculptor has incised the first aphorism of Hippocrates:

ὁ βίος βραχύς ἡ δὲ τεχνη μακρή
(Life is short, the craft long)

Munro's thoughtful figure holds a scroll in his right hand, which is resting on a tripod decorated with the wingless caduceus of Asclepius.

Hippocrates of Cos (*c.460–357* BC) was certainly an historical figure and a physician of lasting renown, though surrounded by an accretion of myth. To get his likeness Munro presumably used the antique bust in the British Museum, which from the early 1800s till 1940 was thought to represent Hippocrates (GR1846). Dr Acland may also have had G. T. Dion's *Galerie Médicale*, Paris 1825, with its lithograph of Hippocrates' head. After 1860, when Munro had completed the six statues, he gave Acland 'sketches' (unspecified medium) of them all.

This plaster was passed by descent to Dr H. A. Munro and then given to the Ashmolean Museum in 1917.

K.M.

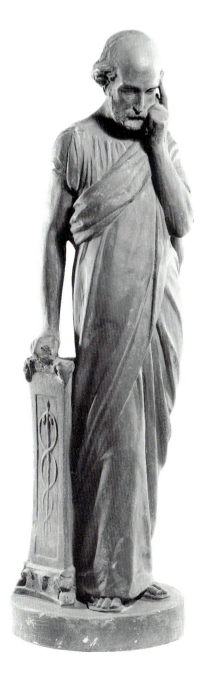

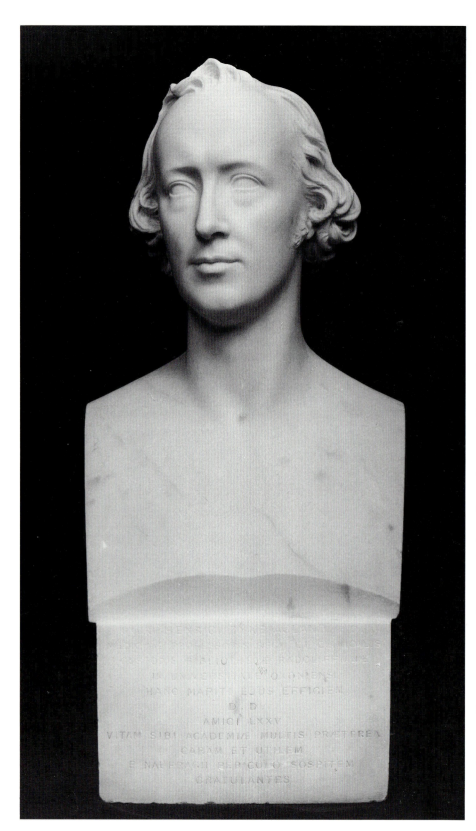

26 Henry Wentworth Acland, MD, FRS, 1857

Marble, 71.5cm (28⅛in)
Signed: ALEX. MUNRO. SC. 1857
Inscr. on integral socle:

UXORI HENRICI DYKE ACLAND M.D.
MEDICINÆ PROFESSORIS REGII ET CLINICALIS
CUSTODIS BIBLIOTHECÆ RADCLIFFIANÆ
IN UNIVERSITATE OXONIENSI
HANC MARITI EJUS EFFIGIEM
D.D.
AMICI LXXV
VITAM SIBI ACADEMIÆ MULTIS PRÆTEREA
CARAM ET UTILEM
E NAUFRAGII PERICULO SOSPITEM
GRATULANTES

Exh: RA 1857 (no.1280)
Lit: Parris, p.109

THE ACLAND NUFFIELD HOSPITAL, OXFORD

Acland (1815–1900), recording for his children the contents of his home in Broad Street, Oxford, describes 'a beautifully executed marble bust of myself . . . a present to your mother on the occasion of my being wrecked in the Channel close by St. Aldhelm's Head in the fine steam-ship "The Tyne"' (Acland Typescript). The bust was presented to Sarah Acland by Pauline Trevelyan on behalf of seventy-five Oxford friends in 1857. The shipwreck occurred on Acland's return from Madeira, where he had taken his old tutor, Dean Liddell, to convalesce. Acland's resourcefulness during the episode was much praised but accounts of the shipwreck vary in accuracy (J. Ruskin, *Praeterita*, Orpington 1885, 2nd ed., vol.1, p.380, contains a particularly imaginative account).

The year the bust was executed, Acland became Regius Professor of Medicine at the University of Oxford. Cultured, well-travelled, Acland is renowned for his encouragement of research, particularly in natural history. The conception of the Oxford Museum was due to him. Through Ruskin's involvement he became 'more intimate with several of the Pre-Raphaelites'; Acland owned several works by his 'dear friend' Alexander Munro and became the guardian of his children (Acland Typescript).

This bust passed through the family, until it was given by Sir William Acland, the sitter's grandson, to The Acland Hospital, formerly a nursing home founded in Sarah Acland's honour. The locations of two plaster versions, one at Hawarden and one at Wallington, reflect Acland's friendships with Gladstone and the Trevelyans. There is a further plaster bust at the Ashmolean Museum. A version with rounded truncation at the shoulders is illustrated in one of Munro's albums of photographs and a smaller plaster maquette is also known.

J.B.

27 Repose. Study of a Babe, 1857

Plaster, Diam 37.5cm (14¾in)

Lit: *ILN*, 28 June 1856, p.717; *National Magazine*, London,
Nov. 1856, p.41 (repr.); Birmingham 1987 (no.215)

BIRMINGHAM CITY MUSEUMS AND ART GALLERY

The themes of children asleep and innocence recur
frequently in Munro's œuvre and it is a subject he treated
with particular sensitivity.

In 1856 Munro exhibited the marble relief of a child sleeping
among hyacinths entitled, *Repose; Study of a Baby* (untraced)
at the Royal Academy (no.1374). The critic from *The
Illustrated London News* (28 June 1856, p.717) commented
'. . . a very beautiful study he has made of infancy and
innocence. The group is better than the poetry by which Mr
Munro has sought to illustrate it:

"But, O my babe, thy lids are laid
Close fast upon thy cheek!
And not a dream of power and sheen
Can make a passage up between."'

The marble relief was also illustrated by an engraving in the
November issue of the *National Magazine*.

Munro later cast replicas of this alto-relievo. The present
roundel was made for W. C. Aitken and a similar one for
the Trevelyans. Munro had completed the Wallington
plaster by 27 February 1857 when he wrote to Pauline
Trevelyan: 'I sent away yesterday your cast of the sleeping
babe wh[ich] I hope may reach you safely . . .' (Trevelyan
Papers).

J.B.

28 William Bingham, Lord Ashburton, 1860

Marble, H 71cm (28in)
Signed: ALEX MUNRO SC/1860

Exh: RA 1860 (no.1081)
Lit: Surtees 1984, pp.102, 110

THE MARQUESS OF NORTHAMPTON D.L.

William Bingham, 2nd Baron Ashburton (1799–1864)
succeeded to the peerage in 1848. His first wife Lady Harriet
Mary Montagu was a great society hostess and close friend
of Thomas Carlyle. A year after her death in 1857, Lord
Ashburton married Louisa Caroline Stewart-Mackenzie; by
this time he was in poor health, suffering considerably from
gout. Their daughter, Mary Florence, married Lord William
Compton, 5th Marquess of Northampton.

Louisa Ashburton drew her husband into her artistic circles
and the commission for this bust the year after their
marriage was probably inspired by Munro's marble

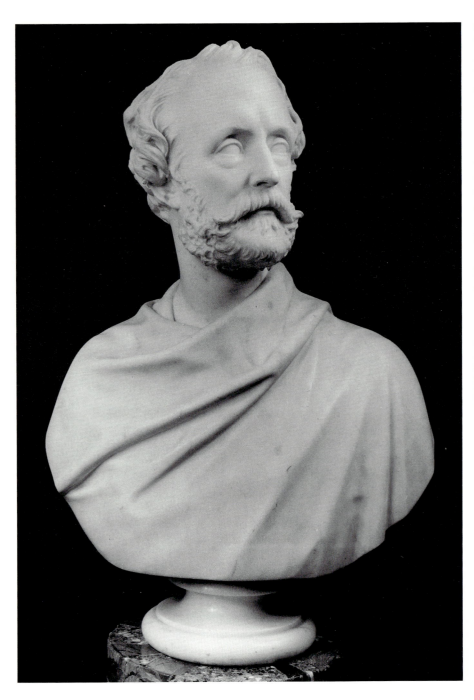

medallion of her close friend, Pauline Trevelyan, which they had seen at Wallington. The bust was exhibited at the Royal Academy in 1860 at which Munro's marble medallion of Louisa's sister-in-law, *Mrs George Stewart-Mackenzie* (no.1016, untraced) was also shown. The following year he exhibited a marble portrait bust of Louisa's mother *The Hon. Mrs Stewart-Mackenzie of Seaforth* (no.1036, untraced).

This all'antica bust belies the criticism that Munro was better able to portray women than men. It is a sensitive, naturalistic, portrayal of Lord Ashburton, very different from Woolner's staid and sober posthumous rendition (cat.74). Jane Carlyle thought Munro's bust 'quite contemptible' in comparison (Surtees, p.102), she was, however, biased towards Woolner's outgoing personality and charm. Certainly Lady Ashburton thought highly of the bust and refused to part with it after Lord Ashburton's death, when requested to do so by his sister, Emily Baring.

J.B.

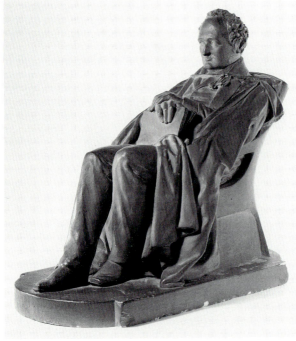

29 Henry Hallam, *c.*1860

Plaster tinted, H 38cm (15in)
Lit: Poole, vol.III, p.99 (no.268)

THE GOVERNING BODY OF CHRIST CHURCH, OXFORD

Henry Hallam (1777–1859) was an historian of medieval and constitutional history. He published only three major works, but his balanced, well-researched writings were widely influential.

Hallam was a reserved man, but highly respected by his contemporaries and plans to commission a monument to him began soon after his death in 1859. In June 1860 Woolner was considering the possibility of commissions for statues of Thomas Macaulay and Hallam, but thought that Baron Marochetti had more friends on both committees

responsible for these statues (A. Woolner, p.195). In the event the statue of Hallam in the crypt of St Paul's Cathedral, London, was executed by William Theed; Woolner, however, did make the statue of Macaulay for Trinity College, Cambridge in 1866.

The model exhibited is the only known version of two models made by Munro for a statue of Hallam, one standing and one sitting, presumably for the commission won by Theed which shows Hallam standing. Various casts seem to have been taken and both models were exhibited at the Birmingham and Midland Institute in 1872 (*Birmingham Post*, 10 Jan. 1872).

A.K.

30 Lovers' Walk, *c.1860*

Parian ware, H 36cm (14⅛in)

Lit: Read 1982, p.209; Parris, p.100, pl.42; Atterbury, fig.875

JOANNA BARNES FINE ARTS, LONDON

'Sweet shall fall the whisper'd tale—
Soft the double shadow'

Lovers' Walk was exhibited as a plaster sketch at the Royal Academy in 1855 (no.1452) and in marble at the Royal Academy in 1858 (no.1213), with the above lines from one of Allingham's songs. Though neither of these works have been located the design is known from contemporary photographs of Munro's studio which show versions in marble and in plaster. In both of these the couple are represented in medieval dress though in the former the youth wears a coat of mail and is hatless while in the plaster version he has a troubadour's hat and wears a pleated tunic, as in the parian version (although it is not identical to the parian model). A similar group shows the couple in modern dress, a version usually known as *Another Reading*.

The conception of the group and its companion piece can be compared with the series of paintings of lovers produced in the mid-1850s by Millais (*The Proscribed Royalist*, 1852–3; *The Huguenot*, 1851–2) and Arthur Hughes (*April Love*, 1855; *The Tryst*, 1860). William Allingham, the author of the lines which accompanied the exhibited version, was a poet and close associate of the Pre-Raphaelites.

The parian ware editions were made soon after the marble group appeared at the Royal Academy in 1858; they remain the only known sculptural representation of the design.

M.G.

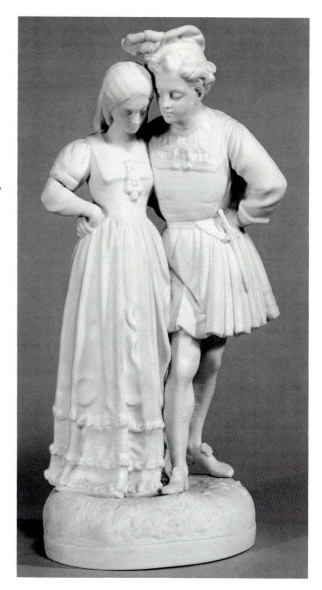

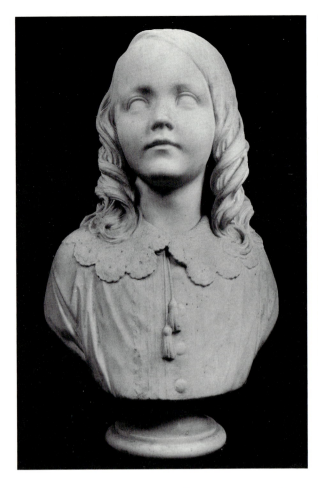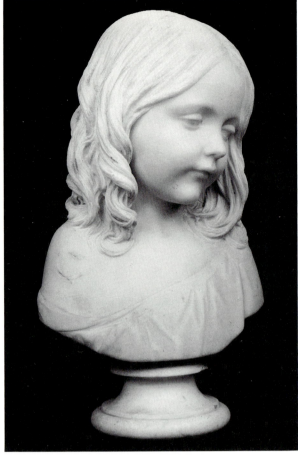

31 Kenneth James Matheson 2nd Baronet of Lochalsh, 1860

Marble, H 50cm (19¾in)

PRIVATE COLLECTION

32 Mary Isabella Matheson, 1860

Marble, H 47cm (18½in)

PRIVATE COLLECTION

Kenneth Matheson (1854–1920) was the eldest son of Alexander Matheson, who returned from a successful business career in China to become a leading Scottish landowner and MP for Inverness Burghs; in 1882 he became 1st Baronet of Lochalsh. Kenneth and Mary (1855–1933) were his children by his second wife, Lavinia Mary Stapleton, who died tragically by drowning in Loch Duich on her way to church in 1855. They were brought up by their great-aunt, Johan(na) Matheson until their father remarried in 1860.

Munro shows the six-year-old Kenneth in contemporary costume with a confident expression, while Mary is shown in a more sentimental manner. Munro also executed a group of the two children, entitled the *Sound of the Shell* (exhibited at the Royal Academy in 1861 (no.993) and illustrated in *The Illustrated London News*, 15 June 1861, p.546). The group, now lost, showed Kenneth and Mary at play on the seashore, Mary holding a shell to her ear, while Kenneth looks up at her affectionately. Munro's work for the Matheson family continued with a marble statue of Alex Matheson's son by his second marriage, Rorie, as an infant Bacchus (private collection).

A.K.

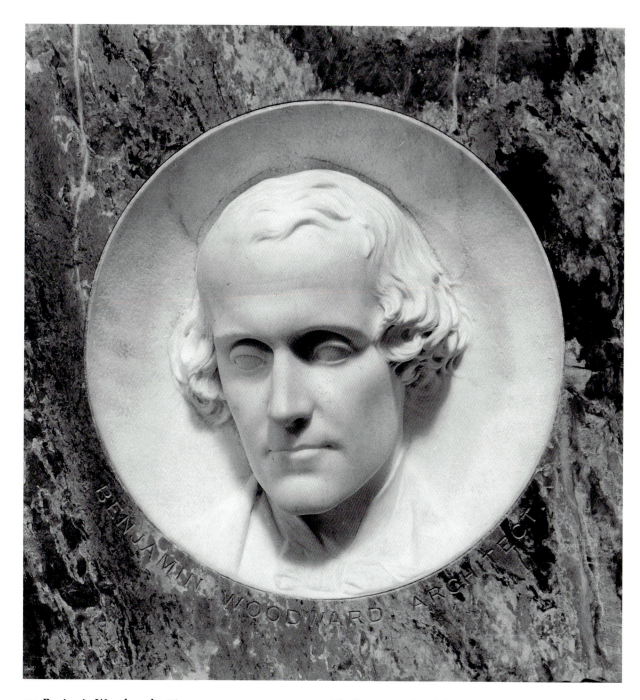

33 Benjamin Woodward, 1861

Marble, 47 × 46.5cm (18½ × 18¼in)
Monogram: IXXI

Exh: Tate Gallery 1984 (no.118)
Lit: Cook & Wedderburn, vol.16, f.p.224, pl.9

UNIVERSITY MUSEUM, OXFORD

Benjamin Woodward (1815–1861) was the architect of the
Oxford University Museum and the Oxford Union Society;
Munro worked on both projects with him. In the Museum
Munro was responsible for six monumental statues of
famous scientists placed along the central arcade:
Hippocrates, Galileo, Davy, Leibniz, Newton, and Watt.
This medallion was commissioned by John Ruskin and
Henry Acland as part of a commemoration after
Woodward's death in 1861.

The Rev. W. Tuckwell described Woodward as 'a man of
rare genius and deep artistic knowledge, beautiful in face and
character, but with the shadow of an early death already
stealing over him' (Tuckwell, p.48). Munro has managed to
capture the quiet suffering of the dying architect; his
haunting cavernous eyes and awkwardly tilted head convey
a moving pathos. Munro varied the design of his portrait
medallions more than Woolner, who restricted his work
almost exclusively to profile portraits. In this example,
Munro shows Woodward's face full-on and carved in such
high relief that it is virtually in the round.

A.K.

34 William Pole Carew, *c.1861*

Marble, H 46cm (18in)

William Lyttelton was the third son of William Henry Pole Carew of Antony (1811–1888) and Frances Anne (d.1902), the daughter of John Buller of Morval. His father was Member of Parliament for East Cornwall (1845–52) and High Sheriff (1854).

William Lyttelton was just five years old at the time of his death, and the bust is possibly posthumous.

Munro may have been introduced to the Pole Carews by Sir Walter and Lady (Pauline) Trevelyan; he is known to have stayed at their Cornish house, Seaton, as well as at Wallington.

K.M.

35 William Henry Hunt, *1861*

Marble, H 53.5cm (21in)
Signed: ALEX MUNRO SC/1861

Exh: RA 1862 (no.1137); RSPW 1864; Birmingham 1872
Lit: *ILN* XLIV, 1864, p.536; Scott 1872, p.133; Roget, vol.2, p.200; Witt, p.62; Crabbe, p.13

William Henry Hunt (1790–1864) became a member of the Old Watercolour Society in 1826 and in his long career exhibited about 800 works there. Despite a physical disability which made walking difficult for him, he became one of the most successful watercolourists of his day. He specialised in landscapes, mainly views from windows and still-life subjects (he was known as 'Birds'-nest Hunt'). Munro's bust of Hunt was exhibited at the Royal Academy in 1862. It had probably been commissioned some time

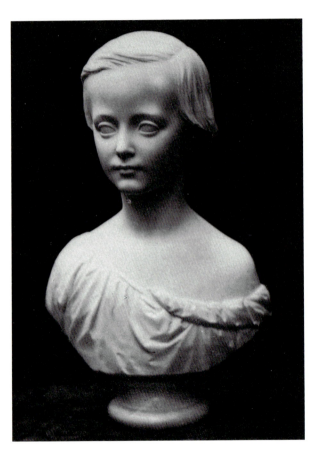

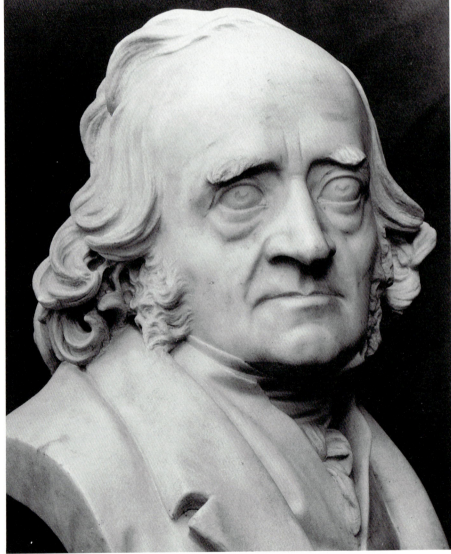

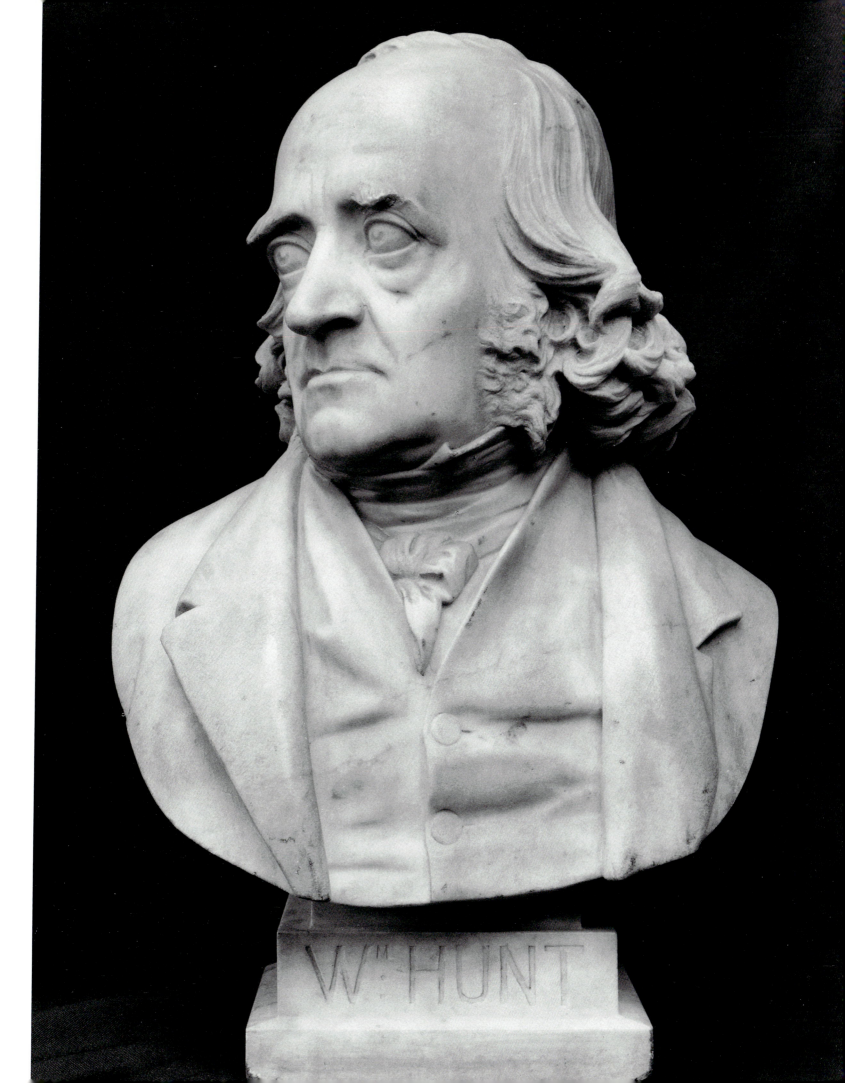

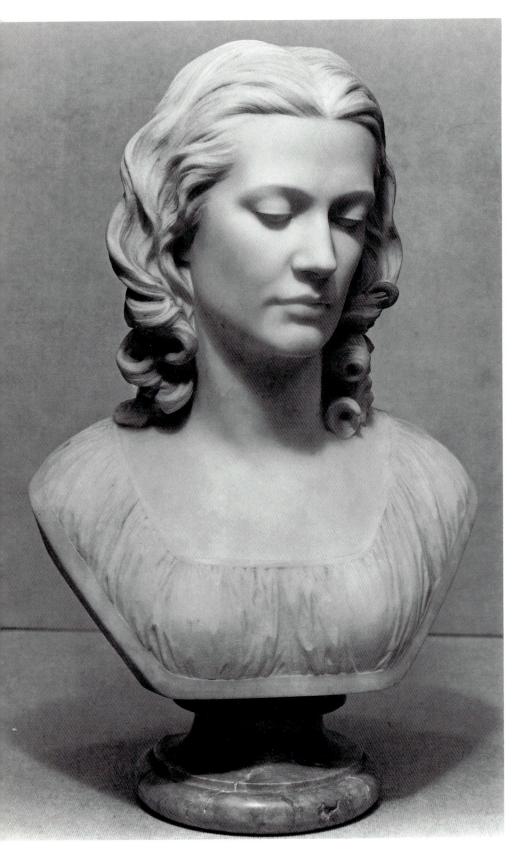

earlier by Barbara Leigh Smith Bodichon (see Cambridge, June 1991), who had received tuition in watercolour painting from Hunt. In April 1864, after Hunt's death, Munro obtained Mme Bodichon's permission for the bust to be lent to the Royal Society of Painters in Watercolour's 60th Exhibition (letter Munro to RSPW, 2 April 1864, Jenkins Papers, Royal Watercolour Society, London). Mme Bodichon presented the bust to the Watercolour Society in 1899 (Roget, p.200).

The bust received very favourable contemporary criticism. William Bell Scott considered it one of Munro's finest. *The Illustrated London News*, which assumed the bust to be posthumous, thought that '. . . so full of life-like individuality is it, and so remarkable were the characteristics of the sculptor's "subject" that the likeness is most striking' (*ILN* XLIV, 1864, p.536). In 1864 Munro gave Burne-Jones a plaster cast of this bust (MS, private coll.).

A.K.

36 Mary Munro, *c.*1861

Marble, H 61cm (24in)

Exh: RA 1956–7, p.137 (no.436)

PRIVATE COLLECTION

Mary Munro (1834–1872) was the daughter of Robert Carruthers (1799–1878), owner/editor of the *Inverness Courier*, editor of Pope's works and co-editor of *Chambers' Cyclopedia*. She married Alexander Munro in 1861 and they had two sons. After his death, she returned to England where she died in 1872.

No other version of this bust is known, but Munro, in comparison with a contemporary photograph of the plaster, clearly simplified the edge of the dress when he came to carve it in marble.

K.M.

37 Fountain Nymph, *c.1863*

Plaster, H 89cm (35in)

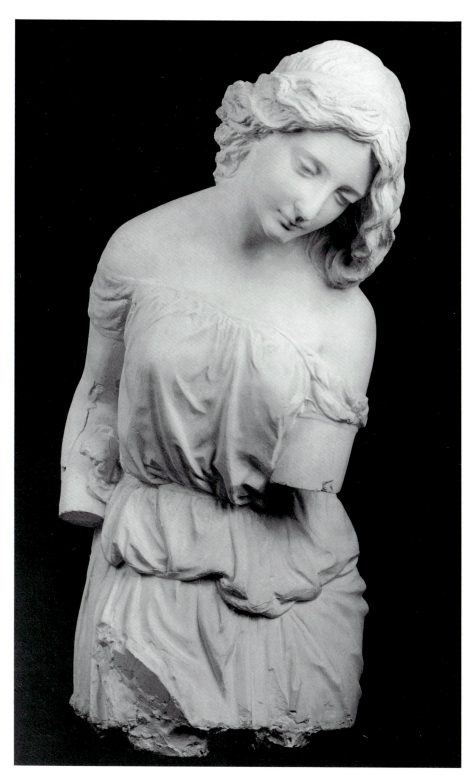

This is a fragment of the plaster model for the Elkington bronze figure, which stands in the niche at the base of Munro's monument to Herbert Ingram, at Boston, Lincs. The statue of Ingram was unveiled in 1862 and the figure of the nymph was added in September 1863. Ingram was the founder and proprietor of *The Illustrated London News*. He was born in Boston, which he represented in Parliament for a number of years, and contributed funds towards the water-works of the town. It may be for this reason a water nymph was thought appropriate for the base of the monument. Munro executed a similar fountain nymph in marble for a drinking fountain in Berkeley Square, London (1865) commissioned by the 3rd Marquess of Lansdowne. About twenty years ago a reduced marble replica of this statue by Munro was placed in Park Town Gardens, Oxford.

A letter from Cannes in 1869 from the sculptor's wife, Mary Munro, to his sister Annie states 'Alick [sic] thinks you did quite right to sell the fragment. He would like Mr Boulton to know that he himself thinks it the best thing in the room . . . He is wondering if Mr Boulton would prefer the *entire* figure for 30gns. It is at the Kensington Museum . . . [now the V&A, where it remains today]' (MS, private coll.). This plaster cast was thus once in the collection of M.P.W. Boulton. It was sold at Christie's Great Tew Park Sale, 27–29 May 1987 (lot 911). Tew Park was owned by the Robb Family into which one of the Boultons married.

K.M.

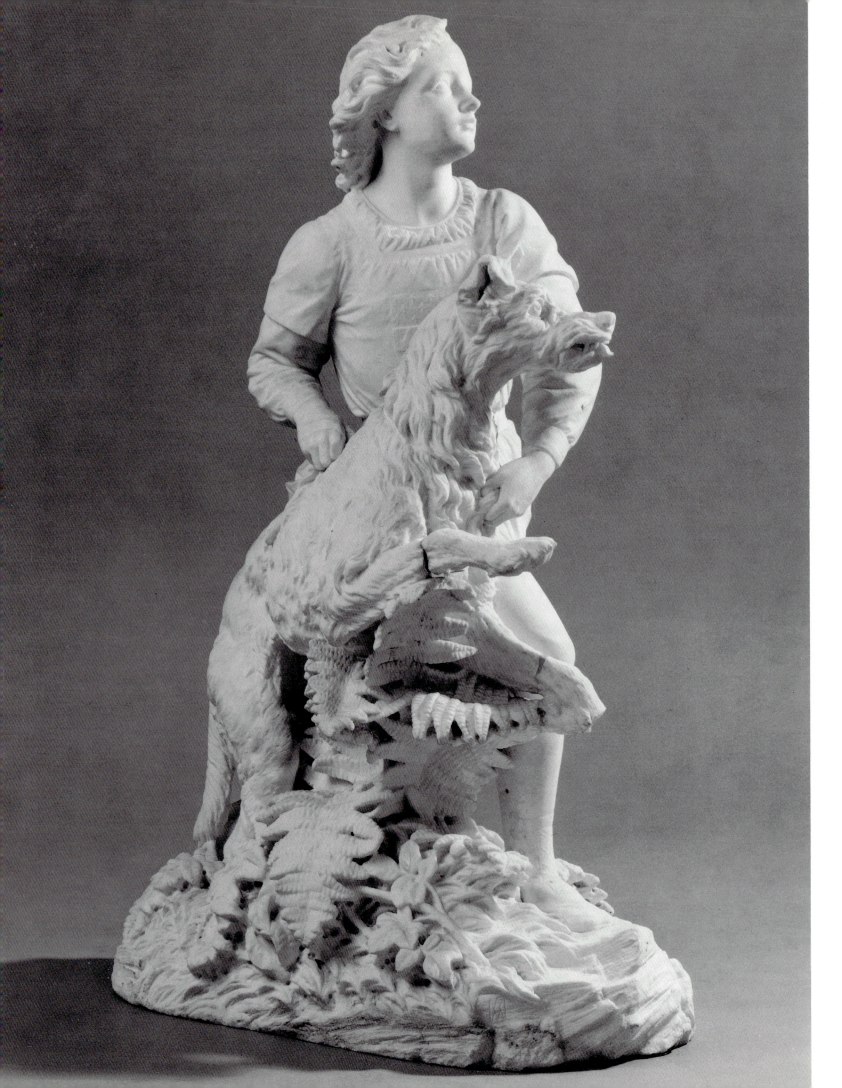

38 Young Romilly, c.1863

Marble, H 97cm (37in)
Signed with monogram: ℟

Exh: RA 1863 (no.1036)
Lit: *Art Journal* 1863, p.116

MATTHIESEN FINE ART LTD, LONDON

This group was exhibited at the Royal Academy in 1863 (no.1036) and was first executed in marble for Lady Ashburton (see p.57). Two versions in marble have recently come on the market: this fine group and another, debased and re-worked, with the dog's paw hanging lifeless. It also exists as a damaged, but still vivid, plaster cast (private collection). It illustrates one of Munro's favourite themes and also his use of foliage. The *Art Journal* commented: 'A work worthy of note for its happy combination of the human figure and the animal form intermingled with interweaving fern leaves.' The inspiration came from

Wordsworth's poem: *The Force of Prayer* (stanza 4, quoted in the RA catalogue), which recounts the legend of the founding of Bolton Abbey. Young Romilly, holding 'a greyhound in a leash' is about to 'bound across the strid' – a narrow chasm above the Wharfe. The dog pulled back and both fell to their deaths. In commemoration, his mother built the priory. In fact, young Romilly – William of Egremont – agreed to the charter of 1151, by which his mother Adeliza granted the manor of Bolton to the canons of Embsay: but there is evidence that he died soon after (Speight, pp.295–6).

To show his noble birth (and right to possess a greyhound) the boy wears a coat-of-arms on his tunic. Young Romilly's line died with him and by 1151 heraldry was hardly established. The model for the boy was Walter Ingram (1855–1888), fourth son of Herbert Ingram (1811–1860), founder of the *ILN*; so Munro playfully used the traditional arms of the Ingram family: ermine on a fesse gules three escallops. Walter's brother later became a baronet and adopted a variation of these arms.

K.M.

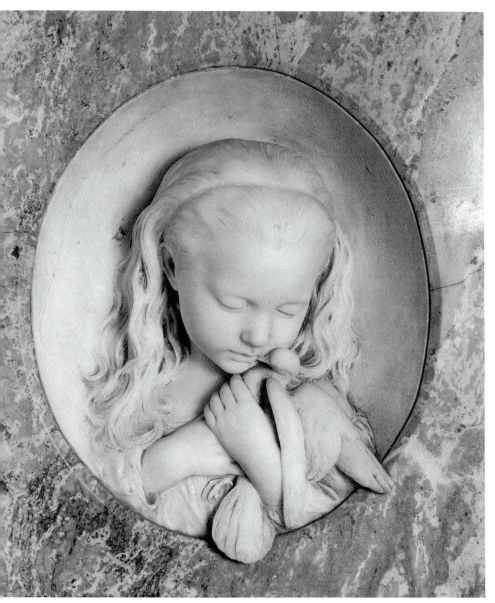

39 Eva Butler with Live Dove, c.1864
colour plate 3
Marble medallion, set into green serpentine,
53.5 × 48 cm (21 × 18⅞in)
Incised with monogram: ℟

Lit: Johnson, repr. f.p.36

THE PUBLIC TRUSTEE

Evangeline, the only daughter of George and Josephine Butler was tragically killed in 1864 at the age of five, when she fell over the banisters. Josephine Butler recalled, 'our only daughter the light and joy of our lives . . . her life was one flowing stream of mirth and fun and abounding love' (Butler, p.153, contains a pathetic account of her death). Munro knew little Eva from his visits to the Butler household and spontaneously carved a tribute to the little girl. William Rivière, the history painter, had presented the Butlers with a sketch of Eva meeting her mother in heaven and George Butler wrote appreciatively to him: 'Alexander Munro has sent us the most perfect likeness of our dear child that marble is capable of conveying. Both as a likeness and as a beautiful work of art, we are delighted with it.' (Butler, p.164). A plaster version of this relief is known in a private collection. Munro carved a companion marble high relief, identically set into green serpentine, with Eva holding a dead dove and it is possible, that this is the version to which Butler was referring (private collection; photograph in Butler Papers).

Munro also executed a charming tondo of Eva in profile looking up at a butterfly (untraced). This is possibly the relief, formerly at Ewart Park, Wooler, which was sent out to Josephine's son, Charles, in British Columbia (Butler Papers; photograph c.1900).

J.B.

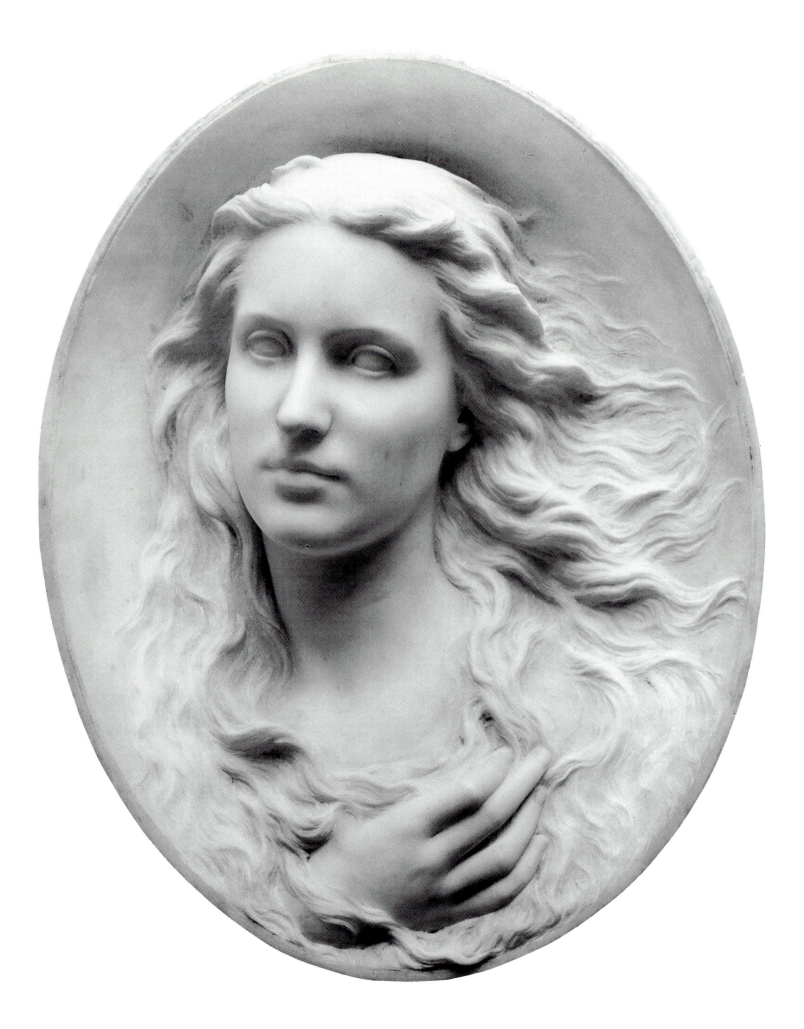

128 Alexander Munro

40 Emily Ursula Hamilton, *c.1865*

Marble, 51 × 42cm (20 × 16½in)

Exh: RA 1865 (no.921)

PRIVATE COLLECTION

Born in Sydney, Australia, Emily Ursula Hamilton (b.1846) was the daughter of Edward William Terrick Hamilton (see cat.59) and Ann Thacker. She came to England with her family in 1855, when her father returned home. She married Francis Carew Charles Barnett in 1877 and had two children by him.

The relief was exhibited at the Royal Academy of 1865 and the *Art Journal* for that year noted that 'the profile medallions by A. Munro possess a refined beauty that has gained popularity' (p.172). The marble was formerly set into the wall of the family home in Abingdon and is still in the possession of the sitter's descendants.

J.B.

41 Three Children, *c.1865*

Plaster, H 21cm (8¼in)
Signed with monogram: ⋈

PRIVATE COLLECTION

This is one of several portrait groups of children and is similar in treatment to *Child Play* (Ingrams; 1853–5) and *Violet and Henry* (Crompton Roberts; 1865), with the difference that the children are loosely robed, not naked. They are on a grassy bank and the two older ones are sprinkling rose petals on to their baby sibling. The hair styles and clothing of mid-Victorian children make it difficult to distinguish between small boys and girls. The children cannot be identified with any certainty from any visual or written record; nor is it known whether this group was ever given a more permanent form. However, the probability is that it is the group referred to by Lewis Carroll in his diary for 18 April, 1865: 'Then on to Mr Munro, who showed me a group in clay of three children of a Mr Gilstrop, which I admired very much' (Green, vol.I, p.229). The children whose surname and birth dates fit this entry best are the three daughters of Mr George Gilstrap (1822–1864) of Winthorpe Hall, near Newark. Munro often gave casts as presents. He may have given this to one of the Boulton/Robb family, who owned it until 1987 (Great Tew Park Sale, Christie's 27–29 May 1987, lot 912) or they may have bought it in 1869/70, when his studio was sold up (see *Fountain Nymph*, cat.37).

K.M.

42 The Duchess of Vallombrosa, 1867

Plaster, Diam 49.5cm (19½in)

PRIVATE COLLECTION

Mlle Pauline Geneviève de Perusse des Cars (1836–1886), daughter of Amedée, duc des Cars, married Riccardo Manca, Duke of Vallombrosa in 1857. Following the birth in Paris in June 1858 of her eldest son Antonio, the marquis de Mores, the Duchess was advised by her doctors to move to the Côte d'Azur and her husband acquired the well-known Villa des Tours at Cannes, where Munro executed this relief.

There are many references to the Vallombrosas and to his work on the marble head of the Duchess in the Munro correspondence (MSS, private coll.). The Duke paid promptly for the work and a letter from the sculptor's wife, Mary Munro to Annie, his sister, records '[he received] a cheque for 100 guineas *instantly without one* day's delay!... The Duke said "tho' the sum was more considerable than he understood from Col. Higginson it would be" so Alick [sic] hoped to explain the difference between the medallion and alto relievo today and instead of abating his price... is going to offer to do the little boy's head in plaster' (20 March 67, MS private coll.).

The marble was exhibited at the International Exhibition of 1867 in Paris (no.9b) and at the Royal Academy in 1869 (no.1280). Mary Munro, writing again to Annie, confides that the latter showing 'was managed by Sir William Alexander, who wrote direct to the Prince of Wales, & he commanded Mr Cole to put it in' (26 March 67, MS private coll.).

The long flowing hair framing the face of the Duchess and star motif on the border make this a particularly idealised type of portrait. Several plaster examples of the relief were made, one of which was in the possession of Sir H. W. Acland (Acland Typescript, p.6) and one, belonging to Tom Taylor, was exhibited at the Birmingham and Midland Institute in 1872. The present example was owned by the Robb family at Great Tew Park (sold Christie's 27–29 May 1987, lot 914). Mrs Robb was née Boulton and since another work by Munro in the sale of that house belonged to M. P. W. Boulton it is likely this relief shares the same provenance (see also cats 37 & 41).

J.B.

William Ernest Reynolds-Stephens
(1862 – 1943)

Born in Detroit of British parents, Reynolds-Stephens came to England as a child. He entered the Royal Academy Schools in 1884. From 1885 Reynolds-Stephens began exhibiting both paintings and sculpture at the Royal Academy. Painting predominated until 1896, when he exhibited the relief *Happy in Beauty* (cat.43). His strong belief in the ideals of the Arts and Crafts movement is apparent in the exhibits he sent to the Royal Academy exhibition of 1897: one was a silver bonbonnière; the other was a chimney-piece, designed by Norman Shaw, with a bronze relief of *The Sleeping Beauty*. Reynolds-Stephens supported and exhibited at the Arts and Crafts Exhibition Society. He was a member of the Art Workers' Guild, President of the Royal Society of British Sculptors, an honorary ARIBA, vice-president of the Royal British Colonial Society of Artists and chairman of the Council of the Imperial Arts League. He was knighted in 1931. In his later work his imagery becomes more sentimental and nationalistic, as in *Love's Coronet* and *A Royal Game*. His decorative schemes include the drawing-room at 185 Queen's Gate, London, and the interior of St Mary, Great Warley, Essex. *The Times* (26 Feb. 1943, p.7) described Reynolds-Stephens thus: 'By affinity he was a belated Pre-Raphaelite. He liked romantic subjects such as *Guinevere's Redemption*, *Lancelot and the Nestling* (cat.44a) and *The Sleeping Beauty*, and he was true to the tradition of the school in practising a great variety of arts and crafts'.

A.K.

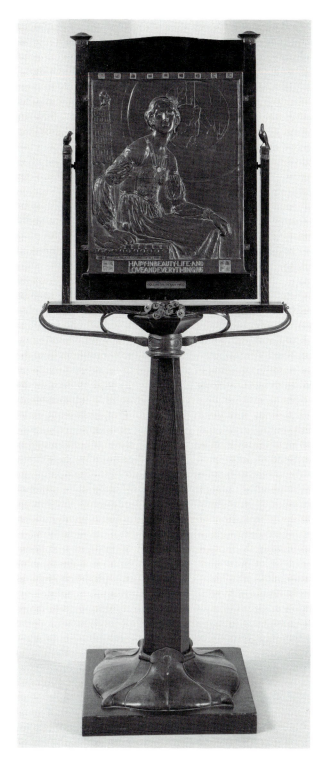

43 Happy in Beauty, Life and Love and Everything,
1896
colour plate 7
Copper and bronze, inset with mother-of-pearl and precious stones, on an original oak stand with wood inlays, metal fittings and ornament, 51×40cm ($20\frac{1}{8} \times 15\frac{3}{4}$in) (plaque); overall height 172cm
Signed: W. Reynolds-Stephens 23.3.96
Inscr in gilt: HAPPY·IN·BEAUTY·LIFE·AND/ LOVE AND EVERYTHING

Exh: ?RA 1896 (no.1845); ?RA 1898 (no.1941); for further exh. see Reynolds-Stephens MS
Lit: Baldry, pp.80–3; Beattie, p.193, pl.194, p.249

PRIVATE COLLECTION

Reynolds-Stephens's relief was exhibited at the Royal Academy in 1896 and the relief with its stand at the Royal Academy in 1898. The ensemble was also exhibited at the Fine Art Society's 1902 exhibition of 'Sculpture for the Home', when it was called *Youth*.

The symbolism of the relief is described in the Fine Art Society's catalogue: 'The mirror in the background typifies (by the sunrise scene) the unclouded brightness of youth's outlook into life' while on the stand are 'emblems of spring, the narcissus, and a bird singing to his mate'. The quotation inscribed on the relief is taken from Keats's poem *Lamia*.

The conception of the relief is comparable to Frampton's Arthurian subjects for the Astor House door panels, which were also exhibited at the Royal Academy in 1896 (see cat.9). Like the latter, Reynolds-Stephens's design was conceived as part of an appropriate decorative setting. As Baldry writes: 'He constructed a stand of carved wood, a column with a revolving top , and carrying a swing arrangement which would admit of the relief being adjusted at any angle that might allow it to be seen to advantage in a room with ordinary lighting'. He described the stand as 'a decorative object of very considerable beauty, as well as an excellently devised piece of construction, possessing

in high degree the artistic quality of fitness for its destined purpose'. Reynolds-Stephens experimented widely with the use of metal-working, mixed materials and polychromatic finishes in sculpture and he designed fittings for churches and private houses and household ornaments such as letter racks, photograph frames and bonbonnières.

According to the Fine Art Society's 1902 catalogue a 'limited number' of the reliefs and stands were available (at 150 guineas each); a version of the relief (without the stand)

is in the Harris Museum and Art Gallery, Preston. The present example bears a label recording that it was shown at the Vienna International Exhibition in 1900 where it won a gold medal.

M.G.

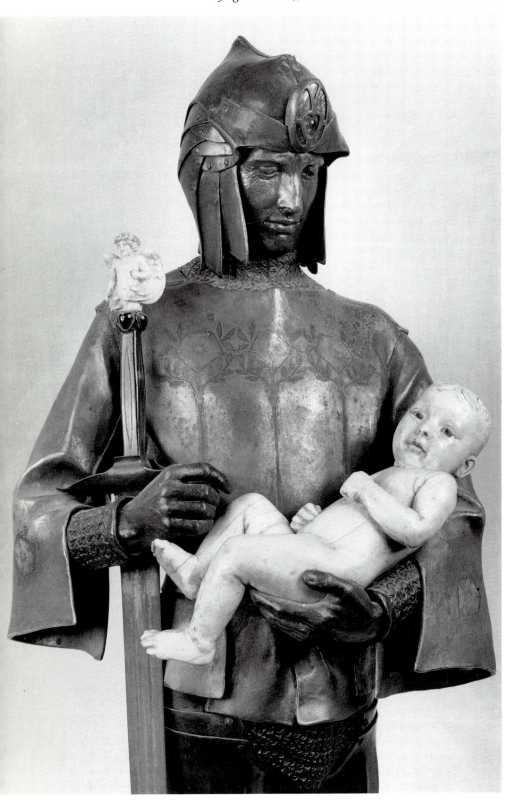

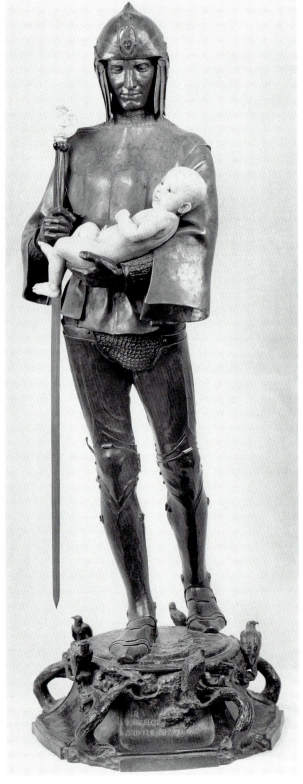

44a Sir Lancelot and the Nestling, 1899

Bronze, ivory, mother-of-pearl and enamel, H 86cm (33¾in)
Signed: W. Reynolds-Stephens 1899 and initialled on base:
W.R.S. 1899
Inscr. on base: SIR −/LANCELOT/AND THE NESTLING

Exh: RA 1899 (no.2037); for further exh. see Reynolds-
Stephens MS
Lit: *The Studio* 1899, XVI, p.226 ill.; *The Athenaeum* 1899,

p.41; RSBS, p.108 ill.; Baldry, p.83; Spielmann, pp.107–8 ill.;
Beattie, pp.167, 249, 259 n.44; Read 1989, p.57

44b Guinevere and the Nestling, 1900

Bronze, ivory, mother-of-pearl and enamel, H 86cm (33¾in)
Signed: 1900 W. Reynolds-Stephens and initialled on base:
W.R.S. 1899
Inscr. on base: GUINEVERE AND / THE NESTLING

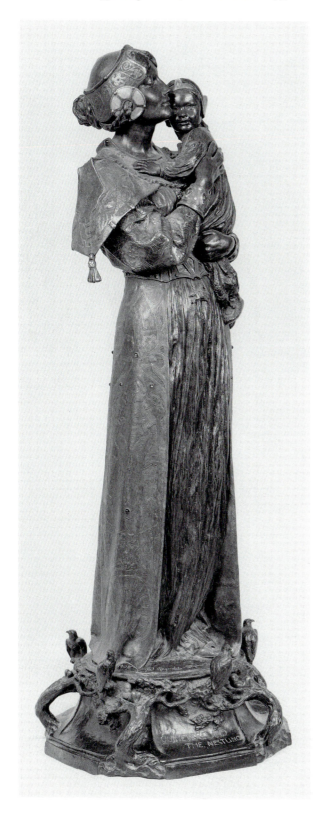

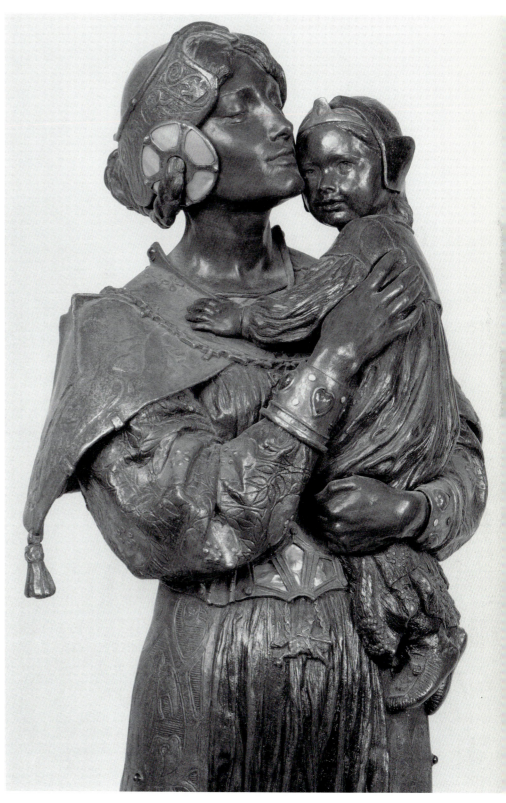

Exh: RA 1900 (no.2023); for further exh. see Reynolds-Stephens MS

Lit: Spielmann as above; *The Studio* 1900, xx, p.13 ill.; RSBS, p.109 ill.; Beattie as above

PRE-RAPHAELITE INC. BY COURTESY OF JULIAN HARTNOLL

The statuettes of *Sir Lancelot and the Nestling* and *Guinevere and the Nestling* were exhibited at the Royal Academy in 1899 and 1900 respectively. The subjects are from Tennyson's *The Last Tournament*.

The Athenaeum described the *Lancelot* as the sculptor's 'best work . . . combining stateliness and grace' and Baldry saw it as 'a very worthy example of craftsmanship and of remarkable quality as an exercise in the technicalities of metal working'. Reynolds-Stephens's skill in the working of mixed materials is evident in these statuettes, particularly the intricately wrought bases and the striking contrast between the pure white ivory of the child's body and the metallic armour of Lancelot.

The pair are related to a third statuette of *Guinevere's Redeeming* (RA 1905; Nottingham Castle Museum & Art Gallery, and other versions); the present examples were formerly in the collection of Percy Eccles.

M.G.

45 Pro Mundo Mortuus, 1904

Bronze, 26.5 × 40.5cm (10½ × 15⅞in)

In original stained wooden frame, with red decorative features
Signed: W. Reynolds-Stephens 1904
Inscr: PRO.MUNDO.MORTUUS

Exh: Buenos Aires 1931 (no.5)

PRIVATE COLLECTION

This is another version of the bronze on the reredos, and the variant marble panel entitled *The Gateway to Life*, on the war memorial reredos in Harrison Townsend's church of St Mary the Virgin, at Great Warley, Essex (RSBS, p.12), on which Reynolds-Stephens worked between 1902–4. This relief seems to display an awareness of the sculptural designs of Burne-Jones and may be compared with *The Entombment* (cat.6b), which was executed in bronze by Joseph Edgar Boehm (fig.55).

J.B.

Dante Gabriel Rossetti
(1828—1882)

Son of an Italian Dante scholar and poet, Rossetti attended Sass's drawing school from summer 1841 to 1844 and then entered the Royal Academy Schools in 1844, becoming a full student in 1845. In 1848 he briefly studied under Ford Madox Brown and in August moved with Holman Hunt to a studio in Cleveland Street. In the same year he helped found the Cyclographic Society and in the autumn was instrumental in forming the Pre-Raphaelite Brotherhood. He was largely responsible for the Pre-Raphaelite magazine *The Germ*, which, under the editorship of his brother William Michael, was published between January and April 1850. In 1849 he showed his first major oil painting *The Girlhood of the Virgin* at the Free Exhibition and in the autumn visited Paris and Flanders with Holman Hunt, where he was very impressed by medieval and Renaissance art. He showed *Ecce Ancilla Domini* at the National Institution in 1850 and after its harsh reception rarely exhibited in public again. He became close to Ruskin in about 1854 and by 1856 was friendly with Burne-Jones and William Morris. In 1857 he worked with them on the Arthurian murals and designed the tympanum by Alexander Munro at the Oxford Union. At this time he executed a large triptych, *The Seed of David*, for Llandaff Cathedral and a carving there of *The Pelican in her Piety* was also after his design. In the same year five of his illustrations were included in Moxon's Tennyson and he showed eight works in the private Pre-Raphaelite exhibition. In 1858 he joined Madox Brown and others in founding the Hogarth Club and at this time met Fanny Cornforth, his main model and mistress for the next decade. In 1860 he married Elizabeth Siddal, who died two years later from an overdose of laudanum. In the late 1860s his health, weakened by chloral, deteriorated and in 1872 he suffered a nervous breakdown following adverse criticism of his poetry by Robert Buchanan. He retreated to Kelmscott Manor, staying with Morris for a short period, but gradually tried the patience of all but a few friends such as Madox Brown. He died at Birchington-on-Sea, Kent, where his grave is marked by a celtic cross designed by Madox Brown.

J.B.

46 How They Met Themselves, 1851–60

Pen and ink, and brush 26.9 × 21.2cm ($10\frac{1}{2}$ × $8\frac{3}{8}$in)
Signed lower right: monogram 1851 1860

First exh. RA 1883 (no.329)
Lit: Surtees 1971, no.118; Grieve, p.61; Tate Gallery 1984, p.254 (no.175)

THE SYNDICS OF THE FITZWILIAM MUSEUM, CAMBRIDGE

This drawing illustrates the legend of the 'Doppelgänger'. Two medieval lovers in a wood at dusk drop dead as a result of encountering their doubles, who, outlined in supernatural light, assert a stronger right to exist. Similar imagery appears in the poetry of Elizabeth Barrett Browning and in Rossetti's own poetic works such as 'Willowwood'. This Pre-Raphaelite drawing was the source of inspiration for John Singer Sargent's sculptural interpretation of the same subject (cat.47).

Executed for the painter George Price Boyce during Rossetti's honeymoon in Paris in 1860, this drawing replaced an earlier composition of identical subject. Two watercolour replicas were made.

J.B.

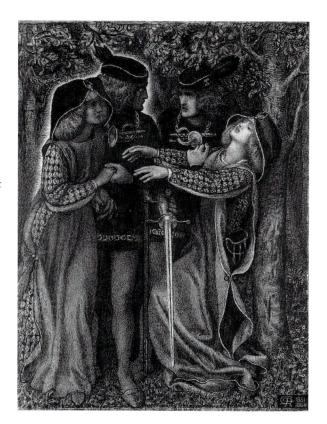

John Singer Sargent (1856–1925)

Born in Florence of American parents, Sargent trained under Carl Welsch and at the Accademia delle Belle Arti in Florence (1870–1), before entering the studio of Carolus-Duran in Paris in 1874 and enrolling at the Ecole des Beaux-Arts. It has been said that the drawings he showed to Carolus-Duran would have pleased Ruskin and the Pre-Raphaelites. Sargent began exhibiting at the Salon in 1877 and caused a *succès de scandale* in 1884 with his *Portrait of Madame Gautreau*. He moved to England in 1885 where his glamorous portraits were much in demand. In the 1890s Sargent painted numerous society portraits on both sides of the Atlantic. In 1890 he was commissioned to decorate the Boston Public Library (USA) with scenes of the history of religious thought. This scheme, regarded by the artist as his most important work, combined sculptural relief and mural painting. Sargent produced other religious sculptures such as the *Crucifixion* in St Paul's Cathedral, London and the bronze *Redemption*. In 1897 Sargent was made a Royal Academician. After 1900 he tired of portrait painting and turned his attention to watercolours. Also at this time he modelled a series of small bronzes including *Leda and the Swan*, *Eros and Psyche* and *Israel and the Law*. In 1916 he began more decorative work in the Museum of Fine Arts, Boston.

A.K.

47 How They Met Themselves, after 1900

Bronze, H 24cm (9½in)

Exh: RA 1972 (no.F50); Tokyo 1989 (no.90)
Lit: Charteris, p.88; RA 1972, p.112 (no.F50); Read 1982, p.273

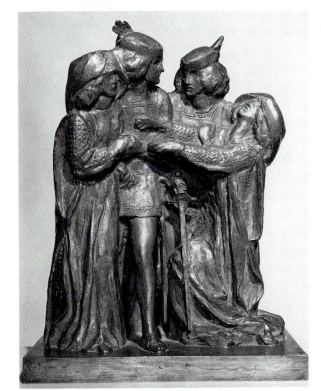

Inspired by Rossetti's earlier drawing of the same subject (cat.46), a cast of this bronze is recorded among the effects in Sargent's studio after his death, 'Bronze. Four figures, after Rossetti. The lovers meeting their own Souls, by J. S. Sargent. 10 inches high.' (MS notebook, p.8, R. L. Ormond coll.). According to Charteris, Sargent 'entertained a deep admiration for Rossetti'. The biographer records that Sargent owned an engraving of the Rossetti drawing (which he calls 'The Meeting of Arthur and Guinevere') and that the last time they met Sargent pointed towards it declaring, 'That is the difficult thing to do, anyone can paint, but to design a group so that it will – well, do in sculpture – that's what counts. Rossetti could do it.' The designs of Rossetti had also been used for earlier Pre-Raphaelite works such as the tympanum of *Arthur and the Knights of the Round Table* by Alexander Munro on the Oxford Union and the *Pelican in her Piety* carved by Edward Clarke at Llandaff Cathedral.

Sargent did not take up sculpture until the late 1890s, when he worked on moulded reliefs for the Boston Public Library. The present bronze is one of a number of small groups he made after 1900. It is an isolated example in Sargent's œuvre which belies the assertion of Charteris that in art he gave no outward sign of kinship with the Pre-Raphaelites. In addition to the obvious debt to Rossetti in subject-matter and design, there is an intriguing similarity between the flattened frontal treatment of this bronze and the Gothic wood groups of northern Europe.

A further example of this bronze is known in a private collection.

J.B.

Bernhard Smith
(1820–1885)

Bernhard Smith was born at Greenwich into a family with strong naval connections; three of his brothers were serving officers. By 1838, Smith was modelling from casts at the British Museum and trying to enter the Royal Academy Schools. At this time he also sculpted portrait medallions and carved a tomb memorial to his sister. He entered the Royal Academy in April 1840, but by October had joined the atelier of Etienne Jules Ramey in Paris. There he studied art in galleries and libraries, and made sketching trips, looking at architecture and natural history. His letters particularly mention his sculpting portrait medallions under Ramey's close attention. His stay in Paris was interrupted by serious illness *c.* June 1841. In 1842 Smith was working in London from a studio in Great Ormond Street and showed *An Old Satyr extracting a Thorn from the Foot of a Young Man* at the Royal Academy. Throughout the mid- to late 1840s he exhibited a number of portrait medallions at the Royal Academy; many of the sitters were connected with his family, but he appears to have had no access to a wider circle of patrons. The breadth of his interests and ability is evident from surviving correspondence (letters from Paris, private coll., Australia), a sketchbook of drawings of medieval architecture (1844; La Trobe Coll.) and accounts of his experimentation with the electrotype process in 1847. Smith was never formally admitted as a member of the PRB, although his daughter's insistence after his death that he had been an elected member gained him some notoriety. He was, however, on terms of familiarity with the group and shared a studio with Woolner in Stanhope Street in London. A key sculptural work from this period is *The Schoolmaster* (1848; cat.50). Towards the end of the 1840s Smith wavered between his artistic vocation and emigrating. He was drawn to Australia not only by the lure of gold, but also by extensive family connections. His brother Alexander, who had been with the Antarctic Expedition, had settled in Hobart by 1844. Smith arrived in Melbourne in 1852 and is mentioned constantly in Woolner's gold-field diary. He abandoned mining in mid-1853 and joined the Gold Commission on 17 May 1854. In the mid-1850s he was working at Avoca and by 1857 at Ballarat. He married Olivia Frances Josephine Boyes in 1863 and became a Police Magistrate at Pleasant Creek (Stawell) in 1860, at Smythedale 1874–8 and at Alexandra 1878–85. He also made natural history observations, collecting data for the Melbourne Observatory and sketched fairy subjects. In his last posting, Smith spent many days travelling away from his family and began to concentrate on elaborate large-scale tableaux in pen and ink, based upon Flaxman, Blake and Victorian fairy pictures with a degree of Ruskinian observation of natural detail and its employment in design. Pressure of work and supporting his large family prevented him from devoting himself to art, although he developed contacts with professional art circles in Melbourne throughout the early 1880s. He sculpted a portrait in 1877 and there are indications that some drawings were to be worked up as reliefs. He died on 7 October 1885, contracting pneumonia after rescuing two children from a flooded stream.

J.P.

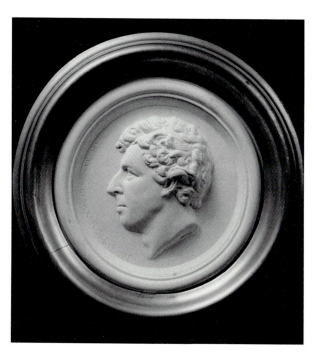

48 James Clark Ross, 1843

Plaster medallion, Diam 19cm ($7\frac{1}{2}$in)
Signed: Bernhard Smith/1843
Inscr: CAPT. JAMES CLARK ROSS R.N.

Lit: R. Ormond 1973, p.401 (described as marble)

THE LINNEAN SOCIETY OF LONDON

A celebrated Arctic and Antarctic explorer, Sir James Clark Ross (1800–1862) was the discoverer of the magnetic pole. In 1839 he commanded the *Erebus* on an expedition to conduct magnetic research and geographical discovery in the Antarctic. It was on this expedition that the active volcano, Mount Erebus, was discovered and named after the ship. During the voyage the *Erebus* was involved in a collision on 13 March 1842, when one of the bows had to

be cut away to effect repairs. Minnie Smith records: 'this wood (oak) was given to my father by his brother Commander Alexander Smith RN, who was an officer on Board at the time and it was used as an inner frame for this medallion' (Vertical Files Library, National Gallery of Victoria). The portrait medallion was executed by Smith, probably at his brother Alexander's instigation, to celebrate the explorer's return. 1843 was also the year of Clark Ross's marriage. The medallion was exhibited at the Royal Academy in 1844 (no.1344; Smith exhibited a medallion portrait of his brother Lieutenant Henry Thomas Smith RN the same year, no.1347).

Two other versions of the medallion dating from the same year are known; one painted plaster in the Scott Polar Institute, Cambridge and a plaster in the National Portrait Gallery, London (no.887) presented by Sir Joseph Dalton Hooker.

J.B.

49 John Richardson, 1844

Plaster, Diam 21cm (8¼in)
Signed indistinctly: Bernhard Smith
Inscr: JOHN RICHARDSON MD

Lit: R. Ormond 1973, p.394 (described as marble)

THE LINNEAN SOCIETY OF LONDON

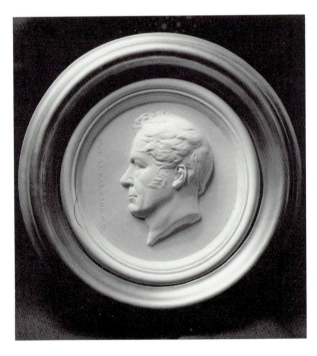

Sir John Richardson (1787–1865) the Arctic explorer, naturalist and ichthyologist was also a qualified physician. In 1819 he was appointed surgeon and naturalist to Franklin's polar expedition. He was specially commissioned to collect minerals, plants and animals, which brought him into contact with Dr John Edward Gray. Richardson accompanied John Franklin again in 1825 and in 1847

commanded the expedition sent to search for that great explorer.

An example of this relief was exhibited at the Royal Academy in 1844 (no.1346). A similar plaster medallion was presented to the National Portrait Gallery, London (no.888) by Sir Joseph Dalton Hooker. A variant, patinated plaster, truncated at the shoulder, is at the Scott Polar Institute, Cambridge (inscribed behind: Bernhard Smith/June 29th 1842/17 Great Ormond St.). A further 1842 example is recorded in the collection of the Rev. Edward Alston.

J.B.

50 The Schoolmaster, 1848

Plaster, H 27cm (10⅝in)
Signed: Bernhard Smith/ Sculp./London 1848

Exh: RA 1848 (no.1068)
Lit: Smith, p.1; Fredeman, pp.5, 192

PRIVATE COLLECTION, AUSTRALIA

Taken to Australia or cast out there by Bernhard Smith, this plaster is recorded by his daughter, Minnie Smith, and is still in the possession of one of his descendants. In her list of the sculptor's works under the year 1848, Minnie describes a 'ten inch Model *highly finished* of a seated figure representing a kindly keen-faced scholastic man called by us *The Schoolmaster*' (Smith, p.1). William Michael Rossetti in his diary entry for 23 May 1849 also mentions that 'Bernhard Smith left us a cast of his Schoolmaster' (Fredeman, p.5).

This work, like the medallions (cats 48 & 49), bears witness to the influence of Smith's training in France. The pose of *The Schoolmaster* has a certain similarity with the seated statue of *Voltaire* by Jean-Antoine Houdon (Louvre), while the sitter's contemporary dress reflects a knowledge of the work of David d'Angers, but carries his naturalistic treatment even further.

J.B.

(see page 16)

John Lucas Tupper
(c.1823–1879)

Tupper was a sculptor, anatomical draughtsman, teacher and poet. In his mid-teens he began to study classical sculpture at the British Museum. Tupper also helped in the family printing and stationery business, providing vignettes, etchings and lithographs. In 1838 he is recorded as entering the Royal Academy Schools. In the 1840s he made medallions and designs for Ideal works. By 1847 Tupper was working as an anatomical draughtsman at Guy's Hospital, London. It was towards the end of the 1840s that he got to know the PRB. He contributed essays and poems to *The Germ* – his father's firm printed the magazine – and he often attended PRB meetings. His major sculptural work during this period was a relief of the chess-playing scene from *The Merchant's Second Tale* by Chaucer of 1851, now lost. At the Royal Academy Tupper exhibited exclusively portrait medallions, mainly of doctors from the London hospitals. In 1857 he exhibited a medallion of Holman Hunt and in 1869 made one of W. M. Rossetti, both lost. Tupper's most important work as a sculptor is his statue of *Linnaeus* (1856–8) in the Oxford University Museum, but it did not lead to other commissions. In 1858 he became a member of the Hogarth Club. In March 1865 Tupper was appointed master of scientific drawing at Rugby School, where he devoted himself to the development of art teaching, publishing a pamphlet on education, setting up a museum and organising exhibitions, in which works by Woolner and others were exhibited. Despite his move to Rugby, Tupper did not lose contact with his Pre-Raphaelite friends, he maintained a long correspondence with Holman Hunt, with whom he and W. M. Rossetti visited Italy in 1869. Tupper married Annie French in 1872; they had two children. He died at Rugby on 29 September 1879.

A.K.

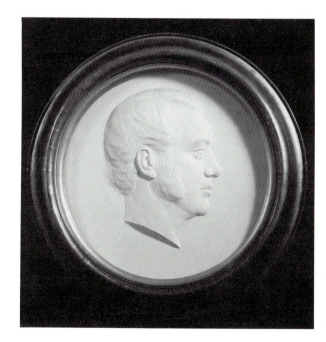

51 John Hilton, 1854

Plaster, Diam 37cm (14½in)
Signed: J.L. Tupper Sculp

Exh: RA 1854 (no.1522)
Lit: LeFanu, p.36 (no.110)

ROYAL COLLEGE OF SURGEONS OF ENGLAND, LONDON

John Hilton (1804–1878) was a surgeon and demonstrator in anatomy at Guy's Hospital, London. In 1867 he became President of the Royal College of Surgeons.

Tupper's work as anatomical draughtsman must have brought him into close contact with Hilton at Guy's Hospital. He illustrated some of Hilton's contributions to the Guy's Hospital Reports (see fig.38) and Hilton's most famous book, *On the Influence of Mechanical and Physiological Rest in the Treatment of Accidents and Surgical Diseases and the Diagnostic Value of Pain*, London 1863.

Hilton was described as 'a very ordinary-looking man in general appearance. As he plodded heavily along it would scarcely have occurred to a passer-by that he was the possessor of a remarkably active intellect. His great peculiarity in this respect lay in his keen powers of observation . . .' (Wilks & Bettany, p.347). Hilton was renowned for his elaborate dissections which would no doubt have appealed to Tupper, who claimed to have made his own dissections as a student in his youth (Tupper, *The Crayon*, 1855). Hilton too would have appreciated this medallion, in which the features are modelled with anatomical precision.

A.K.

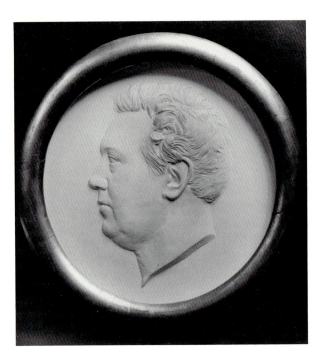

52 Thomas Bell, 1856

Plaster, Diam 42cm (16½in)
Signed: Jack Tupper S.

Exh: RA 1856 (no.1277)

Thomas Bell (1792–1880) was a surgeon, naturalist and lecturer in comparative anatomy. He was a founder of the *Zoological Journal* in 1825 and in the same year took up a lectureship in dentistry at Guy's Hospital. He was one of the earliest practitioners of clinical dentistry. He became a Fellow of the Royal Society, Professor of Zoology at King's College, London and President of the Linnean Society.

Bell was described as a 'thick-set man, with a cheery, chubby face on which there was no appearance of hair. His features were somewhat broad and thick, but he had a pleasant, intelligent, and benevolent face' (Wilks & Bettany, p.347). Tupper has captured Bell's amiable character in this plaster medallion. Bell was a personal friend of the sculptor. When Holman Hunt met him he described Bell as 'a jolly old trump' (Coombs et al., p.53).

A.K.

Thomas Woolner
(1825–1892)

Woolner was born on 17 December 1825 at Hadleigh, Suffolk. He trained in the studio of William Behnes before joining the Royal Academy Schools in 1842. He entered, unsuccessfully, the Westminster Hall competition in 1844. During the 1840s he was associated with Bernhard Smith and John Hancock and through D. G. Rossetti met Holman Hunt and Millais. He became the only sculptor member of the PRB in 1848. Woolner contributed poetry to *The Germ* and introduced Coventry Patmore to the circle; he was also especially close to the Tennysons. Disillusioned with sculpture, he left for Australia in July 1852 with Bernhard Smith, but his failure as a gold prospector meant he was soon working again as a portrait sculptor in Melbourne and Sydney. He returned to England in 1854 and gradually established a substantial practice in portrait sculpture, with occasional architectural and Ideal works, such as at the old Manchester Assize Courts, the Oxford Museum, Llandaff Cathedral, *The Lord's Prayer* and *Love*. He was a founder-member of the Hogarth Club in 1858. In 1861 he bought a house at 29 Welbeck Street and married Alice Waugh on 6 September 1864. He was elected ARA in 1871 and Royal Academician four years later. He was Professor of Sculpture from 1877–9. After 1870 he received several commissions for public monuments and with his increasing prosperity became a collector. He died in London on 7 October 1892.

A.K.

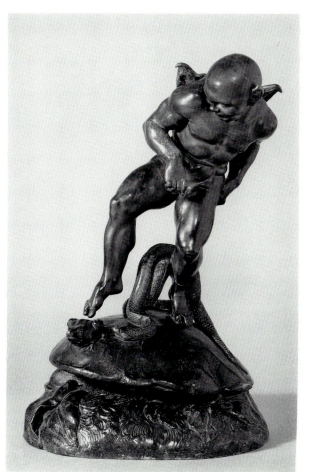

53a

53b

53a Puck, *c*.1847

Plaster painted black, H 49.5cm (19½in)

Exh: BI 1847 (no.550); Tate Gallery 1984 (no.2)
Lit: Tupper 1871, p.99; A. Woolner, pp.4, 7, 65, 283, 336, 339; Tate Gallery 1984 (no.2)

THE TRUSTEES OF THE TATE GALLERY, LONDON

53b Puck, 1847

Bronze, H 48cm (19in)
Signed: T. WOOLNER.SC.1847

PRIVATE COLLECTION

'As he was sailing through the air one day, searching for wherewith to place his humorous malice, right well was he satisfied to alight on a mushroom, and awaken a sleeping frog, of which a hungry snake was about to make a meal.'

Modelled by Woolner in about 1844, *Puck* was first exhibited in plaster at the British Institution in 1847 (no.550, with the above description). A plaster cast was presented by Woolner to his friend Coventry Patmore in 1849 and the design was later cast in bronze for Louisa, Lady Ashburton and shown at the Royal Academy in 1866 (no.932). A bronze cast was also made posthumously in 1908 for Sir John Bland-Sutton of the Middlesex Hospital (later bequeathed to the Royal College of Surgeons; present location unknown).

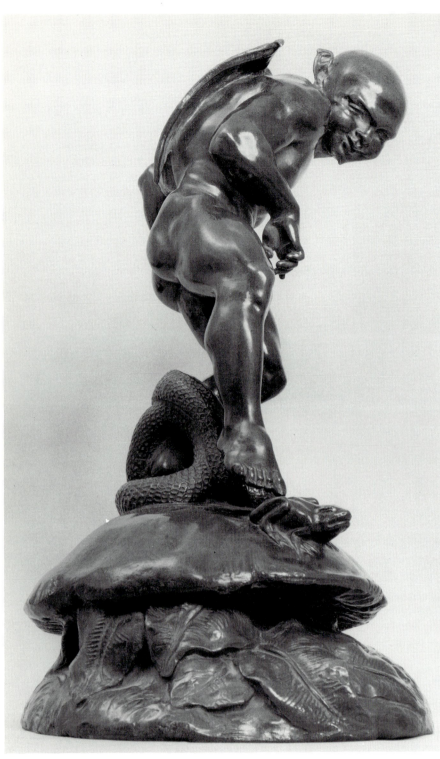

53b

Puck was the sculptor's favourite work. Holman Hunt recalled a visit to Woolner's studio in 1847 when the sculptor showed *Puck* 'with much paternal fondness' (Hunt, vol.I, p.114) and Woolner wrote to his father from Australia in 1854 saying that he wished he had 'little "Puck" here' as 'I know I could get some commissions for him in bronze at a good price' (A. Woolner, p.65). Shakespeare was the textual source for several PRB paintings (Millais' *Ferdinand Lured by Ariel* and *Ophelia*, Hunt's *Claudio and Isabella*) and the image of *Puck* can be related to the hovering spirit figures in *Ferdinand Lured by Ariel* (1849–50) and the supernatural imagery of certain early drawings by D. G. Rossetti (for example the illustrations to *Faust* and *The Raven*, Surtees 1971, 18, 23, 36). When Coventry Patmore received his plaster cast of *Puck* he was pleased to find that it was 'the product of a grotesque fantasy in harmony with the modern mind' rather than a bland transformation of a classical figure (A. Woolner, p.6) and Tupper described it as 'the *puissant* sprite of Shakespeare' not the 'quaint, fat baby of Reynolds', with 'the strength of a mole-cricket and the resilience of a grasshopper'. Despite its supernatural character *Puck* is remarkably convincing as a figurative work, combining a studied naturalism of form, action and musculature.

The naturalism of *Puck* also relates to the anecdote recounted by Amy Woolner connecting *Puck* with Charles Darwin. The pointed ears of *Puck* were based on Woolner's study of the vestigial 'tips' that appear on some human ears, an observation which the sculptor related to Darwin when the latter sat for his portrait: the discovery was incorporated by Darwin in *The Descent of Man* (see cat.78).

A recent examination of the present bronze by the Tate Gallery's conservation department has suggested that it is a lost-wax cast.

M.G.

54 Little Red Riding Hood, *c.*1849

Parian ware, H 29.5cm ($11\frac{5}{8}$in)
Inscr: COPELAND

Lit: A. Woolner, pp.18, 53, 336; Atterbury, fig.500

JOANNA BARNES FINE ARTS, LONDON

Little Red Riding Hood was probably modelled in 1847, as D. G. Rossetti stated that Woolner was working on it when they first met (A. Woolner, p.53). The design was produced shortly afterwards in parian ware by the Staffordshire firm of Copeland, who had begun manufacturing statuettes in this new medium in the mid-1840s. The design was not exhibited at this time nor is it known to have been produced in any other medium. In October 1852, a few days after arriving in Melbourne, Woolner was invited to dine with Charles Latrobe, Governor of Victoria (and uncle of the sculptor's friend Edward Latrobe Bateman) as the 'great man . . . wants to know me because Bateman found that my little figure of Red Riding Hood was one of his favorite ornaments . . .' (A. Woolner, p.18). D.G. Rossetti later wrote

'How queer that Mr. Latrobe should have your "Red Riding Hood"' (A. Woolner, p.53). It seems likely that Latrobe had one of the Copeland figures; either one distributed in Australia or acquired earlier from England.

The subject is not often found in sculpture (versions were produced by William Calder Marshall in 1844, and John Thomas in 1861) and *Little Red Riding Hood* can be compared to other early imaginative works by Woolner, designed on a small scale and low key in their subject-matter (including *Feeding the Hungry, a Child feeding Chickens*, RA 1847, *Titania and the Indian Boy*, BI 1848 and *Puck*, cat.53a & b). The lively characterisation of the wolf curving around the base can be compared with the placing of *Puck* on his pedestal.

M.G.

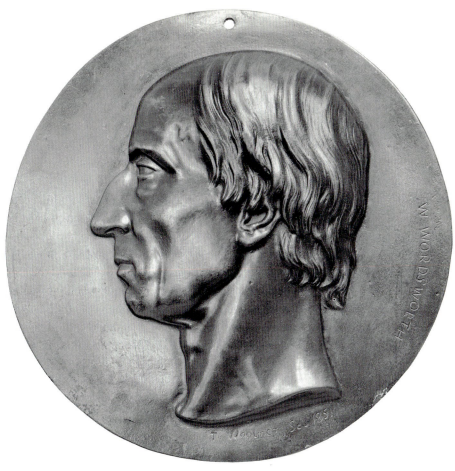

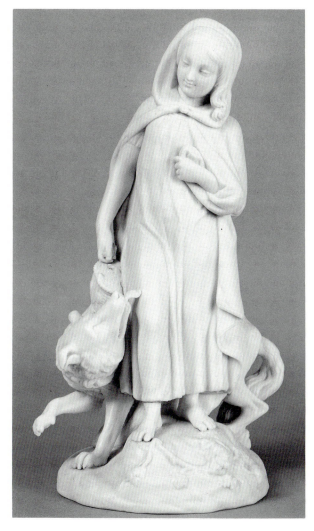

55 William Wordsworth, 1851

Bronze, Diam 27.5cm ($10\frac{7}{8}$in)
Signed: T. Woolner Sc 1851
Inscr: W. WORDSWORTH

Exh: RA 1852 (no.1397)
Lit: W. Knight, pp.54–5

PRIVATE COLLECTION

Woolner's works connected with William Wordsworth (1770–1850) brought him his greatest success, but also his worst disappointment in the period before his Australian expedition. Until 1851 Woolner's exhibits at the Academy had been portrait medallions or models for Ideal groups made without any specific commission. When he exhibited his marble *Wordsworth Memorial Tablet*, however, he had at last won an important commission for a public monument.

Woolner was working on his medallion of Tennyson in the Lake District in 1850 when he met Mrs Eliza Fletcher, who having admired the medallion was sent a cast of it by the sculptor. Soon after, Mrs Fletcher's son Angus and her son-in-law Dr John Davy, helped Woolner secure the commission for the *Wordsworth Memorial Tablet* to be erected in the church of St Oswald, Grasmere (W. Knight, pp.54–5). The carefully observed portrait, though posthumous (it was based on a bust of the poet by Francis Chantrey), and the delicate naturalism of the crocus,

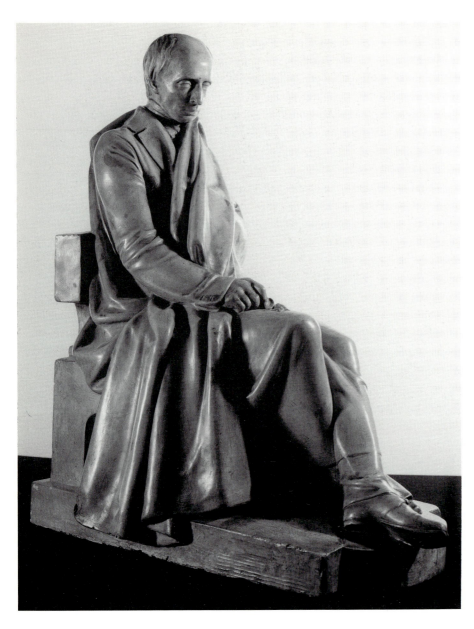

celandine, snowdrop and violet on either side make this one of Woolner's most Pre-Raphaelite works.

The success of this commission led Woolner to execute a bronze medallion of Wordsworth of which this is the only known example. It is clearly based on the Grasmere memorial, but also bears comparison with his portraits of Tennyson, Carlyle and Coventry Patmore.

A.K.

56 Model for the Wordsworth Memorial, Westminster Abbey, 1851

Plaster, 46 × 21 × 42cm ($18\frac{1}{8}$ × $8\frac{1}{4}$ × $16\frac{1}{2}$in)

Exh: RA 1852 (no.1353)
Lit: *The Crayon* 1857, p.362; Rossetti 1867, pp.361–2; W. Knight, frontis; A. Woolner, p.14; Blanshard 1959, pp.64, 105–6, 180, pl.36a, b; Read 1982, p.183

THE WORDSWORTH TRUST, GRASMERE

Plans for a memorial to Wordsworth were begun immediately after the poet's death in 1850, but attempts to raise public subscriptions were only partially successful. Nine sculptors, however, submitted proposals. Frederick Thrupp eventually won the competition over more ambitious proposals, such as Woolner's; this was probably because of financial constraints (*Art Journal*, 1 Aug. 1851, p.222).

Thomas Woolner described the original project (fig.15) as follows:

'In the present design, the aim kept in view has been to embody the "Individual Mind" of Wordsworth. In the centre is the Poet himself: on the pedestal which supports him is an illustration in *relievo* from "Peter Bell". – as being the poem wherein he has most distinctly enunciated his doctrine *that common things can be made equally suggestive and instructive with the most exalted subjects*; whence arose his direct influence on modern literature. The Groups are symbols of the two great principles he strove to inculcate.

1. Control of Passion (Being the basis of Law). This is represented by a father admonishing his sullen boy.
2. Nature contemplated to the glory of God. (Being the basis of Religion). Here a mother, while discovering to her daughter the works of creation, becomes lost in her own sense of their mystery.' (Read, p.183, n.79)

It is significant that Woolner signed this description of the original group 'Thomas Woolner PRB'. Woolner certainly regarded this work as an expression of his Pre-Raphaelite aims in sculpture.

Despite his success with the Grasmere *Wordsworth Memorial* the previous year, Woolner's failure to win the commission for the Westminster Abbey memorial disheartened him and seems to have strengthened his resolve to seek his fortune in the Australian goldfields.

Wordsworth's son acquired this model from Amy Woolner, without the flanking groups, or base, which he regarded as 'distasteful and discordant' (Blanshard, p.180).

A.K.

57 Charles Joseph Latrobe, 1853

Bronze, Diam 22cm (8⅝in)
Signed: T. WOOLNER. SC. 1853 / Melbourne

Lit: A. Woolner, pp.103, 337; R. Ormond 1973, p.262

PRIVATE COLLECTION

Born in London, Charles Joseph Latrobe (1801–1875) was
an extensive traveller and published accounts of his
journeys. In 1839, he was appointed Superintendent of the
Port Philip district of New South Wales and held this post
until 1851, when, at the time of the gold-rush, he became
Lieutenant-Governor of Victoria. Latrobe encouraged an
interest in culture and the sciences in Melbourne, which
gave impetus to the early appreciation of Woolner in
Australia. He resigned from office in 1854 and in 1857 he
returned to England. His nephew, Edward Latrobe Bateman,
who accompanied Woolner to Australia, was instrumental
in helping the sculptor obtain commissions from him. A
version of this relief was exhibited at the Victorian
Intercolonial Exhibition of 1875 at Melbourne (no.2887).

This was a very popular medallion and many versions of
this relief are known; one of the same size is in an English
private collection; the La Trobe Library, Melbourne
possesses two bronze casts and a plaster and there are
further examples at Newcastle City Gallery, New South
Wales, The Mitchell Library, Sydney and the Alexander
Turnball Library, Wellington, New Zealand. The National
Portrait Gallery in London and the National Gallery of
Victoria, Melbourne, contain reductions.

J.B.

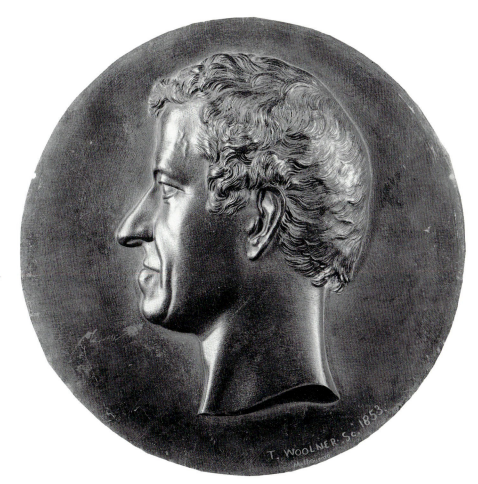

58 Sir Charles Augustus Fitzroy, 1854

Bronze, Diam 22cm (8⅝in)
Signed: T. Woolner Sc 1854

Lit: A. Woolner, pp.103, 337

PRIVATE COLLECTION

Sir Charles Augustus Fitzroy (1796–1858) was the grandson
of the 3rd Duke of Grafton. He was appointed Lieutenant-
Governor of Prince Edward Island in 1837 and from 1841–5
was Governor of the Leeward Islands. Fitzroy was given a
commission as Governor-in-Chief of New South Wales in
1846 and became Governor-General of the Australian
Colonies in 1851. When his term of office expired in 1855,
he returned to England.

The medallion was well received and the *Illustrated Sydney
News* (1 July 1854) reported that 'Both as a likeness, and as
a work of art, it may be considered perfect . . . For the sake
of those friends of Sir Charles Fitzroy who may desire to
possess his likeness, we may mention that Mr Woolner
intends, when he returns home, to take several bronze casts
from this medallion.' Amy Woolner listed it among several
medallions of particular merit, noting the high finish and
crisp detail of the hair. There are further examples at the
Mitchell Library, Sydney and the University of Sydney.

J.B.

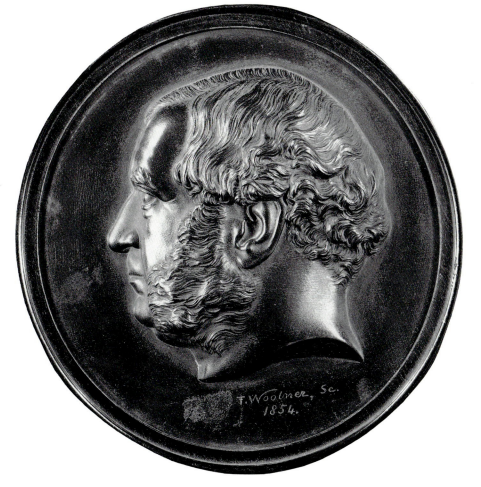

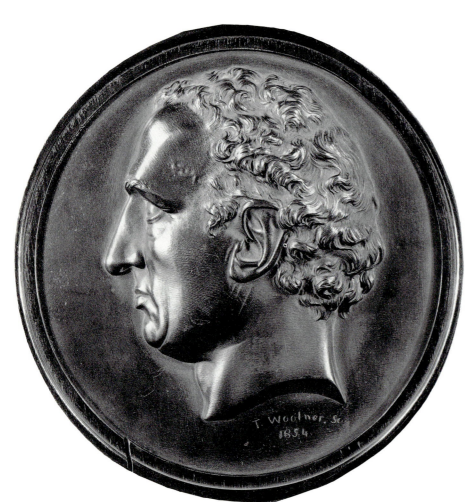

59 Edward William Terrick Hamilton, 1854

Bronze, Diam 22cm (8⅝in)
Signed: T. Woolner Sc. / 1854
Lit: A. Woolner, p.337

PRIVATE COLLECTION

Edward William Terrick Hamilton (1809–1898) was born in England, but in 1840 departed for Sydney to seek a more pastoral life. He held a seat on the Legislative Council of New South Wales from 1843–9 and was first Provost of the University of Sydney from 1851 until 1854. He returned to England with his family in 1855, the year after this medallion was cast. Hamilton retained connections with New South Wales, becoming its representative agent in London in 1863. He had two sons and six daughters, one of whom, Emily, was sculpted by Munro (cat.40). There is a further bronze example of the medallion at the Mitchell Library, Sydney, and the City of Ballarat Fine Art Gallery, Victoria, owns a plaster version.

J.B.

60 James Macarthur, 1854

Bronze, Diam 22cm (8⅝in)
Signed: T. Woolner. Sc / 1854
Lit: A. Woolner, p.337

PRIVATE COLLECTION

Landowner and politician, James Macarthur (1798–1867), was a member of one of the most prominent and intellectual families in early New South Wales, and was on the committee of the Australian Agricultural Company. He visited England in 1837, where he published *New South Wales: Its Present State and Future Prospects*. Nominated to the Legislative Council in 1839, he also became a member of the first Senate of the University of Sydney. He served briefly as Colonial Treasurer and was still a member of the Legislative Council at his death.

There is a version of the medallion in the Mitchell Library, Sydney, and a plaster one is held by the Australiana Fund, Kirribilli House.

J.B.

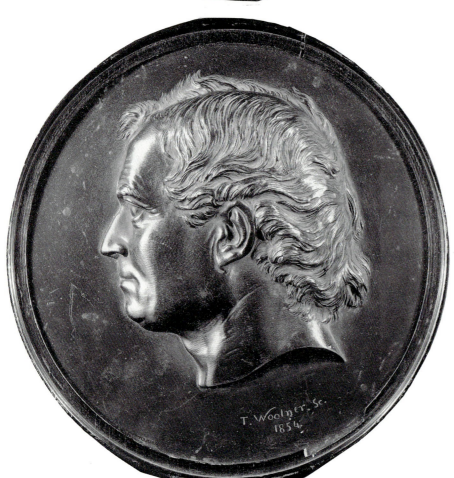

61 Sir James Martin, 1854

Bronze, Diam 22cm (8⅝in)
Signed: T. Woolner Sc. 1854
Lit: A. Woolner, p.337

PRIVATE COLLECTION

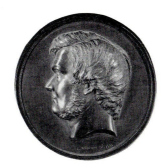

(see page 36)

Of Irish parentage, Sir James Martin (1820–1886) was elected to the Legislative Council of New South Wales in 1848 and to the first Parliament under responsible government in 1856. Martin was Premier of New South Wales from 1863–5 and formed a coalition with Sir Henry Parkes from 1866–8. He became Premier again briefly from 1870 until 1872, when he was succeeded by Parkes. Finally, Martin was appointed Chief Justice in 1873. A lawyer, good journalist and debater, Martin was a strong supporter of educational reform.

There is a version of this bronze medallion (probably a recent cast) in Martin Place, Open Museum, Sydney. Other examples are in the University of Sydney and the Mitchell Library, Sydney.

J.B.

62 William Charles Wentworth, 1854

Bronze, Diam 22cm (8⅝in)
Signed: T. Woolner Sc. 1854

Lit: A. Woolner, pp.73, 103, 337; R. Ormond 1973, p.500

PRIVATE COLLECTION

Educated in England, William Charles Wentworth (1790–1872), landowner, explorer and statesman, was co-founder of *The Australian* newspaper and in 1843 he became a member of the Legislative Council. Wentworth played a leading part in the politics of the period and was instrumental in achieving self-government for New South Wales. He resigned from office in 1862 and returned to England.

Wentworth was delighted with the Woolner medallion (letter, 25 Feb. 1854, BLO) and it was much praised by the newspaper reviewers, who expressed the hope that Woolner would obtain the commission for the statue of Wentworth, which was to be erected at Sydney University (this went to Pietro Tenerani). Together with that of Latrobe, the Wentworth medallion was probably the most popular of all the Australian portrait reliefs. *The Empire* (22 Feb. 1854) commented, 'the artist has caught by a happy inspiration the mental characteristics, the very soul of the man', and later in the year wrote of all Woolner's Australian medallions: 'They are far from mere portraits. They have each an individuality and a character which ordinary intelligence must perceive, but which requires extraordinary skill to convey.'

An example of the Wentworth medallion was exhibited at the Royal Academy in 1856 (no.1282). Woolner made several casts; there are examples in the collection of Miss Anne White; the Australian National Library, Art Gallery

of New South Wales, Sydney; Sydney University; Power
House Museum, Sydney; McClelland Gallery, Langwarrin,
Victoria; La Trobe Library, Melbourne (provenance,
Woolner family); and Lanyon Historic Homestead, Canberra
(loan). The National Portrait Gallery, London, possesses a
reduction.

J.B.

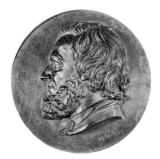

(see page 23)

63 Oriana Fanning, 1854

Plaster, Diam 22cm ($8\frac{5}{8}$in)
Signed: T. Woolner. Sc./1854
Lit: A. Woolner, p.337

JOANNA BARNES FINE ARTS, LONDON

Third daughter of Dr G. A. Richardson of Jamberoo, in 1844
Oriana (d.1905) married an English merchant, William
Fanning, who had settled in New South Wales and ran a
successful business importing wine, spirits and tea. Oriana
was the sister-in-law of the scientist T. H. Huxley, whom
her half-sister Harriet Heathorn married in 1855. Oriana had
two daughters and three sons. The family returned
permanently to England in 1870.

This is an interesting example of one of Woolner's
Australian plaster reliefs in a frame of contemporary,
colonial Australian manufacture. The sculptor subsequently
took several such plasters to London for casting in bronze
(see p.37). A similar plaster relief has appeared on the art
market paired with a medallion of William Fanning
(Christie's, London, 3 July 1985, lot 230). A cast of the latter
is also known in bronze, but it is not known whether the
medallion of Oriana was ever cast in this medium.

J.B.

64 Robert Browning, 1856

Bronze, Diam 24.1cm ($9\frac{1}{2}$in)
Signed: T. Woolner. Sc./1856

Exh: Colnaghi 1990, pp.67–8 (no.61)
Lit: Rossetti 1890, pp.182, 187; A. Woolner, pp.115, 124;
R. Ormond 1979, pp.58–9; Birmingham 1987, p.102
(no.317)

BIRMINGHAM CITY MUSEUMS AND ART GALLERY

Browning had been very impressed by the portrait
medallion of *Tennyson* (cat.66) which Woolner presented to
him in July 1856. By August of the same year work was
already well advanced on a medallion of Browning and
Woolner was pleased with the results. He wrote to Mrs
Tennyson; 'I . . . have made it so like folks make a great fuss
who have seen [it], his wife seems not to know how to
express enough praise . . . I am very glad Browning is
pleased for I have a great admiration for his books . . . and
his character I think noble and chivalric to the highest
degree' (A. Woolner, p.115).

Others, however, were not so wholehearted in their praise.
William Bell Scott, upon receiving a cast admired the
craftsmanship, but commented that he thought the
medallion 'the most unprepossessing poet's head it is well
possible to imagine' (A. Woolner, p.124). Reservations were
expressed by William Michael Rossetti, who thought the
precise contour of the features and penetrative gaze of the
eye were remarkable, but that it was 'somewhat less
acceptable as an ultimate type of the man' (Rossetti, p.187).

Browning himself must have been satisfied with his
medallion for he continued to admire Woolner's work and
even wrote a short poem, *Deaf and Dumb – A Group by
Woolner*, inspired by the sculptor's portrait group of
Constance and Arthur Fairbairn. Woolner's medallions of
Tennyson and *Browning* were exhibited together at the Royal
Academy in 1857 and plaster versions were acquired by Sir
Walter and Lady Trevelyan for the Central Hall at
Wallington. Among other versions known are two bronze
casts at Baylor University, Waco, Texas, USA, and art
market, London 1990. A plaster cast was with J. S. Maas &
Co, 1970, and a further plaster version of 1856 is in the
Australian National Gallery (formerly owned by the poet's
cousin Jane Eliza Browning of Melbourne).

A.K.

65 Love, *c.*1856

Plaster, H 96cm (37¾in)
Signed faintly: T. WOOLNER

Exh: RA 1856 (no.1342)
Lit: *Spectator* 1856, p.592; *The Crayon*, Dec. 1857, p.361; *Fraser's Magazine* (W. M. Rossetti), April 1861, p.505; Palgrave 1862, p.100; Tupper 1871, pp.99–100; A. Woolner, pp.112, 293, 337

IPSWICH BOROUGH MUSEUMS AND GALLERIES

The plaster statuette of *Love* was Woolner's first exhibited Ideal work following his return from Australia and Mrs Tennyson wrote to the sculptor expressing her hope that the 'little statue of yours will do great things for you. We shall look forward with warm interest for any proofs of appreciation' (A. Woolner, p.112).

A marble version was produced several years later for A. H. Novelli, whom Woolner had first met in 1858 and who became a close friend. The work was shown at the 1862 London International Exhibition where this time it was well reviewed (although it was perhaps overshadowed by the sculptor's *Constance and Arthur*). F. T. Palgrave in his *Handbook* to the Exhibition wrote: 'Love, with a charm and individuality rarely given to statues of this class, shows the artist's perfect mastery over truth of surface and sweetness of line'. The statuette was described in *The Crayon*: 'Love represents a young girl over whose mind the first thought of love has come like a blush, the clear light of morning, or like the first faint tint of colour in the petals of a rose; she stands lost in her fancy – half a dream, half a thought – hesitating as her hands are about to place a star-flower in her hair . . .'. The work seems to have been highly thought of, W. M. Rossetti described it as 'a . . . figure of delightful grace and tenderness' and both Rossetti and Tupper pointed to the fact that the sculptor had chosen to represent Love by a modern female figure rather than by the conventional image of Cupid.

The present work is probably the plaster half-life-size statue which was in Woolner's 1913 studio sale. A marble version was acquired from the sculptor by Mr Mandelbaum of New York and a Miss Orme owned a plaster cast.

M.G.

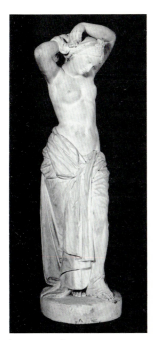

(see page 29)

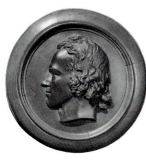

(see page 41)

66 Alfred Tennyson, 1856

Bronze, Diam 24cm (9½in)
Signed: T. Woolner Sc./1856

Exh: RA 1857 (no.1368)
Lit: A. Woolner, pp.105, 112–15, 121–3; L. Ormond 1981, p.8, ill. p.9

PRIVATE COLLECTION

In 1850, Woolner executed a bronze medallion of Tennyson. In December 1854, after his return to England from Australia the sculptor wrote to Mrs Tennyson: 'I have been thinking of the medallion and have concluded it will be better to make another entirely of a smaller size'

(A. Woolner, p.105). He was able to work this later model from his first attempt with little inconvenience to Tennyson, who thought of sittings with 'shoulder-shrugging horror' (A. Woolner, p.109). He worked on it in February 1855, had finished a first cast by November 1855 and finally completed it, after some slight alterations to the nose desired by Mrs Tennyson, in July 1856. It was exhibited at the Royal Academy in 1857 (no.1368).

Robert Browning considered that 'no likeness could possibly be better' (A. Woolner, p.115) and Mrs Tennyson described it as having 'delicate yet lofty beauty' (A. Woolner, p.121). Later in the year the medallion was engraved as the frontispiece to Edward Moxon's illustrated edition of *Poems* by Alfred Tennyson. Thus Woolner's portrait was seen in the same volume as illustrations by fellow members of the Pre-Raphaelites: Rossetti, Holman Hunt and Millais. Woolner produced a number of bronze and plaster casts of his 1856 medallion of Tennyson: examples of the plasters can be found at Wallington, Northumberland, National Portrait Gallery, London, and Tate Gallery, London.

A.K.

67 Alfred Tennyson, 1857

Marble, H 71.1cm (28in)
Signed: T. Woolner Sc.1857
Inscr: ALFRED TENNYSON/1857

Exh: Manchester 1857 (no.145); RA 1956–7 (no.452); Tate Gallery 1984 (no.89)
Lit: *Punch* 12 Nov. 1859, p.194; Watts, pp.39, 43; A. Woolner, pp.109–12, 131–2, 143–5, 173–4, 177–80; Read 1982, pp.65, 179; R. Ormond 1973, pp.452–3; L. Ormond 1981, pp.10–15

THE MASTER AND FELLOWS OF TRINITY COLLEGE, CAMBRIDGE

Woolner's eagerness to carve this bust of Tennyson was so great that he did so without any specific commission and even postponed work on a group for the 1856 Royal Academy exhibition. Mrs Tennyson encouraged Woolner and he himself hoped that the work would establish his reputation. He was not to be disappointed.

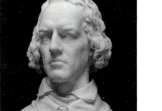

(see page 43)

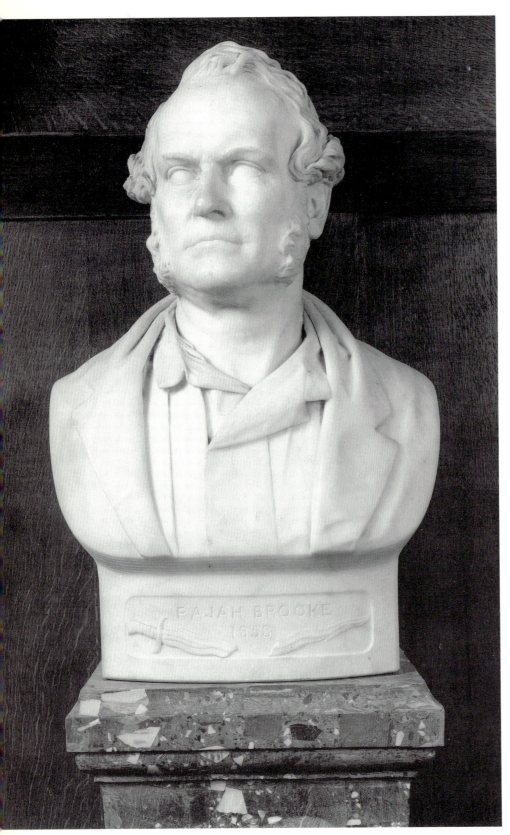

Woolner completed his plaster model by mid-April 1856 and carved this marble between autumn 1856 and spring 1857. He immediately had a stream of visitors admiring the bust. Ruskin is said to have considered it 'to be a triumph of Art' (A. Woolner, p.131), while the Rev. F. D. Maurice thought it should have been in the National Portrait Gallery and Carlyle said it was 'a thorough success, absolutely perfect' (A. Woolner, p.132). Woolner then sent it for inclusion in the Manchester *Art Treasures Exhibition*. Several people were interested in acquiring the bust, including Sir Thomas Fairbairn, Lord Ashburton and a Dr Bellows from Boston, USA. Tennyson was strongly against it going to the United States, so it was with relief that he heard that Trinity College, Cambridge had offered £200 for it in February 1858. However, it took nearly two years for Woolner to complete the sale and the Master of Trinity was unwilling to place a bust of a living person in the library, in respect of college tradition. It was finally placed in the library's vestibule in November 1859. The bust not only brought Woolner twelve more commissions from Trinity College for statues, busts and medallions of college worthies, but Sir Thomas Fairbairn later gave him five commissions.

Two other marble versions of this bust were made by Woolner: one for Charles Jenner, now in Westminster Abbey, and one for Charles Buxton, now in Christchurch Mansion, Ipswich.

A.K.

68 Sir James Brooke, Rajah of Sarawak, 1858

Marble, H 69cm (27⅛in)
Signed: T. WOOLNER SC/ *LONDON*
Integral socle inscr. on front: RAJAH BROOKE/1858
Beneath inscription a broken sword is incised

Exh: RA 1859 (no.1317)
Lit: *The Athenaeum*, 21 May 1859, p.684; Palgrave 1866, p.295; A. Woolner, p.148 ff. & 338; R. Ormond 1973, pp.64–6; Bronkhurst, pp.591–2, fig.2, Parris, p.110

PRIVATE COLLECTION

Sir James Brooke (1803–1868) went to Sarawak, Malaysia, seeking adventure and on quelling a rebellion there in 1841 was invited to govern and formally appointed as rajah in 1842. He instigated many reforms and suppressed piracy. In 1847, he was appointed as British Commissioner and consul-general, but shortly after was accused of cruel, illegal conduct by the House of Commons. In 1857, due to his opposition to the opium trade, he faced a plot to kill him by Chinese immigrants and dramatically escaped at night by swimming across a river. In 1858 he revisited England amidst public acclaim for his role during the Chinese revolt and this bust was commissioned in that year.

In May 1858, Woolner announced to Lady Trevelyan his hope of doing 'a bust of the great Rajah Sir J. Brooke: T. Fairbairn said if he could . . . he would give me a commission in marble, which would be excellent fun, for I regard him as one of the "grand old Raleigh kind", in fact

a man who does history and romance' (Trevelyan Papers). Thomas Fairbairn obviously confirmed the commission and in early August Woolner visited the Rajah at Godstone, Surrey. Later that month he reported to Lady Trevelyan 'there is a massive determined strength in his face and a slow leonine movement of the whole head lit with its frank gray eyes . . . I have never met a man who appeared to me more thoroughly a type of the Englishman' (Trevelyan Papers). The realistic treatment of the Rajah's pock-marked face received mixed reactions at the time, *The Athenaeum* commenting it looked like 'a mask of corrugated leather'.

The plaster was finished by 1858, but Woolner was still working hard to complete the marble for exhibition at the Royal Academy in March 1859, when Fairbairn and his friend Novelli called to see it and told Woolner of their scheme to appeal to the nation on behalf of Sir James since the Government had refused to help him (the appeal failed and the Rajah's great friend Baroness Burdett-Coutts sponsored his independent return to Sarawak). Judith Bronkhurst has suggested the bust's commission was part of this campaign (Bronkhurst, p.591).

A marble replica was bequeathed to the National Portrait Gallery, London, by Mrs T. Knox, presumably a descendant of the Rajah's friend, the journalist Alexander Knox, of whom Woolner made a portrait medallion.

J.B.

69 Moses on Mount Sinai, *c.*1858

Caen stone, 80 × 56cm (31½ × 22in)

Lit: Seddon, pp.29–30, ill. f.p.29; Read 1975–6; Read 1982, pp.58–61, pl.324; Pearson, pp.8, 13, ill. p.9

DEAN AND CHAPTER, LLANDAFF CATHEDRAL, CARDIFF

Moses was one of four relief panels designed by Woolner for the pulpit at Llandaff Cathedral, South Wales. The restoration of the Cathedral was carried out by the architects John Prichard and John Pollard Seddon and involved a substantial programme of redecoration from the early 1850s to the 1880s. Artists involved in the project included D. G. Rossetti (who painted the *Seed of David* reredos), Woolner, the local sculptors Edward Clarke and Milo Griffith and, later, H. H. Armstead. Thomas Seddon, the architect's brother and an artist closely associated with the Pre-Raphaelites, was largely responsible for contracting Rossetti and Woolner for the scheme.

Woolner exhibited plaster sketches of two of his reliefs, *Moses* and *St John the Baptist*, at the Royal Academy of 1858 (no.1203). The plasters were afterwards sent to Llandaff to be executed in stone by Edward Clarke, and fixed to the circular pulpit designed by J.P. Seddon between shafts of coloured marble. The *Moses* is the only one of the four to survive, the others having been damaged irreparably after bombing in the Second World War (the other subjects were *David Harping* and *St Paul*; figs 1–4). The plaster models exhibited at the Royal Academy are also untraced.

M.G.

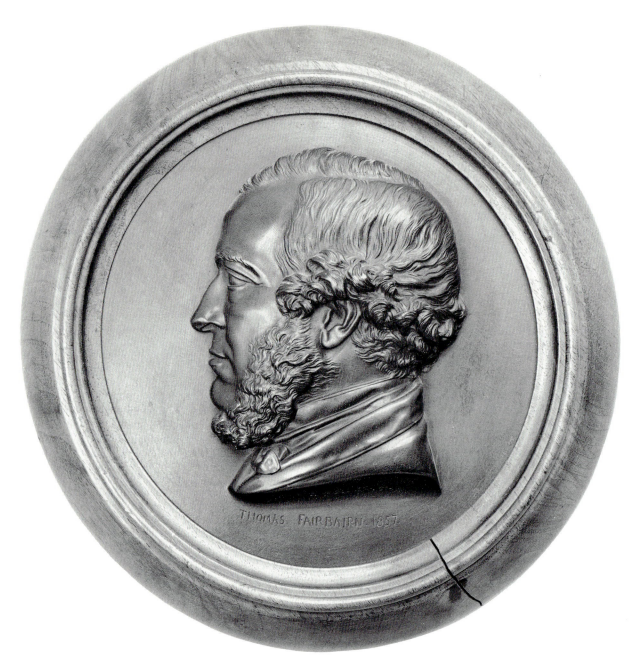

70 Sir Thomas Fairbairn, 1857

Bronze, Diam 24.5cm (9⅝in)
Signed: T. WOOLNER. SC. / THOMAS FAIRBAIRN. 1857.
Inscr. behind: *R.c.*

Lit: A. Woolner, p.142

PRIVATE COLLECTION

In 1857, Woolner was introduced to Sir Thomas Fairbairn (1823–1891), chairman of the *Art Treasures Exhibition* in Manchester, with a warm recommendation from William Holman Hunt. On meeting the Fairbairns at the Manchester exhibition Woolner had 'perfectly charmed them by his enthusiastic responsiveness' (Hunt, vol.II, pp.161–2). Sir Thomas had been interested in acquiring Woolner's bust of Tennyson from the exhibition, but withdrew when he heard Trinity College intended to purchase it. Instead he commissioned two new works from Woolner, this fine bronze medallion of Sir Thomas himself, exhibited at the Royal Academy in 1859 (no.1244) and a group of

Constance and Arthur Fairbairn, his deaf-mute children. *Constance and Arthur* (private collection) received universal acclaim at the International Exhibition in 1862. In addition, Woolner made a marble bust of Fairbairn's father, Sir William Fairbairn (private collection, USA), exhibited at the 1862 International Exhibition, and a marble memorial tablet to Sir William in 1874 (destroyed). In 1858, Sir Thomas also commissioned Woolner to make a bust of Sir James Brooke, the Rajah of Sarawak (cat.68).

On 2 May 1858, Woolner wrote to Lady Trevelyan that he thought his medallion of Sir Thomas 'one of the most carefully studied things I ever did' (Trevelyan Papers, Woolner to Lady Trevelyan, 2 May 1858), but that it had been placed among the 'doubtfuls' at the Royal Academy. The medallion is in the format of his *Browning* medallion; like the latter the sitter is shown in contemporary costume, but its detail is finer and modelling stronger than in the *Browning*.

A.K.

(see page 42)

71 Emily Tennyson, 1859

Painted plaster, Diam 23cm (9in)
Signed: T. Woolner Sc.
Inscr: EMILY TENNYSON 1859

Lit: A. Woolner, pp.159, 161, 337; L. Ormond 1981, p.13, ill.

PRIVATE COLLECTION

Emily Tennyson (née Sellwood) was the daughter of a solicitor from Horncastle. Her younger sister had married Tennyson's brother. As a result of the poet's success with 'In Memoriam' in 1850 Emily and Alfred were able to marry. Emily had a caring and calming influence on her husband and he is reported to have told his son, 'The peace of God came into my life when I wedded her' (*DNB*). They had two sons, Hallam and Lionel. Emily outlived her husband by four years, dying in 1896.

Emily's close friendship with Woolner is reflected in their correspondence which provides a valuable insight into the sculptor's life and work. Woolner had made his first portrait medallion of Emily in 1856. He made this second version in 1859 and wrote telling her that Lady Trevelyan was particularly pleased with it. She thought it 'looked 20 years younger than the old one . . . she did not like the other much yet this she thought charming and beautiful' (A. Woolner, p.159). 'Everybody who sees it', Woolner informed Mrs Tennyson, 'is delighted and says "What a beautiful profile she has"' (A. Woolner, p.161).

A further example of this plaster medallion, also dated 1859, can be found in the Art Gallery of South Australia, Adelaide.

J.B.

72 Adam Sedgwick, 1860

Marble, H 68cm (26¾in)
Signed: T. WOOLNER SC./LONDON
Integral socle inscr. on front: PROFESSOR SEDGWICK/
(Beneath inscription fossil is incised)/1860

Exh: Cambridge 1978, no.67
Lit: A. Woolner, pp.182, 186–8, 202–4, 338, repr. f.p.77; Goodison, p.145; R. Ormond 1973, p.414

THE MASTER AND FELLOWS, TRINITY COLLEGE, CAMBRIDGE

Geology and natural science had become highly fashionable and popular pursuits by the date of this bust. Following his election to the Woodwardian Professorship of Geology at

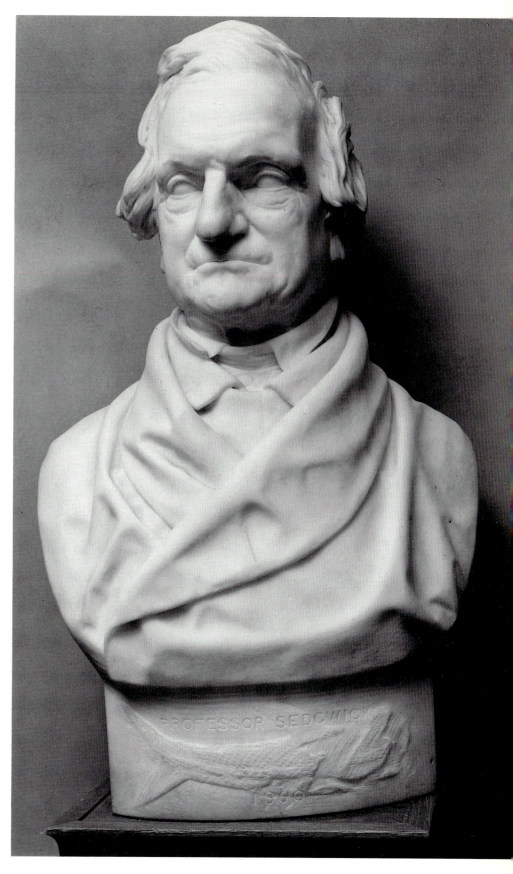

Cambridge in 1818, Adam Sedgwick (1785–1873) became a luminary in this field, promoting the study of natural science at the university and expanding its geological collections. In 1831, he was made President of the Geological Society.

Woolner impressed by Sedgwick hoped 'to get the fine old fellow to sit for a bust; which would be a grand thing, as it has rarely been my lot to contemplate so magnificent a head as his. He looks to have a most powerful intellect . . . another great man added to my gallery' (A. Woolner, p.182).

W. G. Clark, the Public Orator at Cambridge, arranged for Sedgwick's friends to commission the bust (the letter raising the subscription is contained in the Bodleian Library, Oxford). In February 1860 Sedgwick wrote to Woolner, 'It will be hard for you to turn my old, withered, wooden face to good account'. Due to the professor's age and ill-health Woolner worked particularly quickly. Next month he reported to Emily Tennyson that although it had been a tough job, the plaster was finished and 'everyone who has seen it declares it successful, and the enthusiasm expressed is all I can possibly desire' (A. Woolner, p.188).

The marble was completed by November 1860 (letter of 16 Nov. 1860, Trevelyan Papers) and Woolner wrote to Lady Trevelyan with obvious satisfaction: 'My Sedgwick is to be sent to Cambridge and exhibited in the anteroom of the Library . . . a good move on the board because it will I hope help to aid the dons in forming a decision as to the proper sculptor for Lord Macaulay's statue.' (letter of 23 Dec. 1860, Trevelyan Papers). It seems that there had been an earlier suggestion of placing it in the Fitzwilliam Museum (see letter from Woolner to Browning, MS BLO).

The intense realism of the naturalistic detail in this bust make it one of Woolner's most powerful Pre-Raphaelite portraits.

What is possibly the original plaster model of this bust is in the National Portrait Gallery, London (no.1669). A further plaster bust, executed for the Geological Museum in 1874, is now in the Department of Geology, Cambridge (Goodison, p.145).

J.B.

73 Reliefs from The Iliad, *c*.1865–8

Thetis Imploring Zeus; Achilles Shouting from the Trenches; Thetis Rousing Achilles
Plaster, 44 × 23.5cm (17¼ × 9¼in); 45 × 28.5cm (17¾ × 11¼in); 44 × 23.5cm (17¼ × 9¼in) respectively

Exh: RA 1868 (no.1027)
Lit: *The Athenaeum* 1868, p.769; Stephens 1894, p.84;

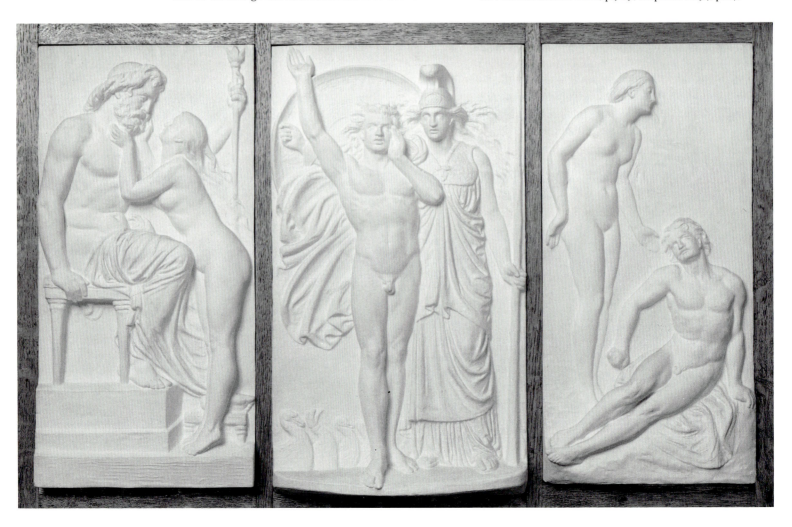

A. Woolner, pp.237–40, 268–9; Read 1982, p.123

These are plaster models for the three marble reliefs on the memorial to William Ewart Gladstone at Oxford (Ashmolean Museum). Woolner received his commission to make a bust of Gladstone in 1863 and he completed the model in August of that year. The marble bust was carved some time afterwards, according to Amy Woolner, and was presented to Oxford University by a group of subscribers in 1866 and placed in the Bodleian Library. The completed memorial consisted of the portrait bust on a plinth decorated with the three reliefs. The plaster models for the reliefs were exhibited at the Royal Academy in 1868.

The reliefs, based on scenes from *The Iliad*, were designed 'as a compliment to Mr. Gladstone's study and knowledge of Greek art' (A. Woolner, p.237). Gladstone, a Greek scholar who read the classics at Oxford, was a renowned commentator on Homer. He had published his *Studies on Homer and the Homeric Age* in 1858 and in 1863 together with his brother-in-law, Lord Lyttelton, he brought out *Translations*, containing passages from *The Iliad*.

Woolner thought it appropriate Gladstone 'should look the living man surrounding the Ideal subjects, to avoid any possibility of being mistaken for the poet himself instead of his commentator' (A. Woolner, p.268). Classical subjects were relatively unusual in Woolner's œuvre; Homer though remained high in Pre-Raphaelite esteem and was a two star 'Immortal'.

Woolner's reliefs are unconventional by neo-classical standards, detailed and sharply modelled, their actions vigorous and expressive. *The Athenaeum* praised the 'vigour of invention which is displayed in the Pallas and Achilles . . .' and F. G. Stephens referred to the 'splendid energy' of the *Achilles* relief.

Woolner carved a marble replica of the *Achilles Shouting from the Trenches* relief as his Diploma work for election as a Royal Academician and another marble version was made for the sculptor's patron Charles Jenner (Christchurch Mansion, Ipswich).

M.G.

74 William Bingham, Lord Ashburton, 1865

Marble, H 69cm (27⅛in)
Signed: T. WOOLNER SC / LONDON 1865
Inscr. on front of integral socle: WILLIAM BINGHAM LORD ASHBURTON
Lit: Surtees 1984, p.102; A. Woolner, p.338

THE MARQUESS OF NORTHAMPTON D.L.

At the time of Lord Ashburton's death in March 1864, Woolner was discussing the commission of a chimney-piece for Lady Ashburton's drawing-room at Melchet (Woolner diary 1864). By 3 June, when Woolner wrote to Pauline Trevelyan from The Grange, Lady Ashburton's Hampshire

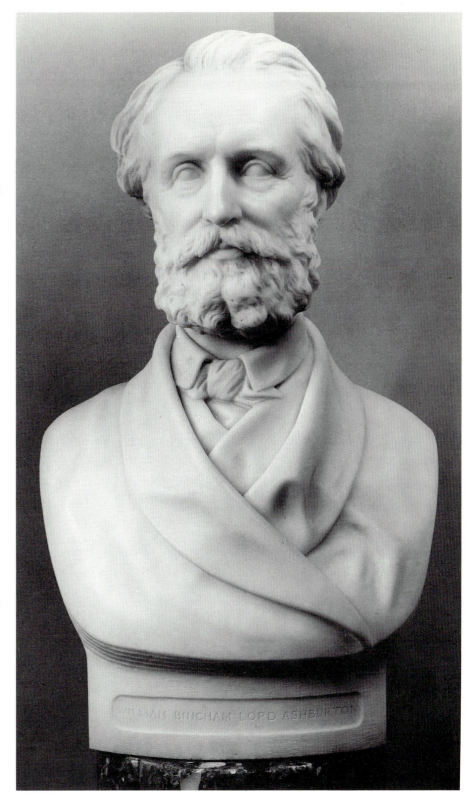

residence, the commission had been extended (there is a possibility that Rossetti was involved in negotiating the commission of the bust, see Surtees, p.102): 'She wants me to do a bust of poor Ld. Ashburton: and also I am to do a piece of sculpture for Melchet – her own house' (Trevelyan Papers, 3 June 1864). By late October, Woolner had commenced 'moulding' the bust and on 19 November, when Lady Ashburton called to see it, Carlyle was also present. Since Woolner had not known Lord Ashburton, it

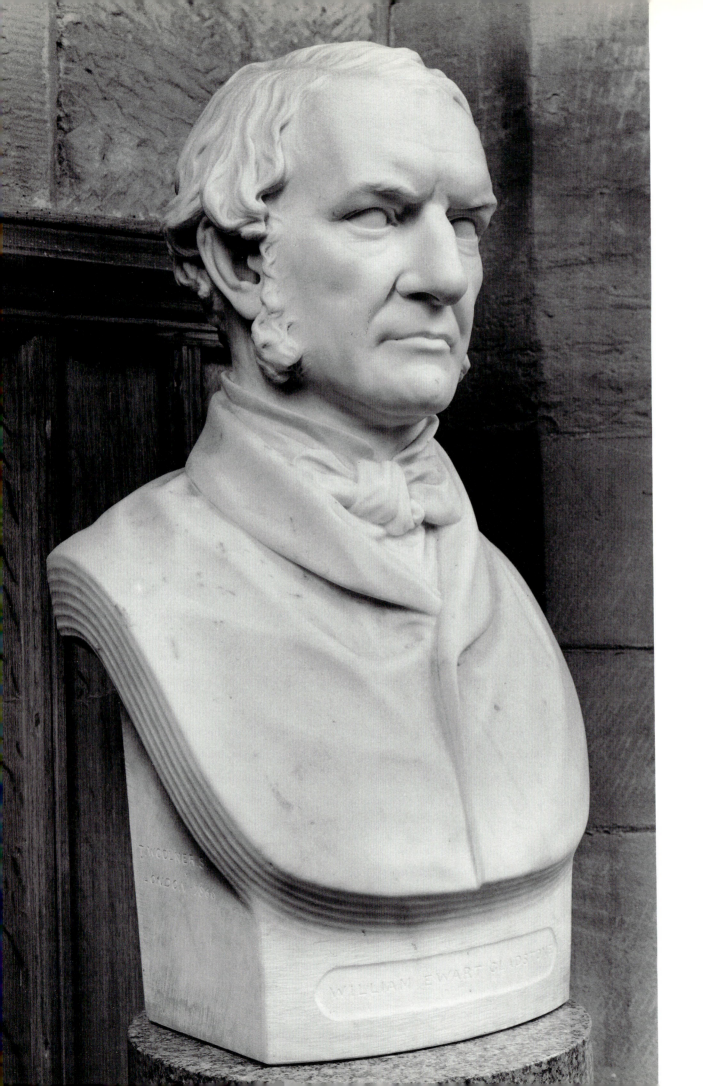

WILLIAM EWART GLADSTONE

seems likely they were advising on the portrait's resemblance to the sitter. Pauline Trevelyan thought Woolner the best person to undertake the bust, but wished he had known 'the exquisite sweetness of the expression and the quiet thoughtfulness and mixture of the gentleness and intellect' (Surtees, p.102). To assist with the likeness, Woolner borrowed Sir Edwin Landseer's portrait of Ashburton, which had been painted in the summer of 1862. By 28 November Woolner was about to begin the marble and purchased a slab from Fontana. His diary entry of 5 December notes he was now working from a photograph. On 15 December he called on Luchesi asking him to cast the bust (this plaster model was included in Woolner's studio sale, 15–28 Feb. 1913, lot 31) and on 27 December, Harrison carried the bust home to point. The marble was finished the following year and Woolner was highly satisfied with the result declaring it one of the most delicately finished works he had ever done (Surtees, p.102).

J.B.

75 William Ewart Gladstone, 1866

Marble, H 66cm (26in)
Signed: T. WOOLNER SC. / LONDON 1866
Front of integral socle inscr: WILLIAM EWART GLADSTONE

Lit: A. Woolner, pp.236–40, 340; Matthew, vol.VI, pp.221–4; Read 1982, pp.123, 174

PRIVATE COLLECTION

The commission in 1863 of this bust of William Ewart Gladstone (1809–1898), the distinguished statesman and author, was in part due to the persuasion of his brother-in-law George William Lyttelton and in part to the persistence of his wife. Gladstone wrote to the sculptor that he himself had 'doubts', but was resigned to pressure from his wife, who 'insists upon my leaving you to your fate' (18 Aug. 1863; A. Woolner, p.236). Woolner replied: 'I have long wished to make a bust of you . . . I will . . . start tomorrow [18 Aug.] . . . I have sent my clay, modelling stool etc., off today addressed to you to avoid mistakes; your servants will consider them uncouth and unintelligible arrivals, and might have refused them with a name they did not know attached' (A. Woolner, p.237). Mrs Gladstone arranged as many sittings as she was able and Gladstone noted these in his diary (Matthew, pp.221–2). The clay model was virtually finished by the end of August and on 4 September Gladstone recorded a 'final & brief sitting to Mr Woolner' (Matthew, p.224).

Two versions were carved in marble, one for Hawarden Castle and one which was presented by Gladstone's election committee to Oxford University, where he had been a Member of Parliament until 1865 (Woolner diary 1864). A pedestal with Homeric reliefs was also created for this latter bust (Exh. RA 1868, no.1268), which was known as the *Gladstone Memorial*. This bust was first placed in the Bodleian Library, but was later transferred to the Ashmolean Museum. The two marbles are almost identical, but there are slight variations in the collar of Gladstone's jacket.

In 1882 Woolner executed a further marble bust of Gladstone for the City of London, which was placed in the Guildhall (destroyed). This time at Gladstone's request it was a severely classical work, with no drapery and it was, he said, as he wished to be remembered (Read, p.174).

J.B.

76 Heavenly Welcome, c.1867

Patinated plaster, 132 × 73cm (52 × 28¾in)
Signed: T. Woolner Sc.

Exh: RA 1867 (no.1068)
Lit: *Saturday Review*, Aug. 1867, p.255; A. Woolner, pp.126, 242, 262, 339

CYRIL HUMPHRIS, LONDON

This is the plaster model for Woolner's life-size marble relief on the monument in Wrexham Church, North Wales, to Mary Ellen Peel and her son Archibald. Mary Ellen was the first wife of Archibald Peel, who was a close friend of the sculptor. She died on 9 September 1863, aged thirty-three, and her son in February 1860 aged one year and seven months. In December 1863 Woolner wrote to Mrs Tennyson to say that he was intending to go over to Ireland at Christmas to see Archibald Peel 'for a few days to study some portraits which he has at his father-in-law's place of his wife for the monument I am to do in her memory'. He added that he was pleased with the initial design and hoped to make a 'pathetic and poetic work to please and help console him' (A. Woolner, p.242). The plaster model was probably finished in 1865 and it was exhibited two years later at the Royal Academy. The *Saturday Review* described the work: '[It is] in high relief and represents a mother received at the gate of heaven by an angel bearing a child, who . . . leaps forward to caress her with a lively action of welcome'; the writer praised the 'ariel freedom of motion in the angel, expressed by the draperies and floating hair (for the artist has rightly spared us the commonplace of wings)' contrasting with 'the clinging earthly robe and the almost hesitating air of the mother, who leans gently forward with the sense of overpowering happiness, whilst the child springs forward with unreflecting eagerness'.

Following the work's completion Woolner wrote to Mrs Tennyson in 1865 that his friend Watkiss Lloyd, who saw it, 'says I shall have nothing to do but babies and Angels for years after this is exhibited', adding 'The Angels I should like very well, but as for the babies I profess no especial admiration for the pretty squalling little creatures' (A. Woolner, p.262).

The monumental alto-relief form gave Woolner the opportunity to work on a large scale, combining 'serious', affecting subjects appropriate to a church memorial, with the expression of tender, domestic sentiments. Monuments by Flaxman, such as that to *Agnes Cromwell* (1798; Chichester Cathedral), provided precedents for the composition and subject, though Woolner's work is more developed in its naturalism. The wingless angel, the detailed treatment of

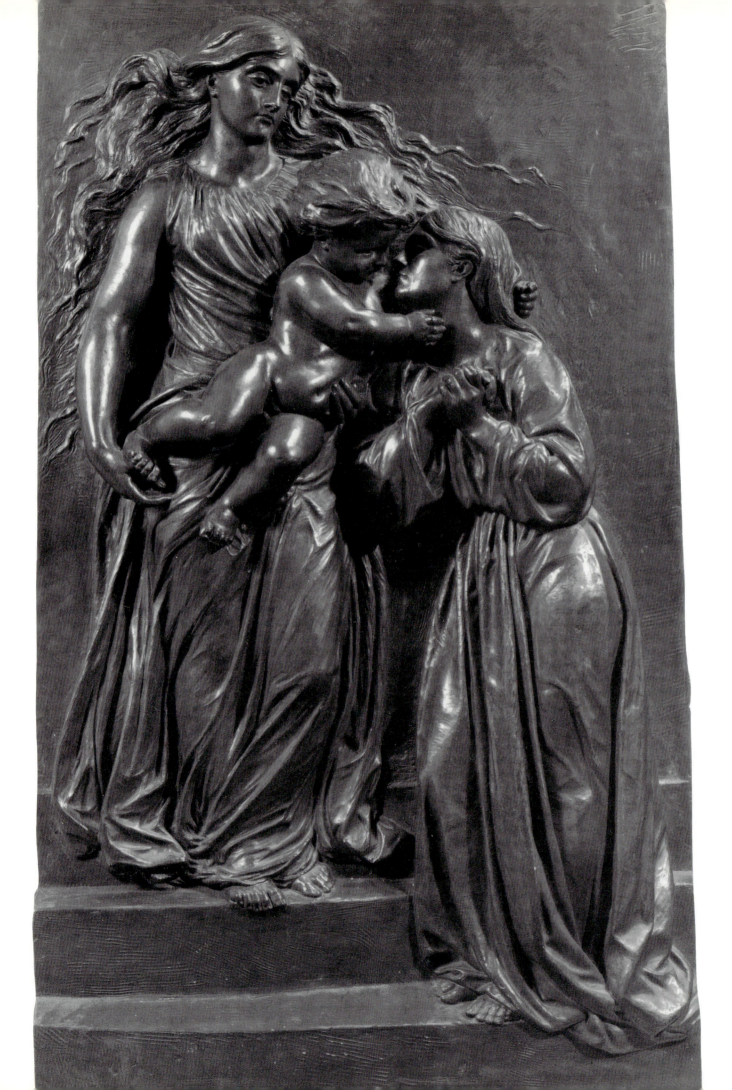

drapery and hair and the vigorously modelled form of the child with its chubby legs are characteristic of his work.

M.G.

77 Ophelia, 1868

Marble, H 96.5cm (38in)
Signed: T. WOOLNER.SC./—LONDON. 1868

Lit: *Saturday Review* 1869, p.710; A. Woolner, pp.317, 340

LENT BY MRS CYNTHIA FLETCHER TO THE GOVERNORS OF THE
ROYAL SHAKESPEARE THEATRE, STRATFORD-UPON-AVON

Woolner's *Ophelia* was exhibited at the Royal Academy in 1869 (no.1248) and several versions of the work were made as well as a bust which was exhibited at the Royal Academy in 1878 (no.1417; Ipswich, Christchurch Mansion).

The statue represents Ophelia as she is described in *Hamlet*, Act IV, Scene vii. Driven mad by the murder of her father by her lover Hamlet, she decks herself with flowers before drowning in a stream. She is represented seated on the river-bank, her hair and dress in disarray, with flowers in her hand and around her feet. The *Saturday Review* thought that 'Mr. Woolner's Ophelia, though on the brink of death, has no sentimentalism or pretty despair . . . Her beauty of feature and limb is cast in a grand and powerful type'.

The best-known representation of Ophelia in Victorian art is probably Millais' painting of 1852 (London, Tate Gallery) though Woolner himself had a particular interest in Shakespearean subjects. His *Puck* (cat.53a & b) was one of his earliest works and in 1882 he gave a speech on Shakespeare to the 'Urban Club' (a literary club), concluding by quoting Ophelia's speech when distributing flowers (A. Woolner, p.317).

The present work may be the marble version that was in the sculptor's studio sale in 1913 (lot 46). It has been on loan to the Royal Shakespeare Theatre since 1948. A marble version was also exhibited at the Garden Palace Exhibition of New South Wales in 1879.

M.G.

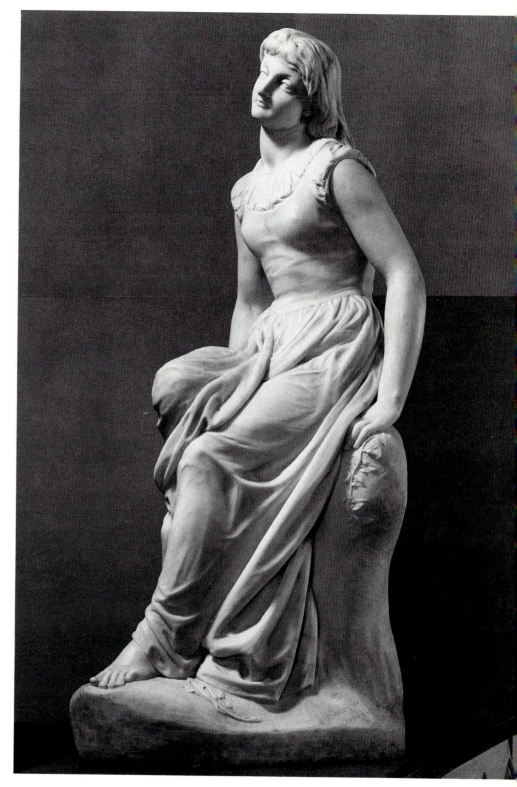

78 Charles Darwin, 1869

Marble, H 69cm (27⅛in)

Signed: T WOOLNER SC / LONDON 1869

Lit: Darwin, vol.III, pp.105, 140; A. Woolner, pp.283, 340;
Goodison , pp.59–60

UNIVERSITY OF CAMBRIDGE, BOTANY DEPARTMENT

The first suggestions that Darwin should sit to Woolner
came in December 1863 and again in August 1864 from
Joseph Dalton Hooker, who wished to have a bust of him.
However, it was not until November 1867 that Darwin

wrote to Hooker saying 'Woolner is coming here to make
a bust of me for my brother [Erasmus Alven]' and later talks
of letting Hooker have a cast of it. It seems from the Darwin
correspondence that Woolner may have made a preliminary
start in December 1867, but it was not until November 1868
that the sittings began in earnest (information kindly
provided by the 'Charles Darwin letters project'). Darwin
disliked sitting, but Woolner did his best to entertain the
great scientist. Darwin described himself 'undergoing the
purgatory of sitting for hours to Woolner, who, however,
is wonderfully pleasant, and lightens as much as man can,
the penance' (Darwin, p.107). During a sitting Woolner once

kept Darwin interested by describing how, while modelling his figure of *Puck* (cat.53a & b), he had noticed a blunt point on the folded edge of the human ear, which he had exaggerated in his statue. Woolner made Darwin a drawing of his observation, which Darwin called the 'Woolnerian tip' or 'Angulus Woolnerianus'; it was illustrated in Darwin's *The Descent of Man and Selection in relation to Sex*, London 1871, vol.1, p.22.

Darwin subsequently kept in touch with Woolner and in April 1871 asked his assistance in some research on the human blush: 'I daresay you often meet and know well painters. Could you persuade some *trustworthy* men to observe young and inexperienced girls who serve as models, and *who at first blush much*, how low down the body the blush extends?' (A. Woolner, p.288). The results of Woolner's researches are not known.

Woolner exhibited a bust of Darwin at the Royal Academy in 1870 (no.1198), but it is not clear which of the two known marble versions it was – the one exhibited here or another recorded as being in the possession of the Darwin family. The Royal College of Surgeons of England has a plaster version (Lefanu, p.65, no.66). A bronze medallion of Darwin was catalogued in Woolner's studio in Feb. 1913 (lot 123), which was presumably the same as that which Charles Darwin provided for Wedgwoods in 1869.

A.K.

79 In Memoriam, 1870

Galvanised plaster, 64 × 89cm ($25\frac{1}{4}$ × 35in)
Signed: T. WOOLNER SC LONDON 1870
Inscr: Blanche/Frances/Maurice/Edith

Lit: *The Athenaeum* 1870, p.647–8; Tupper 1871, f.p.97 ill. p.101; Stephens 1894, p.84; A.Woolner, f.pp.164 ill, p.340

AGNEW'S, LONDON

A galvanised version of the plaster *In Memoriam* which was exhibited at the Royal Academy in 1870 (no.1222); another plaster model is in the National Gallery of Victoria, Melbourne. Also known as *Four Children in Paradise*, it depicts the children of Thomas Hamber, three girls and a boy who died of an epidemic in their early childhood. It is said that the children posed for the plaster model which was intended for a family portrait but that they died shortly afterwards: the marble version was never carried out and the model was exhibited as a memorial and afterwards returned to the sculptor's studio (letter from a descendant of the owner of the plaster relief in Melbourne). One of the plaster versions was lent by Woolner to the exhibition which J. L. Tupper organised at Rugby school in 1879 (*Rugby* 1879, no.440; entitled *In Memoriam*).

The Athenaeum described the work as follows: 'The eldest girl sits on a bench; her juniors are likewise on it, and by her side the boy lies in easy and joy-abundant grace upon her knees, and plays with one of his young sisters, who,

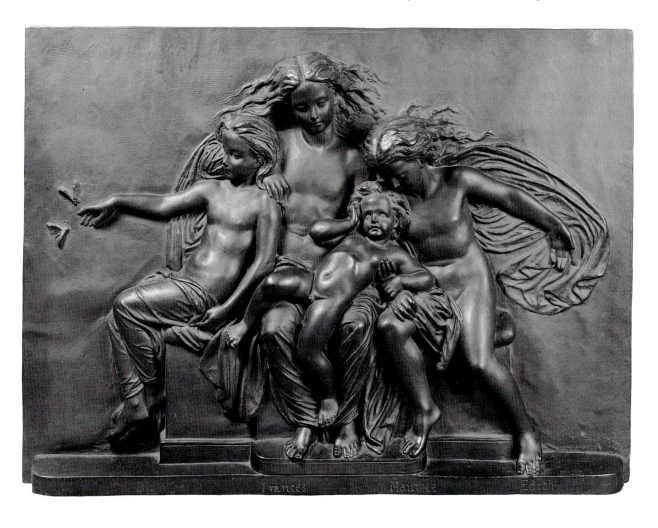

from our right, leans over and lovingly regards him. . . . The fourth child has another character – meditating, and in a dreamy mood; she – the body all apart from the soul – reclines against her eldest sister's side, and is caressed there by that elder, while, with outstretched arm, she extends a hand to where, emblems of the soul, two butterflies hover, – as if these were the souls she would beckon from the lost and lower world'.

Like *Heavenly Welcome* (cat.76), the relief is notable for its vigorous naturalism and for the individual characterisation of the figures. F. G. Stephens commended Woolner's 'skill in composing groups of figures in alto-relief, his rare knowledge of the naked form, and the charm of his faces of children'; Tupper admired Woolner's interpretation with 'No wings, no aurioles, no floating through the air: only vital flesh and earthly raiment', instead of 'devolving the task of spiritual expression upon conventional symbols with no intrinsic life'.

The technique of covering plaster with a thin sheet of metal as in this relief was an innovation made in the second half of the nineteenth century. It was used as a way of preserving studio plasters and later adapted for external statuary.

M.G.

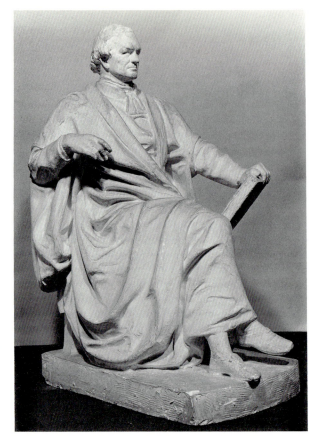

80 William Whewell, DD, FRS, 1870–2

Plaster, 59 × 24 × 39.5cm (23¼ × 9½ × 15½in)

Exh: Cambridge 1978 (no.68)
Lit: Tupper 1871, p.101; Read 1982, pp.22, 54, 128, 177

PRINCIPAL AND FELLOWS, NEWNHAM COLLEGE, CAMBRIDGE

William Whewell (1794–1866) was Professor of Mineralogy 1828–32 and Knightsbridge Professor of Moral Philosophy 1838–55. He was Master of Trinity from 1841 until 1866 and was Vice-Chancellor in 1843 and 1856. Whewell was instrumental in introducing science and mathematics to Cambridge.

This plaster is one of Woolner's models for the posthumous over-life-size seated marble statue of *Whewell* in Trinity College Chapel, which is dated 1872. The marble was exhibited at the Royal Academy in 1873 (no.1516). Another plaster model, which can be traced to Woolner's studio sale of 1913 (lot 67), is in the Fitzwilliam Museum, Cambridge. The model is very close to the final statue, the main variation is that the gown, which is swathed around Whewell in the model, is allowed to fall open in the final work, contributing towards a more expansive pose.

William Michael Rossetti was full of praise for the statue of *Whewell* (Read, p.22), as was J. L. Tupper, who wrote to F. G. Stephens in a letter *c.*1871 that he had seen Woolner, who was working hard to finish the marble relief of *Virgilia* (fig.26) for the Academy Exhibition, 'for my part I am more proud of his grand sitting Portrait of the late Master of Trinity, the background of the Virgilia is fine and spirited, but you know I have some fads as to the specific function of sculpture'. (MS, BLO)

J.B.

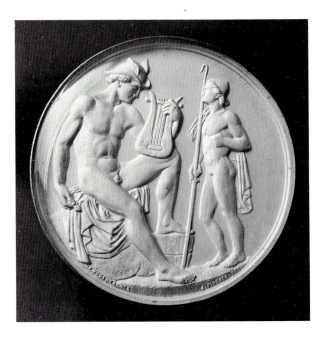

81 The Charles Lucas Medal, 1872

Unpolished silver, Diam 6cm (2⅜in)
Obv. signed: T. WOOLNER, DES. J. PINCHES FEC.
Rev: IN HONOREM / CAROLI LUCAS / APUD REGIAM MUSICAE ARTIS / ACADEMIAM OLIM INTER / PRISTINOS DISCIPULOS / ADSCRIPTI DEINDE PRÆSIDIS / OBIT MDCCCLXIX / ÆT: LXI

Lit: A. Woolner, p.341; Brown, no.2903

ROYAL ACADEMY OF MUSIC, LONDON

Charles Lucas (1801–1869), the composer, studied at the Royal Academy of Music, where in 1832 he was appointed conductor and became Principal from 1859 to 1866. He was an accomplished cellist in demand at major festivals and concerts.

Woolner designed this commemorative medal as a prize for Royal Academy of Music students. It was struck in both silver and bronze by the medallist, John Pinches. Woolner made a larger preparatory design in plaster, which was exhibited at the Royal Academy in 1872 (no.1576), with the description 'Mercury teaching a Shepherd boy to sing'. This is presumably identifiable as the one which, with full inscription on the reverse, was formerly in the possession of the Royal Academy of Music (untraced). A plaster medallion of the same subject is listed in Woolner's studio sale 1913 (lot 195).

J.B.

82 The Coleridge Memorial Prize, 1875

Electrotype bronze, H 34cm (13⅜in)
Signed: T. WOOLNER. SC. 1875

Exh: Christ's Hospital 1972 (no.10)
Lit: A. Woolner, pp.299, 342

THE GOVERNORS OF CHRIST'S HOSPITAL, HORSHAM

In 1872 G. C. Bell, the headmaster of Christ's Hospital, resolved to commemorate the centenary of the birth of its former pupil Samuel Taylor Coleridge (1772–1834), by establishing an annual academic challenge prize. A subscription was set up and funds raised and in July 1873 Bell announced that a silver group representing Coleridge, with two contemporaries, Thomas Fanshaw Middleton (1769–1822) and Charles Lamb (1775–1834), had been commissioned from a Mr Barkentin.

It is not known what happened to Barkentin's silver model of the *Coleridge Memorial*. Woolner started to design the present Coleridge Prize in 1874 and was modelling it early in January 1875. Bell knew Woolner and the sculptor is said to have made the work partly as a labour of love. The Coleridge Prize designed by Woolner follows closely the iconography established two years earlier, but with greater sentiment. Coleridge is shown seated on a high stool reading Virgil. On his left stands the older figure of Middleton leaning over his shoulder, while to his right Lamb stands on tip-toe.

In November 1875 Bell was able to inform the Almoners of Christ's Hospital that the new Coleridge Prize was ready. In a letter dated 16 Nov. to the Governor of Christ's Hospital, Bell writes that he had 'one or two casts from Mr Woolner, who has supplied them to me at £2 each' (MS Christ's Hospital, Bell to Dipnall, 16 Nov. 1875). The present exhibit appears to be one of these contemporary casts provided by Woolner. The whereabouts of the original bronze group is not known.

A.K.

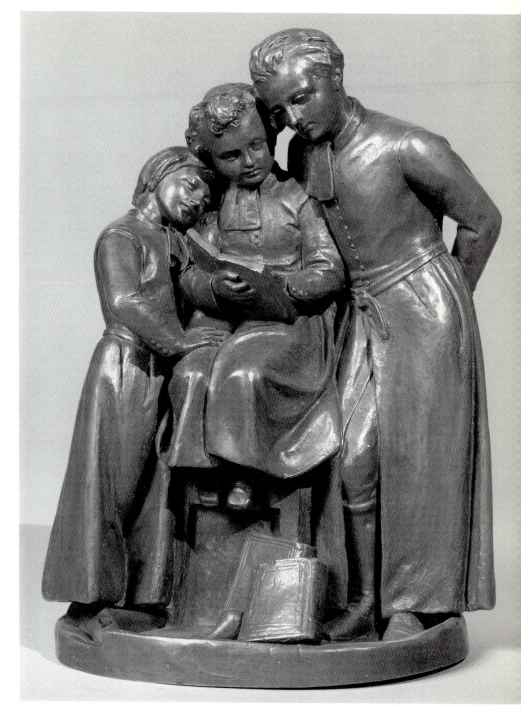

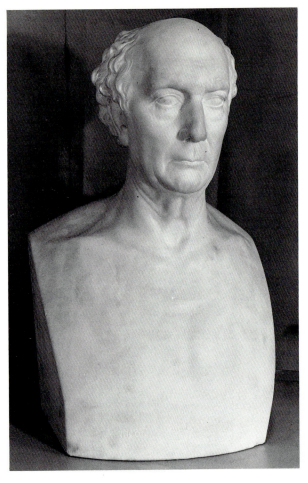

A.K.

84 John Stuart Mill, 1876–7

Patinated plaster, 44.5 × 17.8 × 31.8cm (17½ × 7 × 12½in)

Lit: Read 1982, p.54

WILLIAM MORRIS GALLERY, LONDON BOROUGH OF WALTHAM FOREST

John Stuart Mill (1806–1873) philosopher and economist, founded the Utilitarian Society in 1818. He believed education was the cure for all social evils and pursued the philosophy of the greatest happiness for the greatest possible number. He was a friend of Jeremy Bentham and Thomas Carlyle. His works include *Principles of Political Economy* and *On Liberty*.

This is the only surviving maquette for the large-scale bronze statue of Mill on the Victoria Embankment (fig.19), which was erected in January 1878. It differs in several respects from Woolner's final version in which Mill's pose and seat have been modified. The powerful naturalistic physiognomy apparent in the bronze is absent in the maquette.

The original commission was intended to go to J.H. Foley, but as early as October 1874, Woolner noted the commission in his diary and by November recorded he had visited the site with Arthur Arnold, who had been involved with the construction of the Thames Embankment project since 1861. Nearly a year later Woolner wrote to Sir Henry Parkes that he was just beginning the statue and in July 1876 he wrote, 'I am finishing off John Stuart Mill for the Thames Embankment. His friends tell me that I have not only caught his likeness, but the character of his figure, and have suggested the activity and restlessness of his mind.' The following September he announced: 'My Statue of J.S. Mill is now cast into plaster and will soon be in the hands of the bronze Founders and at the beginning of the year I hope to have it placed in position on the Thames Embankment . . . This embankment is the most magnificent public work that has ever been done in London during my time.' (Parkes Papers)

The artist Frank Brangwyn presented this maquette to the William Morris Gallery in 1937.

J.B.

83 Thomas Hewitt Key, 1875

Marble, H 65cm (25⅝in)
Signed: T. WOOLNER.RA.SC / LONDON 1875

Exh: RA 1876 (no.1423)
Lit: *DNB* 1892, p.85; A. Woolner, p.342

UNIVERSITY COLLEGE, LONDON

Thomas Hewitt Key (1799–1875) studied medicine at Cambridge and Guy's Hospital, London, but in 1825 accepted a professorship in pure mathematics at the University of Virginia, USA. In 1828, back in England, Key changed direction again to become Professor of Latin at the newly founded London University. He remained at University College until his death, becoming joint headmaster of the school attached to the College in 1833 and Professor of Comparative Grammar nine years later. He wrote Latin grammar books and a Latin dictionary. Key became a fellow of the Royal Society in 1860 and was a founding-member of the London Library.

This bust was commissioned by a group of Key's friends and former pupils a few months before his death in November 1875. Woolner has used the herm-shape format, as he did almost exclusively in his later portrait busts. While this formalisation of his busts is generally accompanied by a softening of naturalistic detail, Woolner's most striking late busts still have an intense interpretation of character. Key's tired eye and rippling double chin express something of the

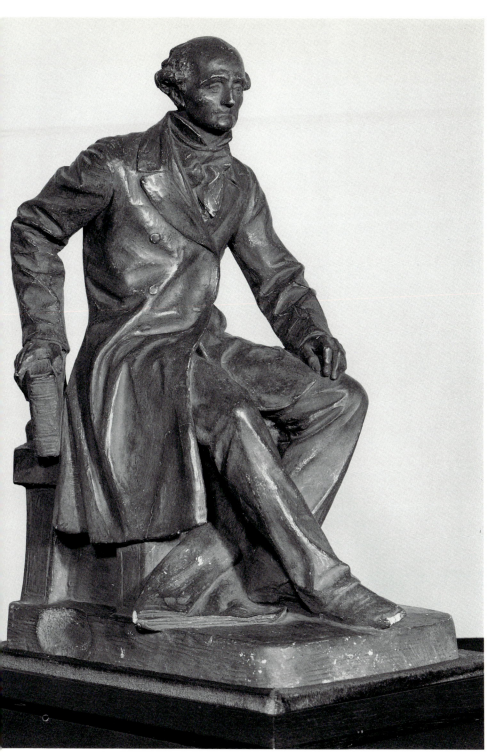

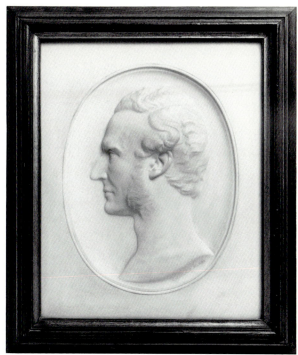

85 A Gentleman, 1882

Marble, 58.5 × 47.5cm (23 × 18⅝in)
Signed: T. WOOLNER SC. 1882

Exh: Thos Agnew & Sons Ltd 1989 (no.82)

JOANNA BARNES FINE ARTS, LONDON

The sitter for this medallion is unknown. The relief is an
interesting development of Woolner's smaller medallion
work and may be compared with his slightly earlier marble
relief depicting the scientist, Professor John Tyndall (exh.
RA 1876, no.1490; Royal Institution of Great Britain). The
present relief, in its original oak frame, is typically detailed
in the treatment of the hair, but shows a slight softening
in the sideburns which is characteristic of Woolner's later
style.

J.B.

86 Dorothy, 1882

Marble, Diam 31.8cm (12½in)
Signed: T.WOOLNER.SC.1882

Exh: RA 1883 (no.1659)
Lit: A. Woolner, f.p.292 ill., p.344; Birmingham 1987
(no.318)

This relief portrays Thomas Woolner's third daughter
Dorothy (b.1873), at the age of nine. She became an
accomplished portrait and figure painter, exhibiting three
times at the Royal Academy and once at the Royal
Institution of Painters and Watercolourists. In 1900 she
married George Henry Stephens, a civil engineer.

There is a plaster version of this medallion in an integral
square frame in the Ipswich Borough Museums. An earlier
cast of 1881 is also recorded (untraced; formerly in Woolner
family). One of the plaster medallions of Dorothy was
exhibited at the Royal Academy of 1882 (no.1603) and a
cast was included in Woolner's studio sale (lot 197).

One of the series of medallions Woolner made of his family
in the 1880s, this appears to have been the only one he
executed in marble. There is a bronzed plaster medallion of
his wife Alice Gertrude of 1883 in the Ipswich Borough
Museums and other plaster versions are recorded. He also
made plaster medallions of two other daughters Phyllis and
Clare (both untraced), which were included in his studio sale
(lots 180 & 181 respectively).

It was also Woolner's practice to cast his children's limbs
from the life and examples such as Amy, his eldest

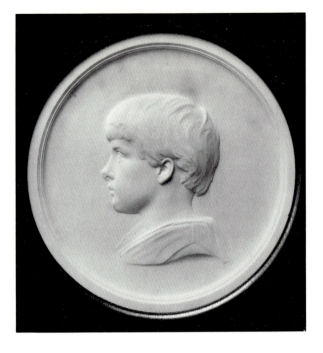

daughter's arm (1867), Hugh's hand and fist (both 1885) and
Geoffrey's hand (1882; in both plaster and bronze) were
formerly in the possession of the family (untraced). There
is no record of such casts of Dorothy having been taken.

This relief was presented to Birmingham City Art Gallery
by the sitter's executors.

J.B.

87 John Laird Mair Lawrence, 1st Baron Lawrence,
1882

Bronze, Diam 5.1cm (2in)
Obv. inscr: OB. 1879
Rev: HEAVENS LIGHT OUR GUIDE / IN HONOUR OF IOHN LORD
LAWRENCE.1882.

Lit: Adcock, p.58; Brown, p.335 (no.3121)

John Laird Mair Lawrence (1811–1879) rose through the
civil service to become, in 1863, Governor-General of India.
In 1869 he retired from the governorship and returned to
England to the title of Baron Lawrence of Punjab and
Grately. Woolner produced several portraits of Lawrence
exploiting a range of types, imagery and techniques.

In 1871 Woolner made a model for a statue of Lawrence
which was cast in bronze and erected in Calcutta in 1875.
At the same time he also made two models for busts: one

was in the classical herm-shape, common to Woolner's late busts; the other showed Lawrence draped in a cloak and wearing the Star of India. Both models seem to have remained as plaster until in 1879 Francis William Buxton, Lawrence's son-in-law, commissioned a bronze of the herm-shaped bust for his wife after her father's death. The other model was made in marble a year later for Lawrence's Memorial in Westminster Abbey (fig.22); a replica dated 1882 is in the National Portrait Gallery, London. Finally, Woolner produced this medal of Lawrence in 1882 with the assistance of Joseph Moore (1817–1892) the Birmingham-based medallist. The surplus of the Lawrence memorial fund was to be devoted to Lawrence studentships, for young north Indians, with each student receiving a gold version of Woolner's design. Although Amy Woolner describes a design for a gold medal, only silver and bronze versions are known to exist. The inscription on the reverse of the medal is the motto of the Most Exalted Order of the Star of India.

A.K.

88 The Housemaid, 1892

Bronze, H 127cm (50in)
Signed: T. WOOLNER.SC RA./1892

Exh: RA 1893 (no.1681)
Lit: *The Athenaeum* 1893, p.772; A. Woolner, pp.332–3, 345; Read 1982, p.212

THE SALTERS' COMPANY, LONDON

The *Housemaid* was Woolner's last work, finished in plaster only a few weeks before the sculptor's death in 1892. It was cast posthumously in bronze and shown at the Royal Academy in 1893.

The subject is described by Amy Woolner: '[it is] a life-sized figure of a servant girl wringing out the cloth with which she washes the doorstep (a sight which may be seen any morning early in the London streets)'. The sculptor had noticed the 'graceful action' of the girls and 'he used to say the servant girls in their plain print frocks were the best dressed women in London on week-days . . .'. (A. Woolner, pp.332–3)

The Housemaid is the only major example of a modern-life subject in Woolner's œuvre. *The Athenaeum* thought that many people 'may be surprised at the choice, by a sculptor trained in the highest art of his day, of such a subject'. The genre subjects produced in the late nineteenth century by sculptors such as Aimé-Jules Dalou (*Paysanne Française Allaitante*, 1873) and Hamo Thornycroft (*The Mower*, 1884) would have provided precedents for such themes though, according to Amy Woolner, it was 'a subject which the sculptor had long wished to do'. Woolner's figure can also be seen as a final manifestation of the Pre-Raphaelite concerns of truth to nature, female beauty and the theme of work, in a heroic contemporary image.

The bronze statue was acquired from the sculptor's wife by the Salters' Company of which Woolner had himself been made an Honorary Freeman in 1891 (A. Woolner, p.332).

M.G.

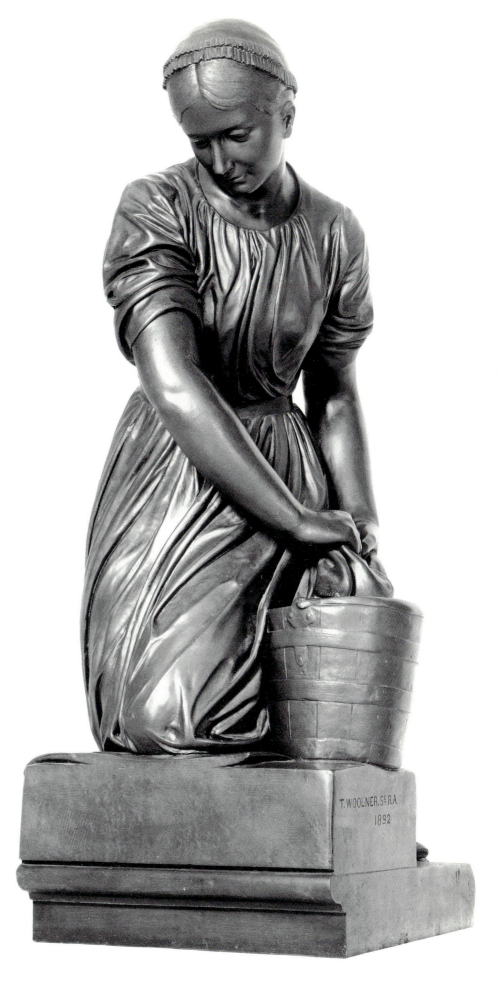

Abbreviations and Bibliography

Abbreviations: General

BI
British Institution

RA
Royal Academy

Abbreviations: Manuscripts

Acland Typescript
Private coll. Oxford

A.O. N.S.W.
Archives Office, Sydney, New South Wales

BLO
Bodleian Library, Oxford

Butler Papers
St Paul Butler Papers, Northumberland Record Office

La Trobe Coll.
La Trobe Collection, State Library of Victoria

MPL
Marylebone Public Library, London

Parkes Papers
Parkes Papers, Mitchell Library, Sydney, Australia

Reynolds-Stephens MS
Reynolds-Stephens MS, 'Most Important: Record of All My Works', c.1934, National Art Library, Victoria and Albert Museum, London

Trevelyan Papers
Trevelyan Papers, Special Collections, University Library, Newcastle upon Tyne

Troxell Coll.
Troxell Collection, Princeton University, USA

Woolner diaries
1864 & 1874 vols, Henry Moore Centre for the Study of Sculpture, Leeds

Abbreviations: Literature

Acland & Ruskin
H. W. Acland & J. Ruskin, *The Oxford Museum*, London & Oxford 1859; London & Orpington 1893

Adcock
R. Adcock, 'Thomas Woolner Sculptor and Medallist', *Coin and Medal News*, Jan. 1986, pp.56–8

Agnew 1989
Master Drawings & Sculpture (exh.cat.), Thos Agnew & Sons Ltd, London 1989

Allingham & Williams
H. Allingham and E. Baumer Williams (eds), *Letters to William Allingham*, London 1911

Amor
A. C. Amor, *William Holman Hunt: the true Pre-Raphaelite*, London 1989

Armstead
C. W. Armstead, *Henry Hugh Armstead RA. A Sketch*, London 1906

Art Union Report
Annual Report of the Council of the Art Union of London 1848–53

Arts Council 1961
Morris and Company 1861–1940 (exh.cat.), London 1961

Arts Council 1975–6
Burne-Jones (exh.cat.), Hayward Gallery, London 1975–6

Atterbury
P. Atterbury (ed.), *The Parian Phenomenon. A Survey of Victorian Parian Porcelain Statuary & Busts*, Shepton Beauchamp 1989

Attwood
P. Attwood, 'Maria Zambaco: *Femme Fatale* of the Pre-Raphaelites', *Apollo*, July 1986, pp.31–7

Baldry
A. L. Baldry, 'The Work of W. Reynolds-Stephens', *Studio*, XVII, no.76, July 1899, pp.75–85

Barbican
J. Christian (ed.), *The Last Romantics* (exh.cat.), Barbican Art Gallery, London 1989

Beattie
S. Beattie, *The New Sculpture*, New Haven & London 1983

Bell
M. Bell, *Sir Edward Burne-Jones. A Record and Review*, London 1892

Bennett 1969
M. Bennett, *William Holman Hunt* (exh.cat.), Liverpool & London 1969

Bennett 1988
M. Bennett, *Artists of the Pre-Raphaelite Circle: The First Generation – Catalogue of Works in the Walker Art Gallery, Lady Lever Art Gallery and Sudley Art Gallery*, London 1988

Birkett & Poland
E. L. Birkett & A. Poland, *Guy's Hospital Reports*, 1853 ed.

Birmingham 1872
Posthumous exhibition of works by Alexander Munro, at Birmingham and Midland Institute, Jan. 1872 (uncatalogued), exhibits listed in *Birmingham Post*, 10 Jan. 1872

Birmingham 1930
Catalogue of the Permanent Collection of Paintings etc, City Art Gallery, Birmingham 1930

Birmingham 1939
Catalogue of The Permanent Collection of Drawings, City Art Gallery, Birmingham 1939

Birmingham 1976
The Last of England (exh.cat.), Birmingham City Art Gallery, Feb.–April 1976

Birmingham 1987
E. Silber, *Sculpture in Birmingham Museum and Art Gallery. A Summary Catalogue*, Birmingham 1987

Blanshard
F. Blanshard, *Portraits of Wordsworth*, London 1959

Blau
E. Blau, *Ruskinian Gothic. The Architecture of Deane and Woodward 1845–61*, Princeton & Guildford 1982

Bornand
O. Bornand (ed.), *Diary of W. M. Rossetti 1871–1873*, Oxford 1977

Bronkhurst
J. Bronkhurst, 'Fruits of a Connoisseur's Friendship: Sir Thomas Fairbairn and William Holman Hunt', *Burlington Magazine*, CXXV, Oct. 1983, pp.586–97

Brown
L. Brown, *A Catalogue of British Historical Medals 1837–1901: The Reign of Queen Victoria*, London 1987

Buenos Aires 1931
British Empire Trade Exhibition (exh.cat.), Buenos Aires 1931

Butler
J. E. Butler (ed.), *Recollections of George Butler*, Bristol 1892

Cambridge 1978
Cambridge Portraits from Lely to Hockney (exh.cat.), Fitzwilliam Museum, Cambridge 1978

Cambridge 1991
Barbara Bodichon 1827–1891 Centenary Exhibition (exh.cat.), Girton College, Cambridge, June 1991

Carr
J. Comyns Carr, *Some Eminent Victorians*, London 1908

Champneys
B. Champneys, *Memoirs and Correspondence of Coventry Patmore*, 2 vols, London 1900

Charteris
E. Charteris, *John Sargent*, London 1927

Christian
J. Christian, '"A Serious Talk": Ruskin's Place in Burne-Jones's Artistic Development', in L. Parris (ed.), *Pre-Raphaelite Papers*, London 1984

Christ's Hospital
Samuel Taylor Coleridge and Christ's Hospital (exh.cat.), Christ's Hospital, Horsham 1972

Clementi
C. Clementi, 'Artists in Society: A Melbourne Circle 1850s–1880s', *Art Bulletin of Victoria*, no.30, 1989, pp.40–57

Colnaghi
Whisper of the Muse. The World of Julia Margaret Cameron (exh.cat.), P. & D. Colnaghi, London 1990

Cook
E. T. Cook, *Life of John Ruskin*, 2 vols, London 1911

Cook & Wedderburn
E. T. Cook & A. Wedderburn (eds), *The Works of John Ruskin*, 39 vols (Library Edition), London 1903–12

Coombs et al.
J. H. Coombs, A. M. Scott, G. P. Landow, A. A. Saunders (eds), *A Pre-Raphaelite Friendship. The Correspondence of W. H. Hunt and J. L. Tupper*, Ann Arbor, Michigan 1986

Crabbe
J. Crabbe, 'Hidden by History – Barbara Bodichon, an artist obscured for a century by her feminist image', *Watercolours Drawings and Prints*, vol.6, no.2, Spring 1991, p.13 f.

The Crayon
'The Two Pre-Raphaelitisms' (Signed L.L.), *The Crayon: A Journal devoted to the Graphic Arts, and Literature related to them*, vol.IV, pt XII, Dec. 1857, pp.361–3

Darwin
F. Darwin (ed.), *The Life and Letters of Charles Darwin*, 3 vols, London 1887

De Lisle
F. De Lisle, *Burne-Jones*, London 1904

DNB
The Dictionary of National Biography

Dolan
D. Dolan, 'Thomas Woolner, Australia's Pre-Raphaelite', *Australian Connoisseur and Collector*, no.4, 1983, pp.88–91

Dorment
R. Dorment, *Alfred Gilbert*, New Haven & London 1985

Doughty & Wahl
O. Doughty & J. R. Wahl (eds), *Letters of Dante Gabriel Rossetti*, 4 vols, London & Oxford 1965

FAS
Robert Anning Bell. Paintings, Drawings and Coloured Reliefs (exh.cat.), Fine Art Society, London 1907

Fitzmaurice
Lord E. Fitzmaurice, *The Life of Granville George Leveson Gower, the Second Earl Granville K.G. 1815–1901*, 2 vols, London 1905

Fredeman
W. E. Fredeman (ed.), *The P.R.B. Journal, William Michael Rossetti's Diary of the Pre-Raphaelite Brotherhood 1849–1853 Together with other Pre-Raphaelite Documents*, Oxford 1975

Galhally
A. Galhally, 'The Lost Museum: Redmond Barry and Melbourne's "Musée des Copies"', *Australian Journal of Art*, vol.VII, 1988, pp.28–49

Ganz
H. F. W. Ganz, *Alfred Gilbert at His Work*, London 1934

Gardiner
A. G. Gardiner, *The Life of Sir William Harcourt*, 2 vols, London 1923

GB-J
G(eorgiana) B(urne)-J(ones), *Memorials of Edward Burne-Jones*, 2 vols, London 1904

Gere
J. Gere, 'Alexander Munro's "Paolo and Francesca"', *Burlington Magazine*, CV, Nov. 1963, pp.509–10

Goodison
J. W. Goodison, *Catalogue of Cambridge Portraits: I The University Collection*, Cambridge 1955

Graham
E. Graham, *The Harrow Life of Henry Montagu Butler D.D.*, London 1920

Green
R. Lancelyn Green (ed.), *The Diaries of Lewis Carroll*, 2 vols, London 1953 [1954]

Greenwood
F. Greenwood, 'Thomas Woolner' *The Illustrated London News*, 15 Oct. 1892, p.475

Grieve
A. I. Grieve, *The Art of Dante Gabriel Rossetti III: The Watercolours and Drawings of 1850–1855*, Norwich 1978

Grosvenor Gallery 1879
Grosvenor Gallery, London (exh.cat.) 1879

Gunnis
R. Gunnis, *Dictionary of British Sculptors 1660–1851*, London 1953; 1964 (2nd ed.)

Hancock
T. Hancock, 'Dante G. Rossetti', *The Academy*, 6 May 1881, p.323

Handley-Read
C. Handley-Read, 'Sculpture in High Victorian Architecture', *The High Victorian Cultural Achievement. Second Conference Report of The Victorian Society*, ill. 2nd ed., London 1967

Harrison & Waters
M. Harrison & B. Waters, *Burne-Jones*, London 1973

Hill
G. B. N. Hill (ed.), *Letters of D.G. Rossetti to William Allingham*, London 1897

Howell
P. Howell, 'Churches with a Welsh Flavour – The Vale of Clwyd II', *Country Life*, CLXII, 20 Oct. 1977, pp.1086–8

Howitt
M. E. B. Howitt, 'The Howitts in Australia', *Victorian Historical Magazine*, vol.3, 1913, pp.1–24

Hueffer
J. L. F. H. M. Hueffer, *Ford Madox Brown: A Record of His Life and Work*, London 1896

Hunt
W. Holman Hunt, *Pre-Raphaelitism and the Pre-Raphaelite Brotherhood*, 2 vols, London 1905–6

Hutchison
Lt-Colonel G. Seton Hutchinson, *The Sculptor, Sir William Reynolds-Stephens. P.R.B.S 1862–1943. A Biographical Note*, Nottingham 1944

ILN
The Illustrated London News

Ironside & Gere
R. Ironside & J. Gere, *Pre-Raphaelite Painters*, London 1948

James 1948
Rev. J. L. B. James, *Among My Friends*, unpublished memoir, c.1948, typescript in private collection

James 1979
F. James, 'An Artist who tired of painting: the work of Charles Hancock 1802–1877', *The Connoisseur*, July 1979, pp.190–3

Johnson
G. W. & L. A. Johnson (eds), *Josephine Butler. An Autobiographical Memoir*, Bristol 1928 (3rd ed.)

Kapoor
S. Kapoor, *John Lucas Tupper. The Life and Works of a Minor Pre-Raphaelite*, unpublished MA thesis, Brown University, USA, June 1982

Kapoor 1984
S. Kapoor, 'John L. Tupper, to 1863: "King of the Cadaverals"', *The Journal of Pre-Raphaelite Studies 1984*, IV, no.2 pp.70–86

Kapoor 1986
S. Kapoor, 'John Lucas Tupper, 1865–79: The Rise of "Outis"', *The Journal of Pre-Raphaelite Studies, 1986*, VI, no.2 pp.37–43

V. Knight
V. Knight, *Works of Art of the Corporation of London a catalogue of paintings etc.*, Cambridge 1986

W. Knight
W. Knight (ed.), *Wordsworthiana, A Selection from Papers read to the Wordsworth Society*, London & New York 1889

Lang & Shannon
C. Y. Lang & E. F. Shannon Jnr (eds), *The Letters of Alfred, Lord Tennyson*, 3 vols, Oxford 1982–90

LeFanu
W. LeFanu, *A Catalogue of the Portraits and other Paintings, Drawings and Sculptures in the Royal College of Surgeons of England*, Edinburgh & London 1960

Lennon
J. Lennon, *Professional Sculpture in Sydney in the 1840s and 1850s*, unpublished Fine Arts 4 Essay, held by Power Institute, University of Sydney

Lessing
D. Lessing, *The Story of a Non-Marrying Man*, London 1975

Löcher
K. Löcher, *Der Perseus-Zyklus von Edward Burne-Jones*, Staatsgalerie Catalogue, Stuttgart 1973

McAllister
I. McAllister, *Alfred Gilbert*, London 1929

McCarthy
J. H. McCarthy, *The Portrait*, no.5 (date unknown)

MacDonald
G. MacDonald, *George MacDonald and his wife*, London 1924

Macdonald
K. Macdonald, 'Alexander Munro, the Pre-Raphaelite Brotherhood and the "Unmentionable"', *Apollo*, March 1982, pp.190–7

Mackail
J. W. Mackail, *Life of William Morris*, 2 vols, London 1950

Manchester 1857
Catalogue of the Art Treasures of the United Kingdom (exh.cat.), Manchester 1857

Manchester 1978–9
Victorian High Renaissance (exh.cat.), Manchester, Minneapolis and Brooklyn 1978–9

Marsh
J. Marsh, *Elizabeth Siddal 1829–1862 Pre-Raphaelite Artist* (exh.cat.), Sheffield, The Ruskin Gallery, 1991

Martin
A. W. Martin, *Henry Parkes. A Biography*, Melbourne University Press, 1980

Matthew
H. C. G. Matthew, *The Gladstone Diaries*, 8 vols, Oxford 1968ffg

Melbourne
Mason, Firth & M'Cutcheon, *Official Record 1882*, Melbourne International Exhibition 1880–1

Metcalf
P. Metcalf, *James Knowles: Victorian editor and architect*, Oxford 1980

Millais
J. G. Millais, *The Life and Letters of Sir John Everett Millais*, 2 vols, London 1899

Moore
H. Moore, 'Introduction', in M. Ayrton *Giovanni Pisano Sculptor*, London 1969

M. Morris
May Morris, *William Morris Artist Writer Socialist*, 2 vols, Oxford 1936

W. Morris
The Collected Works of William Morris (intro. May Morris), 24 vols, London 1910–15

New Gallery 1892–3
Works of Edward Burne-Jones (exh.cat.), London 1892–3

New Gallery 1898–9
Works of Sir Edward Burne-Jones (exh.cat.), London 1898–9

Noakes
V. Noakes, *Edward Lear: Selected Letters*, Oxford 1988

L. Ormond 1981
L. Ormond, *Tennyson & Thomas Woolner*, Tennyson Society Monograph, Lincoln 1981

L. & R. Ormond 1975
L. & R. Ormond, *Lord Leighton*, New Haven & London 1975

R. Ormond 1967
R. Ormond, 'Portraits to Australia', *Apollo*, LXXXV, no.59, Jan. 1967, pp.25–7

R. Ormond 1973
R. Ormond, *Early Victorian Portraits*, 2 vols, London 1973

R. Ormond 1979
R. Ormond, *The Pre-Raphaelites and their circle – A booklet illustrating, with descriptive notes, some of the most important works of the Pre-Raphaelites in the permanent collection of the Birmingham Museum and Art Gallery*, Birmingham 1979

Palgrave 1862
F. T. Palgrave, *Handbook to the Fine Art Collections in the International Exhibition of 1862*, London & Cambridge 1862

Palgrave 1866

F. T. Palgrave, *Essays on Art*, London & Cambridge 1866

Parkes

K. Parkes, *Sculpture of To-day*, 2 vols, London 1921

Parr

L. Parr, 'The Emergence of Contemporary Sculpture' in J. Peers & J. Ross (eds), *Sculpture, the McClelland Gallery Permanent Collection*, Langwarrin 1989, unpaginated

Parris

L. Parris (ed.), *Pre-Raphaelite Papers*, London 1984

Peattie

R. W. Peattie (ed.), *Selected Letters of William Michael Rossetti*, The Pennsylvania State University Press, University Park & London 1990

Poole

Mrs R. Lane Poole, *Catalogue of Portraits in the Possession of the University, Colleges, City and County of Oxford*, 3 vols, Oxford 1925

RA 1956–7

British Portraits (exh.cat.), Royal Academy of Arts, London, 24 Nov. 1956–3 March 1957

RA 1967

Millais (exh.cat.), Royal Academy of Arts, London & Walker Art Gallery, Liverpool, Jan.–April 1967

RA 1972

Victorian and Edwardian Decorative Art: the Handley-Read Collection (exh.cat.), Royal Academy, London 1972

RA 1986

Alfred Gilbert (exh.cat.), Royal Academy of Art, London, 21 March –29 June 1986

Read 1975–6

B. Read, 'The Work of Rossetti and the Pre-Raphaelites at Llandaff' in *43rd Annual Report (1975–76) of the Friends of Llandaff Cathedral*, Cardiff, n.d.

Read 1982

B. Read, *Victorian Sculpture*, New Haven & London 1982

Read 1984

B. Read, 'Was There Pre-Raphaelite Sculpture?' in L. Parris (ed.), *Pre-Raphaelite Papers*, London 1984

Read 1989

B. Read, 'Sailing to Byzantium?' in J. Christian (ed.), *The Last Romantics*, London 1989

Roget

J. L. Roget, *A History of the Old Watercolour-Society*, 2 vols, London 1891

A. Rose

A. Rose, *Pre-Raphaelite Portraits*, Sparkford 1891

P. Rose

P. Rose, 'The Coloured Relief Decoration of Robert Anning Bell', *Journal of the Decorative Arts Society*, 14, 1990, pp.16–23

Rossetti 1867

W. M. Rossetti, *Fine Art, Chiefly Contemporary*, London & Cambridge 1867

Rossetti 1890

W. M. Rossetti, 'Portraits of Robert Browning I', *The Magazine of Art*, 13, 1890, pp.181–8

Rossetti 1895

W. M. Rossetti (ed.), *Dante Gabriel Rossetti: His Family Letters*, London 1895

Rossetti 1897

W. M. Rossetti (ed.), *Poems by the Late John Lucas Tupper*, London 1897

Rossetti 1899

W. M. Rossetti, *Ruskin: Rossetti: Pre-Raphaelitism Papers 1854–62*, London 1899

Rossetti 1906

W. M. Rossetti, *Some Reminiscences of William Michael Rossetti*, 2 vols, London 1906

RSBS

Royal Society of British Sculptors, *Modern British Sculpture . . . Works by Members etc.*, London 1922

RSPW 1864

Royal Society of Painters in Watercolour – 60th Exhibition, London, April 1864

Rugby 1879

Catalogue of Rugby School Art Museum, June & July, Rugby 1879

Rugby 1880

Catalogue of Rugby School Art Museum, June & July, Rugby 1880

Scott 1872

W. Bell Scott, *The British School of Sculpture*, London 1872

Scott 1892

W. Minto (ed.), *Autobiographical Notes of the Life of William Bell Scott etc*, 2 vols, London 1892

Seddon

J. P. Seddon, 'The Works of the P.R.B. in Llandaff Cathedral', *The Public Library Journal: A Quarterly Magazine of the Cardiff and Penarth Free Public Libraries and the Welsh Museum*, IV, 1903–4

Smith

M. Smith, *Bernhard Smith and his connection with art or the seven PRBs*, typescript, British Library 1917; Mitchell Library, Sydney; State Library of Victoria, Melbourne

SFA 1874

Society of French Artists, Ninth Exh. (exh.cat.), London 1874

Speight

H. Speight, *Upper Wharfedale*, London 1900

Spielmann

M. H. Spielmann, *British Sculpture and Sculptors of To-day*, London 1901

Stephens 1892

F. G. Stephens, *The Athenaeum*, no.3390, 15 Oct. 1892, p.522

Stephens 1893

F. G. Stephens, *The Magazine of Art*, 1893, pp.71–2

Stephens 1894

F. G. Stephens, 'Thomas Woolner RA', *Art Journal*, LVI, March 1894, pp.80–6

Surtees 1971

V. Surtees, *The Paintings and Drawings of Dante Gabriel Rossetti (1828–1882). A Catalogue Raisonné*, 2 vols, Oxford 1971

Surtees 1981

V. Surtees (ed.), *The Diary of Ford Madox Brown*, New Haven & London 1981

Surtees 1984

V. Surtees, *The Ludovisi Goddess: The Life of Louisa Lady Ashburton*, Salisbury 1984

Sweeney

J. L. Sweeney (ed.), *The Painter's Eye, Notes and Essays on the Pictorial Arts by Henry James*, London 1956

Swinburne

A. C. Swinburne, *Essays and Studies*, 4th ed., London 1897

Tate Gallery 1933

Burne-Jones Centenary Exhibition (exh.cat.), Tate Gallery, London 1933

Tate Gallery 1984
The Pre-Raphaelites (exh.cat.), Tate Gallery, London 1984

Taylor
H. Taylor, *Autobiography 1800–75*, 2 vols, London 1873

Temple
A. G. Temple, *Guildhall Memories*, London 1918

C. Tennyson & Dyson
C. Tennyson & H. Dyson, *Tennyson, Lincolnshire and Australia*, Lincoln, the Lincoln Association and Tennyson Society, 1984

H. Tennyson
H. Tennyson, *Lord Tennyson: A Memoir*, 2 vols, London 1897

Tokyo 1989
John Singer Sargent (exh.cat.), Tokyo and other Japanese locations 1989

Tolley
M. J. Tolley, 'William à Beckett's Copy of Young's "Night Thoughts"', *Art Bulletin of Victoria*, no.30, 1989, pp.24–35

Trevelyan 1978 (1)
R. Trevelyan, *A Pre-Raphaelite Circle*, London 1978

Trevelyan 1978 (2)
R. Trevelyan, 'Thomas Woolner: Pre-Raphaelite Sculptor: The Beginnings of Success' in *Apollo*, cvii, no.193 March 1978, pp.200–5

Trevelyan 1979
R. Trevelyan, 'Thomas Woolner and Pauline Trevelyan', *Pre-Raphaelite Review*, ii, no.2 May 1979

Tuckwell
W. Tuckwell, *Reminiscences of Oxford*, London 1900

Tupper, The Crayon
J. L. Tupper, 'Extracts from the Diary of an Artist', *The Crayon: A Journal devoted to the graphic arts and the literature related to them*, 1855, vol.ii, no.xi pp.159–60, no.xviii pp.271–2, no.xxi pp.319–21, no.xxii pp.336–7, no.xxiv pp.368–9, no.xxvi pp.400–40; 1856, vol.iii, pt ii pp.43–5, pt iii pp.75–7, 102–5, pt viii pp.234–6; the title then changed to *The Crayon, An American Journal of Art*, 1857, vol.iv, pt iv pp.103–7, pt v pp.145–9, pt vii pp.200–5

Tupper 1871
J. L. Tupper, 'English Artists of the Present Day – Thomas Woolner ARA, *The Portfolio*, no.13, Jan. 1871, pp.97–101

Vallance
A. Vallance, 'The Decorative Art of Sir Edward Burne-Jones', *Art Annual*, Easter, 1900, p.27

Walker
R. J. B. Walker, *A Catalogue of Paintings, Drawings, Sculpture and Engravings in The Palace of Westminster: Part iii, Sculpture*, London 1961

M. S. Watts
M. S. Watts, *George Frederic Watts*, 3 vols, London 1912

T. Watts
T. Watts, 'The Portraits of Lord Tennyson – I', *The Magazine of Art*, 16, 1893, pp.37–43

H. Weekes
H. Weekes, *The Prize Treatise on the Fine Art Section of the Great Exhibition 1851*, London 1852

Whitechapel Art Gallery
G. F. Watts (exh.cat.), Whitechapel Art Gallery, London 1974

Wilks & Bettany
S. Wilks & G. T. Bettany, *A Biographical History of Guy's Hospital*, London 1892

Witt
J. Witt, *William Henry Hunt 1790–1864. Life and Work with a Catalogue*, London 1982

Wood
T. Martin Wood, *Drawings of Sir Edward Burne-Jones*, London 1907

'Woolner's Studio'
Anon, 'Mr Woolner's Studio', *The City Press*, 20 May 1882

A. Woolner
A. Woolner, *Thomas Woolner, RA Sculptor and Poet: His Life in Letters*, London 1917

T. Woolner 1854
T. Woolner, *Queen of the South Journal*, 9 Aug.–11 Oct. 1854, photocopy in private collection, Melbourne

T. Woolner 1881
T. Woolner, *Pygmalion*, London 1881

Wright
S. M. Wright (ed.), 'The Decorative Arts in the Victorian Period', *Society of Antiquaries*, London 1989

List of Lenders

The Trustees of the Cecil Higgins Art Gallery, Bedford cat.13

City Museums and Art Gallery, Birmingham cats 4, 5, 8, 10, 21, 27, 64, 86, 87

Botany Department, University of Cambridge cat.78

The Syndics of the Fitzwilliam Museum, Cambridge cats 6a, 6b, 7, 46

The Mistress and Fellows, Girton College, Cambridge cat.23

The Principal and Fellows of Newnham College, Cambridge cat.80

Master and Fellows of Trinity College, Cambridge cats 67, 72

The Dean and Chapter, Llandaff Cathedral, Cardiff cat.69

The Marquess Northampton DL, Castle Ashby cats 28, 74

The Wordsworth Trust, Grasmere cat.56

The Governors of Christ's Hospital, Horsham cat.82

Borough Museums and Galleries, Ipswich cats 19, 65

Agnew's, London, cat.79

Joanna Barnes Fine Arts, London cats 9, 17, 22, 30, 54, 63, 85

The Fine Art Society, London cat.12

Guildhall Art Gallery, Corporation of London cat.18

Cyril Humphris, London cat.76

The Linnean Society of London cats 48, 49, 52

Matthiesen Fine Art Ltd, London cats 11, 38, 73

The Public Trustee, London cat.39

Royal Academy of Music, London cat.81

Royal College of Surgeons of England, London cat.51

The Trustees of the Royal Watercolour Society, London cat.35

The Salters' Company, London cat.88

The Trustees of the Tate Gallery, London cat.53a

University College, London cat.83

The Trustees of the Victoria and Albert Museum, London cats 16, 47

Pre-Raphaelite Inc. (by courtesy of Julian Hartnoll) cats 44a, 44b

Private Collections cats 1, 2, 3, 14, 15, 24, 31, 32, 34, 36, 37, 40, 41, 42, 43, 45, 50, 53b, 55, 57, 58, 59, 60, 61, 62, 66, 68, 70, 71, 75

The Acland Nuffield Hospital, Oxford cat.26

The Trustees of the Ashmolean Museum, Oxford cat.25

The Governing Body of Christ Church, Oxford cat.29

University Museum, Oxford cat.33

The Governors of the Royal Shakespeare Theatre (lent by Cynthia Fletcher), Stratford-on-Avon cat.77

William Morris Gallery, London Borough of Waltham Forest cats 20, 84

Acknowledgements

William Agnew, J. G. Allen, Steve Allen, James Austin, Gordon Balderston, Joanna Banham, Harold Bartram, Chloe Bennett, David Bindman, Robert Blackmore, Iona Bonham-Carter, Heidi Bradshaw, David Briggs, Judith Bronkhurst, The Librarian, Brotherton Collection, University of Leeds, Margaret Brown, Vicky Burgess, Marie Busco, David Buxton, Tony Chapman, J. R. P. Chapple, Dick Coats, Tania Cooper, Peter Cormack, Robin Creighton, Prudence Cuming, Jane Cunningham, Diana Cuthbert, The Very Rev A. K. Davies, Eileen Dawson, Dominic De Beaumont, I. Dickinson-Gill, Hugh Dixon, Gina Douglas, Christine Downer, Deborah Edwards, Geoffrey Edwards, Sebastian Edwards, Stephen Eeley, Godfrey Evans, Mrs James Evans, Emily Farrow, Tim Fisher, Jonathan Franklin, Terry Friedman, Peter Funnell, Ann Galbally, Albert Gallichan, Frances Gandy, the Hon. Ann Gascoigne, Norah Gillow, Brian Glover, Elizabeth Graham, Halina Graham, A. Grogan, Francesca Gugliemino, Richard Hamer, Robin Hamlyn, Dr Harley, Rupert Harris, Martin Harrison, Julian Hartnoll, Robert Headland, Barry Herbert, Constance Hill, Gareth Hughes, Cyril Humpris, Alison Inglis, Martin Israel, Barbara Jones, Mark Jones, David Jowett, Professor Joan Kerr, Vivien Knight, Alastair Laing, Terry Lane, Mary Lightbown, J. P. Losty, Ian Lyle, Jaqueline McComish, Mrs MacCrory, Frank McDonald, Patricia McDonald, Nan Mackay, Peter H. McKay, P. J. McKitterick, Kirsty McRoberts, the Hon. Crispin Money-Coutts, Mrs Monk, Edward Morris, Gordon Morrison, Tim Morton, Richard Neville, Nicholas Orchard, Richard Ormond, Michael Paraskos, Fiona Pearson, John G. B. Perry, Kate Perry, Jennifer Phipps, Nick Plumley, Derek Pullen, Anthony Radcliffe, Albert Read, Muff Read, Peter Rose, David Russell, Andrew Sayers, David Scaresbrook, David Scrase, Herta Simon, Peyton Skipworth, Elizabeth Smallwood, Alec Smith, Janet Snowman, Michael Spender, Lynn Spurr, Mary-Anne Stevens, Mark Stocker, Virginia Surtees, Keith Taylor, Adrian Tilbrook, Steven Tomlinson, Raleigh Trevelyan, Marjorie Trusted, David Tulissio, Susanna Turner, Jennifer Turpie, Helen Valentine, Michael Watson, Catherine Whistler, Lucy Whitaker, Jon Whiteley, Tim Wilcox, Stephen Wildman, Robert Woof, Irene Zdanowicz

Photographic Credits

Grateful acknowledgement is made to the following for the supply of and the permission to reproduce photographs: Royal Collection, St James's Palace, copyright Her Majesty The Queen col.pl.8. Ashmolean Museum, Oxford cat.25; James Austin col.pls 1, 4, 5 (detail). Australian National Gallery, Canberra fig.14. Birmingham City Museums and Art Gallery col.pl.6; cats 4, 5, 8, 10, 21, 27, 64, 86, 87; figs 8, 9, 10, 27, 47. The Trustees, The Cecil Higgins Art Gallery, Bedford cat.13. The Governing Body, Christchurch, Oxford cat.29. A. C. Cooper cats 34, 38; fig.31. By courtesy of The Conway Library, Courtauld Institute of Art, London cats 16, 23, 24, 26, 28, 31, 32, 33, 35, 37, 40, 41, 42, 44a, 44b, 48, 49, 52, 53b, 55, 67, 68, 69, 70, 71, 72, 74, 75, 78, 80, 81, 88; figs 6, 12, 15, 16, 17, 18, 19, 20, 22, 24, 26, 29, 30, 32, 33, 35, 36, 39, 40, 41, 44, 45, 54, 55. Prudence Cuming Associates Ltd col.pls 2, 7; cats 9, 11, 22, 43, 45, 73, 76, 79, 82, 85. The Fine Art Society, London cat.12. Fitzwilliam Museum, Cambridge, cats 61, 6a, 7, 46; fig.48. Ipswich Art Gallery, Corporation of London cat.18. Guildhall Borough Museums and Galleries cats 19, 65. Reproduced by kind permission of the President & Council of the Royal College of Surgeons, London cat.51. Musée d'Orsay, Paris fig.49. National Museum of Wales, Cardiff fig.50. National Portrait Gallery, London cats 57, 58, 59, 60, 61, 62. By courtesy of The Photographic Survey of the Courtauld Institute of Art, London cats 1, 2. Benedict Read figs 1–4, 23, 25. Royal Commission on the Historical Monuments of England, London figs 7, 21, 34. Royal Shakespeare Company cat.77. David Russell col.pl.3; cat.39. State Library of New South Wales fig.28. State Library of Victoria, Australia fig.11. Gary Summerfield cats 50, 63; fig.13. The Tate Gallery, London cat.53a. Rodney Todd White and Son cats 3, 17, 30, 54, 66; fig.43. University College, London cat.83. Reproduced by courtesy of the Board of Trustees of the Victoria and Albert Museum, London cat.47; figs 5, 51, 52. William Morris Gallery, London Borough of Waltham Forest cats 20, 84; fig.46. Wordsworth Trust, Grasmere cat.56

List of Exhibits

Robert Anning Bell
cat.1 Mermaid
cat.2 Mother and Children

John Brett
cat.3 Alexander Munro

Edward Burne-Jones
cat.4 Two Nude Children
cat.5 Pygmalion and the Image – The Hand Refrains
cat.6a The Nativity
cat.6b The Entombment
cat.7 Study for Perseus in 'The Finding of Medusa'
cat.8 Study for Perseus in 'The Finding of Medusa'

George Frampton
cat.9 Alis La Beale Pilgrim
cat.10 Lamia
cat.11 Enid the Fair

Alfred Gilbert
cat.12 Perseus Arming
cat.13 St George

John Hancock
cat.14 Christ's Journey to Jerusalem
cat.15 Christ Led to Crucifixion
cat.16 Beatrice
cat.17 Undine
cat.18 Penserosa

Alphonse Legros
cat.19 Thomas Woolner

John Everett Millais
cat.20 Alexander Munro

Alexander Munro
cat.21 Paolo and Francesca
cat.22 Lady Constance Grosvenor
cat.23 Josephine Butler
cat.24 Agnes Gladstone
cat.25 Hippocrates
cat.26 Henry Wentworth Acland
cat.27 Repose. Study of a Babe
cat.28 William Bingham, Lord Ashburton
cat.29 Henry Hallam
cat.30 Lovers' Walk
cat.31 Kenneth James Matheson
cat.32 Mary Isabella Matheson
cat.33 Benjamin Woodward
cat.34 William Pole Carew
cat.35 William Henry Hunt
cat.36 Mary Munro
cat.37 Fountain Nymph
cat.38 Young Romilly
cat.39 Eva Butler with Live Dove
cat.40 Emily Ursula Hamilton
cat.41 Three Children
cat.42 The Duchess of Vallombrosa

William Ernest Reynolds-Stephens
cat.43 Happy in Beauty, Life and Love and Everything
cat.44a Sir Lancelot and the Nestling
cat.44b Guinevere and the Nestling
cat.45 Pro Mundo Mortuus

Dante Gabriel Rossetti
cat.46 How They Met Themselves

John Singer Sargent
cat.47 How They Met Themselves

Bernhard Smith
cat.48 James Clark Ross
cat.49 John Richardson
cat.50 The Schoolmaster

John Lucas Tupper
cat.51 John Hilton
cat.52 Thomas Bell

Thomas Woolner
cat.53a Puck
cat.53b Puck
cat.54 Little Red Riding Hood
cat.55 William Wordsworth
cat.56 Model for the Wordsworth Memorial
cat.57 Charles Joseph Latrobe
cat.58 Sir Charles Augustus Fitzroy
cat.59 Edward William Terrick Hamilton
cat.60 James Macarthur
cat.61 Sir James Martin
cat.62 William Charles Wentworth
cat.63 Oriana Fanning
cat.64 Robert Browning
cat.65 Love
cat.66 Alfred Tennyson
cat.67 Alfred Tennyson
cat.68 Sir James Brooke, Rajah of Sarawak
cat.69 Moses on Mount Sinai
cat.70 Sir Thomas Fairbairn
cat.71 Emily Tennyson
cat.72 Adam Sedgwick
cat.73 Reliefs from The Iliad
cat.74 William Bingham, Lord Ashburton
cat.75 William Ewart Gladstone
cat.76 Heavenly Welcome
cat.77 Ophelia
cat.78 Charles Darwin
cat.79 In Memoriam
cat.80 William Whewell
cat.81 The Charles Lucas Medal
cat.82 The Coleridge Memorial Prize
cat.83 Thomas Hewitt Key
cat.84 John Stuart Mill
cat.85 A Gentleman
cat.86 Dorothy
cat.87 John Laird Mair Lawrence
cat.88 The Housemaid